Object-Oriented Feminism

Object-O

Femin

Oriented
sm

Katherine Behar, Editor

 University of Minnesota Press
Minneapolis • London

Published by the University of Minnesota Press
111 Third Avenue South, Suite 290
Minneapolis, MN 55401-2520
http://www.upress.umn.edu

Printed in the United States of America on acid-free paper

The University of Minnesota is an equal-opportunity educator and employer.

22 21 20 19 18 17 16 10 9 8 7 6 5 4 3 2 1

Library of Congress Cataloging-in-Publication Data
Names: Behar, Katherine, editor.
Title: Object-oriented feminism / Katherine Behar, editor.
Description: Minneapolis : University of Minnesota Press, 2016. | Includes bibliographical
 references and index.
Identifiers: LCCN 2016026787 | ISBN 978-1-5179-0108-0 (hc) | ISBN 978-1-5179-
 0109-7 (pb)
Subjects: LCSH: Object (Philosophy) | Feminist theory.
Classification: LCC BD336 .O245 2016 | DDC 305.4201—dc23
LC record available at https://lccn.loc.gov/2016026787

Contents

Katherine Behar

An Introduction to OOF

A Prelude: Bunnies

Spring 2010. I am excited but a little wary as I travel to Atlanta, where the Georgia Institute of Technology is hosting a one-day symposium, "Object-Oriented Ontology." An offshoot of speculative realist philosophy, object-oriented ontology (OOO) theorizes that the world consists exclusively of objects and treats humans as objects like any other, rather than privileged subjects. This thing-centered nonanthropocentrism has captured my imagination, and I am attending the conference because I am certain of the potential for feminist thought and contemporary art practice. After all, both feminism and art have long engagements with the notion of human objects. The symposium is energetic and provocative, with an intangible buzz circulating among people feeling out new contours. Nonetheless, I become aware that my concern about gender imbalance in OOO,[1] while significant, pales beside a far graver feminist problem: there is not a single bunny at this conference. How could this be?

The OOO author Ian Bogost, the symposium organizer, narrates the circumstances surrounding OOO's omission of bunnies in his book *Alien Phenomenology, or What It's Like to Be a Thing*.[2] He describes how he designed a feature for the symposium website that would show a single random Flickr image of an object. His software, which he refers to as the "image toy," queries Flickr's database for images tagged by users as "object" or "thing" or "stuff" and displays a random

result, with a new random selection overwriting the prior image upon reload. Its surprising mismatches express a wondrously unpredictable and nonanthropocentric "universe of things."

The image toy is significant for object-oriented ontology because it illustrates the central notion of "carpentry," a praxis-based, materialist form of philosophical inquiry.³ In Bogost's words, "carpentry entails making things that explain how things make their world." The image toy generates what he calls a "tiny ontology," a microcosmic image of the diversity of being. But it is the sad fate of this tiny ontology to appear on a website advertising the OOO symposium. There, what the toy object makes is a world of trouble. Bogost explains:

> The trouble started when Bryant, one of the symposium speakers, related to me that a (female) colleague had shown the site to her (female) dean—at a women's college no less. The image that apparently popped up was a woman in a bunny suit. . . . [The] dean drew the conclusion that object-oriented ontology was all about objectification.

This sounds like "trouble," indeed! And the OOO response is radical—to reprogram the ontology itself:

> [As] anyone who has used the Internet knows all too well, the web is chock-full of just the sort of objectifying images exemplified by the woman in the bunny suit. Something would have to be done lest the spirit of tiny ontology risk misinterpretation. I relented, changing the search query . . .

With that, the appearance of sexually objectified women within the toy's tiny ontology provokes a decision to eliminate the offensive objects altogether by altering the Boolean code. Edited, the toy now displays only images that *are* tagged as "object" or "thing" or "stuff," *and are not* tagged as "sexy" or "woman" or "girl."

In what can only be characterized as ontological slut shaming, bunnies—which is to say, sexualized female bodies—are barred from ontology. And if, reading this, we think OOO must be joking by committing to this founding gesture (in print, at that), it is assuredly not. Now this ontology looks not only tiny but impoverished.

In many ways this episode stands as a parable for the complex tensions between feminism and object orientation. In their responses

to bunnies, both object-oriented ontologists and feminists (if we are to assume the women's college dean is one) end up enacting crippling misrecognitions of the stakes around objects, objectification, and material practices. I return to this scenario, and unpack its rich ironies, in a case study later in this chapter. But first, fast-forward to the fall of 2014. Many of the authors in this volume are in Dallas for the Society for Literature, Science, and the Arts conference. SLSA's interdisciplinary meetings have provided a quirky and remarkably unpretentious home for staging six panels over four years that have laid out the foundations for feminist object-oriented thought: OOF. Now, in Dallas, we are convening a roundtable where Irina Aristarkhova poses a sly question: *Is OOF a joke?*

As one might suspect, the answer can only be *maybe*. OOF—a grunt of an acronym meant to stand for "object-oriented feminism"—is, after all, called "OOF." And faced with situations like these, what other response can we muster?

OOF

OOF originated as a feminist intervention into philosophical discourses—like speculative realism, particularly its subset OOO, and new materialism—that take objects, things, stuff, and matter as primary. It seeks to capitalize perhaps somewhat parasitically on the contributions of that thought while twisting it toward more agential, political, embodied terrain. Object-oriented feminism turns the position of philosophy inside out to study objects while being an object oneself. Such self-implication allows OOF to develop three important aspects of feminist thinking in the philosophy of things: politics, in which OOF engages with histories of treating certain humans (women, people of color, and the poor) as objects; erotics, in which OOF employs humor to foment unseemly entanglements between things; and ethics, in which OOF refuses to make grand philosophical truth claims, instead staking a modest ethical position that arrives at being "in the right" even if it means being "wrong."

Welcoming wrongness affords OOF a polyamorous knack for adopting multiple, sometimes contradictory perspectives. Readers will find that among the chapters in this volume, there is neither an interest in resolving difference nor an investment in arriving at an ontologically

"correct" master theory. As a result, OOF holds itself in tension with the many discourses it touches and is always as ready to apply a thought as trouble it. This variance prioritizes feminist intersectionality, which ontological framings, hinging on totality and exclusivity, would seem to overwrite. Accordingly, this volume and OOF as a whole aim to bring intersectionality to the fore, and to unsettle, queer, interject, and foment more critical work around the resurgence of objects and all things material in contemporary thought.

Reflecting feminist ideals of inclusivity, OOF forges alliances by participating in endeavors in theory and practice that share not only OOF's commitment to feminism but also its key interests in nonanthropocentrism and the nonhuman, materialism and thingness, and objectification and instrumentalization. For example, work in feminist new materialisms that highlights our common condition as matter to overcome anthropocentric human–nonhuman distinctions is compatible with OOF's concern with object relations (and is explored in greater detail in the section on erotics below); and this same concern connects OOF with artistic and curatorial practices that establish representational and nonrepresentational relationships between objects. Studies of the Anthropocene, exposing the ecological fallout of utilitarian objectification of the planet, or studies in digital labor, examining the productivist networking of human and nonhuman data objects, likewise align with OOF's object-oriented analysis of exploitation (and are discussed in the section on objects and objections and the section on politics, respectively). Simultaneously, OOF's methodological stakes in praxis introduce object theory to forms of feminist and social justice activism that also interrogate and seek to transform the very power relations objectification describes (and are considered in the section on being otherwise oriented as well as in a case study, using the bunny example, in the section on ethics).

Accordingly, while OOO and speculative realism represent important points of reference (and provide significant points of departure), they are by no means the only or primary context for OOF. Indeed, as I show, OOF's approach to these and all subject areas involves appropriating certain elements and rejecting others, always in the interest of cultivating feminist praxis. Though OOF's sights are set on broader horizons than the narrow philosophical position staking that sometimes echoes in these debates, its accordances with

and deviations from OOO and speculative realism nevertheless warrant special elaboration in the remainder of this section on OOF's genealogy.

OOF gladly seizes on speculative realism's nonanthropocentric conception of the world as a pluralist population of objects, in which humans are objects no more privileged than any other. This provides a welcome respite from theories of subjecthood that many feminist philosophers point out are fundamentally dependent on the logic of phallocentrism. It also avails itself of the important insight that in objects we can locate ontic "realism." This too promises a positive return to the "real world" after a generation of feminist thought that has been accused of ascribing gender as a construct in language.[4] However, these merits notwithstanding, as its awestruck acronym might imply, OOO's tone often appears somewhat too elated by discovering a universe composed of objects. What is more, OOO seems to relish, in the idea that humans too are objects, a sense of liberation from the shackles of subjectivity, especially from the "unreal" delusions of correlationism.[5] Finding neither of these positions tenable, OOF therefore positions itself as a friendly if pointed rejoinder, reminding this flourishing philosophical discussion first, that object-oriented approaches to the world are practiced in disciplines outside philosophy, and second, that all too many humans are well aware of being objects, without finding cause to celebrate in that reality.

Thus, by swapping OOO's gasp for a gutsier grunt, OOF aims to inject feminism into this discourse, but without dismissing these notions that, in fact, are essential for contemporary activism. To this point, a third contention of OOO, developed in the work of Graham Harman, is that objects are fundamentally withdrawn and sealed off from one another.[6] For feminists, this idea is particularly provocative: those concerned with activist struggles in late capitalism would do well to imagine its implications. On the one hand, the separateness of objects recalls Jean-Paul Sartre's theory of seriality, an idea Iris Marion Young applied to the feminist movement to account for political affiliation of individuals mobilizing around an issue without being reduced to group identity.[7] But on the other, withdrawn objects suggest an end to affiliation as such, and with it the neoliberal imperative to network individuals into populations. This ambiguity should give us pause. Despite OOO's disavowal of "object-oriented programming," it can

be no coincidence that object-oriented thinking is emerging at a historical juncture characterized by networks, or the capacity for ordering through code. Programmability is paramount. It remains to be seen whether this may prepare objects for a feminist conception of networks such as Donna Haraway's "integrated circuit," or whether "withdrawal" makes objects more or less susceptible to regimes of control.[8] Steven Shaviro and others favor versions of speculative realism that privilege Whiteheadian relation over Harman's isolated objects, and in this respect would appear compatible with Haraway's notion of a connectivity that reflects and resists the ubiquity of code toward feminist ends.[9] As Haraway explains, "'Networking' is both a feminist practice and a multinational corporate strategy—weaving is for oppositional cyborgs."

In fact, we might say the same of branding. On this front, OOF takes this cue from OOO: it is a brand. As a brand, object-oriented ontology has leveraged a calculated posture of coolness to make waves among various communities. OOO struck some as radical partly because it was largely developed in the blogosphere and could afford a somewhat punkish attitude toward institutionalized forms of academic publishing, appearing to buck a blindsided and sluggish philosophical establishment. However (notwithstanding Timothy Morton's suggestion that OOO's politics may be anarchic), the self-proclaimed radicality of OOO's discursive intervention was not matched by a radical politics. For this reason, and no doubt coupled with the fact that the primary OOO authors were four white men (from whom the choice to *not* engage politics might appear as an act of privilege), OOO left some readers with a bad aftertaste and feelings of frustration.

This is where OOF steps in, offering an alternative brand that is, following Haraway's vision, both a feminist practice and a multinational corporate strategy. OOF is a brand for oppositional cyborgs. So is it a joke? Consider: Object. Oriented. Feminism. Perhaps this sounds funny? Surely, taken together, these terms are either paradoxical or redundant. After all, doesn't feminism already deal with objectification? Or on the contrary, isn't feminism oriented toward subjects, not objects? Doesn't object-oriented thought, at least as espoused in recent speculative realist ontologies, steer clear of the political, which is the avowed terrain of feminism? As one must expect, OOF's surface silliness carries seeds of something serious.

Objects and Objections

What is the object of a feminist orientation? Historically, feminism's object or at least its *objective* has been political. Specifically, it has involved inward ways of orienting politics through subjectivity, whether translating private domestic practices into the public sphere of politics or advancing inner personal affect as a source of knowledge. But what if the *impersonal* is political?[10] A better question to ask might be *who* is the object of feminism? Feminist politics might also arise from outward orientation, from looking to the abounding realm of inanimate, inert, nonhuman objects. In this case, the call for solidarity should be to rally around objects, not subjects. Primarily a white, male, hetero, abled, rational heir to Enlightenment humanism, the subject is a red herring. Immersed among other objects, a "personal" experience of subjecthood, as in culturally or legally viable personhood, might proceed for some human objects, but only secondarily, and given this baggage it is something to be questioned, not prized.

Orientating feminism toward objects means attuning it to the object world. While at first such a move may seem to risk abandoning the concerns of real human subjects (i.e., women), the object world is precisely a world of exploitation, of things ready-at-hand, to adopt Harman's Heideggerian terminology.[11] This world of tools, there for the using, is the world to which women, people of color, and the poor have been assigned under patriarchy, colonialism, and capitalism throughout history. If, in Audre Lorde's famous words, "the master's tools will never dismantle the master's house," how are we, as feminists, to account for "tool being" as Harman would have it, much less his notion of "carpentry" developed by Bogost?[12]

Perceiving continuity with other objects in the world, not as subjects but as subject to subjects' dominion, allows us to rework assumptions about feminist political priorities and the what and who of feminist ethics. Object-oriented feminism does not abandon feminist attention to interiority. Rather, as Bogost commented in his response to OOF's 2010 panels, the speculative realist philosopher Quentin Meillassoux's entreaty to "re-join 'the great outdoors'" is a metaphor he ordinarily cites "as a lever to show how big and great the world is outside our tiny, forlorn minds." However, Bogost notes that object-oriented feminism shows

the value of looking for the outdoors inside. Indeed, one of the goals and victories of feminism involves making insides and outsides accessible and welcoming, whether they involve rights, ideals, identities, or everyday practices. And when we go outside, we track that world's dirt back in, and vice versa.[13]

Object-oriented feminism's intervention is to approach all objects from the inside-out position of being an object, too.

Shifting focus from feminist subjects to feminist objects extends a classic tenet of feminism, the ethic of care, to promote sympathies and camaraderie with nonhuman neighbors. For instance, consider Evelyn Fox Keller's classic work on gender and science in which scientific "objectivity" is gendered as masculine precisely because it enforces "the reciprocal autonomy of the object," forbidding erotic entanglements that confuse boundaries of self and other,[14] or Maria Puig de la Bellacasa's more recent work on care as ontological as opposed to moral, as it is more typically understood. Drawing on work by Haraway, Sandra Harding, and others, Puig de la Bellacasa defines care, practiced through "*thinking-with, dissenting-within,* and *thinking-for,*" as a central function in relational ontology.[15] In keeping with ecofeminisms and cyberfeminisms, these transfers from subject to object welcome absurd coalitions and hospitably accommodate asociality.

A feminist perspective imparts political urgency to the ideas that humans and nonhuman objects are of a kind, and that the nonsubjective quality of being an object is grittily, physically realist. Recall, for example, the theory of Gaia as living mother Earth, or Haraway's cyborg, a part-organic, part-cybernetic feminist hybrid. These examples induce what Haraway names interspecies companionship,[16] including companionship with inorganic "species" of objects, and they cultivate new forms of becoming other than strictly human.

Moreover, reorienting from feminist subjects to feminist objects puts critiques of utilitarianism, instrumentalization, and objectification in no uncertain terms. People are not treated "like" objects when they are objects as such from the outset. By extending the concept of objectification and its ethical critique to the world of things, object-oriented thinking stands to evolve feminist and postcolonial practices to reconsider how the very processes of objectification work. In this new terrain, what does it mean for feminists to objectify someone

who is already an object? What is the transformative potential for a feminist politics that assumes no transformation, when all things are and remain objects? Bringing such notions to bear makes for a politics that is real without being speculative, enriching both new theories of things and feminist discourses.

These feminisms undertake an important political function. Redirecting feminism from a paradigm of personal visibility toward what Elizabeth Grosz calls the impersonal politics of imperceptibility,[17] object-oriented feminism shifts its operational agencies from a "politics of recognition," of *standing out*, to a politics of immersion, of *being with*. Following Grosz, imperceptibility supplants the Hegelian framework of reciprocal identity formation that concerns "the becoming of being" and is inseparable from individuation and subjecthood, with a Nietzschean model in which active, self-modifying forces unfurl, "[seeking] the being of becoming."[18] Here, object-oriented feminism coincides with perspectives in feminist new materialisms, wherein our common status as matter makes way for continuity between all objects, whether human or nonhuman, organic or inorganic, animate or inanimate.[19]

To this end, Patricia Clough describes how recent work on bodies, science, and technology propels feminist theory to "[open] the study of bodies to bodies other than the human body."[20] For Clough, this revision forges compatibility, even co-constitution, between bodies and the technics of measurement that support advances in genetics and digital media. Underscoring this same technicity, Nigel Thrift conceives of a transformation within capitalism toward territorializing a "new land" on the model of tenancy in which "site, organic and inorganic bodies, and information are mixed up in an anorganic mass that is continuously cultivated—but with a much greater turnover time."[21] New materialist authors along with numerous others including Morton and Elizabeth A. Povinelli (both in this volume) emphasize how this understanding of continuity between humans and the material world is revealing itself in new ways as we near ecological collapse on a planetary scale in the Anthropocene, a new geological era marked by immense human influence on the Earth.[22]

Similarly striving to shed subjecthood—which is to say, the damaging legacy of humanist exceptionalism—object-oriented ontologists and speculative realists also embrace objecthood. They view the latter

as a way to liberate humans from the trap of correlationism, precisely because correlationism is so deeply entangled with Enlightenment humanism's conception of the thinking subject.[23] But here we must tread lightly. For while the intention to slough off the humanist trappings of subjecthood is worthy as a gesture toward feminist camaraderie with nonhumans, in practice it is likely to remain aspirational; and while, for those not already accustomed to it, human objecthood (which is not to say subjecthood) can be illuminating, rarely will it prove liberating. Certainly examples of objectification's benefiting the objectified are few and far between.

Otherwise Oriented

Object-oriented feminism participates in long histories of feminist, postcolonial, and queer practices and promotes continuity with and accountability to diverse pasts stemming from multiple regions and disciplines.[24] To wit, the chapters in this book reflect multiple orientations spanning science and technology studies, technoscience, bioart, philosophy, new media, sociology, anthropology, performance art, and more.[25] In philosophy, the main foci for object-oriented inquiry include relations between objects, objects' phenomenological encounters, objects in "flat" or nonhierarchical arrangements, relations and interactions between objects, and assemblages of objects. But of course these important questions are not solely philosophical pursuits, and during the past century practitioners of avant-gardism, feminism, and postcolonialism have frequently found traction in similar ideas. Indeed, the "object" in object-oriented feminism connects with past and present engagements and experiments including nonanthropocentric art practices,[26] queer/postcolonial/feminist critiques of objectification and marginalization, and psychoanalytic critiques of relation.[27]

For example, Frantz Fanon famously described the experience of being "sealed into ... crushing objecthood" upon realizing that he "was an object in the midst of other objects."[28] Or, in quite a different spirit of investigation, the artist Lawrence Weiner wrote of his work, "ART IS NOT A METAPHOR UPON THE RELATIONSHIP OF HUMAN BEINGS TO OBJECTS & OBJECTS TO OBJECTS IN RELATION TO HUMAN BEINGS BUT A REPRESENTATION OF AN EMPIRICAL EXISTING FACT."[29] By

invoking representation, Weiner contradicts what Rick Dolphijn and Iris van der Tuin herald as new materialism's antirepresentationalism, pushing instead for a form of facticity in objects, like Fanon's "fact of blackness."[30] In this sense, we can understand what Weiner calls "the reality concerning that relationship" between human beings and objects and objects and objects as their orientation.

Along these lines, Fanon's comment harks back to Edward Said's orientalism, the dynamic by which the objectified Other orients and thus confirms the subject's central position.[31] Here, our pursuit of a feminist object-orientation brings us unexpectedly to Sara Ahmed's "queer phenomenology," a specifically subject-oriented endeavor. Usefully for OOF, Ahmed's excavation of queer orientations leads her to parse multiple meanings of "orient" and to distinguish between being "orientated toward" and being "orientated around."[32] In orientalism, and under conditions of white supremacy, we are orientated "toward" the Orient, the East as visible object (disorientingly overembodied in the racialized/sexualized/classed other), but orientated "around" the Occident, the West as transparent whiteness (embodied in habit, which goes always overlooked). The blind spots inherent to this dynamic require our close attention, precisely because in its object orientation, OOF suffers from a similar scheme. We must recognize that even this volume, OOF's first effort, contains too little material on the specific concerns of people of color. So criticisms of OOO, speculative realism, and new materialism's whiteness, and of mainstream feminism's whiteness, pertain, disappointingly, to this endeavor

ART IS NOT A METAPHOR UPON THE RELATIONSHIPS OF HUMAN BEINGS TO OBJECTS & OBJECTS TO OBJECTS IN RELATION TO HUMAN BEINGS BUT A REPRESENTATION OF AN EMPIRICAL EXISTING FACT
IT DOES NOT TELL THE POTENTIAL & CAPABILITIES OF AN OBJECT (MATERIAL) BUT PRESENTS A REALITY CONCERNING THAT RELATIONSHIP

Figure I.1. Lawrence Weiner, *Notes from Art (4 pages)*, 1982. Detail of an artist project originally published in "Words and Wordworks," the summer 1982 issue of *Art Journal*. Copyright 2015 Lawrence Weiner / Artists Rights Society (ARS), New York.

as well—but can feminist object-orientation help us to understand why, or what we might do otherwise?

For Ahmed, being orientated toward something is "to take up" that thing as thing, but being orientated around something is "to be taken up" by a thing, so that that thing becomes the very "center of one's being or action."[33] In OOF, even when we construe ourselves as objects among objects, we take ourselves up as things, "orientating toward" our selfsame objecthood. Yet perhaps we are "orientating around" a larger and still unanswered question of what to do with our objecthood as such. For example, while the (white) feminist struggle has made room for postfeminism as one possible answer to this question, the antiracist struggle does—and should—not accept postraciality.[34] Indeed, these two possibilities for "post" objecthood answer the question of what we can do otherwise with our objecthood quite differently: either claim objectification, giving it heightened visibility, or deny if not objectification then its salience, further obscuring it. In the latter, objectification threatens to disappear from awareness, like another Occidental habit. This sharp divergence signals a serious pressure point requiring close reflection and demands that future OOF inquiry "take up" conditions of white supremacy—conditions that may be so fundamental to our understanding of objectification, utilitarianism, and exploitation that we have become inadvertently "taken up by" them, even when considering our own objecthood.

In this, OOF connects with object-oriented work in feminist indigenous studies, such as Kim TallBear's revealing studies of Native American DNA and pipestone, or Povinelli's work on aboriginal arrangements and "geontology," in which race, object-orientation, and indigenous nonanthropocentrism converge around questions of sovereignty.[35] Indigenous approaches to nonanthropocentrism and object-orientation forge a distinct line between an artifactual mode, also employed in object-oriented theory, and a vitalist perspective that also appears in new materialism. This stance is compatible with OOF, especially insofar as it is forthright about having real political objectives. Here, again, OOF departs from ontological speculation. For if, to borrow Weiner's phrase, this is "the reality concerning that relationship," then "reality" will require intervention and change. So object-oriented feminism professes no innocence, but offers a prescriptive activist practice, rejecting the noninterventionist, descriptive stance of

ontologists—which remains too redolent of the aloof distancing of orientalism.

Erotics: Methods by Artificial Means

Orientalism's object-Other anchors and guarantees the occidental subject's so-called "view from nowhere," making a further leap from objectification to objectivity. Yet, as Lorraine Daston notes in her history of "aperspectival objectivity," contemporary understandings of objectivity are founded in the nineteenth century's distancing of scientific activity from the individualistic artistic or philosophical subject position cultivated in intellectual solitude.[36] Instead, aperspectival objectivity, which becomes synonymous first with scientific objectivity and later with objectivity in general, was understood to arise out of scientific correspondence in burgeoning communication networks: an anonymous, convivial, (and often deskilled) collective mind. While we often consider rational, disinterested objectivity to be a hallmark of humanist subjects, it in fact emerges at the moment when creative individual subjects disseminate into networks of things.

Hence, in practice, and a shared commitment to nonanthropocentrism, OOF also resonates with new materialist thought, in particular with feminist new materialism.[37] OOO and OOF share a constructivist orientation; in new materialism, methods often manifest around scientific experimentation with all manner of objects. This includes even minute and slippery objects residing well below the usual threshold for human access such as those at the undeniably nonanthropocentric level of quantum physics. For example, a physicist as well as a philosopher, Karen Barad demonstrates how new materialism provides opportunities for testing out certain theories about time, identity, and so forth, in an empirical laboratory setting.[38]

Object-oriented feminism shares this penchant for experimentation over speculation. Where an ontologist might speculate, describing the world, "This is the way things are," object-oriented feminists and feminist new materialists engage in the world using experimental praxis, "This is a way of being with things." Or more simply, "This is a way of being things." With experimentation, feminist new materialism embraces the agency of things, apart from any human influence. Like the Whiteheadian "panpsychism" Shaviro identifies in speculative

realism, new materialism defers to the abounding animism in the world of things,[39] as well as to political formations that need not include humans.[40] So, with careful attentiveness to objects, and the precise orientation of self into a human–nonhuman assemblage, the work of Jane Bennett yields a material world rife with impersonal affective power and loaded with thoughtful implications for human–nonhuman politics. In *Vibrant Matter*, Bennett describes the independent "thing-power" of "man-made objects" to "become vibrant things with a certain effectivity of their own, a perhaps small but irreducible degree of independence."[41] Encounters with the outside world of things, including inorganic matter, expose their "vibrant" quality, seducing and estranging us.

Whereas Barad's experiments occur against the more rarified backdrop of a physics lab, Bennett's are conducted in daily experience, at such banal sites as an unswept sidewalk. This broad and nonhierarchical experimentalist disposition is shared by object-oriented feminism and echoes over the wide range of objects engaged in the different chapters of this volume. In any milieu, experimentation is always participatory, always both observational and interventionist. This allows for tinkering with received truths, priming us for alliances with hacked realities, investigative arrangements in living, and radical aesthetic practices in art.

Anne Pollock has observed that objects in object-oriented feminism, as in OOO, are usually blatantly artificial things, typical of engineering and art.[42] Here, object-oriented feminism and new materialisms may begin to diverge. New materialism's object of study is frequently a thing of science, some essential dollop or granular manifestation of matter that originates in the natural world. Like the human-made objects that emit Bennett's thing-power, or Haraway's naturecultures, artificial objects can lay no claim to any purity or the naturalness that might be associated with proper scientific inquiry.[43] Perhaps for this reason, new materialism's approach often bears a note of sincerity, of reverence for something that is, in some way, yet pure.

Contrast this with Aristarkhova's assertion that humor is a feat of thought that is becoming increasingly difficult for theorists, philosophers, and even scientists, but can be achieved by artists, immersed as they are in artifice. Rooted in Friedrich Nietzsche's nihilistic will to

laugh at truth, OOF's humor is in keeping with traditions of radical feminist laughter.[44] Moreover, and key for object-oriented feminist methodologies, humor is a creative, constructivist practice. Humor, too, is a form of making—making ourselves laugh.

For example, Annie Sprinkle's *Public Cervix Announcement* crystallizes object-oriented feminist humor through performance art. Sprinkle, reclining with a speculum inserted into her vagina, invites audience members to approach her with a flashlight to familiarize themselves with the cervix's hidden beauty.[45] For OOF, this performance is seminal (pun intended) first and foremost for placing the object of the cervix, quite literally, on center stage. Moreover, as a former sex worker and porn star, Sprinkle is uniquely self-possessed of her own status as a sex object, and by objectifying herself in her performances, she foments radical laughter, joy, and pleasure. Writing with characteristic cheeky cheeriness about this project, Sprinkle states, "I adore my cervix. I am proud of her in every way, and am happy to put her on display." To those who call her work demystification, she quips, "You can never demystify a cervix."

This generative aspect of laughter brings to mind the erotic, precisely as it complicates science's truth claims. Fox Keller writes, "The image of science is antithetical to Eros."[46] She perceives a connection between the desexualization of science and its masculine gendering, which, she observes, "connotes a radical rejection of any commingling of subject and object . . . consistently identified as male and female." And so Isabelle Stengers laments, "Our sciences no longer make us laugh."[47] Like the preference for lowbrow artificiality over purebred knowledge, Stengers's laughing science aspires to the passion of amateurism and the promiscuity of outside influences. "Scientists," she affirms, "might ally with other passions."

The serious endeavor of science as such hinges on prohibiting both erotic generativity and nonheteronormativity. To this end, Angela Willey calls for "new conceptual resources that problematize biology as the locus of claims about the materiality of bodies" that she finds problematically invoked in feminist new materialisms.[48] The existing methods will not do. Willey draws on Audre Lorde's expansive erotics: inclusive human–nonhuman intimacies that "[postulate] . . . no qualitative difference between the experiences of building a bookcase, thinking about an idea, making love to a woman, listening to music,

and writing a poem."[49] All of these "other passions," as Stengers puts it, revivify joy. Although Lorde's eroticism accepts nonhuman entanglements, it remains life- and self-affirming. Perhaps surprisingly, then, OOF's erotics are better aligned with a version of eroticism theorized by Georges Bataille, as the radical surrender of self in becoming other-than-subject. Through physical, emotional, and religious eroticism, "discontinuous" individuals attain continuity with the object world. Forgoing the subject's instinct for self-preservation, eroticism heeds no boundary, neither the boundary between self and other, nor even the boundary between life and nonlife, putting connection and continuity with the world above self-annihilation. "Eroticism," Bataille writes, "is assenting to life even in death." Bataille's eroticism remains grounded in a humanist subject-position of sovereignty (doomed insofar as it is precisely the position eroticism seeks to overcome), a transformational aesthetics that assumes movement between subjects and objects rather than a flat ontology of objects alone, and a gendered dynamic that cannot begin to hold up to contemporary feminist analysis. Still, Bataille's erotic ideas about eschewing subjecthood through excess, unholy alliances, and nonlife are influential for object-oriented feminism. Like laughter, fomenting erotic fusion with an object, as a means of becoming object, is a creative, generative act.

Such important prehistories for today's object-orientation also include feminist practices around the body, like fetishistic subcultures and body art. While as we have seen, with Sprinkle's performance, some strategic, erotic reclamations of objecthood can make us laugh, others are plainly politically resistive. For instance, in an expanded cinema work, *Touch and Tap Cinema*, the artist Valie Export became an object, twice over.[50] Attaching a cardboard maquette of a movie theater to her bare chest, and offering passersby a free grope, she used her body to embody the cinematic apparatus. Export turned herself simultaneously into the architectural object of the theater and the filmic object of the male gaze, later canonized in feminist film theory by Laura Mulvey's 1975 essay "Visual Pleasure and Narrative Cinema."[51] The erotic affirmation of being *both and* presents viewers with an internal contradiction, and has the effect of doubling down against objectification, making clear that her political statement, even when disguised as half-kidding, is entirely serious. Returning then to

Aristarkhova's lucid question, *Is OOF a joke?*, object-oriented feminism maintains an always charged relationship with earnestness and
the seriousness of sovereignty. Erotic nonsense breaks down ideology's common sense. Problematic erotic pairings provoke insights into
things' innards. And perhaps most important, erotic agility sidesteps
the weighty burden of truth claims.

This last concern, with truth, is equally crucial for object-oriented
feminist methods, ethics, and politics. It is often the case that humor
carries a note of truth, but at least on the face of things, object-
oriented feminism appears to keep its distance, remaining aligned
with artifice and unconcerned with being complete or being right. On

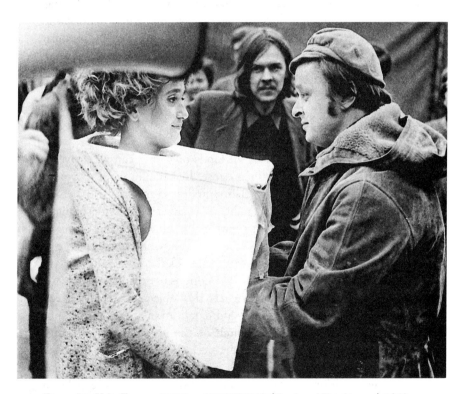

Figure I.2. Valie Export, *TAPP und TASTKINO (Touch and Tap Cinema)*, 1968.
Document of performance action by Valie Export. Tapp and Tastfilm—street
film, mobile film, body action, authentic woman film. Photograph by Werner
Schulz. Copyright 2015 Valie Export/Artists Rights Scoeity (ARS), New York/
Bildrecht Vienna.

the one hand, object-oriented feminism draws from a postmodern legacy in which truth is first and foremost radically relativized. On the other, it recognizes that insisting on the salience of post-structuralism, capitalism, and psychoanalysis to explain *everything* turns those relativizing gestures back into master narratives.

While a constructivist edge coupled with rhetorical levity are features that object-oriented feminism shares with both art and OOO, the latter remains invested in philosophical truth claims about an accurate ontology. Likewise, new materialism claims truths surrounding nonanthropocentric science and the nature and inherency of matter as such. But based as it is on a redundant paradox, and riddled through with artifice, object-oriented feminism is on track for being beyond untrue, in an erotic sense, in excess of singular truth. So it strives to be wrong, but not in the sense of being incorrect. Its promise is to be wrong as in being *botched*, as in "girl, that's all wrong"—flat indifference to correctness. Being wrong in this way is radical, political work. It means setting aside truth and correctness in favor of being artificial and botched, all to make room for an erotics of generative thinking and doing. The underlying wager is that right thinking gets worked out in the doing of the making.

Only in willingness to be all kinds of wrong can we arrive at being in the right, in the ethical sense. In her film work, Povinelli points to how variance in truth claims produces varying worlds, which is to say, an array of differing political arrangements. Philosophical, fictional, scientific, and everyday truth claims all wield social power to different degrees, such that power relations and unevenness emerge in what the OOO author Levi R. Bryant calls a flat ontology.[52] Bryant refers to a "democracy of objects," but notions of democracy are complicated by uneven power everywhere that objects are systematized into arrangements. Biomedicine and datafication are cases in point. For example, although the research of the geneticist Rick Kittles reveals that 30 percent of African American men have a Y chromosome indicating European descent, Kittles emphasizes that you cannot show a Y chromosome to a policeman who pulls you over.[53] From new science comes new objects, but old problems persist.[54]

Wrong truths and reclamations of objecthood often reveal that feminist objects are inaccessible, at once obdurate and retiring. By removing the cinematic screen and providing "access" to her body

as object, Export's performance exposes the emptiness of cinema's promises: the haptic experience is equally dry. Likewise, the Y chromosome keeps quiet, refusing to speak until it becomes woven, in Haraway's sense, in just such a way as to form specific fabrics binding genetic research and the Atlantic slave trade. OOO's conception of objects as fundamentally withdrawn and self-contained resonates with feminist objects that resist us, and the feminist notion that as objects, we resist. Yet, forsaking that ambition for exclusive or conclusive truth in truth claims (and for grandeur in all such grand claims) makes for a modest theory and a humble practice. Like assenting to erotic self-erasure, insistent self-implication and meticulous modesty are methodologically necessary if the hope is to achieve anything resembling nonanthropocentrism. And this is the hope on offer: to be objects, generously and generatively, together; to recognize how fraught that position is, always for all parties, as power articulates itself through each and every arrangement of objects; and from this recognition about objecthood, which is to say self-recognition in objecthood, to cultivate a praxis of care.

Ethics: Out of the Closet or under the Carpet

So, as a case study for OOF analysis, let us return to that earlier "troubling" example pertaining to feminism to ask, how exactly did the bunny come to be swept under the carpet of carpentry? Something is wrong about this.

The truth claim of ontologies is to account for being; as such, they profess completeness and suggest neutrality. An ontologist will assert, "This is the way things are." But is an ontologist also alleging something more? "This is (just) the way things are." In short, are ontologies subject to ethics? OOF submits that they are. Recall that carpentry, OOO's mode of thing-praxis, "entails making things that explain how things make their world." Not only the object or artifact is of import here; tantamount is the sense of orientation. The thing, not the maker, explains the world; so orientating or listening to things begets ontology.

In Bogost's larger discussion, the image toy is one of two examples of carpentry he coded. The first is the *Latour Litanizer,* a piece of software that generates lists of incongruous objects in the style of those

found in the writings of Bruno Latour. Mimicking Latour's predilection for lists of things, the *Latour Litanizer* operates in a similar fashion to the image toy. The software calls up series of titles of random Wikipedia articles with links, and generates a novel list of objects (i.e., entries) with every refresh. Importantly, Bogost submits that in the interest of nonanthropocentrism, his *Litanizer* improves on Latour's handwritten technique by eliminating the bias of human authorship.

The *Latour Litanizer* makes less "trouble" than the image toy in that it requires no editing to remove the offensive presence of women, girls, or sexiness, but only because that "editing" has taken place in advance. The sexist skew of Wikipedia is well known. Its "systematic gender bias" was the subject of two National Science Foundation grants in 2014,[54] and despite activist Wikipedia Edit-a-Thons that seek to increase articles about women, it is estimated that a measly 10 percent of Wikipedia contributors are women.[55] For this reason, it would be redundant to code the *Litanizer* to remove women from Wikipedia. This tiny ontology already reflects a bigger problem.

Such is not the case for the image toy precisely because while encyclopedia articles that feature women and their achievements remain statistically rare, images that objectify women proliferate online. Hence it is both easy for a dean to see a bunny, and easy for her to "conclu[de] that object-oriented ontology [is] all about objectification." Bogost acknowledges that the dean's interpretation was "understandable," although "unintended," while insisting that "sexist objectification" is "certainly unsupported by OOO thought itself."[56]

While the implication of nonsexist objectification remains an open question, Bogost correctly notes that in the object-experiment of his tiny ontology, his "change also risks excluding a whole category of units from the realm of being!" Certainly the choice to erase the ontological status of women, girls, and sexiness is a move that deserves further scrutiny. I would argue that by coding against further incursions of sexually objectified women into a programmed ontological purview, OOO misses the point. Sexual objectification is not "certainly unsupported by OOO thought." *On the contrary, objectification, utilitarianism, and instrumentalization are presences that haunt OOO, and are among the very questions at the heart of object-oriented feminism.*

Orientation toward the object of carpentry should teach us that the bunny in our midst is not "the problem." Rather, the bunny stands,

objectified and objectively, as evidence that OOO rests precisely on an ontological condition that includes objectification, as uncomfortable as that realization may be. The dean's question of "why Playboy bunnies would be featured at a philosophy conference" is not a matter of misinterpretation; rather, the comment astutely identifies the messy, nay, wrong philosophical intervention that this ontology, by orientating to objects, would have been poised to make. And such an intervention truly would have been profound. The status quo, in which philosophy conferences are devoid of Playboy bunnies, is entirely in keeping with the comfort zone of humanist morality, not to mention with patriarchal institutional mores that prefer to engage female bodies in the abstract if at all. The dean's response very well may have been motivated by this sort of politically correct (and thus politically impotent) feminism. But by abolishing women, girls, and sexiness, OOO perpetuates this same abstraction and silencing.

Bogost states that the image toy's "philosophical accomplishment comes from the question it poses about the challenge flat ontology and feminism pose to one another." But the OOO response has the opposite effect—disposing of rather than posing any questions at all. Here carpentry performs the sad inverse of object-orientation. By reasserting authorial control, OOO reinserts the same biased human decision making that it has been argued contaminated Latour's hand-composed lists. In the end, we may know ontologies as subject to ethics if simply because they provoke such censorship.

Returning to the definition of carpentry as "making things that explain how things make their world," if we are to understand the world as explained by the image toy object, this sexist plaything—if we can call it that—flips our expectations. Outmoded humanist politics asks who counts as a subject (and criticizes the objectification of women on the basis that classing women as objects means that they are less-than-subjects). Object-orientation sets forth an entirely different political problem: the question of what counts as an object. Perversely, in this example "being objectified" prevents "being" in the ontological category of "object." In setting out to correct the first problem about who counts as a subject—which it must be stressed is ontologically irrelevant, even if it is socially awkward, OOO produces the second problem concerning what counts as an object—which does carry important ontological stakes.

This is not to diminish the value of carpentry in itself—far from it. The lesson to be gained, it would seem, is about the power of carpentry, the potency of praxis, and the ethics of establishing ontological orders.

Politics: Retooling

Finally, and to this end, object-oriented feminism contributes a critical reorientation of the concept of object-orientation itself. When asked, OOO's proponents insist that the term *object-oriented ontology* has nothing to do with "object-oriented programming" (OOP). Harman, the story goes, simply found the term appealing and appropriated it. But what is OOP?

Object-oriented programming is a form of computer programming that makes use of "objects" to organize information. In OOP a programmer creates objects, prototypical entities in code that have defined qualities, known as "attributes," and capabilities, known as "methods." This allows the programmer to subsequently generate multiple instances of that object, each of which, while unique, conforms to its template.

While OOO may deny the association, much work conducted under the mantle of object-oriented feminism suggests that a connection does exist. In speculative realism, object-oriented ontology, and new materialism, we find a new wave of theories that takes objects, things, and matter as fundamental units. These ideas are emerging now amid a particular set of historical conditions. Although OOO's and new materialism's assertions about being transcend history, object-oriented feminism suggests that some form of historical contingency is at work. Alexander R. Galloway critiques OOO similarly for reiterating the language of post-Fordist capitalism, yet OOF has stakes in a different formulation of OOO's historical specificity.[58] Materialism and object-oriented thought are popular now, for a reason, and it is not because the linguistic turn rewrote distinctions like gender as seemingly irrelevant constructs. Rather, at this moment, paradigms like gender are all the more worthy of our attention because they are in the process of becoming something other than what we thought we knew. Increasingly, we understand them as secondary qualities of objects. The primary quality of objects is that they are, simply, objects

qua objects, in exactly the sense that for a philosopher like Harman, objects are objects through to the core. But being objects first has direct implications in programming. In OOP, secondary qualities, like gender distinctions, are simply attributes. From the perspective of code, when all things are objects, they are individually nameable and, as such, can be interpolated into a program. This means that all things, as individuals, can be networked together, subsumed in software, and thereby systematized, operationalized, and instrumentalized. Now OOP may look more like OOO's Freudian slip. And here is the catch: If in OOP, *all things as individuals* can be networked and instrumentalized, in OOO, *all individuals as things* can be so instrumentalized. Although OOO disavows the "P" dropped from its name much as it repudiates politics, programming lends shape to object-oriented politics. It can be no coincidence that this theory is emerging from within a global culture that fetishizes programmability. An aura of programming saturates these philosophies, hinting at something fundamental about contemporary objecthood.

Harman's conception of objects rests on his Heideggerian tool analysis, and his view that objects are always fundamentally tools ready-to-hand, or broken tools present-at-hand, pervades object-oriented thought. With this in mind, object-oriented feminism links Harman's "tool-being" to the instrumentalization of all objects, irrespective of their utility or unusability. Networked through code, all objects are compelled to generate that "hyperobject"—to borrow Morton's term— data itself. This is true, R. Joshua Scannell has noted, even when an object does nothing at all. A broken tool generates "no" data in real time, which itself is commodifiable information about its brokenness.

In some of the chapters that follow, object-oriented feminist thinking turns to necropolitics. In necropolitics, the capacity of all objects to be instrumentalized, whether living or dead, puts a different spin on dark ecologies' investments in the nonhuman and nonlife, and indeed returns "darkness" to the question of racism. Here Harman's broken tool resonates, but not with vibrant animism. Instead, this notion of the tool connects with Achilles Mbembe's assessment in his seminal essay that "the slave's life is like a 'thing,'" a "mere tool and instrument of production."[59] Just as biopower asserts a racial division, "a split between the living and the dead," necropower translates

the sovereign right to distinguish those who live and those who die differently.[60] Mbembe, writing on slavery, could be describing the brokenness of the tool when he writes, "As an instrument of labor, the slave has a price. As a property, he or she has a value. His or her labor is needed and used. The slave is therefore kept alive but in a *state of injury* ..." He continues, "Slave life, in many ways, is a form of death-in-life."[61]

OOF's fundamental tension between objectification and self-possession is brought to the surface in the artist Barbara DeGenevieve's *The Panhandler Project*.[62] DeGenevieve photographed and video documented five homeless men in Chicago between 2004 and 2006. The men agreed to pose nude for her in exchange for lunch and dinner, $100, and a night in a hotel room. As DeGenevieve explains to one of the models during their shoot, "Just because you're homeless, there's going to be someone who says I'm exploiting you because I've asked you to take your clothes off. ... That is the ultimate in the art world of exploitation." DeGenevieve's project unsettles what she calls the "knee-jerk political correctness" of the art world and academe by targeting power conventions of gender, class, and race, and empowering naked homeless black men to make choices about their objectification by a white female university professor. She asks rhetorically, "Did I exploit them? They've all answered no. ... It was a matter of how much it was worth to me versus how much it was worth to him."[63] And indeed, as she points out, she would be without a project were it not for their consent. *The Panhandler Project* asks who controls this interaction. What is more, it reflects a critical question for object-oriented feminism: is it time to abandon subject-oriented terms like control, consent, and coercion if our aim is object-oriented self-possession?

OOF emphasizes ontology as a political arrangement, realism as an arena for self-possession and relation, and objecthood as a situational orientation, so as to apprehend and alter objects' intersectional prospects for self-determination, solidarity, and resistance. The internal resistant quality of objects may deserve our closest attention. In object-oriented feminism, objects carry internal resistance, even insofar as an erotic whisper of death-in-life, of self-destruction, always haunts objecthood. In this kind of "being wrong," where the modest ethics of self-implication joins the necropolitical erotics of self-sacrifice, OOF

Figure I.3. Barbara DeGenevieve, *Mike #6*, 2005. Inkjet print, 12 × 14⅜ inches. Courtesy of the Estate of Barbara DeGenevieve and the Museum of Contemporary Photography at Columbia College Chicago.

retools its politics. In the essays collected in this volume, we deploy them into the feminist, queer, postcolonial, anticapitalist concerns discussed above.

Chapter Overview

OOF's emergent methodology, set into practice in the following pages, traffics in art and artifice, technology and humor, erotics and politics. Several of the chapters below were composed for this volume; others developed out of papers first presented at OOF panels convened at the Society for Literature, Science, and the Arts conferences between 2010 and 2014. Many of the themes of those panels, *Programs, Parts, Closer, Deviance,* and *Futures,* echo throughout this collection. In

object-oriented fashion, readers may approach these essays individually, sequentially, or in any order. Here, they are arranged into three suggestive proximate groupings.

The first essays take on questions about the independence of and relations between objects. How do objects self-constitute or constitute one another? What distinguishes one object from a neighboring object or a whole from a part? How do objects self-identify and self-objectify, particularly in a cultural milieu? How can we account for and even characterize relations between objects?

Excavating the distinction between objects and things, which is often elided in object-oriented theory, Aristarkhova returns to Martin Heidegger's account of the "assaultive" process of objectification by which things become objects. Heidegger defines a girl as "a young thing" (neither object nor fully human) and suggests that philosophers and artists have a special relationship to and even protective responsibility for such "mere" things, different, for example, from objects of science. Examining this relationship in the context of human artists and nonhuman art objects, Aristarkhova considers feminist artworks aimed at troubling objects' objectification and theorizes the difficult ethical potential for "a feminist object."

Following OOO's principle of the withdrawal of objects and arguing against the metaphysics of presence, Morton develops the concept of weird essentialism. Morton suggests that withdrawal makes all objects inherently deviant, "looping" through other objects, and in a loop with themselves. He suggests that all objects perform an internal deviant self-differing, which he compares to Luce Irigaray's theorization of woman's divergence from phallocentric logic.

Frenchy Lunning compares metaphor in Graham Harman's allure and Julia Kristeva's abjection. Where Harman's metaphor for allure describes a "come hither" gesture soliciting the otherness of withdrawn other objects, Kristeva's metaphor for abjection is a "violent repulsing thrusting aside of 'otherness.'" Delving into these twin movements from the perspective of performances of femininity, Lunning explores how allure and abjection play out in relation to the female body as fetish object. In her reading of Lolita subculture fetish fashions, Lunning uncovers a complex by which the abject menstrual body, covered over with signifiers of an alluring premenstrual body, is resexualized and compounded as abject again.

The next essays explore questions posed by object-oriented feminism concerning truth, art, and erotics. What truth claims does object-oriented thinking pose? What is the value of truth claims as such, and what is the value of that which exceeds truth, such as falsity or fiction? What ethics derive from truths and untruths, and what ethical and unethical insights can art and artificiality produce? What roles do art, artists, and artifice play in engendering entanglements with objects in experimental, experiential erotics?

Aesthetic allure claims to flatten the playing field for all objects, but as Povinelli points out, allure is impossible when there is no aesthetic encounter in the first place. Indeed, the social power accompanying certain objects can prevent encounters for subaltern objects. In contrast to Meillassoux's concept of ancestrality, Povinelli discusses indigenous works of fiction. Two films, *When the Dogs Talked* and *The Origins of Bigfoot*, and a short story, "That Not Monster," articulate how fantastic and contested truth claims produce material relations among social and nonlife communities of objects, and are themselves results of such relations.

Using perspectives from media and performance art to counterbalance life-affirming vitalistic materialisms, I offer a proposal for necrophiliac ethics. Applying Catherine Malabou's concept of plasticity to works by feminist performance and body artists, in particular the plastic surgery artist Orlan, I recommend self-objectification through similar plastic procedures. Cosmetic Botox, employed in elective deadening of the face, provides an opportunity to radically objectify the self, suppressing faciality, and with it the subject-oriented Levinasean ethics of faciality and liveness.

The bioartist Adam Zaretsky considers object cathexis by focusing on adjectival modifiers in place of object-oriented nouns. Using modifying technologies like the "gene gun," transgeneticists and bioartists often produce failed and partial forms that suggest disability studies could well inform object-oriented feminism alongside discourses of gender and postcoloniality. Signaling an object-oriented feminist erotics, Zaretsky identifies how modification—through bioarts, transgenic technologies, or adjectives—produces differently abled, cross-coded, augmented qualities in radical excess of objects themselves.

Anne Pollock delves into the quandaries posed by "artificial" natures, exemplified by the case of endocrine disruption in birds. The

result of pollution, endocrine disruption appears to cause queer traits and behaviors like same-sex partnering or intersex characteristics in wildlife. Responding playfully and provocatively to the sex panic around this issue, Pollock carefully parses the competing feminist stakes involved in accepting nonreproductivity as an end in itself. Related to Zaretsky's queer adjectival erotics, Pollock exposes the multiple valences of being "trashed" or "intoxicated" with toxins, and toasts to the potential pleasures produced therein.

The final essays address economies that connect human and non-human objects. In economic circulation, all objects are continually repositioned as producers, consumers, and commodities. As these roles grow increasingly difficult to differentiate, we return to questions of relations between objects, and to questions of the human, understood here as political concerns. When drawn into histories of exchange and linked into systems of exploitation, how do objects talk back, and what forms of politics does this talk-back express? How do these economies mitigate and enforce categories of life and nonlife, productivity and nonproductivity?

Against those who would appeal to new materialism for a suitably nonanthropocentric politics, Marina Gržinić argues that, like OOO, new materialism participates in an ahistorical (perhaps even dehistoricizing) project. Going well beyond complaints about the objectification and commodification of humans, Gržinić shows how new materialism replicates what she terms the "humanization of capital." This move shifts the argument from a Marxist–feminist critique at the level of commodities to a far larger interrogation at the level of capital, which in turn echoes the shift from biopolitics to necropolitics. Gržinić implies that we are falsely concerned with objectification, that is, of humans in OOO; we should instead be concerned with humanization, that is, of capital in new materialism.

In her caring and careful sociological account of Tarot practices, Karen Gregory perceives inversions in the active and passive roles assumed by Tarot cards and Tarot card readers. The cards' agency and communicative liveliness is foregrounded, contrasting the passive stance of the human reader, listening meditatively for messages from the cards. But the cards also compel humans to activity in the form of affective work, cultivating a sense of self and personal authority. Nevertheless, this specialized self refashions the reader's skill or affective prowess into commodity.

R. Joshua Scannell considers the example of the New York Police Department and its Domain Awareness System (DAS), a vast proprietary experiment in statistical predictive policing using real-time data in what Scannell calls "governance by algorithm." For Scannell, the DAS typifies how the pervasive object of "big data" conjures a reorientation away from human subjects and toward objects. In big data, a peculiar inversion sets in such that all objects must be rendered computational to be considered "real," which is to say commensurate with systems in which algorithms demand "care" from humans, even "draw[ing] labor towards them." Ultimately, algorithmic governance is directed not toward the human but toward the mathematical.

This book seeks not to define object-oriented feminism but to enact it. The ideas, methods, and aspirations found here have developed over several years in conversations and collaborations, both personal and professional. In many respects this book is as retrospective as it is forward-looking. Like any artifact of practice, it contains within it tacit logs of its past lives, and amendments and assessments accrued in all attempts along the way. For this reason, and if we comprehend OOF as a feminist object of collective thought, there are numerous contributors to this volume who deserve thanks within the body of this text. The authors: Irina Aristarkhova, Karen Gregory, Marina Gržinić, Frenchy Lunning, Timothy Morton, Anne Pollock, Elizabeth A. Povinelli, R. Joshua Scannell, and Adam Zaretsky; OOF panelists, respondents, and audience interlocutors: Jamie "Skye" Bianco, Ian Bogost, Wendy Hui Kyong Chun, Patricia Ticineto Clough, Melanie Doherty, Orit Halpern, N. Katherine Hayles, Eileen Joy, Danielle Kasprzak, Amit Ray, Steven Shaviro, Rebekah Sheldon, Susan Squier, and members of the Society for Literature, Science, and the Arts; and those who have offered generous support, encouragement, and insights along the way: Jane Bennett, Alexander R. Galloway, Graham Harman, Emmy Mikelson, Katy Siegel, Trevor Smith, and Iris van der Tuin.

Notes

1. Of the entire program of nine speakers, only the last, a respondent, was a woman. This gender imbalance is symptomatic of a larger trend in speculative realism. The encyclopedic *The Speculative Turn: Continental Materialism and Realism*'s twenty-five chapters include only one woman. The same is true

of *Collapse II: Speculative Realism*, which includes just one woman among its nine authors. In *New Materialism: Interviews and Cartographies*, Iris van der Tuin and Rick Dolphijn write that because the key speculative realist thinkers are men and more new materialist authors are women, some may see new materialist thought as more compatible with feminism than speculative realism. Michael O'Rourke was among the first to address these compatibilities and imbalances in his essay "'Girls Welcome!!!': Speculative Realism, Object Oriented Ontology, and Queer Theory." See Levi Bryant, Nick Srnicek, and Graham Harman, eds., *The Speculative Turn: Continental Materialism and Realism* (Melbourne: re.press, 2011); Robin Mackay, ed., *Collapse II: Speculative Realism* (Falmouth, U.K.: Urbanomic, 2012); Dolphijn and van der Tuin, eds., *New Materialism: Interviews and Cartographies* (Ann Arbor: Open Humanities Press, 2012); and O'Rourke, "'Girls Welcome!!!': Speculative Realism, Object Oriented Ontology, and Queer Theory," *Speculations* 2 (2011): 275–312.

2. The discussion of the image toy appears in the chapter "Carpentry" on pages 93–99. See Ian Bogost, *Alien Phenomenology, or What It's Like to Be a Thing* (Minneapolis: University of Minnesota Press, 2012).

3. Bogost draws a distinction between his conception and the making of other things such as "tools and art." Object-oriented feminism embraces carpentry, though it is also aligned with experimentalist practices of making and engaging artifacts in every discipline. Indeed, the idea of "making things that explain how things make their world" is neatly embodied in the sculptor Robert Morris's canonical work of carpentry, *Box with the Sound of Its Own Making* (1961), a wooden box, sealed and withdrawn, that contains an internal speaker playing a hidden cassette recording of the start to finish process of the box's own construction.

4. For a nuanced discussion, see Rick Dolphijn and Iris van der Tuin, "Sexual Differing," in Dolphijn and van der Tuin, *New Materialism*.

5. "Correlationism" is the speculative realist philosopher Quentin Meillassoux's term for philosophies following from Kantian transcendentalism in which thought can only access thought, never the world-in-itself. See Meillassoux, *After Finitude: An Essay on the Necessity of Contingency*, translated by Ray Brassier (New York: Continuum, 2009).

6. See Graham Harman, "On Vicarious Causation," in Mackay, *Collapse II*, 187–221.

7. Iris Marion Young, "Gender as Seriality: Thinking about Women as a Social Collective," *Signs: Journal of Women in Culture and Society* 19, no. 3 (1994): 713–38.

8. Donna Haraway, "A Cyborg Manifesto: Science, Technology, and Socialist-Feminism in the Late Twentieth Century," in *Simians, Cyborgs, and Women: The Reinvention of Nature* (New York: Routledge, 1991), 149–81.

9. Steven Shaviro, *The Universe of Things: On Speculative Realism* (Minneapolis: University of Minnesota Press, 2014).

10. I borrow this phrase from Hasana Sharp, "The Impersonal Is Political: Spinoza and a Feminist Politics of Imperceptibility," *Hypatia* 24, no. 4 (2009): 84–103.

11. Graham Harman, *Tool-Being: Heidegger and the Metaphysics of Objects* (Chicago: Open Court, 2002).

12. In fact, "tool being" aside, Lorde's essay harks to the current gender imbalance in speculative realism. Sadly, the avoidance patterns and justifications she identifies in white feminists' exclusion of queer people of color are at risk of resurfacing wholesale in this context, and her 1984 critique still stands ("The Master's Tools Will Never Dismantle the Master's House," in *Sister Outsider: Essays and Speeches by Audre Lorde* [Berkeley, Calif.: Crossing, 2007], 110–13).

13. Ian Bogost, "Object-Oriented Feminism: At the 2010 Society for Literature Science and the Arts Conference," accessed January 30, 2015, http://bogost.com/writing/blog/object-oriented_feminism_1/.

14. See Evelyn Fox Keller, "Gender and Science," in *Reflections on Gender and Science* (New Haven, Conn.: Yale University Press, 1985), 75–94.

15. See Maria Puig de la Bellacasa, "'Nothing Comes without Its World': Thinking with Care," *Sociological Review* 60, no. 2 (2012): 197–216.

16. Donna Haraway, "Cyborgs to Companion Species: Reconfiguring Kinship in Technoscience," in *The Haraway Reader* (New York: Routledge, 2004), 295–320.

17. Elizabeth Grosz, "A Politics of Imperceptibility: A Response to 'Anti-racism, Multiculturalism and the Ethics of Identification,'" *Philosophy & Social Criticism* 28 (2002): 463–72. See also Hasana Sharp, "The Impersonal Is Political."

18. Grosz, "Politics of Imperceptibility," 466.

19. On feminist new materialisms, see the special issue "Feminist Matters: The Politics of New Materialism," edited by Pita Hinton and Iris van der Tuin, *Women: A Cultural Review* 25 (1).

20. See Patricia Ticineto Clough, "Feminist Theory: Bodies, Science and Technology," in *Handbook of Body Studies*, edited by Bryan S. Turner (New York: Routledge, 2012), 94–105.

21. See Nigel Thrift, "The Insubstantial Pageant: Producing an Untoward Land," *Cultural Geographies* 19, no. 2 (2012): 141–68.

22. The "Anthropocene Feminism" conference held at the Center for 21st Century Thought investigated this topic directly and resonates strongly with object-oriented feminism. See the collected conference edition, *Anthropocene Feminism*, edited by Richard Grusin (Minneapolis: University of Minnesota Press, forthcoming).

23. The argument for noncorrelationism is presented in Meillassoux, *After Finitude*; for a thorough account of this position, see Bryant, Smicek, and Harman, *Speculative Turn*.

24. By way of contrast, speculative realism's noncorrelationism is understood as a rupture with a reigning philosophical canon. This narrative of rupture positions speculative realism as progressive and futuritive.

25. This diversity reflects the fertile interdisciplinary climate of the Society for Literature, Science, and the Arts conferences where OOF discussions originated. Some of these connections will be sketched in the anthology *After the "Speculative" Turn: Realism, Philosophy, and Feminism*, edited by Eileen A. Joy, Katerina Kolozova, and Ben Woodard (Earth, Milky Way: punctum books, 2016).

26. Resonances with art have been explored in recent exhibitions including *And Another Thing*, which I co-curated with Emmy Mikelson at the James Gallery in 2011, and *Speculations on Anonymous Materials*, curated by Susanne Pfeffer at the Fridericianum in 2013, among others. Focusing on art objects in circulation, Joshua Simon has coined the term "Neo-Materialism" in a three-part essay published in *e-flux journal* in 2010–11. More recently, in the edited volume *Realism, Materialism, Art*, Christoph Cox, Jenny Jaskey, and Suhail Malik have queried the relevance of speculative realism for curatorial practice; a longer history of art's "new" interest in objects is captured in Katy Siegel's essay "Worlds with Us." See Katherine Behar and Emmy Mikelson, eds., *And Another Thing: Nonanthropocentrism and Art* (Earth, Milky Way: punctum books, 2016); Suzanne Pfeffer, *Speculations on Anonymous Materials* (Kassel: Verlag der Buchhandlung Walther Konig, 2015); Joshua Simon, "Neo-Materialism, Part I: The Commodity and the Exhibition," "Neo-Materialism, Part II: The Unreadymade," and "Neo-Materialism, Part III: The Language of Commodities," *e-flux journal*, accessed August 1, 2015, http://www.e-flux.com/journals/?user=8417; Christoph Cox, Jenny Jaskey, and Suhail Malik, eds., *Realism, Materialism, Art* (Annandale-on-Hudson, N.Y.: Center for Curatorial Studies, Bard College/Sternberg, 2015); and Katy Siegel, "Worlds with Us," *Brooklyn Rail*, July 15, 2013, http://www.brooklynrail.org/2013/07/art/words-with-us.

27. The psychoanalytic dimension of object-oriented feminism is depicted in Patricia Ticineto Clough's contributions to OOF panels in 2010 and 2012, subsequently published as "A Dream of Falling: Philosophy and Family Violence," in *Handbook of Object Matters*, edited by Eleanor Casella et al. (New York: Routledge, 2013); and "The Object's Affect: The Rosary," in *Timing of Affect, Epistemologies, Aesthetics, Politics*, edited by Marie Luise Angerer et al. (Chicago: Diaphanes, 2014).

28. Frantz Fanon, "The Fact of Blackness," translated by Charles Lam Markmann, in *Theories of Race and Racism: A Reader*, edited by Les Back and John Solomos (New York: Routledge, 2009), 257–65.

29. Lawrence Weiner, "Notes from Art (4 pages)," "Words and Word-works," summer issue, *Art Journal* 42, no. 2 (1982): 122–25.

30. On antirepresentationalism in new materialism, see Dolphijn and van der Tuin, "The Transversality of New Materialism" in Dolphijn and van der Tuin, eds., *New Materialism*.

31. Edward Said, *Orientalism* (New York: Vintage Books, 1979).

32. Sara Ahmed, *Queer Phenomenology: Orientations, Objects, Others* (Durham, N.C.: Duke University Press, 2006), 112–17.

33. Ibid., 116.

34. My thinking on the postracial is indebted to the rich discussion at "Archives of the Non-Racial," a mobile workshop organized by the Johannesburg Workshop in Theory and Criticism in partnership with the University of California Humanities Research Institute Seminar in Experimental Critical Theory, which I had the opportunity to participate in during the summer of 2014. See the "Archives of the Non-Racial" website, accessed August 5, 2015, http://jwtc.org.za/the_workshop/session_2014.htm.

35. Indigenous studies is yet another field that has long conducted significant feminist and postcolonial object-oriented work, though often under different disciplinary terminology. For examples, see Kim TallBear, *Native American DNA* (Minneapolis: University of Minnesota Press, 2013); and Elizabeth A. Povinelli, "The Four Figures of the Anthropocene," paper presented at "Anthropocene Feminism," April 10, 2014, Center for 21st Century Thought, University of Wisconsin, Milwaukee, video, https://www.youtube.com/watch?v=V0gcOqWNG9M.

36. Lorraine Daston, "Objectivity and the Escape from Perspective," *Social Studies of Science* 22, no. 4 (1992): 597–618.

37. The recent upswing in materialist philosophies includes several noteworthy anthologies: Diana Coole and Samantha Frost, eds., *New Materialisms: Ontology, Agency, and Politics* (Durham, N.C.: Duke University Press, 2010); Dolphijn and van der Tuin, *New Materialism*; and of special import for object-oriented feminism's interdisciplinary interests, Estelle Barrett and Barbara Bolt, eds., *Carnal Knowledge: Towards a New Materialism through the Arts* (New York: I. B. Tauris, 2013); and Victoria Pitts-Taylor, ed., *Mattering: Feminism, Science, and Materialism* (New York: New York University Press, 2016).

38. See, in particular, Barad's theory of "agential realism" discussed in *Meeting the Universe Halfway: Quantum Physics and the Entanglement of Matter and Meaning* (Durham, N.C.: Duke University Press, 2007).

39. Shaviro, *Universe of Things.*

40. On political formations of things, see Bruno Latour and Peter Weibel, eds., *Making Things Public: Atmospheres of Democracy* (Cambridge, Mass.: MIT Press, 2005); Jorinde Seijdel, ed., *Politics of Things: What Art and Design Do in Democracy,* special issue, *Open: Cahier on Art and the Public Domain* 11, no. 24 (2012); and Noortje Marres, *Material Participation: Technology, the Environment, and Everyday Publics* (New York: Palgrave MacMillan, 2012).

41. Jane Bennett, *Vibrant Matter: A Political Ecology of Things* (Durham, N.C.: Duke University Press, 2010), xvi.

42. Anne Pollock, "Heart Feminism," *Catalyst: Feminism, Theory, Technoscience* 1, no. 1 (2015), http://catalystjournal.org/ojs/index.php/catalyst/article/view/pollock/98.

43. For David Berry, OOO's artificial objects, insofar as they are human-made "products of neoliberal capitalism," evince a blind spot in OOO's nonanthropocentrism. While Berry sees these objects as "contaminated" by human intervention, this impurity is precisely where OOF finds common ground. In answer to Berry's call to "catch sight of *what* is being listed in [OOO's] descriptive litanies," OOF observes that human and nonhuman objects are now equally products of neoliberal capitalism. See Berry, "The Uses of Object-Oriented Ontology," *Stunlaw: A Critical Review of Politics, Arts, and Technology,* May 25, 2012, http://stunlaw.blogspot.nl/2012/05/uses-of-object-oriented-ontology.html.

44. The early works of Rosi Braidotti, and other feminist theorists like Luce Irigaray and Hélène Cixous, build on the positivistic force of laughter in Nietzsche. On humor and the role of laughter in feminist creative and theoretical work, see Braidotti, "Cyberfeminism with a Difference," accessed August 1, 2015, http://www.let.uu.nl/womens_studies/rosi/cyberfem.htm#par1, which has an extensive section on humor and the role that laughter plays in feminist creative and theoretical work. A foundational text on laughter in feminist theory is Cixous, "The Laugh of the Medusa," translated by Keith Cohen and Paula Cohen, *Signs* 1, no. 4 (1975): 875–93. On laughter and humor as a deconstructive gesture in feminist philosophy, especially in response to patriarchal "seriousness" of the Father, see Irigaray, *This Sex Which Is Not One,* translated by Catherine Porter with Carolyn Burke (Ithaca, N.Y.: Cornell University Press, 1985).

45. Annie Sprinkle, "A Public Cervix Announcement" (n.d.), accessed January 30, 2015, http://anniesprinkle.org/a-public-cervix-anouncement/. In her current projects Sprinkle collaborates with her partner, Elizabeth Stephens, to take object-oriented feminist erotics to a nonanthropocentric extreme. In projects like *Dirty Sexology—Twenty-Five Ways to Make Love to*

the Earth and *Green Wedding*, Sprinkle and Stephens perform as "ecosexuals" pursuing erotic encounters of a planetary kind. See http://anniesprinkle.org/ projects/current-projects/dirty-sexecology-25-ways-to-make-love-to-the -earth/ and http://anniesprinkle.org/projects/current-projects/love-art-labora tory/green-wedding, both available online and accessed January 30, 2015.

46. Fox Keller, "Gender and Science."

47. Isabelle Stengers, "Another Look: Relearning to Laugh," translated by Penelope Deutscher, revised by Isabelle Stengers, *Hypatia* 15, no. 4 (2000): 41–54.

48. Angela Willey, "Biopossibility: A Queer Feminist Materialist Science Studies Manifesto, with Special Reference to the Question of Monogamous Behavior," *Signs: Journal of Women in Culture and Society* 41, no. 3 (2016): 556. Willey carefully dissects a debate on new materialism's "founding gestures," which played out in the pages of *European Journal of Women's Studies*. For more, see Sara Ahmed, "Open Forum Imaginary Prohibitions: Some Preliminary Remarks on the Founding Gestures of the 'New Materialism,'" *European Journal of Women's Studies* 15, no. 1 (2008): 23–39; Noela Davis, "New Materialism and Feminism's Anti-Biologism: A Response to Sara Ahmed," *European Journal of Women's Studies* 16, no. 1 (2009): 67–80; and Nikki Sullivan, "The Somatechnics of Perception and the Matter of the Non/human: A Critical Response to the New Materialism," *European Journal of Women's Studies* 19, no. 3 (2012): 299–313.

49. Willey, "Biopossibility," 561. See also Audre Lorde, "Uses of the Erotic: The Erotic as Power," in *Sister Outsider*, 53–59.

50. See Valie Export, "TAPP und TASTKINO, 1968" (German), accessed January 30, 2015, http://www.valieexport.at/en/werke/werke/?tx_ttnews%5Btt_news%5D=1956. See synopsis in "Valie Export: Tapp und Tastkino," *re.act.feminism: A Performing Archive*, accessed January 30, 2015, http://www.reactfeminism.org/entry.php?l=lb&id=46&e=. See also discussion of this and other works in Charles LaBelle, "Valie Export," *Frieze* 60 (June–August 2001), accessed January 30, 2015, http://www.frieze.com/ issue/review/valie_export/.

51. Laura Mulvey, "Visual Pleasure and Narrative Cinema," *Screen* 16, no. 4 (1975): 6–18.

52. Levi R. Bryant, *The Democracy of Objects* (Ann Arbor, Mich.: Open Humanities Press, 2011).

53. Rick Kittles, interview, *African American Lives: Hosted by Henry Louis Gates, Jr.*, "Beyond the Middle Passage," episode 4 (PBS Home Video, Kunhardt Productions, Inc., Educational Broadcasting Corporation, and Henry Louis Gates, Jr., 2006).

54. Indeed, though projects like *African American Lives* seem to up-hold a scientifically determined notion of ancestry, they nevertheless demonstrate how statistics like these are relics of slavery and other material social relations.

55. Hannah Brueckner, "Collaborative Research: Wikipedia and the Democratization of Academic Knowledge," Award Abstract No. 1322971, National Science Foundation, accessed January 30, 2015, http://www.nsf.gov/awardsearch/showAward?AWD_ID=1322971. See also Elizabeth Harrington, "Government-Funded Study: Why Is Wikipedia Sexist? $202,000 to Address 'Gender Bias' in World's Biggest Online Encyclopedia," *Washington Free Beacon*, July 30, 2014, http://freebeacon.com/issues/government-funded-study-why-is-wikipedia-sexist/.

56. Numerous sources discuss the gender bias in Wikipedia. On the gender gap in contributors, see David Auerbach, "Encyclopedia Frown," *Slate*, December 11, 2014, http://www.slate.com/articles/technology/bitwise/2014/12/wikipedia_editing_disputes_the_crowdsourced_encyclopedia_has_become_a_rancorous.html. On gender bias in content, see Amanda Filipacchi, "Wikipedia's Sexism toward Female Novelists," *New York Times*, April 24, 2013, http://www.nytimes.com/2013/04/28/opinion/sunday/wikipedias-sexism-toward-female-novelists.html?_r=0.

57. Bogost, *Alien Phenomenology*, 98.

58. Alexander R. Galloway, "The Poverty of Philosophy: Realism and Post-Fordism," *Critical Inquiry* 39, no. 2 (2013): 347–66.

59. Achille Mbembe, "Necropolitics," translated by Libby Meintjes, *Public Culture* 15, no. 1 (2003): 22.

60. Ibid., 17.

61. Ibid., 21.

62. An excerpted version of the fifty-minute video documentation gives an overview of this project. Barbara DeGenevieve, *The Panhandler Project* (video), accessed January 30, 2015, https://vimeo.com/29540736. See also the artist's profile, including photographs from the project, at the Museum of Contemporary Photography, accessed January 30, 2015, http://www.mocp.org/detail.php?type=related&kv=7036&t=people.

63. School of the Art Institute of Chicago, "Documenting The Panhandler Project by Barbara DeGenevieve," accessed January 30, 2015, https://vimeo.com/52015733.

One

*It is true that if things take to speaking,
that's the end of the world.*

—LUCE IRIGARAY

Irina Aristarkhova

A Feminist Object

A student in my Sexual Objects class shared a video for which he served as a videographer. His friend, a painting student, had difficulty in parting with paintings or subjecting them to the scrutiny and critique of others. He felt that he wanted to represent this through a video artwork, which would channel his love toward one of his paintings. In this video a young man sits in a restaurant in front of an abstract painting and treats this painting as if it were his girlfriend. This *as if* means here the following: he offers her food and wine, picks up the check, and then brings "her"—the painting—to his car after dinner, and the car shakes as if they are having sex, in the video's final scene. Other class participants made a few critical comments, with the videographer agreeing with most of the criticism. Two months later, at the end of the semester, I received an electronic letter from two other students (not members of my class) stating that they were concerned about this video artwork. The students protested the context of the video as one that objectifies women, presenting them as silent, passive, and unable to give consent, and as someone who can be treated as a sexual object. The original video disturbed them, and they appropriated it for their own creative response. They inserted subtitles into the original video *as if* the painting had an inner monologue, responding to the young man.[1] The painting "mentally commented" that it did not give him its consent and that it could not eat or was not interested in eating human food. The ambivalent nature of the subtitles—on the one hand, agreeing with the original intention of giving

39

the painting an identity of a woman by speaking on behalf of this painting-woman, and on the other hand, trying to highlight the human and nonhuman qualities of the object by identifying with the painting's object-qualities—created an effect that explores subject–object, artist–artwork, and human–things relations. It also created an effect of us, viewers, being confidants of the painting, while the student who was attracted to it did not seem to know what it was thinking. The title of the new video artwork: "I, Object," is open and multilayered as well, pointing directly to the question of identification with the object. At my meeting with the artists who made this new video, Kathleen Parks and Emily Dibble, they emphasized their long discussions about whether they double-objectified the original object, the painting, and also assumed to speak on behalf of all women. They also explained why their video work cuts off the original by ending without the "sex in the car" scene. They felt that presenting that scene potentially as a "rape scene" (the painting could not consent to having sex) would "go too far" and be unfair to the student who made the painting and came up with the original idea of the video, as well as to the videographer, both of whom were their college friends. Moreover, the scene could be potentially read as disrespecting victims of sexual violence by presenting them as akin to a painting, with a possibility that a painting could be "raped." The topic was discussed widely at the school, as several town halls and meetings over these two video works took place that semester (the student who came up with the original idea remained silent, however). It had also been suggested that the appropriation done to the original video amounted to vandalism and plagiarism.

Parks and Dibble are also studying sciences and involved in research with scientific data (Parks as a minor and Dibble as a double major). They are aware of ecofeminism and feminist science studies. They felt that working on this video complicated their relation with other objects, including nonliving things made by humans and other living beings used in their labs. Their original impulse to respond, however, was based first and foremost on their feminist convictions and concerns with questions of sexual violence and consent, which are major issues on college campuses right now. In fact, at the same time as the "I, Object" discussions took place on whether a painting could give consent to its maker, the University of Michigan updated

its definition of consent, once again. An independent (or so it seems) issue that comes out of this story is also the question of this chapter: objectification of objects, what it might mean in feminism, and what, if anything, to do about it.

This story highlights the difficulty of identifying, on the one hand, with objects, and hence anthropomorphizing them and objectifying us, and on the other hand, attempting to move beyond the objects as existing par excellence only for human use. The students who critiqued the original video tried to speak on behalf of those who are silent, objectified, and victimized, but the original video and their subsequent critique largely missed the question of the painting as an art object. It is a difficult question, without a doubt, and might explain the shortcut to heteronormative pop-cultural boy-girl cliché, which nevertheless should not be dismissed or discounted, as the appropriation work has well demonstrated. What is the relation between the artist and the artwork, and how does it relate to the status of other, non-human-made objects, defined as inanimate and nonliving? This story of two videos also indicates the difficulty of the application of definitions of violence, respect, and consent from humans to nonhumans, how they complicate each other, and their relation to contemporary feminism (I am particularly thinking of feminist animal studies, science and technology studies, and ecofeminism).

Before I discuss "objectification of objects," let us consider the terms we are using: what stands behind the object, the thing, and how they are thought. These are the questions that Martin Heidegger started with when thinking through the work of art—a topic very much at the center of the above story. As Heidegger directly deals with the subject matter of this chapter—the status of objects and their objectification—his ideas might be helpful in my consideration of how feminist orientation toward objects changes, or not, their ecology. The differences between things and objects are especially relevant here, as they tend to be overlooked and their interchangeability, their sameness, assumed. What are things and objects in Heidegger, and why are their differences important? In my discussion of Heidegger on things and objects, I rely on two main texts: "The Origin of the Work of Art," and "The Thing," both from the same collection.[2]

The definition of a thing in Heidegger is negative: "On the whole the word 'thing' here designates whatever is not simply nothing."[3]

Heidegger uses this definition immediately after declaring that "Death and judgment—there are ultimate things."[4] One assumes a death of a human being (based on Heidegger's later use of the word *mortals* in the same series of publications on things), and a judgment after death, whatever it can be, of those mortals. God is not a thing, and a peasant is not a thing, we learn. However, a girl is called "a young thing," "but only because we feel that being human is in a certain way missing here and think that instead we have to do here with the factor that constitutes the thingly character of things."[5] In his interpretation of this passage, Peter Geimer explains that "this girl as 'a young thing' that is called 'a thing' in Heidegger's analysis because it is *not yet human enough*, is opposed to another thing: the body, *that is no longer* human. Heidegger writes that the dead body transforms into a 'corpse-thing.' The boundary between Human (man) and thing can therefore always be sharply separated."[6] A new translation, however, of the original passage clarifies why the young girl is not yet human enough: "However, we may call a young girl who attempts an excessive task, a 'still too young thing' but only because in this case we are missing the 'human-being-ness' in a certain way, and instead seek to find what it is that makes the 'Thingness' of things."[7] This *excessive task*—beyond the ability of a young girl—is the key that is missing in the above-quoted English translation, but essential to our understanding of the reason for her disqualification from being fully human and, therefore, of her crossover into thingness. One could only wonder what such an excessive task could be, physical, intellectual, and so forth, for Heidegger, but without this qualifier it is hard to understand how a young girl could be connected to "the thingness of things." Unless one does not even need, perhaps, a good reason, or any reason, for an explanation of why a young girl is a young thing (thus, in Geimer, as quoted above, it is simply assumed, without a reason, that she is a thing). We know it, the translation also suggests, omitting the reason, by default. But Heidegger has an explanation: excessive tasks belong to the fully human.

Following a hesitation to call many other living things, like plants, a thing, Heidegger comes to conclude that calling human-made or inanimate objects—such as a stone or a hammer—a thing is much easier. He uses the word *mere* in relation to things (just as above he used *simply* in relation to *nothing*). So, a thing is not simply a no-thing—nothing. Things, properly speaking, are "lifeless beings of

nature and objects of use. Natural things and utensils are the things commonly so called."[8] Heidegger explains, in relation to the whole class of "mere things": "'Mere' here means, first, the pure thing, which is simply a thing and nothing more; but then, at the same time, it means that which is only a thing, in an almost pejorative sense. It is mere things, excluding even use-objects, that count as things in the strict sense."[9] Heidegger, thus, narrows his definition considerably. If at first, everything (which is not nothing) is a thing—including human beings, plants, all living and non-living beings—now, only certain entities are things. They must possess a particular thingness.

What is this factor of thingness? Heidegger goes back to the etymology and history of these terms, including the grammar. He shows how they were borrowed, translated, confused, and changed from Greek into Latin and so forth to other European languages, becoming what we call today the subject, predicate, and object, with their substantial and accidental qualities. The thing that is often pointed to through the object has a presence outside language and has to present itself to us before we can think it. But it is not a simple mirror relation. That is, if thoughts and sentences start with things, it does not mean that they are well-grounded interpretations. After all, our grammar does not distinguish between "mere things" and everything else. All beings are things as far as words are concerned (subject/predicate/ object). And this lack of care, between mere things and others as things, or how the things are treated as this "thing-concept" without care for things' "independent and self-contained character," is not simply an accidental innocent semantic confusion.[10] It is a matter of violence: "Occasionally we still have the feeling that violence has long been done to the thingly element of things and that thought has played a part of this violence, for which reason people disavow thought instead of taking pains to make it more thoughtful."[11] Being called a thing is, then, a precondition to becoming an object, defined by its availability for being used (in a scientific laboratory or in a household, for example). An object is a thing that has been made available to us, both figuratively and literally, one feeding the other.

The issue under consideration is whether the thinking of things and objects more thoughtfully would resolve the question of violence against them, through care for their "thingness." Heidegger thinks so and calls for a feeling to play a part in this thinking anew. Feeling is

not separated from thinking but rather challenges this dichotomy of senses and reason, because it is "more open to Being than all that reason which, having meanwhile become *ratio,* was misinterpreted as being rational." Thus, reason does not equal rationality but rather has been reduced to it. Such rational thinking of the thing-concept "does not lay hold of the thing as it is in its own being, but makes an assault upon it."[12] And the direct feeling, direct sensing of things, which has a relation to reason without being reduced to being merely rational, might help us think them for themselves, with less violence and assault.

Strong words: to not think a thing in its own being is to assault it. But how is it possible to hold it, in order to think it (because of a desire to hold, to have, to think), and not to assault something in the process? Heidegger's answer is surprising, especially as far as the question of sexual difference is concerned: "Only, certainly, by granting the thing, as it were, a free field to display its thingly character directly. Everything that might interpose itself between the thing and us in apprehending and talking about it must first be set aside."[13] Heidegger seems to be calling on us to listen to things, to notice their talking to us. And it is philosophers and artists who are left to listen to things, to their talking.

Let us consider, then, what kinds of qualities a young girl has as a thing in itself. Here, rather than simply dismiss Heideggerian outrageous logic, I move to understand, in principle, how else art or philosophy can approach her as a thing, not as a reduction in status from a human to a thing (a feminist response often seeks to prove her humanness in order to elevate her status to that of a human). This might allow us to understand what is in her that is thingness rather than "humanness." Let us then take Heidegger at his word and approach her as a thing thoughtfully so as not to assault her but rather to enable, to reveal her independent and self-contained character. Here it would be revealed, however, that things (and young girls) still perform a function for a philosopher, and there is no path for us yet to enact this approach. That painting with which I started, the painting in the students' videos, performed a function, did something, for the purpose of the work, even though the feelings of artists were invested in it and it is due to its existence that the videos were made. The environment in which objects and young girls appear is one factor that leads to their objectification, where they appear to be "at hand" for a

philosopher to be so innocently taken by their immediate presence, their aesthetic qualities as things-in-themselves.[14] Heidegger's contradiction of terms ("human is no thing," "a young girl is a young thing") raises an issue of the standpoint of this environment of objectification, where potentially any thing is a thing except the self. What Heidegger is saying, however, is that there is no need to search far and wide for a thing to be recognized in itself. It is right in front of us, in its perceptibility "by sensations in the senses belonging to sensibility."[15] That is, the thing is here by its aesthetic quality; before we think it, we already taste it, touch it, see it, feel it, sense it variously.

This also explains Heidegger's hesitation with intermediaries between humans and things, for example, science, in its claims to truth through representational, mathematical, or other mediators of things. Science obscures rather than reveals things, as it presents them as its (scientific) objects: "Statements of physics are correct. By means of them, science represents something real, by which it is objectively controlled. But—is this reality the jug? No. Science always encounters only what *its* kind of representation has admitted beforehand as an object possible for science."[16] Heidegger goes on to say that since scientific knowledge deals with the sphere of objects, it already "annihilated things as things." Heidegger's argument presents us with a word of caution on using his philosophy of things and objects for feminist new materialist discussions, for example, which often depend so much on quantum physics, biomedical sciences, or other science-based methodologies to understand things and objects in the world. These new theories privilege scientific knowledge as providing us with support of postmodern and posthuman theories of cobecoming and coexistence. Art and poetry, on the other hand, with their much more direct (aesthetic) but also modest truth claims, reveal things for themselves.

Within Heideggerian cosmology, an intermediary between a thing and a thinker—such as a microscope, for example—does not provide any "higher" truth about matter and things, more penetrating than the one a thinker has access to by his or her own sensibility in relation to the thing, through his feeling of things. Our vocabulary attests to that, since on the level of quantum physics or other smaller- or larger-than-human-scale knowledge construction, any evidence— any thing—is still brought into the scale of human body, human mind,

and their abilities to make sense and create meaning via mediators of language, representation, mathematics, and other epistemological prostheses. Heidegger's point is certainly not that they are not true—"statements of physics are correct," he says—but they are not necessarily helping us understand "things as things," or furthermore, they might be annihilating "things as things."

Hence, another cautionary tale from Heidegger for object-oriented feminism: first, in privileging scientific epistemology as having more direct access to the object, we might actually be moving further away from it as a thing-in-itself; and second, in privileging objects as a sight of ethical and ontological investment, we might be still moving further away from other living beings, human and non-human included.[17] Because proximity to things is essential for their study, such proximity and access raise questions of control and power of humans over those whom they study, with subsequent problems of harm, containment, and destruction.

There are potential problems with Heidegger's position. It does not question anthropomorphism sufficiently: human senses are being affected, and human means make things available to human perception. In addition, human ideals of respectful, nonviolent treatment are used in presenting things for themselves (such as independence or self-containment, for example, that evoke autonomy). It is also not clear why feelings and thoughtful thinking are privileged over mathematics. Heidegger wishes to protect things against those in Western physics and metaphysics who desire to "objectively control" them, like science and engineering, for example. A philosopher competes with a scientist for interpreting things. An important issue here is the intention, since Heidegger wants to protect things for themselves. Another question here is whether things speak to a philosopher or an artist in a privileged manner. There is something deeply misanthropic about Heideggerian *thing-ism* (rather than humanism) here, where the Being is claimed as one with nature (earth, sky, things-in-themselves, or with young girls, still pure in their thingness) rather than with other human beings.

Thus, sensibility toward things in themselves is the reason Heidegger privileges art over science or some other human activity where objects get instrumentalized. Unlike a peasant who uses boots to go

and work in the field, or a thirsty person who uses a jug for drinking, a painter has no other relation to these things—the jug or the boots—than revealing them, as they are to themselves, through the senses. Moreover, an artist is aware of the limitations of those senses to be able to "capture" the thing, and hence needs to present the thing for itself, without the need to be used in any other way than in it being itself. This point was already made by Immanuel Kant, and Heidegger is developing it, even valorizing its contemplative (rather than functional) qualities. With the help of the Kantian definition of things-in-themselves, unlike things for us, objects, Heidegger presents a jug as a thing that things:

> But for Kant, that which is becomes the object of a representing that runs its course in the self-consciousness of the human ego. The thing-in-itself means for Kant: the object-in-itself. To Kant, the character of the "in-itself" signifies that the object is an object in itself without reference to the human act of representing it, that is, without the opposing "ob-" by which it is first of all put before this representing act. "Thing-in-itself," thought in a rigorously Kantian way, means an object that is no object for us, because it is supposed to stand, stay put, without a possible before: for the human representational act that encounters it. . . . The jug is a thing insofar as it things. The presence of something present such as the jug comes into its own, appropriatively manifests and determines itself, only from the thinging of the thing.[18]

Heidegger, as a human, needs the thing for a larger project of holding his world, his ecology of various things and their elements. That jug, as a thing, has important work to do for the thinker, through its agency, its ability, to thing things: "Thinging, the thing stays the united four, earth and sky, divinities and mortals, in the simple onefold of their self-unified four-fold."[19] The jug gathers these four, makes them one as four, enables their gathering by being made of earth, by mortals, who communally evoke divinities with their libations directed at the sky. This "wholeness" as interconnectedness of all in Heidegger works well for contemporary interest in objects and things, and how they are connected with humans and the cosmos, and contributes greatly to the ecological theory of self-forming.

Heidegger, though, finds himself alone, as a mortal, with the rest of the world: "Earth is the building bearer, nourishing with its fruits, tending water and rock, plant and animal."[20] His mortality, of the man, the fully human, is very important here, and remains at the heart of his mourning. Does Heidegger mourn any other thing than the self? Unlikely, because "only man dies, animal perishes." The thingy quality of nonhumans, including "mere things," does not help them, no matter how independent and self-contained they are. Heidegger does not leave a space for their mourning (they are mourned only as fetishes?). This mourning brings us back to those two ultimate things, such as death and judgment, but now with the affirmation of the thing as a gatherer of the world: "The gathered presence of the mirror-play of the world, joining in this way, is the ringing. In the ringing of the mirror-plying ring, the four nestle into their unifying presence, in which each one retains its own nature. So nestling, they join together, worlding, the world.... The thing stays—gathers and unifies—the fourfold. The thing things world.... If we let the thing be present in its thinging from out of the worlding world, then we are thinking of the thing as thing."[21]

Let us summarize the above. Things are all that is not nothing. Some things are more things, as "mere things," because of their nature of thingness as such, rather than other defining characteristics. Thus, plants, nonhuman living beings, and animals (and we can include earth here) are not "mere things." Nature is not a mere thing, though some of her elements are, as well as some human-made things, such as a jug, stones, a hammer, and so forth. They stop being objects as soon as we allow them to be things, for they present themselves to us in their independence, in their ability to gather the whole world in the self-contained manner. The ascendance of objects to things is what would help to treat them differently, as things-in-themselves, rather than being used for human consumption. It is not clear what the next step would need to be, and here is where the students who remade the video, Kathleen Parks and Emily Dibble, became ambivalent too. The next logical step seems to be giving things rights, soul, feelings, consent, in order to break the logic of objectification and its violence. This step, after all, would not be taken for the first time, as many animistic traditions showed us. But as much as this logic seems preposterous, especially in feminist terms, it is also not the same as animism.

Heidegger is famously technophobic in his writing on the modern world, where technology pretends to make things come nearer to us, but in reality planes, radio, and television cause us to lose sight of nearness. Things are so near to us (much nearer than ever) that we do not see them (or each other?) any longer. In the desire to annihilate distance, we do not recognize nearness and its nature in distancing. But the change in our orientation, or our attitude, to things is not enough to be able to think things in themselves, and not only as objects in front of or for us: "nothing that stands today as an object in the distanceless can ever be simply switched over into a thing. Nor do things as things ever come about if we merely avoid objects and recollect former objects which perhaps were once on the way to becoming things and even to actually presencing as things."[22]

Converting objects into things would not do, as it would not make them into independent things-in-themselves. Because just as things, including animals, human-made or natural entities, are innumerable, they remain modest, and nothing in comparison with "the countless objects" and "the measureless mass of men as living beings." In the end, "men alone, as mortals, by dwelling attain to the world as world. Only what conjoins itself out of world becomes a thing."[23] Thus, Heidegger comes back to his earlier definition (anything is potentially a kind of a thing), but he redefines it with a humanistic twist: men are different as things, even if they could be things at all. But why did Heidegger need the last sentence, a thought that seemingly crosses his own text on the thing as thing-in-itself? The last insistence on men as the only ones capable to attain to the world as world? Even if it is true, it does not change things.

Heidegger clearly resists the earthly judgment here based on some instrumental arbitrariness. We are left with a solipsistic tautology, even if it is the one that attempts to show but fails to enact its own method of approaching the difference between things and objects. They appear, or as Heidegger says, presence themselves for the philosopher as it is handy for his world attainment. To say this is not to deny him this pleasure but to ask what it is for things in philosophical thoughtfulness about their thingness. If Heidegger suggested that thinking further and differently about things in themselves, listening to them, hearing them speak in their immediate sensory qualities, reduces the violence and assault on them, then one assumes that even

more so it would be done in relation to "more-than-mere-things," like, for example, other living beings, human and nonhuman. How much is Heidegger listening to them or wanting to hear from them? In her fascinating feminist reading of Heidegger, *The Forgetting of Air in Martin Heidegger*,[24] Luce Irigaray shows that in his desire to listen to things carefully, Heidegger dispenses with their history, trying to recover their original states and disregarding change as a question of contamination of their true nature. In Heidegger's account there is "nature that is excluded from history."[25] Blaming others for annihilating things, he does not admit that he also only thinks things and objects that are important to him as a representative of the mortals. And nature, with her ability to cradle the philosopher, does not seem to speak to him in any other form than in soothing and reassuring terms: "Will man speak to himself, still and always, through a medium that is determined by him, through an other defined in him, through a god or divinity created or interpreted by him"?[26] Nature with its intelligible language of the senses that the thinker can feel is the echo of his mourning of himself, his death and judgment.

Irigaray starts her book with an epigraph from Angelus Silesius: "The rose is without 'why'; it flowers because it flowers." This line was used by Heidegger, translated in his *Principle of Reason* as "The rose is without why; it blooms because it blooms, It pays no attention to itself, asks not whether it is seen."[27] There, Heidegger claims: "Humans, in the concealed grounds of their essential being, first truly are when in their own way they are like the rose—without why."[28] Irigaray questions this comparison throughout the book, asking whether the rose is ever a thing-in-itself, whether Heidegger has been true to Silesius. If the rose in its flowering is appropriated, when Heidegger seeks to speak "for all growth and flowering that is still in silence. . . . Making of its whole self an offering, the rose would have no 'why' other than to flower. It would offer itself to sight without foreseeing or overseeing an impact."[29] But man speaks of this kind of flowering in order to "re-cloak this groundless ground for the dwelling of Being in reason,"[30] and in effect robs the rose of its history, of its own story, where even flowering might not be the reason for it to be. What if there is no reason to be? If the man is like the rose, as Heidegger claims above, without "why," then how does he sustain the dividing line between things, objects, and mortals? They are all appropriated for the state of

Being, and here Irigaray's critique of Heidegger's *orientation* is particularly useful for object-oriented feminisms:

> But a wall separates the rose from the question that is addressed to it at this point. . . . The rose is there, though, static before our eyes. Too close for what is most singular about it to be perceived. . . . To tell of the rose, wouldn't speech forever have to appropriate the rose anew for itself by proceeding toward an origin the rose does not have? Seeking, in the rose, a false depth: the reason for its Being. Relinquishing naïve admiration to discover the cause of the flower in thinking. Into which the flower cannot be transposed? The metaphorical rose no longer blooms— fixed in an ideal figure. A figure possible only thanks to immediate sensible perception, something man ends up forgetting.[31]

Though Irigaray underplays Heidegger's position on the importance of the senses (his notion of thinking is more complex, as I showed earlier), this paragraph provides a forceful critique of Heidegger's fetishization of the object–thing couple as an unchanging standing reserve, which is available to a thinker. I see this critique also as a warning, a word of caution, to the recent feminist valorization of the object: what do they do for us that we have turned to them right now? In other words, there is a need to consider what such objectification of the object does for Heidegger and, potentially, for object-oriented feminism, material culture studies, new materialism, and other thinking that seeks out and speaks so much of objects in their objectness, in their agency, as things in themselves.

Irigaray also warns Heidegger and his philosophical followers of valorization of the rose/nature/earth (the environment) that hides a "silent feminine other" through the suppression of a "female other whose voice would be different" and who is "always assimilated and not known or recognized in her irreducible difference," unlike Being, "spared as that which overflows appropriation."[32] This back-and-forth between giving others (other than mortals, than men) the same status of overflowing appropriation and the known, and not giving it to them, depending on what the philosopher's needs are, is what prevents thinking of things and objects (rather than men) and being with them anew, differently. Are we ready, in other words, to give them their mobility and overflowing, and not only take:

Would some "thing" that philosophy would never have thought
out always and already have been of use to Being? The utility of
a being for the constitution of Being.... He creates things,
immanent and transcendent, matter and form. Things whose
approximation is remote, for in them past forces are evoked, and
future forces invoked, that resist any present co-belonging. They
remain at rest, but recall, or call for, movements. Immobile, their
forms commemorate the mobility deployed. To let them be, then,
means to leave to them the forces that they contain or retain.[33]

The rose, then, only flowers *because of*; otherwise, without the flow-
ering, there would be no rose. As Heidegger would say, the rose,
flowering, roses itself. Without its characteristic rose petals, there is no
rose. Immobility, silence, lack of history, and change (their own story)
are characteristics of things and objects in Heidegger that Irigaray
unpacks as tied to sexual difference. That is why Irigaray's warning
about the end of the world if things start speaking includes gendered
and sexed things as they are in Heidegger's thought. As we approach
objects, then, and orient ourselves toward them with renewed desire
to understand, interpret, and experience, it is important to remain
mindful of this danger of assault that Heidegger warns us about and
Irigaray brings forth as also a question of sexual difference. Heidegger
did not elaborate on such strong terms (and corresponding practices?)
as violence and assault on things if they are not approached as things in
themselves. One assumes, from his account, that violence and assault
are the result of what today is called objectification: only thinking of
and presenting things for their use value, for exploitative purposes. Not
being ends in themselves, but being means to achieve something else
(to satisfy thirst, lust, hunger). When non-mere-things (men, other
living beings) are reduced to things (as mere things), and mere things
are, in turn, reduced to objects of use, violence happens. It is also pos-
sible to speculate that Heidegger takes time here to distance himself
from violence that has already happened by giving things—"mere
things"—more space and respect to be contained independently in
themselves, rather than being instrumental to the needs of people.
 As I mentioned above, there is a sense of protection that Heideg-
ger demonstrates toward objects. His protection is akin to contem-
porary art projects that deal with materiality of things and what they

do for us. I agree with Heidegger that art—especially contemporary art, I would add—reveals objects in ways that are important and often undervalued compared with other paths of sensing, knowing, and interpreting. For example, it is difficult for a scientist to study an object and at the same time include this object's labor into this study (not just acknowledging its labor but making the labor itself part of the subject matter). I started with an example where the labor of a painting came into discussion as a problem for feminist claims, or at least what the young artists and scientists Parks and Dibble identified as a problem. I would like to discuss here another art project about objects, which is engaged directly with questions of their work and environmental degradation, and what a new thinking about and caring for objects might mean. In her project *E-Waste*, Katherine Behar, an artist and scholar whose work focuses on issues of objectification and objects, elegantly explores things as if for and among themselves.

Here a multilayered, hidden, life of objects takes place. Behar emphatically creates a world for and of USB devices:

> But what of all the gadgets those factories churned out, the always-on armies that once served the human race? Their plastic bodies prove impervious to eventual climate change and sudden catastrophe. Indeed they hastened this.
>
> But without humans to program them, to direct their work and give them purpose, the devices persist in their empty routines. As years go by, the Earth beneath them takes pity. The stony ground creeps toward the orphaned gadgets, embracing their fragile frames to soothe and brace them for their burden of infinite work.[34]

Humans are no more, or nowhere to be seen, and those left (out?) USB devices have to fend for themselves. But instead of being poor things or mere things, they are in a community and also act individually. The work is an installation of various things, each a separate work. They need electric grids to feed on, and they also carry on being because of humans who created them. But they do not remember that any longer, and it does not matter anymore. These devices finished their work for humans, though their "infinite work" is never done. They are not defined by their functionality. A human from the audience

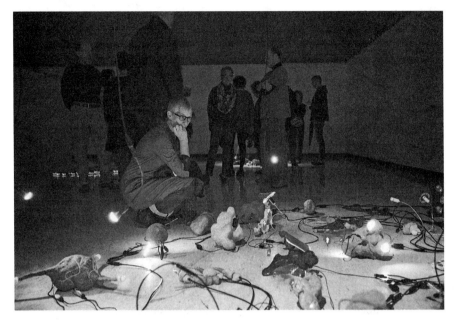

Figure 1.1. Katherine Behar, *E-Waste*, 2014. Installation view at the Tuska
Center for Contemporary Art, Lexington, Kentucky. Photograph by
Dana Rogers. Courtesy of the artist.

looks at these objects as if in wonder and familiarity at the same time.
We are left contemplating (with) them.

Today it is customary to discuss issues of sustainability and waste
in relation to plastics and electronics, and this intention is certainly
present in a work with the title of *E-Waste*. But Behar also chooses
to focus on the beings and lives of these plastic devices that are
demonstratively connected to unconcealed wires and exist in this
techno-futuristic, complicated paradise. They seem to be comfortable
and independent from those who made them. The fact that they will
potentially *be* forever is not a naive position here but a beginning
of thinking of objects for themselves and not as tools only for some-
one else. Their form, their needs, their shapes and movement, their
color, their self-representation and communication—yes, this is all in
our heads (eyes and ears), but not really. That is not all that there is.
Here they are, in front of us, and who is to assert that there is nothing
else going on. The ridiculous question of USB devices' *Being* is not

that far removed from the question of investing any other object, such as a painting, a cell, or a particle, with a meaning to have an ability of being a complex interface in the material relation with others. If we can invest so much intellectual, philosophical, scientific, emotional, and spiritual force into "DNA" and other objects and things, certainly Behar's USB devices should not be excluded too.

Their "loneliness" transforms the installation into a peep show for humans. USB devices left to themselves might not, after all, need us. They are just fine by themselves. Never mind that this is a man-made (woman-made, to be precise) community. And what? Now they are, there, among themselves, whether we want it or not. The relation between the thing and the work of art is not that simple. But it is right here, in front of us, comfortably arranged.

Behar's work also tests the arguments about "objects' agency" in her unique comfortable aesthetic; its edginess being in this comfort, the lack of guilt or anxiety about their plastic future. That agency is

Figure 1.2. Katherine Behar, *E-Waste*, 2014. Installation view at the Tuska Center for Contemporary Art, Lexington, Kentucky. Photograph by Dana Rogers. Courtesy of the artist.

usually defined in anthropomorphic terms: independent movement; autonomy and life on its own, without humans around; "the rose" that does not need "why" to flower, as a rose in herself, for herself, and not an audience member or a philosopher.[35] In that sense, being human-made here creates an even more radical community of self-sustainability. A world without people, where machines, plastic, metal things, our "creations" that are nonhuman and nonliving, will long outlive us, will exist in such a literally posthuman world. We only imagine it, in theory, but it is already here. After all, human-made space explorers might well have a better chance to see this solar system end in around four billion years. They might still be around when the Milky Way–Andromeda galaxies collide, just before or after our Sun's death. Do we hate them and love them because of that? Then their "agency" is omnipotent if it is defined as simply "we don't die as you do." These USB creations are laughing at us, mortals! For Heidegger, death and judgment remained the "last" important questions that things do not need to care about, and it makes them less than human. Behar's work messes up all these questions by not taking this separation of animate and inanimate objects too seriously. One can wonder if it indicates an ethical flaw. It would be too easy to fall into Behar's trap of misplaced fetishism of the contemporary artist who is not serious about the human condition. Her ironic self-representation here as a "lost" posthuman feminist who envisions and farms USB devices subverts the question of labor as always already human (depending on who defines human, of course). Would these devices pass the test of humanness as in fulfilling "excessive tasks," as in Heidegger's definition of a "young girl as a young thing"? Her *E-Waste* things have their Being without even trying to have it: we do not know what is excessive to them or not.

My discussions with Behar on various possibilities of approaching things anew touched on the meaning of "things for themselves" as "being left alone." This new possibility, of what she called in relation to her *E-Waste* series "care as neglect and neglect as care," outlines various consequences of other treatment of objects, when our definitions between human, nonhuman, and posthuman are interrogated. Behar's affinity with non-Western approaches to nonhuman beings is close to other feminist concerns and my own engagement with Jainism and its philosophy of nonharm as it poses critical questions to the

Figure 1.3. Katherine Behar, *E-Waste*, 2014. Installation view at the Tuska Center for Contemporary Art, Lexington, Kentucky. Photograph by Dana Rogers. Courtesy of the artist.

feminist ethics of care and ecofeminism.[36] *E-Waste* is not simply illustrating these topics but produces ethics and politics of such "objects-for-themselves" futures. *E-Waste* heralds new aesthetics in a feminist orientation toward objects.

Bringing together aesthetic and philosophical concerns discussed so far, I can identify the following reasons to be cautious in our search for a feminist object, defined here simply as an object that would satisfy various feminist concerns and be good to think with in feminist scholarship:

1. Objects, defined in relation to subjects as objects to be used, have limitations for feminist thought, because women have been often defined as objects to be used and violated.
2. Redefinitions of objects and subjects with the aim to complicate their complementarity and oppositionality are limited by the lack of changes in the context of the relations between subjects

and objects: subjects continue to be subjects, and objects continue to be objects for the use of subjects.

3. Objects provide essential labor, they do important things for subjects, and this dynamic creates a hierarchy between them that endures.

4. "Elevating" objects to things-in-themselves would not necessarily change what happens to objects unless the position of subjects and how they are defined change too. Subjects would need to agree to give up their power and control over objects (including the hierarchy and unequal status).

5. Assigning agency to objects is useful, especially theoretically, but has its limitations in the extent to which this agency is assigned in anthropomorphic terms. Giving up power, relinquishing control, leaving objects alone, might enable them to become things, as in things-in-themselves.

6. The following terms might be useful, to highlight the conundrum of assigning agency to objects: consent, freedom of choice and expression, a right to self-determination, freedom of movement, dignity, quality of life, nonharm. Here I am not saying that assigning agency to objects is necessarily futile. On the contrary, I am asking how consistently feminist scholars who welcome objects into feminism are willing to apply their feminist values to nonhuman, nonliving beings ("mere things" in Heidegger's account). The uncanny (*unheimlich*) and potentially problematic proposition of *consensual objects* demands our continuous demarcation, reorientation, juxtaposition, and clarification of the notions, the commitments, and value judgments that they represent. Here, the artwork of Behar risks what in other circumstances might not feel "right." And where she might intend to foment solidarities of various labor groups, her work also enables the question of machine labor for the sake of machines themselves, not as a topic that needs to be bracketed outside our (post)human ethics.

7. As questionable as it might seem, within object-oriented feminism and new materialist discussions, it is important to at least pose a question of objectification of objects and what such objectification makes of feminist goals.

The notion of objectification creates a contradiction in terms when applied to objects. After all, most charges of objectification are levied when other-than-objects are treated as objects. In her definitive text on objectification, Martha Nussbaum defined objectification, following the work of Catharine MacKinnon and Andrea Dworkin, through seven characteristics: instrumentality, denial of autonomy, inertness, fungibility (exchangeability), violability, ownership, and the denial of subjectivity.[37] Heidegger warned of instrumentality in relation to things, a gesture that made things into objects. In this context, their value is based only on their usefulness and their function. In relation to objects today, a question of their subjectivity is in order. If they can be objectified, they have subjectivity that could be denied to them. After all, subjectivity, as a term, was introduced to end the subject–object dichotomy. When they do have it, in literature or art, that subjectivity is being given to them. But so is the subjectivity of humans being given to them by others (otherwise they, too, could not be objectified).

The relation between being owned and being objectified presents another complication. In Behar's work, the objects exist in a science fiction story as free and not owned by anyone, since there are no humans around any longer. Is there a concept of ownership outside the human definition of the word? More important, the issue of ownership raises the question of value: objects certainly perform labor and have value in terms of the market. But this is not a necessary definition, and other terms rather than ownership (especially as private property) start being applied to those who until recently have been seen as property of others as a norm: pets, zoo animals, biomaterials in the biomedical sciences. More countries object to defining any living matter as "mere things." These objections take the form of governmental position statements, referendums, or changes in their legal treatment. These follow and produce changes in ethical approach, principles, and ontological status of those objects. If previously such changes have been easily dismissed as misplaced in the face of violence, assault, and annihilation of humans that are not sufficiently dealt with, today forces that want changes in the status of objectified humans claim affinity with those who protest objectification of nonhumans (including "mere things"). Behar's work engenders this human–nonhuman affinity. This affinity cannot be simply reduced to the problematic claim of identification between human and nonhuman victims, as

Parks and Dibble felt not "right" about framing a "sex scene" with a painting as a "rape scene" (in the story that began this chapter).

This might all seem like a ridiculous idea, and it is here, I believe, where the power of object-oriented feminism might shine the most: in the fact that it claims ethics (how is it possible today to claim ontology without ethics?) to things, to objects, the most inanimate, life-free things out there. Certainly, many feminists who are following the tradition of women's liberation might find it objectionable and even dangerous: we do not have respect, equality, and consent for women and sexual minorities, and here we are, seriously talking about problems with the objectification of things! And what a theory we have in which to be a thing is a great improvement—from being a mere object! Isn't being a thing also not that great? Heidegger initially wrote the texts I am quoting from here before World War II, and finished them after it. His discussion on things and violence and assault against things should not be taken lightly, as an exercise only in philosophy. His thought should be interrogated as complicit in the violence and assault against humans as things, as later thinkers, such as Jacques Derrida and Irigaray, and Emmanuel Levinas, his student, have shown. Similar to this postwar turn in European philosophy, the philosophical conditions of elevating objects to things-in-themselves (without necessarily reverting to animism) and making sure that no humans are objectified and made into "mere things" in order to be annihilated have been developed further also by feminist, civil rights, and ecological movements. The hesitation of Parks and Dibble in objectifying a painting because they felt that it would weaken the consistency of their other feminist positions in relation to the environment, for example, or nonhumans speaks to these changes that allow a question of the objectification of objects not to be so easily dismissed.

Heidegger speaks about listening to and feeling things for themselves. The terminology of peaceful coexistence, cobecoming, and coevolution established itself within various strands of feminist theory. But what does this mean from a nonhuman side, the side of things and objects, living or not? Pointing in the direction of object rights or consensual objects, I am not trying to be clever and merely funny here; rather, I am trying to exemplify the stakes of this question within this new feminist orientation toward objects with full understanding of and appreciation for the conflicting definitions and divergent intentions.

Figure 1.4. Katherine Behar, *E-Waste*, 2014. Installation view at the Tuska Center for Contemporary Art, Lexington, Kentucky. Photograph by Dana Rogers. Courtesy of the artist.

Initially I felt sad for Behar's USB devices. I felt that they were left out. Then I started pondering things as they are for themselves, even if human-made, as in Behar's work, as they go about their own business. Their labor for us, whether it is in holding the world or storing our memories, is done. Things left us, mortals, a long time ago and will be here long after we die, creating their own worlds and stories. Our world is ended. They do not need us. Earth and sky, the jug and the young girl, the animal and *E-Waste*, could not care less about humanity's death and judgment. It might be time to forgive them for that and learn to let them be.

Notes

1. I thank Kathleen Parks and Emily Dibble for bringing their response in the form of video artwork to my attention and for clarifying their intentions, which I represent here in my best capacity (Emily Dibble and Kit

Parks, *I, Object,* video artwork, accessed April 15, 2015, https://vimeo.com/122930466).
 2. Martin Heidegger, *Poetry, Language, Thought,* translated by Albert Hofstadter (New York: HarperCollins, 2001).
 3. Ibid., 21.
 4. Ibid.
 5. Ibid.
 6. Peter Geimer, "Verkörperungen im Ding," in *Verkörperungen,* edited by André Blum, John Krois, and Hans-Jörg Rheinberger, translated by Faith Wilding (Berlin: Akademie Verlag, 2012), 120–21.
 7. Martin Heidegger, "Der Ursprung des Kunstwerks," in *Holzwege* (Frankfurt: Vittorio Klostermann, 1977), 5. I thank Faith Wilding for translating for me Geimer's earlier quotation and also for a new translation of the original Heidegger passage that clarifies why the young girl (lit. one young maiden; "ein junges Mädchen" in the original) is not yet human enough. In another, later, translation there is an indication of this excessive task, left out in the above-quoted translation: "True, we say of a young girl who has a task to perform that is beyond her that she is 'too young a thing'" (Heidegger, *Off the Beaten Track,* edited and translated by Julian Young and Kenneth Haynes [Cambridge: Cambridge University Press, 2002], 4). One wonders, however, if a "young boy" (or better, a youth, as in "a male young maiden"?) could also be considered a "young thing" and under which problematic circumstances.
 8. Heidegger, *Poetry, Language, Thought,* 21.
 9. Ibid.
 10. Ibid., 24.
 11. Ibid.
 12. Ibid., 24–25.
 13. Ibid., 25.
 14. A feminist collection on Kant raised some of the issues that also underlie Heidegger's account: see Robin May Schott, ed., *Feminist Interpretations of Immanuel Kant* (State College: Pennsylvania State University Press, 1997).
 15. Heidegger, *Poetry, Language, Thought,* 25.
 16. Ibid., 167–68.
 17. Elsewhere I made a similar point in my discussion on "biomedical realism" in relation to employing the placenta within feminist theory as a privileged object in light of the recent studies in reproductive immunology. Having access to biomedical data that support feminist theories on intersubjectivity does not mean that the placenta as an object becomes more materially substantiated, more feminist, or more accurately explained or known to us as a thing that represents the maternal. See Irina Aristarkhova, *Hospitality*

of the Matrix: Philosophy, Biomedicine, and Culture (New York: Columbia University Press, 2012).

18. Heidegger, *Poetry, Language, Thought,* 174–75.

19. Ibid., 175–76.

20. Ibid., 176.

21. Ibid., 178.

22. Ibid., 179.

23. Ibid., 180.

24. Luce Irigaray, *The Forgetting of Air in Martin Heidegger,* translated by Mary Beth Mader (Austin: University of Texas Press, 1999).

25. Ibid., 142.

26. Ibid.

27. Martin Heidegger, *Principle of Reason,* translated by Reginald Lilly (Bloomington: Indiana University Press, 1996), 35.

28. Ibid., 38.

29. Irigaray, *Forgetting of Air,* 143.

30. Ibid., 144.

31. Ibid., 145.

32. Ibid., 140, 147, 149.

33. Ibid., 152–53.

34. Katherine Behar, *E-Waste* (Lexington, Ky.: Tuska Center for Contemporary Art, 2014), 7. See also Behar, *Prologue,* 2014, video, accessed August 1, 2015, https://vimeo.com/111667912.

35. I say "her," emphasizing its feminine gender in French and Russian ("la rose" and "roza"), following Irigaray, rather than the neuter gender in German or English.

36. Katherine Behar, private conversations and e-mail correspondence, October 2014–April 2015. I thank Behar for our discussions of the feminist ethics of care and non-Western approaches to nonhuman and other living beings. I have outlined my position on what it might mean to "leave alone" nonhuman beings in my engagement with Jainism, in Irina Aristarkhova, "Thou Shall Not Kill All Living Beings: Feminism, Jainism, and Animals," *Hypatia: A Journal of Feminist Philosophy* 27, no. 3 (2012): 636–50.

37. Martha C. Nussbaum, "Objectification," *Philosophy and Public Affairs* 24, no. 4 (1995): 249–91.

Two

All Objects Are Deviant

FEMINISM AND ECOLOGICAL INTIMACY

Plato's Cave and the Proximity of Things

This chapter is going to argue that because of withdrawal, objects are intrinsically deviant. They are never straight. They always swerve. I shall first argue for a view of objects that counterintuitively posits them as irreducibly "close," despite their reputation for being distant, "objectified," background beings. This proximity cannot be thought as immediacy; rather, it is the ultimate subversion of the metaphysics of presence. The metaphysics of presence depends on a certain visuality and on a certain distance. Object-oriented ontology (OOO) subverts the metaphysics of presence by arguing that all beings *withdraw*, that is, they are incapable of being (fully) accessed by another entity: my idea of this glass is not the glass, the parts of the glass are not the glass, and so on.[1]

"Withdraw" cannot be thought ontically: it cannot be thought as distancing in space or time. Withdrawal rather underscores the unspeakable suchness of a thing. *Withdrawal* is a paradoxical term, since it might be better to imagine what it consists in as an *intimacy* or *proximity* that makes a thing impossible to access because it is *too close.* Impossible to "see" not because they are too far away but because they are too intimate, objects crowd upon one another like characters in an Expressionist carnival. They cannot be fully subjected or subjugated by us (or indeed by anything). Nonmetaphysical proximity is better thought when we replace the language of vision with a language of kinesthesis. A reading of Plato's allegory of the cave will establish this.[2]

What this chapter outlines, then, is a strange new form of essentialism, which perhaps we could call *weird essentialism*. In this weird new essentialism, we have dropped the metaphysics of presence—namely, the idea that in order to exist you have to be constantly present. This idea of constant presence affects metaphysics whether it has to do with basic substance ontology or with more recent and perhaps sophisticated forms of process philosophy in the lineage of Henri Bergson, Alfred North Whitehead, and Gilles Deleuze.

Why is that? Because with substances or with fluids, what we are thinking of when we think of an existing thing is something that is present in such a way that it can be subdivided—it is constantly there, so there can be parts of a thing, whose removal will at some point drastically alter that thing's existence. Say, for example, I am an ecologist studying a meadow. If I think that the meadow is constantly present, I can remove pieces of it—a blade of grass here, a blade of grass there. At some point I imagine that the meadow will not exist anymore. The trouble is, when exactly is that?

I remove a single blade of grass—the meadow is still there. I remove another one—still the same meadow. I can go on removing blades of grass and verifying that the meadow is still there, perfectly logically, until all I am looking at is a bald patch of dirt. I conclude from this, mistakenly, that there must not have been a meadow there in the first place—again, I am cleaving to "being a meadow there" in terms of something that must be constantly present. Likewise, I can start the process in reverse. I plant a blade of grass on the dirt patch. This is evidently not a meadow. I plant another one—the same logic applies. I plant ten thousand blades of grass, and still I do not have a meadow.

This is known as the Sorites paradox, the paradox of the heap: how many grains of sand are there in a heap of sand? How many cloud puffs are there in a cloud? The Sorites paradox applies to vague predicates, which is to say that it applies on my view to real objects in the real world, such as meadows, and indeed to other entities that ecologists and biologists study. I can do what I did to a meadow to the biosphere as a whole, I can do the same with an individual life-form such as a meadowlark, and so on. If I regard them as existing insofar as they are constantly present, I can apply the Sorites paradox to them and make them evaporate. Either the beings that biology and ecology

study are not very real, or my logic is faulty. I may have to accept at some point that to exist is to be fuzzy—that is, if I am not an antirealist or a nominalist for whom nothing exists but as it is designated or named as existing.

I use the term *fuzzy* in a way that is far from fuzzy, but indeed rather sharp. A thing is a set of other things that do not sum to it. These other things include its various parts and the way it appears. There is an intrinsic and irreducible gap within a thing between what it is and how it appears, a gap I call the Rift.[3] This gap cannot be located anywhere in what I am calling ontically given space-time. That is, I can travel all around the surfaces and depths of a thing, study its history, think about how it is used, interview it—if it can speak—and I will never be able to locate the Rift.

I cannot point to the Rift because a thing does not sum to its uses, or history, or relations, or pieces. A thing is an irreducible unicity. This means that I have to accept that things can be themselves and not-quite-themselves at the very same time, because the appearance of a thing just is not the thing. This means that to be a thing means to be in a state of logical contradiction, which means that our OOO view is diametrically opposed to Alain Badiou, for whom to exist is to be consistent.

This line of thought brings us to Plato's allegory of the cave in the seventh book of *The Republic*. Reality is something to be seen, suggests the allegory. After considerable mental toil you infer the existence of real things of which the shadows on the wall are just distorted projections. But what are the conditions of possibility for this toil? Why would one even start in the first place, chained to the spot and totally taken in as one is? Isn't there something like a faint echo, in the very fact that you are able to turn around and stumble toward the fire, and then make your way up the tunnel into the light, a faint echo of an intuitive grasp of reality, already installed in your mind?

Plato may think here of the doctrine of transmigration of souls and of the soul's task of remembering its previous existence, and better yet, remembering what it is. Yet there is a more satisfying, less tacked-on way of thinking about this already installed knowing. It has to do with the fact that *I am physically there*, sitting in the cave, chained up. Martin Heidegger reads Plato's figurative language about the cave as an artifact of some nonmetaphysical way of thinking reality: there

are all kinds of motions and movement in the cave, all kinds of things are happening already—it is not simply a hypnotic spectacle. To move toward the light of the truth, I have to *turn*—and Heidegger makes a lot of this physical motion, which for him suggests the *kehre* or turning (or bending, or swerving, just to make it more physical) within his own philosophy, the way that thinking can turn from the metaphysics of presence.[4]

I feel the warmth of the fire on my limbs. I sense the coexistence with a host of people all watching the display. What I see on the wall are shadows, fluid, motile, flickering—I see what indigenous humans saw painted on cave walls, dancing figures. Figures that are distorted shadows—distortion itself, as a dis-torsion, a twisting away or apart, as movement. They are shadows of things, but they are also shadows in themselves. It is as if, buried within the imagery of Plato's cave, there resides a deeply ancient figure of Paleolithic humans watching shamanic displays.

At no point in the display, at this level of thinking about the allegory, am I ever separated from reality. It is not correct to say that reality is outside the cave, waiting for me up there, waiting for me to see correctly. Reality is literally all over me—in the sweat from the fire's heat, in the dancing shadows. Reality is already here. Plato seems to want us to struggle away from this reality to see the truth that must reside somewhere outside it. But what is more interesting is that there is a kind of "beyond" *within* things, not *outside* them—I feel my way along, totally shrink-wrapped in reality, unable to get a firm purchase outside it from which to see perfectly. This groping, grasping, handling, and turning is more like what OOO means when it thinks about how entities are.

It is not some fantasized immediacy of touch, as opposed to seeing, that intrigues me about Plato's kinesthetic imagery. It is rather the total opposite. What intrigues me is that when I handle a thing, when I walk along a corridor, when I turn my head, when I walk upward toward the light, I do not exhaust the corridor or my neck bones or the upwardly sloping passage. When I handle a thing, I can never see it all at once. What was the underside of the object is now the front side—I can never see the underside of this rock as its underside, but only by rotating it so that a new face presents itself to me. A cross section of the rock now gives me the rock sliced in two—in a

sense, I now have two problems, or more, where before I had just one. My grasping or apprehension of the thing never gives me the thing itself. This is an insight that Immanuel Kant has about raindrops. I feel them on my head—but I don't feel *them*. I feel anthropomorphic, or better, human head–shaped renderings of them. The intimacy of a thing, the intimacy afforded to me by its haptic nudging, reminds me not of its constant presence but of its withdrawnness. The essence of the raindrop is not just any old thing. A raindrop is not a stick of butter. It is raindroppy, not buttery. It has just these qualities of wetness, a certain heaviness as gravity pulls it toward my skull, a slight or extreme coldness, the explosive thing it does to some of the hairs on the top of my head. Yet none of these things is the raindrop as such. Consider how Kant talks about it:

In phenomena, we commonly, indeed, distinguish that which essentially belongs to the intuition of them, and is valid for the sensuous faculty of every human being, from that which belongs to the same intuition accidentally, as valid not for the sensuous faculty in general, but for a particular state or organization of this or that sense. Accordingly, we are accustomed to say that the former is a cognition which represents the object itself, whilst the latter presents only a particular appearance or phenomenon thereof. This distinction, however, is only empirical. If we stop here (as is usual), and do not regard the empirical intuition as itself a mere phenomenon (as we ought to do), in which nothing that can appertain to a thing in itself is to be found, our transcendental distinction is lost, and we believe that we cognize objects as things in themselves, although in the whole range of the sensuous world, investigate the nature of its objects as profoundly as we may, we have to do with nothing but phenomena. Thus, we call the rainbow a mere appearance of phenomenon in a sunny shower, and the rain, the reality or thing in itself; and this is right enough, if we understand the latter conception in a merely physical sense, that is, as that which in universal experience, and under whatever conditions of sensuous perception, is known in intuition to be so and so determined, and not otherwise. But if we consider this empirical datum generally,

and inquire, without reference to its accordance with all our senses, whether there can be discovered in it aught which represents an object as a thing in itself (the raindrops of course are not such, for they are, as phenomena, empirical objects), the question of the relation of the representation to the object is transcendental; and not only are the raindrops mere phenomena, but even their circular form, nay, the space itself through which they fall, is nothing in itself, but both are mere modifications or fundamental dispositions of our sensuous intuition, whilst the transcendental object remains for us utterly unknown.[5]

This means that there is a gap between subjects and everything else, which for the anthropocentric Kant means that there is a gap between humans and everything else. But to return to the cave, there is also a gap between the fire in the cave and the walls of the cave. There is a gap between the walls of the cave and the shadows projected onto the walls. There are gaps within the shadows themselves, which I detect as their flickering motility. There are all kinds of gaps, at least as many as there are things—and exponentially more, when we consider that things interact in all sorts of ways with all sorts of other things. Trillions of gaps. The OOO reality is like a beautiful piece of Japanese raku wear, cracked to smithereens yet somehow coherent.

I cannot peel myself away from the so-called illusion level of reality, the level of appearance. It means that reality has the quality of art, and as we know for Plato, art is a little bit evil, because it tells lies in the form of the truth, lies that are thus contradictory on the inside. It is not the laser guns and hyperdrives that would disturb a Plato about *Star Wars,* it is the expressions of fatherhood. Art also exerts a demonic influence insofar as it renders my free will somewhat inoperative. It flows all over me, it pushes me or hits me, communicating some kind of force from a dimension beyond me. The trouble with the shadows is that I simply cannot tell whether they are illusions or not: "What constitutes pretense is that, in the end, you don't know whether it's pretense or not."[6]

To put it in Heideggerian terms, what happens in the cave is a play of nothingness. Of nihilation. The shadows both are and are not translations of other entities, projections of puppets and fire. To be immersed in them is to experience a never-ending play of illusion.

This is not absolutely nothing at all, but rather a-ness, a quality of nothing, "nothing-ing," if you like. A philosopher, goes the allegory, is someone who tries to tear himself or herself away from the illusion. But this act of wresting oneself away results in a fourfold series of blindings, as one is dazzled by higher and higher levels of truth. Even this truth is seen as a kind of nothing at first, since the onlooker cannot assimilate to her experiences in the cave.

But outside the cave, the philosopher knows the illusions to be illusions. Within the cave, the illusions are not known as such. How on earth, unless the inkling that there are illusions is already present, is the protophilosopher to move upward? Or even imagine doing so? Plato strives to separate the language of seeing, of insight into truth, of clarity, from the haptic confusion of the cave's interior. Yet this is impossible without reducing the nothingness within the cave to absolutely nothing—to pure illusion, which one knows is illusion. Once illusion has been reduced this way, it is not really an illusion, because we can tell whether it is an illusion or not—we are sure that it indeed is an illusion. The cave's display has been totally negated. The clear seeing of the philosopher is separated from the warm, haptic seeing of the cave dwellers.

Within the cave, the essence of things is weirdly hidden inside them—the shadows distort the puppets, but not completely. There are puppets and there are shadows. Outside the cave, however, there is a clear bright line between truth and falsity. What Heidegger calls *alētheia*, undisclosedness, is already there inside the cave. It must be, as Heidegger argues—it is an always already, a condition of possibility for the metaphysical journey. What the metaphysician does is to posit some things as more real than other things and to draw a thin, bright distinction between them. Realness here means constant presence—the sun of truth keeps shining no matter what, more real than the shadows on the cave wall.

The object-oriented reality is withdrawn precisely because it is so proximate—it is in your face; it *is* your face. The most incontestable fact about me, the fact that I just am me, whatever that is (let us call me a *human*) is phenomenologically the most distant thing about me! This is the same as saying that my glasses, through which I see everything else, are hiding on my nose. Hiding in plain sight in the allegory of the cave are all kinds of objects, and all kinds of human

relation to objects. And objects in the mirror, as my American car tells me, are closer than they appear. This means that what is most intimate about me is in fact *nonhuman*, if by *human* we mean not "just exactly what I am" but "this graspable, given entity that I can point to in a mirror." Indeed, as Kant showed, this nonhuman being is within thinking itself as a condition of possibility for pointing at myself in the mirror!

What suggests itself here is a return to the kind of essentialism advocated by 1970s feminism, but with a weird twist: *weird essentialism*. In this weird essentialism there are real things, but they are not subject to the metaphysics of presence. It is this weird essentialism that provides a fourth position on the logic square of common arguments about existence these days.

This is just what we need for navigating the strange and disturbing ocean of ecological awareness. Why? Because ecological awareness is coexistence with beings that are sometimes terrifyingly real at least in spatiotemporal, scale terms, yet downright impossible to locate as constantly present. Beings such as *evolution, biosphere,* and *climate.* Let alone beings such as *human* and *species.* Beings such as global warming, a gigantic entity executing itself in a high-dimensional phase space that happens to have an amortization rate of one hundred thousand years.

1. Essentialism + metaphysics 2. Nonessentialism + metaphysics of
 of presence presence (relationism, process)

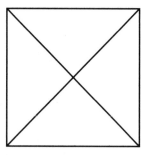

4. Essentialism – metaphysics 3. Nonessentialism – metaphysics
 of presence (OOO) of presence (deconstruction)

Figure 2.1. Ontology: a logic square.

The Deviance of Things

Now that we have established the need to return to something like a *weird essentialism*, promoted for instance in the work of Luce Irigaray, let us proceed with more detailed thoughts about how things might be if we understood them this way. In brief, *objects would be deviant*.

All objects are deviant insofar as they exist in difference from themselves. This is because they are riven from within between what they are and how they appear. To say this is to continue the thought of Irigaray, for whom at least one entity, known as woman, falls outside the logical Law of Noncontradiction, insofar as female physicality cannot be thought either as one or as two but as a weird touching between one and two, a loop-like self-touching denigrated as narcissism.[7] Irigaray observes that women's speech is alogical: "she steps ever so slightly aside from herself" with "contradictory words."[8] Irigaray asserts that women's bodies are "neither one nor two."[9] What object-oriented ontology does is simply apply this thought to any object whatsoever.

The question is, in so doing is one exiting logic altogether? Are objects (people, fish, stars, gurgling fountains) just illogical? Or does logic require rethinking from within? I shall argue that the latter is the better option, and not only for the strategic reason that an entire region of thought should not be handed over without struggle to reactionary forces. The main reason for working on logic is that logic works much better if it is able to think deviance, to think deviantly.

First, consider Jacques Lacan's formula for subjectivity, $ \diamond a$.[10] This means that the "split subject" is constituted in relation to a fantasy thing, the object-cause of desire. $ \diamond a$ is also his formula for perversion. Why? Because, and this is a general truth of correlationist thought, the subject and its fantasy thingy are mutually constituting—there is no subject *before* its correlation with the object. Thus the subject is looped through the other, which is best expressed in forms of so-called perversion where my desire is looped through your pleasure—this so-called perversion expresses a general truth about desire and being a subject at all.

Barred S, the subject: $. This means the transcendental subject as opposed to phenomenal me, which follows from Kant's grounding of David Hume. This is not a subject that exists when you subtract all

of the phenomenal me—my clothes, what I am wearing, my fondness for those little cubes of lemon-flavored gum. There is nothing that is not me in those phenomena, yet they are not me. It is the same with a raindrop. There is a raindrop, it is not a gumdrop, alas—or a little lemon-flavored gum cube—but when I reach for it with my fingers or with my tongue or my thinking, what I find are raindrop phenomena.[11] I do not find lemon gum phenomena. There is a real raindrop, but it is, to use the object-oriented language, withdrawn. This does not mean that something is lurking behind the phenomena. It means *ontologically* withdrawn—there is an irreducible gap between what a thing is and how it appears.

This is how Kant grounded Hume. For Hume there are data, such as the iron-y or leathery taste of some red wine (as he puts it in "Essay on the Standard of Taste"). But what I do not have is the ability to see the actual cause of this taste, definitely, once and for all, unnecessary to repeat. In a way Hume could have written the lyrics to Pink Floyd's song "Breathe": "All you touch and all you see / Is all your life will ever be."[12] Then you drink the cask of wine and find that there is a key on a leather strap at the bottom.[13] But now the wine has gone—you cannot have direct contact with the key in the wine. Yet the wine has been, in OOO terms, *translated* by the key and its leather strap. Now here comes a further twist. When you get hold of the key, argues Kant, you do not have the key either—you have key data; it is shiny and makes a certain crunching sound in a lock, and so on—inseparable from the actual key, but not the key. Any bald metaphysical assertion that there is a key (or a cause, or an effect) would be scraping the bottom of the barrel (groan).

At this point we need to explain *a*, which stands for *autre*, the little other, the thingy, on the other side of the manifold. This *a* is the fantasy thing that you structurally cannot directly get ahold of. It is like the soap in the bath: if you grip it too hard, it slips out of your fingers. It is what in advertising is called the *reason to buy*: it is not the product itself but the dream that happens when I think about consuming the product. What I am buying is this elusive dream, and of course it slips away as the product slips down my throat, so I will need to get another product, thanks very much. I am coconstituted by my idea of me, which is in a loop with actual me: it is me insofar as it is me-phenomena, as it were—but it is not me. Anyone who has

meditated will easily discern here the funny thing that happens when you do so—you notice your thinking and you notice it is not you, but that you are not anywhere else, either.

For the rest of this chapter, I shall call the manifold $ ◊ *a* by the name "Roadrunner," after the misadventures of Wile E. Coyote, a desperately desirous being in pursuit of his obscure object of desire, even at the cost of his happily malleable life. It is both funny and true. If Wile E. Coyote ever actually caught up with Roadrunner, he would eat Roadrunner, and Roadrunner would become him. So he can never truly catch up with Roadrunner.

And we must explain ◊, the funny little lozenge in between the subject and the little thingy. This symbol simply means *has a loop form*. By *loop* I mean *mutually determining*: the two things on either side of the symbol are coconstituting such that neither one has ontological priority. Consider trying to find out whether the light is on in your fridge. You have to open the fridge to find out. But now you have changed your fridge, so you cannot ever find out whether the light is really on before you open the door. But the idea that the light might be on is a kind of fantasy thingy that gets you to want to open the door in the first place. So you and the fantasy light are in a loop.

This manifold, Roadrunner, sits on top of what I here call *object*. Roadrunner, the dialectic of desire, happens because there is an irreducible Rift between Roadrunner and the *object*. Consider it again in terms of fridges. I wonder about the light in the fridge because there is a fridge. I cannot specify what that is in advance, because all I touch and all I see are all my life will ever be, so I just have to go ahead and open the fridge.

This might give me the masculine fantasy that I am Harold and the Purple Crayon and I can do anything to anything—reality is a kind of wonderful Play-Doh, and I get to mold this plasticity as I like. Kant is already associated with the Marquis de Sade by Lacan for this very reason. Yet this is to assume that the object is just a lump of whatever, and we have already ruled that out. The sadism in Kant does not come from correlationism. It actually comes from a viral piece of code that I believe derives from patriarchal agricultural "civilization": the idea that a thing is an extensive lump decorated with accidents, like something that comes out of an Easy-Bake Oven, the Hasbro toy. Let us call this kind of substance (alas, it is still default)

the Easy Think Substance. Actual objects are not Easy Think Substances. They are not lumps of blah decorated with accidents. Their phenomena are inseparable from them.

This means that there is a flip side to the supposed Harold and the Purple Crayon approach to things, just as we know that masochism subtends sadism. There are already things; they issue directives in whose tractor beams I find myself, always already. There is a givenness about reality that is not quite the same as saying that there is a god or there is substance or any other metaphysical assertion. To assert such things, which Quentin Meillassoux calls the Ancestral Statement, is not so different as the well-rehearsed deconstructive argument that for every sentence there must be some kind of writing, an arche-writing.[14] I am not going to find it when I look directly for it—but that is not so much a proof that it does not exist, as oblique evidence that it *does* exist.

Let us name the manifold \$ ◊ *a / object* Looney Tunes.

Looney Tunes is truly loony and loopy. This is because *object* is sparklingly uniquely itself, its phenomena inseparable from it, yet not it. Because this is true, I can have fantasy thingies that do not coincide with it. Because I can have fantasy thingies, I can have Roadrunner. Imagine all the fun when the object, the fantasy thing, and the supposed subject all have the same name, like Tim or whatever. You could write a lot of Romantic poems that way!

Next, consider this: Roadrunner is the formal structure of the appearance of any object whatsoever, not just a (human) subject. I have already shown that, by the way: there has to be some kind of object (in the object-oriented) sense for Roadrunner to happen. And all the terms in Looney Tunes can coincide, as I just mentioned with my autobiographical example. So there is no need for an external perceiver who "makes it real" by observing or otherwise correlating with it. There is already a difference between a thing and itself. But since this de-anthropocentrism is still quite counterintuitive, let us run through it a little.

I cannot have fridge light fantasies without fridges and lights. Yet when I look for the fridge and its light, I have the same dilemma with which I started. I cannot jump out of Roadrunner. When I try, I find myself in Roadrunner. But that does not mean that there is nothing at all. Yet, and for the same reasons, it is not me who makes

the fridge and its light—I am not Harold and the Purple Crayon, tempted as I am to resolve the Kantian tension in that familiar and patriarchal way, running to technologically intoxicated idealism or what one might call Happy Nihilism: How I learned to stop worrying and love the bomb. . . . So although I cannot access the fridge in itself, there is a fridge, in itself. The fridge appearance is not the fridge reality. Yet the fridge is not this purple crayon, and so on. It just is a fridge. The way a photon accesses the fridge will be just the same as the way I access the fridge. It is actually well established at that very small scale that *to see* is also *to change*, so that a photon cannot directly see what it ends up touching. Quantum-scale phenomena give very elegant examples of how when you isolate a thing as much as possible by cooling it right down and putting it in a vacuum, it starts to shimmer, without the aid of anything else, such that its appearance and its weird essence do not directly coincide.[15] But meditation also does this: when you isolate yourself and relatively immobilize yourself, you discover that you are sort of rushing with thought, while sitting quite still watching yourself, at the same time.

There is no reason why $ needs to be a human. It could be a camera, a photon, or a line of code. Quantum-scale phenomena show decisively how things quite happily get caught in Roadrunner all the time—they do it without humans, in vacuums close to absolute zero, conditions that would be violated if I were able to peer in. They happen in physically isolated systems. Yet they happen, I claim, because things are just like that in general. A cask of wine talks about a key and a leather strap. But what it says is not the key and the leather strap. This means you can have debates about whether your wine is iron-y or leathery. The trees talk about the wind. But the sound of the wind in the trees is not the wind. And so on.

Now let us proceed. Roadrunner is the structure of how anything appears. Moreover, Looney Tunes is the formal structure of any object whatsoever: human, crowd of humans, grass blade, grassy meadow, spoon, spoon collection. Everything is riven from its appearance yet inseparable from its appearance. This means that Roadrunner deviates from Looney Tunes, and it also means that Roadrunner is deviation (from itself), since its loop form is recursive. It is not symmetrical, because $ and *a* are coconstituting. We have Roadrunner deviations because of the more encompassing Looney Tunes deviation, which is

between an object and its appearance. The soap in the bath is slippery because the entire bath, and the bathroom, and me looking for the soap are also a slippery bar of soap.

Thus an object deviates from itself, let alone other things. This deviation violates the "Law" of Noncontradiction. But this violation is a good thing because it is the price you pay to part decisively from Easy Think Substances. If I cannot peel how an object appears away from what it is, I cannot make a neat metaphysical dotted line that tells me where the key data stop, the key appearances (sparkly metal, crunching sounds, etc.). I am stuck with appearance wherever I look. But these appearances are not the object. Again this is quite evident at scales that are small enough and isolated enough for the blurry, shimmering qualities of things to become more obvious. Sparkling and shimmering are metaphorical qualities of the nothingness—which is the soapy slip of this weird, undetectable yet real and irreducible gap. Sparking is a visual fluctuation of reflected light that appears to travel across a thing, like the surface of a lake or a Christmas ornament. Things are sparkly with nothingness, dappled by shadows.

An object is deviation—*objects in general turn,* not just the human (Heidegger's *kehre*). Not simply from our (human) idea of it, but from other entities' models, conceptions, plans, frameworks. And not simply from other objects, but from itself. We are not talking about movement of an Easy Think Substance in some Easy Think space or time. Movement is part of being a thing, period, such that a thing deviates from itself, just to exist. Preventing a thing from deviating is called destroying it.

Thus Irigaray's theory of woman as self-touching loop is in fact a theory of everything. A loop is a looping, or a circle is a circling, just as nothingness is nothing-ing or as Heidegger puts it, nihilation. Circles are not all that holistic. They are lines that constantly deviate from themselves. In the same way pi, which rules the world of circling, cannot be found anywhere in the infinite set of rational numbers. But you can think it easily, and you can somewhat see it, by looking at the diagonal proof of Cantor. Imagine this fantasy thingy: a grid on which are arranged all the rational numbers, in sequence from the first to the whateverest. Appearing down the diagonal of this incredible list is a weird, monstrous, deviant number that literally slants away from the others. An irrational number such as pi is not in the infinite set of

rational numbers, by definition! No wonder there is a rumor that Pythagoras, worshipper of the sacred integer, drowned Hippasus, who discovered irrational numbers.

We need to explore the term *veer*, from which we obtain the term *perversion*. Fascinatingly, we get the term *environment* from the same root.[16] The environment is a *veering* insofar as it circles in the deviant sense just outlined, all around us and within us. It is not your granddaddy's Nature, as contemporary data concerning the Anthropocene and its global warming have made all too clear. What is called Nature is just an Easy Think Substance version of the actual, deviant veering around, the evolution, the symbiosis, the feedback loops, never returning to the same place.

The marvelous thing about *veer* is that it is disturbingly poised between activity and passivity—and here I beg your indulgence, as we are all inclined toward the Law of the Excluded Middle, which is a consequence of the Law of Noncontradiction. When a ship veers, is it turning by itself or following the current—or is that whole way of questioning not relevant? There is a deep poetic truth in Lucretius's account of how things got started—with a veer, an inclination (*clinamen*). Perhaps *veer* is a better term for that than the popular *swerve*, because that verb implies something from which I am swerving. But veering may not imply a simple state from which I deviate. It disturbingly or wonderfully suggests that I will not find a simple, undeviant state.

I veer toward the refrigerator. Am I choosing of my own free will to open it and find the cool sparkling water? Or do the fridge and my sparkling water fantasy of what is inside the fridge emit kinds of tractor beams, such that like a good surfer I catch their waves and find myself drawn toward them? There is a basic uncertainty there, an uncertainty we should not try to crush or ignore. Don't we know from consumerism that there is a good way to handle a glass of wine, a bottle of sparkling water, a small rubber toy?

Free will is overrated. What is now required is a mutual veering (attunement). This mutual veering takes the form of Roadrunner—it is irreducibly perverse. There is some Easy Think Substance code in Kant, which ended up in Lacan, who deviates a little bit from deviation when he thinks Roadrunner. It is as if the object itself is only a blank screen or a mirror. This tendency is corrected by Alphonso

Lingis in his theory of directives and levels, the masochism that underlies sadism, and in the transition from Lingis to Graham Harman, with his theory of objects that are too unique to be exhausted by their appearances or relations.[17] Yet Lingis also suffers from the residual Easy Think code insofar as he wants to show that there is a proper way to consume a thing, a proper way to follow its directives. There is a good, natural way to handle a glass of wine, and a bad artificial way. Don't these two positions of Kant and Lingis, like two halves of a torn whole, say something about the profound ambiguity of modernity, with its consumerism? Isn't there perhaps a glimpse, within my relationship to the sparkling water, of a relating to nonhuman beings and among human beings that is not instrumental or sadistic? Or anthropocentric?

And isn't it thus necessary to think how things, and how thinking, can be ambiguous and contradictory, without being wrong? And isn't this what Irigaray says about the fluid being she calls woman?

Thinking is a form of deviance. Insofar as thinking is deviance, it is environmental.

Notes

1. The locus classicus is Graham Harman, *Tool-Being: Heidegger and the Metaphysics of Objects* (Chicago: Open Court, 2002), 133.

2. Plato, *The Republic*, 7.51a–517a, http://classics.mit.edu/Plato/repub lic.html, accessed November 14, 2014.

3. Timothy Morton, *Realist Magic: Objects, Ontology, Causality* (Ann Arbor, Mich.: Open Humanities Press, 2013), 28, 38, 40–41, 56–62.

4. Martin Heidegger, *The Essence of Truth: On Plato's Cave Allegory and Theaetetus,* translated by Ted Sadler (London: Continuum, 2002).

5. Immanuel Kant, *Critique of Pure Reason,* translated by Norman Kemp Smith (Boston: Bedford, 1965), 84–85, A45–A47/B63–64.

6. Jacques Lacan, *Le seminaire, Livre III: Les psychoses* (Paris: Editions de Seuil, 1981), 48.

7. See also Hélène Cixous, *The Laugh of the Medusa,* translated by Keith Cohen and Paula Cohen, *Signs* 1, no. 4 (1976): 882.

8. Luce Irigaray, *This Sex Which Is Not One,* 6th ed. (Ithaca, N.Y.: Cornell University Press, 1996), 29.

9. Ibid., 26.

10. Jacques Lacan, *The Four Fundamental Concepts of Psychoanalysis: The Seminar of Jacques Lacan Book XI*, edited by Jacques-Alain Miller, translated by Alan Sheridan (New York: Norton, 1998), 209.

11. Kant, *Critique of Pure Reason*, 84–85, A45–A47/B63–64.

12. Pink Floyd, "Breathe," *The Dark Side of the Moon*, EMI, 1973.

13. David Hume, "Of the Standard of Taste," http://www.fordham.edu/halsall/mod/1760hume-taste.asp, accessed November 14, 2014.

14. Quentin Meillassoux, *After Finitude: An Essay on the Necessity of Contingency*, translated by Ray Brassier (New York: Continuum, 2009), 10–11.

15. Amir H. Safavi-Naeini, Jasper Chan, Jeff T. Hill, T. P. Mayer Alegre, Alex Krause, and Oskar Painter, "Observation of Quantum Motion of a Nanomechanical Resonator," *Physical Review Letters*, art. 033602, January 17, 2012.

16. I follow here a wonderful book by Nicholas Royle, *Veering: A Theory of Literature* (Edinburgh: Edinburgh University Press, 2011), 2–5.

17. Alphonso Lingis, *The Imperative* (Bloomington: Indiana University Press, 1998).

Three

*For me one of the more interesting dimensions of
OOO is precisely what happens when objects interact.*

—IAN BOGOST, "WHAT IS OBJECT-ORIENTED
ONTOLOGY? A DEFINITION FOR ORDINARY FOLK"

Frenchy Lunning

Allure and Abjection

THE POSSIBLE POTENTIAL OF
SEVERED QUALITIES

This is a tale of two gestures that meet in the heat of a metaphoric confrontation of transformation. In comparing Graham Harman's work on allure juxtaposed with Julia Kristeva's work on abjection, certain relationships, similarities, and movements suggest a way to read across each of their central metaphors in structure and movement, and in their implications of marginal identities and aesthetic locations. Both Harman and Kristeva offer unique aspects that can be used in critiquing the other, such as in the intriguing leftovers of severed qualities or "dark agents" found in the gaps between objects and the note-objects created in the metaphoric gesture of the abjection process.

Even more essential is the potential for similarity in the movement of the "thrust aside" of Kristevian abjection and the "special sort of interference . . . or strife between an object and its own qualities, which seem to be severed from that object" of Harman.[1] In the explication of both movements is the use of the metaphor as a mode of narration to explain the invisible, the real / not real, and the possibilities of the desire–disgust binary as not only the generator of the gestures of separation and attraction but also the landscape of a potential agency, as they lie at the very limits of representation. And extending beyond the allure between two objects lie the implications for this condition of allure/abjection to be considered in terms of their notes on a cosmic scale . . . as a set of notes caught in the meronymic maelstrom of a *hyperobject*. As Timothy Morton defines it: "Hyperobjects

stretch our ideas of time and space, since they far outlast most human time scales, or they're massively distributed in terrestrial space and so are unavailable to immediate experience."[2]

In investigating object-oriented ontology's "landscape of entangled object stuff which has given us the diagram ... of the object world," Harman asks, where is the key to activating this "difference engine"? It arrives in the form of a special situation in the interaction of objects called *allure* and seems to operate in the aesthetic realms. Harman describes it as a situation where "the sensual object somehow breaks loose from its own qualities and meets them in a kind of dual."[3] This is possible because many of these qualities become objects themselves as they are exuded from the original object—objects with their own notes of connotations and associations and, further, those new qualities also become objects—forming a chain or echo effect of potential and actual interactions with other objects in the "element" that Harman describes as the "ether in which objects bathe."

In allure, "there is a combat between the object and itself, between the monad and its traits."[4] And this operation, Harman suggests, can lead us to understand other operations and interactions in the world of objects. Principally, we are led to one of Harman's two spaces in which they—the colliding objects—"meet ... in a sort of chemical technique that shows the mechanisms by which objects break apart or melt together,"[5] which, for Harman, results in the play of comedy and metaphor.

Harman uses the notion of the metaphor to explain the operation:

> ... two objects collide: shattering the bond between the object, and its notes, and uses one or more of these notes as a secret pipeline through which all the mysterious resonances of one of the objects flow directly into the body of the other object. ... The object recedes, while still dominating its notes—becoming a brooding subterranean power—but no longer identical with its notes.[6]

Allure, which provides the process for metaphor, does not take us any closer to the object—but merely translates it into object language—redolent with the pull of the now withdrawn object, but engineering a mysterious exchange of qualities that are left in the gap of the conceptual field that is the heart of the metaphor. As Harman states, with

his usual poetic loft: "Given that no direct links are possible between objects of any sort, we might turn to the *qualities* of objects as the glue of the universe, as the tingling skin through which entities are able to communicate."[7] Further, "these qualities form a vicarious link between objects by means of these qualities as intermediaries."[8] These qualities are linked as quality-objects, but they do not act as objects because they are, in fact, the sensual world of things we identify as objects in the world. So Harman has named them "elements" to clarify their status. They seem to be the primary actors in this drama of transformation, as they "form a bridge between objects that otherwise could never interact."[9] As Harman stresses, "Elements are the glue of the world, the vicarious cause that holds the reality together, the trade secret of the carpentry of things."[10]

So now to the mechanics of the operation: we know that the mechanism of change occurs in the amniotic fluid of bubbling masses of elements that have been issued from the sensual object and have become object-like, but still approachable, still mobile. Their qualities are, in fact—in their elemental form—the sensual notes of the sensual object (not to be confused by the notes of the object itself) that remain behind. Harman begins with a general rule: one object seems to convert another object into notes, although in metaphor, the notes themselves are somehow converted into objects. If we use the metaphor "the abject subject in rejection of an aspect of the self," which as an aesthetic object also places it into the situation of allure, we can trace Harman's explanation and perhaps learn where the point of transfer lies and how it was done.

Metaphor—the special theatrical event that provides us with the "secret pipeline"—also draws close a network of other supporting actor-objects with their own ganglia of qualities and yet, in that metaphoric moment of eternally paradoxical swiveling, wherein linkages are formed through a theatrics of similarity, while retaining their otherness through difference, creates the moment of meaning that absolutely defies the specific qualities of the entire cast of objects involved. The resulting and unrelenting gap formed in the fire of this exchange, or "duel" as Harman calls it, is *precisely* where meaning resides—always tentative, provisional, and wavering—but never actually "breaking or melting together," as Harman would have it, instead creating a shimmering haze of potential that thrusts the objects into the aesthetic

realm, making it perceivable only through imaginative cognition. It is in this indeterminate haze that the engine of metaphor resides, never actually ending Harman's "duel" but sustaining it forever in a timelessness and placelessness of an eternal potential contact. In fact, the shimmering potential is the "element"—to use his term—in which these qualities swim. These severed qualities—the star performers of this chapter—are created in the "strife between an object and its own qualities, which seem to be severed from that object."[11]

Casting these severed qualities as "dark agents" created by the event of metaphor, but juxtaposed to "normal experience" of visible, perceptible surface qualities, allure creates the shimmering of invisible but ghostly presence of meaning as the metaphoric event brings them into a sort of distorted-mirror relationship that defies explanation as it simultaneously creates meaning. We "get it" at the same time as we have difficulty explaining *why* we get it. In fact, Harman suggests "that metaphor actually generates new objects rather than passing straight toward those already stockpiled ... It liberates qualities or notes from their banal servitude to withdrawn objects and sets them loose as objects in their own right," and in the performance allowing one object to be seduced by another, consequently "bathing those notes in the music of the new object that ensnares them."[12] Despite Harman's assertion of ensnarement, these objects made of severed qualities never totally consummate their attraction. Instead, they remain forever in foreplay, in flux, in desire, and sometimes, in disgust. And it is in that strange alchemical exchange that the metaphor is successfully achieved.

Such a metaphoric play is found in much of Kristeva's work on abjection. Her most famous metaphor for abjection has characterized this movement as a gesture of a violent repulsing thrusting aside of "otherness"—the otherness that is the "subject/object"—as I refer to the subject in the language of Harman, or "I." Abjection entails a denial of an aspect of self, a denial that appears desirable within a regime that expects it. Abjection generates a phantom object—to use another term from the OOO lexicon—an ever-present shadow of "dark agents" dogging the subject's every move and disturbing its identity, system, and order, without respect for borders, positions, or rules.[13] It conjures forth the place, says Kristeva, that harks back to the earliest stage of development and the establishment of boundaries and borders that demark our selves from the maternal, and from the

moment of "the pure materiality of existence, or what Lacan terms 'the Real.'"[14] It is a state in which meaning breaks down, in which we are left trying to locate the boundaries of self and other, subject and object. It is before language, before words can comfort with their defining and naming functions, and thus removing the dread of the drifting amorphous state between abjection and language.

In Kristeva's metaphoric formation, it is the mother, the defining subject/object position for females, which is necessarily thrust aside. This leaves the emerging female subject/object in a rather sticky spot, especially under patriarchal conditions. For under the patriarchy, women are reduced to various image-objects of their singular and necessary function of reproduction: not just the mother, but also the bodacious babe who is codified and commodified in terms of breeding potential. As such, women are abjected and degraded as objects in all senses of the word, and so is any linkage with the maternal and feminine objects in the culture. The coded trappings of feminine objects—the notes of these objects—and especially those clustered around the extreme manifestations of feminine qualities, are thus regarded as cloying, obnoxious, and disgusting objects.

Another metaphor cites the fear of seepage between the inner psychic notes and the qualities that denote the outer-body-object in the real. For young female bodies, the menstrual blood of the mature female body represents this seepage. As the "threat that seems to emanate from an exorbitant outside or inside," menstrual blood represents within the heterosexual matrix the cultural onset of the heavy responsibilities of sexual maturity and maternity for females, which results in the threat of being "ejected beyond the scope of the possible, the tolerable, the thinkable."[15] That inner state is signified on the female object through a figuration understood to reside within the body and is "signified through its inscription *on* the body."[16] It is this signification through the various objects of abjection, chosen from a particular range of associated objects—commonly having to do with clothing or fashion—which provides a structure for the identity of the self, contained or enclosed within the body. Identity is, in a sense, a label inscribed on the body, illustrated by how that outside is fashioned.

To begin the translation, and thus discover the potential for agency, by reading abjection through the process of allure, we can use Harman's forms of vicarious causation in which he posits allure as "a

good candidate for providing a key to the other forms of such inter-
action, serving as a kind of primitive atom-smasher for exposing the
simplest workings of relationality."[17] First, he introduces the various
relations existing between the distinct objects in the experiential world,
which he considers a "genuine riddle, given that objects or toolbeings
are supposed to withdraw from one another, failing to grasp or exhaust
each other despite their mutual interference through subtle connec-
tions and outright blows," that is, the "causal bonds between things."[18]

For example, the causal bond generated in the confrontation be-
tween the subject/object of say, a young female—susceptible to power
in relation to an image, or more succinctly, an *imago*, generated by the
highly effective media that results in an abjection (the shame in an
acknowledgment of the self's difference from the ideal and thus a
disgust of the perceived imperfections of the bodily self) and the "not
'I'" of Kristavian metaphor. This is the most pervasive and profoundly
destructive aspect of the patriarchal culture's effect on female subject/
objects. Yet how precisely does this work? And where is the potential
for agency in this process to be found? Harman has described the
center of the object as a withdrawn aspect deep in "infinite recess"
to the point of becoming "a veiled being." Levi Bryant refers to this
formation as an "essence, withdrawn from any actuality or presence,
and is therefore, analogous to a ghost or poltergeist,"[19] an echo of
the ghost in the machine concept, yet as I would suggest, much more
powerful. In its secretive unknowableness, it nevertheless can tell us
something of itself. From this deeply recessed perch within the object,
Harman's "Virtual Proper Being" emits a sort of radiating belt of "qual-
ities." These qualities are the complex structures of various forms of
aspects that are "the joints and glue that hold the universe together."[20]
These are the sensual properties of the object: the "sensual traits" that
we commonly understand and perceive as the object in the world. But
there is yet another quality formation, and that is the "notes." In a
sense, notes are the cultural concepts attached to the object. The notes
not only refer to this particular object but instantly drag in the vast
community of objects that are related via its history, and its other tan-
gential relations, concepts, conditions that surround and many times
define that object in the world.

Yet all of this action—this slamming into the sensual object and
its expanding qualities of notes and thingnesses—must occur in some

Figure 3.1. Meg Gaiger, *Outside Influences: Project Fashion Edition*, 2014. An imagined scene of a young girl caught in the throes of abjection/allure after viewing the preferred fashion image of the model body. The girl accurately represents the age when most young girls begin to hate their bodies, but it can happen even younger. Courtesy of the artist.

medium, some aspect of spatial objectness to allow us to comprehend this universe of objects all jostled together. Harman introduces the term *elements* to begin to describe the diagram:

> The sensual ether in which objects "bathe" is made up of elements: those vague yet distinct bits, chips, flakes, fragments or shards of being that neither recede into the dignified aloofness of objects, nor flood us with incomprehensible rawness. . . . the interaction between elements in the sensual sphere has the character of vicarious causation—the sensual world is packed full of elements pressed up against each other—bubbles of reality somehow engaged in mutual influence without direct contact.[21]

Following this causal bond into the process of allure, we can see how the disgust of the mature matriarchal female body and its promise of heavy breasts and abdomen run up against the ideal of the thin, fashion model body so prevalent in all forms of popular media. In Harman's metaphor, the qualities of the image of the maternal female object "breaks loose from its own qualities and meets them in a kind of duel" in collision with both the image of the fashion model and its loose qualities—and the loosened qualities of the subject/object.[22] The duel becomes—if you will excuse the term—a cluster-fuck of severed qualities transforming into new objects in the shimmering hazy element that provides the space of negotiation that forms as a metaphoric event. In essence, abjection forms as the connotative notes belonging to the subject/object's disgust, altering the polarity suggested by Harman's term of allure—that is: a seduction, a come-hither gesture—to a gesture of repulsion, a violent and propulsive thrusting away. Metaphor forms the only formation possible for these severed and negatively charged qualities—a formation that is perpetually open and never, ever actual.

But a potential for agency arises within the fever of transforming severed qualities confronting other female-related but severed qualities swirling near the abjected subject/object. This formation congeals, through the process of allure, other and perhaps positive qualities, and are cast into metaphoric, constructed, and idealized identity objects. Their fictive but powerful and positively charged qualities that have been exuded by image objects found in popular culture become what Harman calls the "beautiful object." He explains that the beautiful or

aestheticized object "strikes us as an active power infused throughout its various beautiful properties while also surpassing them … and hints at a fertile surplus vaster than its sum of visible deeds, none of them ever capturing the style as a whole."[23]

For example, as the pivotal defense against the threatening sexuality and bodily form of a mature woman, the current fad of the *Lolita*—a popular cultural character focused on a fictive identity not of any single character but a pastiche collection of various Victorian images, stories, myths, clothes, films, and other media, all centered on the image of the wealthy Victorian little girl—promises a "sealing up" of the body surfaces against the confrontation with the mature materiality of the Real, to secure the subject with an armor constructed from the safe costumes and totems of this mythic childhood. In other words, those qualities—dark and severed—adrift in the subject/object's encounter with the other objects in the experience of both the psychical and the sensual world, offer a metaphoric identity comprising those qualities now reconstructed into an object in its own right, that works therapeutically to elide the founding somatic identity with an overlay of severed qualities and notes from the vanquished object of Victorian girlhood. As Harman suggests, "Allure contends with objects and notes in separation rather than through the usual fusion of the two,"[24] the so-called dark agents that also become objects, sever their qualities and, through allure, create yet another layer of metaphoric events and potential. We can see this effect on the ever-changing iterations of the Lolita on the Internet, as the fad proliferates creating communities of Lolita, just as the bonds of vicarious relationships proliferate further iterations of this abject fashioning.

As the highly mediated and fan-produced conception of a historical—yet entirely fictive—subject/object of the Victorian young girl, the Lolita is a direct response to the abjection of maturity. The consequent desire for agency and power is paradoxically configured through a metaphor as a masquerade of the severed qualities of innocence and purity: the infantilized signs of cute heroines proliferated in popular culture and media.

The origins of the Lolita are found in the historic styles of the Victorian period. This is not an arbitrary choice but a recognition of a mirrored reality. British Victorians had developed a dual aspect to their culture: a proper bourgeois surface of morality with rigid proper

Figure 3.2. Two "Sweet Lolitas," wearing one of many different categories of Lolita fashion, on the cover of *Gothic&Lolita* (Phaidon, 2007). Photograph by Masayuki Yoshinaga.

family values, and its gothic demimonde, a welter of landmark pornography, eccentric social practices, and obsessions: "A characteristic
feature of the Victorian middle class was its peculiarly intense preoccupation with rigid boundaries. . . . crisis and boundary confusion
were warded off and contained by fetishes, absolution rituals and liminal scenes."[25] The obsessive concern over deployments of purity and
cleanliness signified the culture's intense abjection of the contamination of the foreign and feminine body/objects. These associations with
bodily fluids and excrement rendered a cultural fetishizing of vestments that provided not only protection for the body from outside
contamination objects but, in terms of the notes of the feminine, a way
to constrain, manipulate, and label female bodies.[26] And it is here, in
this very specific time and place (late nineteenth-century Paris) where
we can further observe abjection involved in a more complex level of
allure as a *hyperobject*—or, as I tend to think of it, a *hyperobject agent*—
which in its sweeping active abjecting motion creates a cultural movement in which one gender, abjected by another, leads to the male-
heroicized culture of the hyperobject that is modernism, evidenced by
its severed qualities of abjection made visible on the sartorial subject/
objects of the time.

In *The Ecological Thought* (2012),[27] Timothy Morton coins "the
term *hyperobject* to refer to things that are massively distributed in time
and space relative to humans."[28] His key distinction lies in his admonition that if we think we can perceive the presence of the hyperobject, it is not because it is an event that is eminent; it is that we are
indeed already deeply and impenetrably immersed within its planetary maelstrom of colliding qualities, notes, and objects that are at once
"*viscous*, which means they stick to beings that are involved," and
"*nonlocal*; in other words, any 'local manifestation' of a hyperobject is
not directly *the* hyperobject." Further, they "involve profoundly different temporalities than the human-scale ones . . . occupy[ing] a high-
dimensional phase space that results in their being invisible to humans
for stretches of time."[29] But the most pertinent aspect of the qualities of
the hyperobject object(s), for this discussion, is their resulting effect
of "*interobjectivity*; that is, they can be detected in a space that consists
of interrelationships between aesthetic properties of objects."[30]

In this odd sense, the modernist hyperobject can be seen—or
tracked visibly—from the bizarre interrelationships that evolved around

three strange flourishes in the clothing behaviors of this period in Paris: primarily in the invention of the ubiquitous male uniform of the dark three-piece suit—or *habit noir*—the stable uniform of businessmen to this day, which as a class of objects signifies its rigorous notes of an almost parodic, standardized masculinity, ensured authority, and stiff phallic profile.

A second example lies in the development of the male-controlled practice of couture design of the still-rococo-esque styles of women's fashions. In the couture houses in which the designer—usually male—created the fashion objects of the day, women became swaddled in layer upon layer of ruffled white muslin crinolines, ribbon and lace trims, silk skirts, slips, shirts, shawls, feathers, and fur pieces. These feminine qualities were scripted as a caricature of the maternal note—the "queen bee"—with her exaggerated hourglass profile, her hygienic regimes, and her protective cocoon of feminine objects locked in a prison of ignorance, fear, and desire.[31]

Finally, the most telling and transgressive development of clothing behaviors was that of the severed qualities in what became the fetish subculture, appearing at this time, which was focused around the sadistic female dominatrix, the domineering subject/object, whose costume was constructed of the feminine Victorian underwear—a practice and a style of costume that continues to this day. But also, fetish describes the entire thought and practice of the hyperobjected state of allure that intensely involved *all* clothing objects, notes, and subjects in a whirling constellation within the emerging commercialized system of couture; they themselves became fetishized as *fashion*. Fashion *is* fetish, and fetish *is* fashion.

Morton positions the hyperobject as "responsible for ... *the end of the world.*" Certainly, the onset of what we call—since it is now possible to perceive it in the world-object phase-space we call *modernism*—a cultural phenomenon that was composed of particular objects, notes, and qualities that presented themselves as unified, as utterly new, as absolutely pure. This *phase*, to use the quantum deployment of this term,[32] is mapped on what we understand to be the cultural paradigm shift from feudalism via a long, slow emergence of modernist tendencies, sped up by industrialization and the innovations of media, and made visible in this late nineteenth-century moment in Paris. Morton typifies this phase for humans as that of "*hypocrisy, weakness,*

Figure 3.3. "Mistress Jean Bardot," an internationally known dominatrix, wearing the classic costume based on the underwear of late nineteenth-century women. Photograph by Drayke Larson of Photosynthetique.

and *lameness*,"[33] and although he is writing in terms of our great planetary ecological disaster and so is positioned a bit differently, yet it is still possible to call on the conditions of culture at that moment and find the same phase conditions to be extant.

Morton reminds us to bear in mind that we cannot "naturalize" this phase as comprehensible and thus a fixable set of "collections, systems, or assemblages,"[34] since what we are dealing with is vastly more complex and defies our abilities to conceptualize with any "proof" in a phenomenological sense, but also states emphatically that it is indeed an ontological reality: "Hyperobjects are real whether or not someone is thinking of them. Indeed ... hyperobjects end the possibility of transcendental leaps 'outside' physical reality. Hyperobjects force us to acknowledge the immanence of thinking to the physical."[35]

Modernism was a Western metaculture that appeared invincible by the cultural standards and objects those Western white guys developed for themselves. But in fact, if we look at the objects that twinkle out from the maelstrom, which evince hypocrisy, weakness, and lameness, we find the aesthetic notes from abjecting/abjected objects as they appear in the heat of exchange—in allure—and thus we are able to, in Morton's words, "establish what phenomenological 'experience' is in the absence of anything meaningfully like a 'world' at all."[36] Allure on this scale explodes from mere clusters-of-fucking to a seething boil of object-note exchanges—not just in a rhizomic formation but compounded into many dimensions and time shifts, resembling an imaginative metaphoric visual phase of, the birth of—ah, yes—the universe.

Hypocrisy is, of course, a term that even in its dictionary definition fits the conditions of culture in specifically late nineteenth-century Paris perfectly, though it is still applicable in less aesthetic terms to the rest of Western culture of the time. Morton's description of the hypocrisies fits this cultural turn, but it is in his description of hyperobjects as "messages in a bottle from the future: [in that] they do not quite exist in a present, since they scoop the standard reference points from the idea of the present time" that he begins to clamp down on the peculiarities of this particular "moment" of allure. He suggests that "to cope with them, we require theories of ethics that are based on scales and scopes that hugely transcend normative self-interest theories, even when we modify self-interest by many orders of magnitude to include several generations down the line."[37] Modernism stretches in

its phasic formation from roughly the Renaissance to the present time, as it continues to breathe its bad breath into what we currently refer to as the postmodern period. That postmodern turn in its seminal utopic formations was first itemized in binary opposition to then abjected modernism, which made it easier to teach to freshmen, but vastly ignored the scale and complex implications of what had happened. The theories of ethics that evolve in that aesthetic phase in nineteenth-century France reveal *weak* and *lame* attempts at bandaging the gaping wounds that broke open on the bodies of those fin de siècle subject/objects.

Further, Morton explains that hyperobjects "do something still more disturbing to our conceptual frames of reference"; that hyperobjects such as this "undermine normative ideas of what an 'object' is in the first place," resulting in an "uncanny effect" of making us "question commonsensical ideas about the utility and benefits" of—in this case—social, gender, and sexual rules, roles, and definitions.[38] And just as Morton suggests, under these same uncanny conditions, the skewed view of these very particular objects within the welter of this massive state of allure produced a highly unstable and almost surrealistic sense of reality, "turning ordinary reality into a dangerous place ... a 'risk society' ... in which government policy now involves the distribution of risk across populations"; ultimately, "we cannot abolish this awareness, and so it corrodes our ability to make firm decisions in the present."[39]

The "uncanny objects" in this case extended from "a weakened government, under which France found itself in a self-conscious nationalistic dither concerning the slow adaption to new forms of production and industrialization, and new constructions of society and class."[40] But also, as the French government "lagged behind other more prosperous and prepared nations ... principally Germany, the geopolitical status of the nation underwent a steady deterioration during this era, from the undisputed primacy under Napoleon I to the position of a second-rate power following the ignominious defeat at the hands of Prussia in 1870."[41] Not only was France behind in terms of economy and industrialization, but the country was also experiencing a much lower birth rate.

This particular issue had profound effects on scientific, psychiatric, and medical developments in France in the latter decades of the

century. As Robert Nye notes, there were two principal concerns: first, that in addition to the lower birth rate that indicated a future with less workers to bolster a flagging economy, and fewer natural resources, was the prospect that "by 1910 Germany would be able to put two soldiers in the field for every Frenchman . . . [and] exposed France to future dismemberment at the hands of its more aggressive and fertile neighbors."[42] But even more significant, it fanned a welter of fears about impotency, criminality, and insanity centered on the medical concept of *degeneration*[43]—a concept that suggested evidence of the existence of a "hereditary stain" of weakness of mind and body that would inevitably lead to sterility. This fear was rationalized by the newly formed medical authorities as a "degeneracy" that had infected the masculine drive to reproduce and, further, though ironically, that excessive sexual activity was a key force in this depletion of male desire. The culprit was masturbation, which drained the apparently limited potential of what these authorities referred to as the "genital instincts" of both men and women, but that women—being more "instinctual" and "biologically primitive"[44]—did not deplete themselves so much as did males, who also were depleted by their exercise of reason.[45]

It is in this rather fearful and hysterical consideration that the suggestion emerged that the objects that were the subject of obsessional sexual fixations could so pervert the attentions of the male subject/object that he would not be able to respond to the "proper object."[46] This condition was referred to as "erotomania" in *Des maladies mentales* (1838) by Jean-Étienne Esquirol, for whom the solution—the cure—was to be found only in a "moral treatment," through a dose of "mental reasoning." That "proper object" was the wife in a marital relationship where children would be the result of desire, and it was only through a moral restructuring toward the "family" that the male would recover his drive.[47]

As for the position of female subject/objects in this same time, the role of the Salon contributed to their growing political and cultural influence in Paris of the late nineteenth century, promoting discussion of contemporary events and thinking among both men and women who attended these salons. The central concern for feminists in this period was a pervasive, toxic hegemony of masculine authority and control referred to as *masculinisme*.[48] Female subject/objects in

France were excluded from politics, higher education, and legal and other professions, and even where such exclusion did not exist, such as the home and the factory, women were confined to profoundly subordinate positions, prompted by a key tenet under *masculinisme* that held that women had only one place and function, as mothers and teachers in the home: "In thus presuming a fundamental link between social role and innate characteristics, *masculinisme* resembled nothing so much as a form of racism in which the presence of female genitalia prefigured a common, unindividualized social destiny for half a population."[49] This constriction was punitively legalized and promulgated by the Napoleonic Code of 1804—a "'Paper Bastille' of legal restrictions"[50] that excluded and restricted the lives of women to the home under the total authority of husband and father: "Woman belongs to man, Napoleon maintained, as the tree and its fruit belong to the gardener."[51]

Yet more revealing among the myriad profound restrictions to the body and soul of women by *masculinisme*, and certainly in terms of the formation of the fetishizing of clothing objects and fashion, is what Patrick Bidelman refers to as the restrictions to personal mobility—particularly as it concerned the rules of dress for women. In France at this time, it was against the law for women to wear pants. Only women whose work outside the home required the wearing of pants as a safety concern could successfully petition for a permit to wear pants. Women's clothing was radically gendered, by law and by class, as the "elaborate and expensive costumery worn by women became visible icons of male prosperity and class status."[52] This regimented, highly restrictive, and abjected social condition encoded clothing objects as a particular collection of objects of a femininity whose qualities signified the female subject/object as abjected because of their domesticated, subjugated, idle, powerless, and sentimental qualities— against a masculine costume coded as militaristic, rational, scientific, authoritative, and related to work and power in the world.[53]

As representative objects of the abjected past, women's clothes were heavily layered with undergarments, all of which were obsessively overdetailed in a rigidly specific and heavily coded fashion. Undergarment objects were white or the natural muslin color as a boundary of cleanliness against the moist "impurities" of the female body-object: the source of feminine fluids, especially menstrual blood.

The female subject/object it created was, in its mythic bourgeois form, a welter of qualities suggesting a femininity of purity, a pink-tinged-delicacy, and a virginal sexuality. This flurry of skirts and petticoats for women and especially for little girls, from the closeted culture of Victorian hyperfeminine objects and qualities, developed a state of allure in which notes of imagined safety and delight-filled narcissism allowed the abject gender to create an abject community.[54]

Like most cultural artifacts from the Victorian period, this image of femininity was full of notes of contradictions and ambiguities, hidden powers, and subversive sexualities. Under the overrationalized and instrumental patriarchy of the time, the artifactual objects of this feminine culture were structured through the eccentricities of male desire. Yet it is not the fashions of the adult female subject/object captured in the cult of the Lolita: it is the feminine aspects that reside in an even deeper level of abjection, the Victorian girl-child. She is positioned with qualities that are simultaneously presexual and hyper-sexual: virginal but seductive, innocent but dangerous. The premenstrual little girl presents the ideal female-object profile in which the boundaries of bourgeois hygienic regimes and moralistic sexual restrictions come together in allure to form an ideal subject/object for the heterosexual male matrix. Even more than her adult form, the Victorian bourgeois "little girl" is swaddled in white and pastel-colored dresses with flowers, ribbons, and lace, and ruffles upon ruffles. Her puffed sleeves stand in for a large bust, her waist made smaller through the wide dimensions of her petticoats and puffed sleeves. Her legs are exposed, an erogenous zone of that era, yet enclosed in white stockings that purified and amplified their representation of sexual presence. She has little hats, gloves, and other accessories, but in a miniaturized and consequently fetishized version of the adult model.[55]

Other forms and variations in the Lolita family of styles of the "little girl" are the "schoolgirl" (a decidedly Japanese contribution) and the "maid," who although an adult model is dressed as a child to accentuate her subservient position and utter lack of power in society. For the Lolita (the specific practice of dressing and performing as the highly mediated, fan-produced conception of the historical subject/object of the Victorian young girl), the response to the abjection of maturity and the consequent desire for agency and power are both configured through a masquerade of qualities of innocence and purity:

Figure 3.4. Antique postcard of young Victorian girl in her classic late nineteenth-century costume and pose.

the infantilized qualities of cute heroines proliferated in contemporary popular culture and media. Yet, even as heroines imply power and agency, little girls are notoriously considered the weakest human subjects. This seeming contradiction is answered in Anne McClintock's explanation of sadomasochism as "a historical subculture that draws its symbolic logic from the changing social contradictions." McClintock also quotes G. W. Levi Kamel: "The desire for submission represents a peculiar transposition of the desire for recognition."[56]

For the Victorian "little girl" subject/object, these fabrications not only supplied the armor of a gender identity but now create a cultural space that nurtures and reiterates the missing *jouissance* of the mythical historical notes of this girlhood, for contemporary young women in patriarchal cultures. An idealized form has been set aside for the young female subject/object, one that was valorized in the Victorian period, one that evokes a particular "scene" of innocence, purity, sweetness, and a feminine qualities whose power is derived not from her ability to reproduce but from her power as an aesthetic image of a potentially "pure and innocent" sexuality. Thus metaphor provides a transformation in identity of subject/objects, and ultimately, in the culture—itself a metaphor for the vast hive of eternally transforming severed qualities—the active agent-objects of cultural production. This is the key to the revolutionary and paradoxical agency created in the allure of the severed qualities, soldered together through metaphor, to form new objects and, ultimately, the hyperobject theater of transforming cultures.

This demonstration was but a mere example of the cultural hyperobject in a state of allure. Its potential lies in the actual dissection of the transformation of various Victorian women's clothing into the fetish objects they became and, in various forms, remain active today. The actual exchange phase of objects and their notes and qualities, extended over time and space—from about the 1870s to the 1890s—and through allure, created a variety of "dark agents" from across the social, military, cultural, governmental, medical, fashion, and economic object-clusters and communities. But this "strife between [the cultural quantities] of concealed sensual object[s] and [their] own qualities" circled to bear down on a particular note:[57] the pressure of the hegemonic patriarchy on the notions of gender. As Harman asserts, "*Allure*, with its severing of objects and qualities, *is the paradigm shift*

of the senses,"[58] but also, in the hyperobject, the culture as it is made visible through its subject/objects at large.

Notes

1. Graham Harman, *Guerrilla Metaphysics: Phenomenology and the Carpentry of Things* (Chicago: Open Court, 2005), 50.

2. Timothy Morton, "Hyperobjects and the End of Common Sense," *The Contemporary Condition* (blog), March, 18, 2010, http://contemporary condition.blogspot.com/2010/03/hyperobjects-and-end-of-common-sense.html.

3. Harman, *Guerrilla,* 148.

4. Ibid.

5. Ibid., 101.

6. Ibid., 176.

7. Ibid., 164.

8. Ibid.

9. Ibid., 165–66.

10. Ibid., 166.

11. Ibid., 150.

12. Ibid., 163, 178.

13. Julia Kristeva, *Powers of Horror: An Essay on Abjection,* translated by Leon S. Roudiez (New York: Columbia University Press, 1982), 4.

14. Dino Felluga, "Modules on Kristeva: On Psychosexual Development," in *Introductory Guide to Critical Theory,* November 2003, Purdue University, https://www.cla.purdue.edu/english/theory/.

15. Kristeva, *Powers of Horror,* 1.

16. Ibid.

17. Harman, *Guerrilla Metaphysics,* 148.

18. Ibid., 148–49.

19. Levi Bryant, "A Lexicon of Onticology," "Object-Oriented Philosophy," *Larval Subjects* (blog), accessed October 11, 2010, http://larvalsubjects.wordpress.com/2010/05/22/a-lexicon-of-onticology/.

20. Harman, *Guerrilla,* 20.

21. Ibid., 159.

22. Ibid., 148.

23. Ibid.

24. Ibid., 151.

25. Ibid., 33.

26. Anne McClintock, *Imperial Leather: Race, Gender, and Sexuality in the Colonial Conquest* (New York: Routledge, 1995), 33.

27. Timothy Morton, *The Ecological Thought* (Cambridge, Mass.: Harvard University Press, 2010), 130–35.

28. Timothy Morton, *Hyperobjects: Philosophy and Ecology after the End of the World* (Minneapolis: University of Minnesota Press, 2013), 1.

29. Ibid.

30. Ibid.

31. Frenchy Lunning, *Subcultural Style: Fetish Style* (Minneapolis: University of Minnesota Press, 2013), 36.

32. Represented as a "beginner-level question," this is a response to the definition of *phase* in quantum physics: "Quantum states are represented by wave functions. . . . In quantum mechanics, there is no *absolute* phase, and indeed, we're not interested in an absolute phase anyway. What we can measure is phase difference, that is, the relative effect on the states in question. It's the 'relative' that we are more interested in. A good example of the effect of phase in quantum mechanics is the Aharonov-Bohm effect. It talks about the coupling between the complex phase of a charged particle's wavefunction and an electromagnetic potential, despite the particle being kept in a region where both electric and magnetic fields are zero" (Radha Pyari Sandhir, "What Is Meant by Phase in Quantum Mechanics?," *Function Space* (blog), http://functionspace.org/topic/169/What-is-meant-by-phase-in-quantum -mechanics-). Yet Wikipedia on the question of the "phase" in quantum mechanics suggests that "*differences* in phase factors between two interacting quantum states [such as cultures] can sometimes be measurable and this can have important consequences." Perhaps this helps. However, I got my understanding of quantum "phasing" from watching *Star Trek*.

33. Morton, *Hyperobjects*, 2.

34. Ibid.

35. Ibid.

36. Ibid., 3.

37. Ibid., 138.

38. Ibid., 139.

39. Ibid., 140.

40. Lunning, *Subcultural Style*, 14.

41. Robert Nye, "Medical Origins of Sexual Fetishism," in *Fetishism as Cultural Discourse*, edited by Emily Apter and William Pietz (Ithaca: Cornell University Press, 1993), 15.

42. Ibid.

43. Ibid.

44. Ibid., 16–17.

45. Lunning, *Subcultural Style*, 14.

46. Nye, "Medical Origins," 18.

47. Much of this section on the conditions of male desire that are considered by both governmental and medical agencies of the late nineteenth-century France, and the position of women that follows, is taken from my book on fetish and fashion: *Subcultural Style: Fetish Style* (Minneapolis: University of Minnesota Press, 2013).

48. Patrick Kay Bidelman, *Pariahs Stand Up! The Founding of the Liberal Feminist Movement in France, 1858–1889* (Westport, Conn.: Greenwood, 1982), 3.

49. Ibid., 17.

50. Hubertine Auclert, *Historique de la société le droit des femmes 1876–1880* (Paris, 1881), 19.

51. Bidelman, *Pariahs Stand Up!*, 4–5. In this section, Bidelman also recounts a story that somewhere in a museum is a chair that Napoleon ripped and gashed while in a rage after being confronted with the criticism that he had been too harsh on women.

52. Anne McClintock, *Imperial Leather: Race, Gender and Sexuality in the Colonial Conquest* (New York: Routledge, 1995), 98.

53. Lunning, *Style*, 18.

54. Ibid.

55. Ibid.

56. Kamel, quoted in McClintock, *Imperial Leather*, 155.

57. Harman, *Guerrilla Metaphysics*, 150.

58. Ibid.

Four

Elizabeth A. Povinelli

The World Is Flat and Other Super Weird Ideas

If a common thread can be said to connect the diverse schools of speculative realism (or, speculative materialism), that thread would be common abhorrence of Immanuel Kant's influence on metaphysics and critical theory. Kant's correlationalism is the bête noire of the speculatists and the defeat of correlationalism their common purpose. Steven Shaviro observes that "to do away with correlationism" most have tried "to eliminate all [human] thinking about the object, in order to allow the object just to be, in and of itself."[1] Shaviro's own solution for how to sidestep the correlationalist trap is to intervene in how we think about thought: "We need to grasp thinking in a different way; we need, as Deleuze might put it, a new 'image of thought.'"[2] "We need to recognise that thought is not, after all, an especially human privilege. This is one of the driving insights behind panpsychism. Also, recent biological research indicates that something much like thinking—an experiential sensitivity, at the very least—goes on in such entities as trees, slime mold, and bacteria, even though none of these organisms have brains."[3] Other forms of existence might not think like humans think, that is, apprehend through the semiotic forms of human cognition (categories and reason). A noncorrelational approach to thought—pulled from Charles Peirce's model of the interpretant or George Molnar's concept of aboutness—seems to exist in all things.[4] But advancing such a mode of thought "means developing a notion of thought that is pre-cognitive (involving "feeling" rather than articulated judgments) and non-intentional (not directed towards an object

with which it would be correlated)."[5] Here Shaviro finds himself in agreement with Graham Harman, a founder of object-oriented ontology. Rather than miring oneself in a philosophical contradiction, *thinking* how objects can be let to be *without human thought* transforms first philosophy into aesthetics.[6]

Shaviro's agreement with Harman on what philosophy becomes when it returns to the object in a precognitive nonintentional manner stands out because of his disagreement with Harman on so many other substantive issues. Whereas Shaviro finds conceptual inspiration in the work of Alfred North Whitehead and Gilles Deleuze, and understands objects as, originally, assemblages, Harman has been a scathing critic of "postmodernism" and understands objects as autonomous and independent even as they are withdrawn and unknowable.[7] For Harman, all objects are objects in a robust sense, that is, each is an independent and autonomous entity with its own unique and independent essence. But all objects, including human subjects, distort their essence in relation to other objects and themselves. As a result, objects are withdrawn from each other (they elude knowledge) and absolutely irreducible to the qualities they manifest in any specific relation with other objects. The qualities they express only allude to what is foundationally eluded. Thus while real objects are posited as absolutely, truly existing, they can never be known. But objects do not merely elude other objects and allude to themselves in the distorting contact with other objects; they also allure other objects.[8] The allure of objects solves Kantian correlationalism via *aesthetic* rather than ethical or logical means. As Katherine Halsall notes, the "aesthetic reflection takes advantage of aesthetic experience and offers the promise of glimpse of reality *beyond* experience."[9] But as Svenja Bromber notes, this understanding of aesthetic sense and judgment seems, ironically, to reboot the Kantian project in order to unplug it.[10] For all the anti-Kantianism that defines the speculatists, it is Kant who posited aesthetic judgments as a mode of universal truth that is not subsumed under a concept (the categories) or reason (the syllogisms). Thus we judge something as "beautiful" not because it conforms to a set of concepts and reasons—it might also do so—but because the judgment results in a disinterested pleasure; it is purposive without a discernable purpose (no determinate cognition). For Kant, aesthetic judgment experiences a form of truth (beauty) freed from *our* purpose. And this

is primarily the purpose of aesthetics for object-oriented ontology: to provide us with a sense-perception of objects independent of our cognitive capture. In this short chapter, I want to pull out three strands of Harman's object-oriented ontology and place them in conversation with three fictional pieces produced by members of the Karrabing Film Collective. The three strands are, first, Harman's claim that objects *are* and reality *is* the way theory describes it independent of the thought-mediated nature of the theory itself. In other words, although we cannot know objects and thus reality, and trying to know them reproduces the correlational fallacy, we can know that they are objects because, and this is the second strand, we can encounter the truth of the theory through an aesthetic experience. The third strand is in a reciprocal relation to this second. Because the human–world relation does not fundamentally differ from other object relations, all objects relations are aesthetic relations. Thus not only are all existents (objects) made to be the same kinds of things, but all relations between objects are also the same. And this might well be put in another way: to experience the truth of object relations, one must make all objects and their relations the same. The world must be a flat world—we must, in other words, homogenize before we equalize. Then we can know the alluding allure of things. The three fictional pieces are a short film by the Karrabing Film Collective, *When the Dogs Talked*; a short story created by a member of the Karrabing, Sheree Bianamu, "That Not Monster"; and a short animated film, *The Origins of Bigfoot*, that I made for another Karrabing member.

Let me first say a few words about each Karrabing piece before putting them in conversation with this strand of object-oriented ontology's approach to truth, aesthetics, and leveled worlds. *When the Dogs Talked* tells the tale of an extended Indigenous family who must find a missing member if they are not to lose their government housing. In the process their truck breaks down, and they find themselves stranded in their bush outstation. An argument breaks out about whether they will take their boat back to the city to save their housing or continue with a GPS project to map the travels of the Dog Dreaming—a series of geographic formations created by ancestral dogs who walked and talked like humans. As the adults argue, the young kids try to decide how the geographic powers of ancestral talking and walking

dogs make sense in their contemporary lives. Bianamu first told "That Not Monster" in a tent when members of the Karrabing were out bush. She was trying to get a toddler to go to sleep. The story begins with an infant being placed in a basket by her parents as they are about to perish at sea. An Indigenous woman discovers the basket and its contents at the site Mengentha (Orphan) Dreaming. Thinking it is a small monster, she tries to drown it. Her husband intervenes, saying, "That is not a monster; it is a small human being." They decide to name it Parrabat, but also to call it Beth if white people are around. The couple's other children are jealous of the new addition—"maybe because there is not enough food and tea"—and so they decide to push Parrabat/Beth back into the sea. Their father intervenes once again, swatting them on the bottom. After that everyone gets along. *The Origins of Bigfoot* was my response to a question Sheree's brother, Ricky, asked me on a long night out bush, in the middle of shooting *When the Dogs Talked*. After listening to several stories about the adventures of the ancestral dogs, Ricky asked me if Bigfoot was real, and if so where did it come from? *Bigfoot* tells how *Homo sapiens* viciously descended on Neanderthals, spearing entire tribes until the last surviving family had been driven to the edge of a

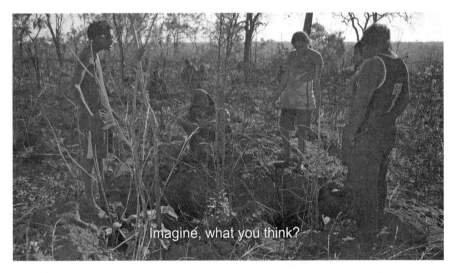

Figure 4.1. The Karrabing Film Collective, *When the Dogs Talked*, 2014. Film still. Courtesy of the artists.

vast swamp. The Neanderthal elders said that they had two choices, die or go into the swamp. But if they went into the swamp, they would have to eat raw food so that the *Homo sapiens* would not be able to see their fire, and they would have to grow their hair long to survive the cold of the night. They go into the swamp and become Bigfoot. But the elders also say that the world is actually a gigantic porcupine produced from all the spears the *Homo sapiens* have thrust into the body of the Earth and that, one day, the Earth would shake them off.

If we approach these stories from a text-external perspective, then none of them seems oriented to aesthetic sense and judgment. Each text is purposive insofar as each seems to account for, or at least describe, a causal relationship between objects in order to answer a factual question about reality. In other words, they seem oriented to a logical, maybe ethical, judgment rather than an aesthetic one. What caused these holes? (Ancestral dogs made them while trying to light a fire to cook cheeky yams.) Given that she is white, where does Beth come from such that she calls my father, Trevor Bianamu, and they behave like other siblings behave? (Our grandparents' and great-grandparents' generations transformed her from a monster orphan into a merely potentially dangerous human being, just like, though very differently from, all Indigenous siblings.) If Bigfoot is real, where did it come from? (Vicious colonialists drove perfectly peaceful beings to the edges of existence.)

But as these texts circulate through the world, they also produce an aesthetic experience (or let's just say they do). They produce a sense experience of a purposiveness without purpose (or let's say there is)— an object that is simultaneously alluring to universal truth and alluding to any capture of its essence in thought (as categorical or relational truth). This may be due to how, in the various stories, the central object is obscured rather than revealed by its encounter with other objects (including discourses). The narratives do not attempt to subsume their objects in a categorical concept or even a singular relational logic, but instead allude to an entire assemblage of attributes and qualities that are expressed and withdrawn, actual and emergent, when the object comes into contact with other objects. In *Dogs*, for instance, the film is less interested in deciding what made the holes than in the various ways in which their presence elude, allude to, and allure other objects— wind, rain, excavators, fire-sticks, ghosts, people—and their cognizable

Figure 4.2. Elizabeth A. Povinelli, *The Origins of Bigfoot*, 2013. Stills from animation. Courtesy of the artist.

powers. It is the capture of a drama about what might have made the holes and how this drama manifests the full if nontotalizable topology of power that interests it. Similarly in "That Not Monster," the object Parrabat/Beth is an occasion for revealing the circulatory insufficiency of available concepts (categories) and reasons (syllogisms) to account for awkwardly emergent social relations. And *Bigfoot* brings evolutionary reason and colonial reason in contact through Bigfoot in order to create an encounter with a "hyperobject" that cuts through and knits the two together.

Of course, part of the aesthetic experience derives from the relationship between the "I" producing these narratives and the narratives as statements. That is, in this case, the authors of these objects (the texts as objects and the object referred to in the texts) are also objects that allure and allude to other objects (subjects) and thus are part of the larger field that is producing an aesthetic experience and judgment. The Karrabing Film Collective is itself an object that alludes and allures insofar as it is primarily but not exclusively Indigenous, nor are the Indigenous all members of one tribe or one perspective. Indeed, their films center on the various ways that an object presents its qualities depending on what other objects it encounters—including the array of human forms and formations. As a young female, Sheree Bianamu's enunciation of "That Not Monster" likewise foregrounds the field of objects as continually eluding even as it continually presents itself in any particular surrounds. And in *Bigfoot* the author, a white aunt, is part of what is indexed and preserved in the expression, retreat, and desire of the object-text. Obviously the author–object–audience assemblage in these cases includes far more than mere humans and their textual excretions. Vocal cords, computers, projectors, lighting, sun, and weather are all within the things called "Dogs," "Monster," and "Bigfoot." And the eluding, alluring, and alluding nature of this field of objects only intensifies as one moves from the restricted area of author–text–audience to "hyperobjects" (or let's just say it does) of colonialism and capitalism.[11] Here we see the author–text–audience is not before these hyperobjects but an effect of them, creating these as kinds and qualities vis-à-vis the contact and creating a withdrawal of what they are or might be in the wake of the relationship.[12] In other words, these hyperobjects continually intrude on the expressive

facets of these objects (geological formation, social formation, species formation), separating them as kinds of things even as they provide an aesthetic feeling of *somethingness thereness*. But this *somethingness thereness* is the experience of a deranged arrangement or an arranged derangement—the constant disturbance produced by the multiple arrangements and derangements of their composite objects. This dynamic-as-truth is felt not because we place all objects (and subjects) on a level conceptual field but because we allow them to be, or express, the concept-interpretant as itself produced by the unequal relations between objects.

This leads directly to the third strand of object-oriented ontology, namely, the dance of truth made possible, or sought, after the relations between objects have been leveled. I am not interested in the content of that truth but rather the truth as a kind of object that is everywhere all the same and autonomous, alluding and alluring in the same way. Remember Harman and other OOOs and speculatists are making truth claims. Quentin Meillassoux and Ray Brassier engage in very different conceptual and rhetorical tactics to overturn Kantian correlationalism. Harman distinguishes between his approach and Meillassoux's speculative realism in how they approach two Kantian propositions: first, that "human knowledge is finite, since the things-in-themselves can be thought but never known," and second, that "the human-world relation (mediated by space, time, and the categories) is philosophically privileged over every other sort of relation; philosophy is primarily about human access to the world, or at least must take this access as its starting point."[13] Harman sees the main difference between speculative realism and object-oriented ontology pivoting on their opposite answers to these two propositions. Speculative realism disagrees with the first proposition but agrees with the second; object-oriented ontology agrees with the first and disagrees with the second. Nevertheless, and uncontroversially, Harman's philosophy is claiming to truthfully (represent) how things are in the world—things *correspond* to his description of them. Of course, I hear what I am saying, that is, I am noting how his approach to objects iterates a certain correspondence approach to truth—the very bête noir of speculatists and object-oriented ontologists. I am less interested, however, in this simple gotcha moment, when a human thinks the defeat of

How? It doesn't make any sense.

Figure 4.3. The Karrabing Film Collective, *When the Dogs Talked*, 2014. Film still. Courtesy of the artists.

thought, than in the social status of truth claims in and among the speculativists, that is, in how truth claims function as demands to treat objects in a specific way.

Take for instance, *When the Dogs Talked*. It presents the viewer with competing truth claims (the various interactions of objects and potential objects that might account for a geologic feature). Indeed the film is, in a significant way, about how the various truth claims maintain their force in the world as it is currently constructed. And it expresses how a truth claim, as a kind of object, withdraws and expresses itself differently depending on its context. (The truth claim that ancestral dogs made these holes might morph from a factual statement to a cultural one—rather than true in a natural science correspondence of dog and hole, it is true in a cultural recognition of the truth of the social nature of believers and disbelievers.) Of course, no one making the film or in the film is claiming that these ancestral beings created all geologic features. That is, the film's truth claim is of a more restricted nature than Harman's, although we could say that one strand of the film is saying all things may well be like this in the sense that we should be cognizant that all things might be the result

of similar kinds of interactions (ancestral geologic, settler colonial, and capital). In contrast, "Monster" is *not* a truth claim. Indeed people like the story Bianamu authored but are quick, as she is, to disclaim it as just a made-up story, not true. It has real people and real places, but these things did not happen, even though their happening seems more likely than huge, ancestral walking and talking dogs. Finally, *Bigfoot* seems most like *Dogs* in making a causal claim about two objects, Bigfoot is what remains of Neanderthals. But it is framed as a made-up story in the same way as "Monster." It might provide an aesthetic judgment, but no one in Karrabing thinks it is producing a truth claim of equal weight as certain positions in *Dogs*.

But does this truth claim (as a sort of object) encounter a level flat world with other truth claim objects? Certainly not for one protagonist in the speculatist field. In *After Finitude* Meillassoux begins by trying to persuade his readers that they actually already have an intuition of absolute knowledge freed from correlationalism by placing his readers in a trap. The jaws of the trap are "ancestral statements" and the "arche-fossil." Ancestral statements refer to any reality anterior to the emergence of the human species or any other form of life on earth. Arche-fossils include all materials indicating the existence of this anterior reality or event.[14] In philosophical terms, arche-fossils are traces of being before givenness; ancestral statements are statements about being before being-given (for) humans or life—being outside or before or after givenness or (human) thought. Ancestral statements could certainly also include all statements indicating an existence long after human beings vanish, such as the future archaeologies imagined by Trevor Paglen's *The Last Pictures*, in which the artist created a visual archive of contemporary human life for a satellite that will remain within the Earth's orbit long after humans are gone, or Katherine Behar's *E-Waste*, discussed in Irina Aristarkhova's chapter, "A Feminist Object," in the present volume.[15]

When Meillassoux asks his reader, don't *we all* agree, that at the minimum, science is making a true statement when it claims that what arche-fossils were existed prior to human existence, he reminds his reader what she will become if she answers in the negative. She will find "herself dangerously close to contemporary creationists: those quaint believers who assert today, in accordance with the 'literal' reading of the Bible, that the earth is no more than six thousand years

Must be from a ghost.

Figure 4.4. The Karrabing Film Collective, *When the Dogs Talked,* 2014. Film still. Courtesy of the artists.

old, and who, when confronted with the much older dates arrived at by science, reply unperturbed that God also created at the same time as the earth six thousand years ago those radioactive compounds that seem to indicate that the earth is much older than it is—in order to test the physicists' faith."[16] Or she will become a primitive who thinks fossil caves are communicating to her when they are revealed by kind tides. Much pivots on the idea of the arche-fossil as a *trace* of being before givenness; that these arche-fossils are indifferent to us; that we can know them nevertheless. But Meillassoux is not indifferent to what a way of thinking makes things—fossils and ourselves. And Meillassoux is canny enough to mobilize this intense self-involvement. The existential terror evoked but then directed by another equally terrifying prospect: if we do not allow human existents to be one entity on a temporal line of entities, then we will become a creationist; maybe a primitivist, an animist, an irrational buffoon. If we are not to become them, we must admit that what we touch here and in this place is radically indifferent to us. To be sure, Meillassoux, as opposed to Harman, is seeking to know reality in and of itself. But Harman agrees with Meillassoux that the realm of objects is independent and

indifferent to us. They are acting before and beyond being given to or for us. Meillassoux includes in this indifference an indifference to reason—that the truth of reality is that it can change at any moment *for no reason.*

What should we make of this indifferent action? On the one hand, the films themselves posit a realm of objects behaving for their own reasons—this is especially clear in *Dogs.* That is, the world is best and most truthfully understood when agency/interpretation is extended to all object assemblages. And *Dogs* expresses the truth that no object is known by us or any other objects but only expressed as an allusion at the point of contact. But we also find that the reason certain qualities or facets of "objects" are expressed in encounters with other "objects" is not because they are evidence of the same ontological status but because they encounter different material forces. And objects do not stay one thing but become other things because of these forces of shaping and shifting and assemblage. And thus the real question is not merely, or even primarily, how objects withdraw, allude, and allure but also, and perhaps more important, why it is that there are object-assemblages that are enticing and being (not) encountered. Aesthetic experience and judgment exist, after all, nowhere but in whatever assemblage of objects are being encountered and judged. And this world is not flat when viewed from the unequal forces redrawing and demanding certain formations as the condition for an object's endurance, extension, and domination of interest. This is not to make humans the center of the object-assemblage world or to make other things passive. Rather, it is to make the forces that produce centers and passivities the name of the game. And part and parcel of this force is, of course, whose arguments about truth and persuasion gain the power to affect our relation with objects and reality—those who are careful to abide by the noncontradictory mandates of a certain mode of reason; those who abstract a universal equivalence among objects in reality in order to decenter human politics and social conditions; or those who attempt to experience truth through a maximal saturation of the possibility of the object and its assemblage via all the unequal forces of its constitution?

Notes

1. Steven Shaviro, "Non-Phenomenological Thought," *Speculations: A Journal of Speculative Realism* 5 (2014): 50, http://static1.1.sqspcdn.com/static/f/1181229/24797439/1398712509557/02_Shaviro_Non_Phenome nological_Thought.pdf?token=PX%2Bfs2uGCQOfaZUrMTrqkYOYRa M%3D.

2. Ibid., 53.

3. Ibid., 52.

4. George Molnar, *Powers: A Study in Metaphysics* (New York: Oxford University Press, 2007), 72.

5. Shaviro, "Non-Phenomenological Thought," 56.

6. Graham Harman, "On Vicarious Causation," in *Collapse Vol. II: Speculative Realism,* edited by R. Mackay (Oxford: Urbanonic, March 2007), 187–221.

7. "Real objects withdraw from our access to them, in fully Heideggerian fashion. The metaphors of concealment, veiling, sheltering, harboring, and protecting are all relevant here. The real cats continue to do their work even as I sleep. These cats are not equivalent to my conception of them, and not even equivalent to their own *self*-conceptions; nor are they exhausted by their various modifications and perturbations of the objects they handle or damage during the night. The cats themselves exist at a level deeper than their effects on anything. Real objects are non-relational" (Graham Harman, *Prince of Networks: Bruno Latour and Metaphysics* [Melbourne: re.press, 2009], 195).

8. According to Harman, the notion of allure "pinpoints the bewitching emotional effect that often accompanies this event for humans, and also suggests the related term 'allusion,' since allure merely alludes to the object without making its inner life directly present" ("On Vicarious Causation," 215).

9. Francis Halsall, "Art and Guerilla Metaphysics," *Speculations: A Journal of Speculative Realism* 5 (2014): 382–410.

10. Svenja Bromber, "Anti-Political Aesthetics of Objects and Worlds Beyond," *Mute,* July 25, 2013, http://www.metamute.org/editorial/articles/anti-political-aesthetics-objects-and-worlds-beyond.

11. Timothy Morton, *Hyperobjects: Philosophy and Ecology after the End of the World* (Minneapolis: University of Minnesota Press, 2013).

12. We can consider these as meta-indexical relations. From this perspective, the type of thing a token expresses (the indexical relation between instance and kind) does not predate a meta-indexical level that mediates the appearance of all tokens via preexisting figurating types. Thus we are not dealing with concepts and logical relation but with figures, figurating forces, and habitats.

13. Graham Harman, "The Road to Objects," *Continent* 1, no. 3 (2011): 171–79, http://www.continentcontinent.cc/index.php/continent/article/view/48.

14. Quentin Meillassoux, *After Finitude: An Essay of the Necessity of Contingency*, translated by Ray Brassier (London: Bloomsbury, 2009), 10.

15. Amelia Barikin, "Arche-Fossils and Future Fossils: The Speculative Paleontology of Julian Charrière," in *Julian Charrière: Future Fossil Spaces*, edited by Nicole Schweizer (Milan and Lausanne: Mousse Publishing and Musée cantonal des Beaux-Arts, 2014), 18–29.

16. Meillassoux, *After Finitude*, 18.

Five

Katherine Behar

Facing Necrophilia, or "Botox Ethics"

Philosophies are means to ends. New ideas beg the question not of whether they are right or wrong but of whether they make for being rightly or wrongly. For this reason, ideas deserve deployment.[1]

This chapter asks after the deployment of recent object-oriented thought, and whether, when deployed, it lives up to its promises. Do speculative realism, object-oriented ontology, and new materialism truly banish philosophy's thinking humanist subject? Can they manage, finally, to put philosophers into contact, and philosophy into action, with and within the world? In other words, do these ideas "work" in an artistic sense? Can philosophy hold its own as performance art?[2]

Conceiving of the world as objects or matter sounds like a savvy strategy for avoiding the hubris and distortion of anthropocentrism. (And certainly we are agreed that anthropocentrism has proved again and again to be an enormous liability in deployment: from the ecological to the epistemological to the ethical.) But when put into practice, object-oriented thinking remains hindered by two obstacles. The first is a trend toward privileging connectivity that results in a fetishization of liveliness.[3] This tendency may be most evident in new materialist thought, and given that some object-oriented ontologies propose that objects are ultimately independent and apart from relation, this claim may seem counterintuitive. Still, I fear liveliness lurks not only in new materialist animism and agential realism but also in object-oriented theories of relation and causation. Like a Trojan

horse, liveliness is poised to smuggle anthropocentrism back into the game. Even more concerning, the second obstacle is a failure to truly implicate the self as an object. By not exploiting the self as a specimen, object-oriented thinkers can miss what may be their only opportunity to discuss and engage with objects' perspectives and experiences. Without the modesty of self-implication, anthropocentrism's arrogant exceptionalism returns.

These two sticking points place our object-oriented endeavors in an untenable ethical position. Either we disrespect objects in the name of commonality by projecting our own liveliness onto them, or we set ourselves apart as nonobjects by saying that we know nothing of objects' perspectives, implicitly denying that an object's perspective is ours, too. We seem to have backed ourselves into an ethical corner.

Happily, we can regain our modesty with the help of an object usually associated with vanity: Botox. This misunderstood object's assistance offers a practical way out of our ethical dead end. In the following pages, I set forth ample evidence that Botox will remedy our woes, easing our brows and righting our philosophy. Yet we must first attend to these points of contention.

Loving Life: Liveliness as Anthropocentric Relapse

Like new materialism, object-oriented ontology stresses connectivity between objects.[4] For example, in *Prince of Networks,* his beautiful book on Bruno Latour's metaphysics, Graham Harman indicates that for Latour, the very "reality" of objects hinges on their connectivity. Harman puts Latour forward as an anticipatory figure for object-oriented metaphysics. In Latour's view, objects (or in his terminology, "actors") are "real" only insofar as they are connected and, through their connections, have measureable effects on other objects. In Harman's words, an "actor that makes no difference is not a real actor."[5] For Latour, a real object is networked with others.

Harman's view is closer to my own. He sees objects as disconnected and sealed off from each other. Still, Harman is not content to let autonomous objects lie. To accommodate interaction, he formulates a theory of "vicarious causation," a complex system of allure and all-enveloping, third-party intentions, which allows him to explain how sealed objects may enter into relations after all.[6] Even while

deviating from Latour's networked connectivity, Harman asserts that some form of influence must remain possible. With vicarious causation, he accounts for interaction between objects without the direct causation of overt connection; indeed, for Harman, the latter's impossibility is precisely what makes the former necessary. The alternative—radical disconnect—is untenable, so vicarious causation is Harman's solution for preserving autonomy without sacrificing connection or influence.

In effect, this concession to connection betrays a preference for lively objects, an inclination not only of Harman's but one that, as Harman establishes, appears in Latour and runs throughout much of object-oriented thought. Liveliness also features especially strongly in the Whiteheadian brand of object-oriented ontology favored by Steven Shaviro.[7] In various configurations, the preference is for objects that get up and *do* things, that twist and turn and nudge one another, influencing and making differences by, as Harman writes of Latour, "modifying, transforming, perturbing or creating" their allied friends.[8]

Simply put, for Latour, a disconnected object doesn't count. Latour's theory of alliances is a means to validate the "reality" of objects on the basis of their network effects. A real object *does* make a difference. In this view objects are informatic; they are a "difference which makes a difference,"[9] so they can be sustained only as a circulating network effect. For his part, Harman accepts that real objects can have "no relation at all" without compromising their status as real,[10] but he too explains his theory of vicarious causation in informatic terms as a "problem of *communication* between substances" wherein relation amounts to "signaling" (emphasis added).[11] This informatic formulation is critical. As information, objects must continually generate change (in Latour's language, by modifying, transforming, perturbing, or creating), and this imperative to change—this dynamism—is nothing if not lively.

In her excellent book *Vibrant Matter,* Jane Bennett, an author who has been associated both with object-orientation in speculative realism and with new materialism, refers to this same networked dynamism as "distributive agency."[12] Taking an embedded view of the liveliness of objects, Bennett writes of the vital "Thing-Power" of objects, which she explains is "the curious ability of inanimate things to animate, to act, to produce effects dramatic and subtle."[13]

Yet reveling in objects by recognizing their inner material life, and appreciating how their actorly connectivity produces lifelike, emergent complexity, is symptomatic of what I call *vivophilia*: loving objects for their liveliness. And herein lies my first point of contention. In privileging alliances, object-oriented ontologies risk reinstating anthropocentrism, where what is "anthro" is no longer the subject but instead the networked individual. Such object-oriented ontologies are in danger of merely rewriting the terms for anthropocentrism. In effect, object-oriented ontology's philosophical intervention promotes a new view of the human self, in which to be a self, it is more critical to be connected than to be a thinking subject. Objects represent this change from a subject that thinks, and therefore *is,* to an informatic self that *is* in connection. The trouble is that this reformulation takes its cues from something residually "anthro," and not from objects in and of themselves.[14]

Aside from undoing the hard work undertaken thus far in whittling away anthropocentrism's death grip on philosophical thought, this move should be rejected for the simple reason that it is bad for all parties: it is bad for philosophy because it mistakes a meta-phenomenon (connectivity or alliances) for a structure (the self-contained nature of the object's black box). It is bad for human objects because the imperative to connect is detrimental to individuals who suffer from the overconnection compulsions of neoliberal subjectivity. And it is bad for nonhuman objects that get theoretically mangled when they must bear the (human) "indignity of speaking for others."[15]

And on that note, object-oriented ontology's second obstacle concerns this question: What of speaking for oneself?

The Missing Me: The Self as Omitted Object

Object-oriented ontology correctly states that humans are a kind of object. However, when pressed to account for their ontology from an object's perspective, object-oriented thinkers seem to draw a blank.[16] Perhaps the problem lies in thinking of "humans" as objects to begin with. By "human," one always seems to mean those other self-conscious bipeds, never *me.* Yet this remove is immediately problematic. Ontologizing objects must come from a first-person (if you will forgive the

term) perspective. The particular self, not a human generality, is needed as an exemplary object precisely to orient this ontology.

Object-oriented philosophy is a joy to read because it is peppered with witty lists—Latour Litanies of screamingly incongruous specimens.[17] But object-oriented thinkers should be their own first specimens because anyone's ability to articulate the being of "phlogiston, unicorns, [and] bald kings of France" is at best severely curtailed by the very black boxes those objects describe.[18] Really implicating ourselves as objects is the only chance we have to say anything at all about objects' being.

Donna Haraway argues that "feminist objectivity means quite simply *situated knowledges*."[19] Object-oriented ontology's claim to speak of or for or as "humans" is a "god-trick of seeing everything from nowhere."[20] Instead, object-oriented ontologies should be limited to—or delimited by—the personal viewpoint I have when the object I am is "quite simply situated" in being only me. We must name ourselves. Until we do so, our discussion remains abstract conjecture because talking about objects from the perspective of anything other than an object cannot help but foreclose the object's real, independently formulated perspective.

And yet, merely taking ourselves as specimens is not enough. To *ethically* interrogate ourselves as objects requires something more: that we take ourselves not as living specimens but as dead ones. Otherwise, we risk reverting to vivophilia, on the one hand (by anthropomorphically ascribing lifelike experience to objects), or phenomenology, or some such, on the other (by anthropocentrically focusing on our lived subjective experience).

We have now identified the two key issues this chapter seeks to overcome. Our goals are to eradicate vivophiliac bias toward objects and to instate the self-object's "first person" perspective, which we can best accomplish by coming face-to-face with the alternative: necrophilia.

Facing Necrophilia

In lieu of vivophilia (loving objects for their liveliness), and against the omission of the self-object from its own ontology, I advocate for

an opposite approach: *a necrophiliac orientation to objects.* Vivophilia's imperative to connect insists that we look outward, but necrophilia allows us to turn our gaze within. Rather than see something living in the abounding world of objects, facing necrophilia entails that we find—and love—something dead within ourselves. A necrophiliac philosophy is a philosophy that takes dead objects as love objects.

It is a question of perspective. Vivophilia says that most things in the world are, in some significant way, as alive as I am. Necrophilia says that I am, in some significant way, as dead as are most things in the world.

The former statement sounds surreal, but more significantly, it carries an epistemological liability: it does not generate new insight into the nature of objects because, living or dead, objects other than myself remain black-boxed and unknowable. The latter argument is only marginally more commonsensical, yet it allows for an inroad toward credible knowledge or further understanding about the being of objects.

Necrophilia thus seems the better bet. Finding liveliness in every-thing is a Sisyphean task, requiring not just connectivity but omni-science. But implicating myself as an object, and finding the deadness I have in common with my inanimate neighbors, is far easier to im-plement. Necrophilia suggests that it may not be necessary, to borrow Bennett's phrase, to "[distinguish] me from my corpse."[21]

Necrophilia has better promise for yielding a concrete, ethical, object-oriented practice. In fact, we can already observe necrophilia at play in self-implicating object-oriented feminist practices. Beyond the enormous body of work by feminists on women's objectifica-tion in culture, we encounter examples of overtly necrophiliac object-orientation in the philosopher Catherine Malabou's account of brain plasticity and in the work of feminist body artists like Orlan.

Plasticity

What Should We Do with Our Brain?, Malabou's stunning book, explores brain plasticity and its implications for consciousness and identity. Plasticity, for Malabou, is not only generative and lively but also deadly.

As Malabou defines it, plasticity is the threefold capacity for giving form, receiving form, and destroying form.[22] Plasticity is a near-perfect description of the material quality of being an object. Latour has warned us not to think of objects as substances but as performances;[23] my own experiences of deploying myself as an object in my work as a performance artist accord with this view. Experience shows that while objects are not substance, their performance does have material consistency. Objects' performed material quality is plasticity. Objects consist of plasticity; they perform plasticity's qualities. In this case and to stress the ontological point, if to be an object is to be plastic, what is plastic being?

Malabou associates receiving form with materials like "clay [that are] called 'plastic,'" and giving form with "the plastic arts or . . . plastic surgery," and she relates plasticity's annihilation of form to "*plastique*," or plastic explosives.[24] Plasticity thus encompasses what Malabou calls "two extremes." One plasticity sculpts. This is the plasticity of sculpture, plastic objects, and plastic surgery. It is a plasticity that models. A second plasticity disobeys. This is the plasticity of explosives. It is a plasticity that refuses the model.[25]

Plasticity suggests that the self as an object is both moldable and resistive. Malabou explains that being only moldable, only ready to connect to the model, is not plasticity in the full, potentially liberating, sense of the word. Alone, the side that persists in models, that exists by opening alliances, is not plasticity but mere flexibility, which she calls "plasticity minus its genius."[26]

Flexibility is the harmful, neoliberal sensibility that I have identified as being perpetuated by vivophilia's imperative to form creative, generative alliances; to network the self; to increase the object's power;[27] to participate in the model.[28] Its necessary counterpart is destruction. There is no polite way to refuse the compulsory form of the network; Latour is right in saying that the disconnected object that makes no difference is not real, but with the following caveat: *so far as the network is concerned.* The "I'd prefer not to" of Herman Melville's Bartleby gets us close to disconnected objecthood, but is not strong enough here. In Latour's terms, the passivity of "I'd prefer not to" just makes for a weak object.[29] It is a biopolitical moment par excellence. The only way to disconnect, to get off the grid, is to

self-destruct. Plasticity reminds us that our repertoire of self-practices includes this capacity for deadliness, too: a necropolitical aesthetics.

As objects consisting in plasticity—which is to say, as plastic objects—we engage both creative and destructive processes in the work of "self-fashioning" ourselves. Malabou writes, "Self-fashioning implies at once the elaboration of a form, a face, a figure, and the effacement of another form, another face, another figure."[30] Far from an abstraction, plastic self-fashioning—this activity at once lively and deadly— is a concrete practice that we have opportunities to examine: it has already been realized in many forms, among them, feminist body art.

Feminist Body Art:
Object-Orientation and Plasticity

Considerable work in the practice of being plastic objects has been carried out since the 1960s by feminist body artists who, while not using this terminology, have rigorously investigated these very concepts: object-orientation, plasticity, and necrophilia. In body art, artists use their own bodies as material in their artwork, quite literally elaborating and effacing their own faces, figures, and forms. The bodily self of body art is an eminently plastic, not to mention evidently necrophiliac, object.

To take but a few art historical examples of body art's object-orientation, Hannah Wilke has undermined and exploited her eroticization and objectification as a posing female nude.[31] Yayoi Kusama has diffused herself into obsessive surfaces of polka dots and phalluses, and in a further gesture of disregarding her difference from other objects, has subsumed herself into the art market as an art object commodity.[32] Eleanor Antin has "carved" her body in the manner of "classical sculpture" through dieting.[33] And Adrian Piper, a performance artist and philosopher whose work also thoroughly investigates objectification through gender and race, has re-formed herself in a Kantian, yogic fast.[34] Yet the most quintessential example of body art's object-orientation within a plastic attitude appears in the work of Orlan, where the sculptural plasticity of body art intersects with and is reinforced by the surgical plasticity of plastic surgery.

Orlan has been working with her body as sculptural material since the 1960s. She is best known for *Reincarnation,* a series completed

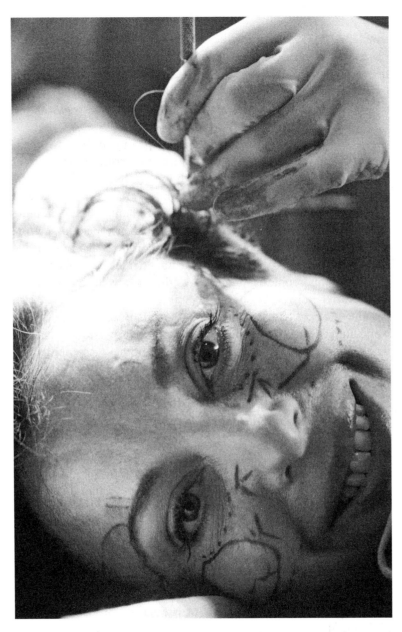

Figure 5.1. Orlan *Omnipresence–Surgery*, 1993. Close-up of laughter during the Seventh Performance n°1, New York. Cibrachrome in Diasec mount, 65 × 43 inches. Copyright 2015 Orlan/Artists Rights Society (ARS), New York/ADAGP, Paris. Courtesy of the artist.

from 1990 to 1993, in which she designed and staged nine multimedia plastic surgery performances. Turning herself into her own "ultimate masterpiece," Orlan has aesthetically transformed her body and face by appropriating and literally incorporating (i.e., into her body) elements from art historical sources including notoriously distinctive forehead implants.

Following a computer-generated compilation of her own making, Orlan has surgically collaged her face to merge, in the words of the cosmetic surgery scholar Meredith Jones, "the chin of Botticelli's *Venus*, the forehead of Leonardo da Vinci's *Mona Lisa*, the lips of Boucher's *Europa*, the nose of the School of Fountainbleau sculpture of Diana, and the eyes of Gerard's *Psyche*."[35] In her operation performances, Orlan collaborates with plastic surgeons who share and enable her artistic vision. As performances, the surgeries include elaborate sets and props, philosophical monologues by the artist (who remains anaesthetized but fully conscious throughout the operations), and lavish designer surgical gowns for the artist and the medical staff. Orlan's work literally involves "at once the elaboration of a form, a face, a figure, and the effacement of another form, another face, another figure."[36] In her words, "I've chosen to put some face on my face: I develop a work on figuration and re-figuration."[37]

Body art's object-orientation is patent enough, but Orlan's work shows its double significance for our discussion: in body art, object-orientation expresses both plasticity and necrophilia. With regard to plasticity, body art sets into practice all three of plasticity's capacities. In the first sense, body art is an example of lively self-fashioning. From the authorial perspective of the artist who sculpts, the body-self-object is an experiential and intentional object that self-fabricates. In this respect, body art is a practice of giving form. In the second sense, body art is an example of a self-implicating feminist object-oriented practice. From the interpretive perspective of feminist critique, the body-self-object is a readymade cultural object. By placing the body-self-object in the artwork as a "preloaded" culturally determined signifier, body artists show their capacity for receiving form. In the third sense, body art is an example of feminist object-oriented necrophilia. It is a practice that promotes a necrophiliac relation to self in which any notion of the self's liveliness is beside the point. From the physical perspective of the artwork, the body-self-object is

a convenient art material, comparable to any other material object. In its ruthless re-rendering of the body-self-object, body art shows an unparalleled capacity for destroying form.

Feminist Body Art: Necrophilia and "Specific Objects"

In this destructive light, and with regard to necrophilia, feminist body art exploits the body-self-object as an artistic medium for its formal properties and material specificity. Body art's matter-of-fact, inglorious approach to the body-self-object as material shows its connection to a contemporaneous art movement, minimalism.[38] Minimalist artists use nonprecious industrial materials and fabrication processes, cheapening the status of sculpture by "phoning in" its manufacture, and rendering the authentic art object simultaneously singular and absolute, and serial and replaceable. Body art takes this cavalier, deadpan, necrophiliac attitude toward its primary material, the body-self-object, which it both takes as inviolable and is willing to destroy and replace.

Because of this connection to minimalism, feminist body art should be understood in contrast with essentialist and gynocentric feminist art, which deploys the body for its anthropomorphic symbolism and insists that the body is in the representational register more than it is in the material register.[39] Instead, in feminist body art, the body-self-object is a singular, "specific object," a term that the minimalist artist Donald Judd coined to describe works that evince their own singleness and absolute presence. Through absolute presence, the specific objects of minimalism undermine the anthropomorphism inherent in the "part-by-part" narrativist structure of European traditions in sculpture. Describing the specific objects of "the new work" (now called minimalism), which was gaining prominence in the same conjuncture as feminist body art, Judd wrote,

> Materials vary greatly and are simply materials—formica, aluminum, cold-rolled steel, plexiglas, red and common brass, and so forth. They are specific. If they are used directly, they are more specific. Also, they are usually aggressive. There is an objectivity to the obdurate identity of a material.[40]

Vladimir Ivanovich Vernadsky, quoted by Bennett, declares, "We are walking, talking minerals."[41] It is in this sense of being no more or less than minerals that the body-self-object appears in body art as "aggressive . . . obdurate identity." As plastic material, body artists have both the sculptural obduracy to create their form and the aggressiveness to explode it. For Malabou, "the threat of the explosion of form structurally inhabits every form."[42] In this way, body artists who assume what the body art historian Amelia Jones calls "the rhetoric of the pose" are always ready to dispose of themselves.[43] Body artists expose themselves as plastic (disposable) objects.

At once blasé and brutal, body artists like Orlan treat their own bodies as fully plastic objects and, as such, regard themselves with necrophilia. Body art uses plasticity to catapult us over the stumbling blocks of vivophilia and self-omission. Denouncing the fetishization of lively integrity in body objects, body art foregrounds the self not only as a deadly object to be killed off but also as the scene of the crime.

Body art is a concrete practice for facing necrophilia. But its necrophilia is extreme and aesthetic. What quotidian version of necrophilia can a greater population of objects enjoy? How can object-oriented thought incorporate necrophilia, bringing this deadness into the corpus of philosophy and into the corpus of the self? To integrate necrophilia into our philosophy and our bodies, the obvious drug of choice is Botox.

Botox Plasticity

Botox is the brand-name for a suite of pharmaceutical products manufactured by Allergan, all of which consist of injections of onabotulinumtoxinA (the same toxin found in botulism). The product line includes prescription treatments with medical applications for relieving facial spasms, strabismus, limb spasticity, and cervical dystonia, as well as severe underarm sweating, but by far the most widely popular and widely known treatment is a product called Botox® Cosmetic, which is used to temporarily "improve the look of moderate to severe frown lines between the eyebrows ([known as] glabellar lines)."[44]

The toxin in Botox injections inhibits the connections between nerves and muscles, engendering local, short-term paralysis around

the site of injection; the effect takes about fourteen days to set in and lasts, on average, for three to six months. With Botox® Cosmetic, paralysis lessens frown lines by disabling the brow muscles' capacity to furrow. The cosmetic advantage of this paralysis is amplified in that Botox not only suppresses existing frown lines but simultaneously prevents the muscular engagements that create the formation of new ones. In effect, the paralyzing toxins create a temporary "dead zone" in the body. As a self-practice, Botox directs its necrophilia squarely at the body-self-object, forbidding the omission of "me." Moreover, the resulting internal dead zone exercises a certain necrophiliac attraction. The widespread adoption of Botox indicates that individuals (perhaps even philosophers) may be poised to accept its uniquely necrophiliac form of plasticity.[45] In addition to its merits as a self-directed practice, Botox has the right blend of plastic capacities to cure our thinking of residual vivophilia.

Botox expresses its plasticity in three different ways in medical, military, and cosmetic contexts. When applied for medical purposes, Botox is an example of the plastic capacity of receiving form. Used as a cure, Botox restores deviant bodies to normativity. Bodies that receive Botox receive the form of health.

Applied in military contexts, botulinum toxin demonstrates plasticity's destructive capacity. Used as a biological weapon, botulinum toxin eradicates form. In "Effacing the Face," Grayson Cooke defines Botox as a pharmakon that always simultaneously occupies "a double role of creator/destroyer and poison/cure."[46] As pharmakon, Botox is itself a plastic object, encompassing the two extremes Malabou identifies in plasticity. Cooke reminds us that apart from its use in "highly diluted form" in the plastic treatment of faces, botulinum toxin is "one of the deadliest and most powerful neurotoxins known."[47] As a biological weapon, botulinum toxin—arguably the ur-form of Botox—is applied much like plastique explosives. Through active annihilation, it erases forms of life, creating a clean slate for humanity,[48] or, perhaps, for a world without humans or humanity at all—what Alan Weisman and Eugene Thacker call "the world without us."[49]

Finally, in cosmetic applications, Botox gives new form. Botox inhibits the old forms of faciality, interrupting muscle memory and habits of facial expression. By inhibiting the modes of expression we have come to expect, Botox creates a new form of inner-directedness.

Cooke's interpretation of the face and its relation to Botox centers on communication. The face records and communicates its archive of experience, which Botox erases and censors. The face expresses; Botox represses. Cooke defines expressing as "a sending out, an outering,"[50] which returns us to the vivophiliac imperative to connect. In Cooke's interpretation, Botox "is pure repression, the repression of expressions" (punctuation modified).[51] In its role as an inhibitor, Botox represses the outering, the other-directedness of the informatic self that is in connection. It inhibits the vivophiliac, neoliberal self that is real only when it expresses itself in the communicative act of making a difference, of sending and receiving information.

In weapon form, Botulinum toxin is a matter of force; Botox medical treatments, considered medically necessary, are a matter of necessity. Yet Botox® Cosmetic injections are deemed optional. They are a matter of choice and, thus, of ethics. Botox represents a new, necrophiliac direction for ethics in an object-oriented feminist practice.

Conclusion: Botox Ethics

The choice is this: Do we use the face, as Emmanuel Levinas would have it, as a vivophiliac site for living ethical encounter? Or do we put on dead faces, suppress errant expressivity and lively countenances, and remind ourselves, with a thwack on the forehead, that object-oriented ethics occurs between mutually dead objects?

For Levinas, the moment of ethical encounter is when, meeting face-to-face, the living visage of the Other apprehends the ethical subject with the silent entreaty "Don't kill me!" The numbed face of Botox, however, renders this version of ethics meaningless. Not only is a partly paralyzed face incapable of expressing such signals, but these become pointless requests when coming from a face that is, in significant portion, already dead. The alternative to Levinasean ethics is Botox ethics, the encounter between objects that silently acknowledges the independent mutuality of their deadness.

Joanna Zylinska has written, also in the context of cosmetic surgical body practices, about what she terms "prosthetic ethics."[52] Describing the work of Orlan and another body artist, Stelarc, whose best-known project is his robotic third arm, Zylinska advocates for an "ethics of welcome" that accommodates difference and engenders

Figure 5.2. Katherine Behar, *Levinas / Botox Faciality Grid*, 2010. Screenshot collage. Courtesy of the artist.

hybridity between living and nonliving forms—in this case, the body and technology. Meredith Jones describes Zylinska's "'prosthetic ethics of welcome'" as a "perform[ance of] hospitality, openness, and invitation."[53] In Zylinska's insightful formulation, prosthesis is "an articulation of connections"[54] that creates, in Jones's words, "unbounded, networked, and changeable subjects."[55]

Botox ethics represents the exact inversion of prosthetic ethics. Botox ethics seeks not to articulate connections but to inhibit them; to create not unbounded subjects but enclosed objects; it recommends not outward-directed networking and changeability but inward-directed unexpressivity and singularity.

Prosthetic ethics is an extension of Levinas's ethics of facialized living encounter. Both place a vivophiliac demand for living responsiveness from every single thing we greet "face-to-face," or "welcome" aboard. Levinasean ethics is sustained by communication through the face and its expression and response. Prosthetic ethics, too, is sustained by communication, in ongoing exchanges and transfers of information. Where in Levinasean ethics, communication occurs on the surface of the face, in prosthetic ethics, communicating subjects are networked at their core. In the expansive gesture of prosthetic welcoming, network alliances are invited in.

Welcoming is the sort of inclusive practice that feminism has traditionally promoted. But here, object-oriented thinking offers an alternative direction for practicing feminists. In this, an object-oriented feminism might diverge from historical feminisms that embrace the body beautiful in unaltered form or that promote Other-directed camaraderie and practices of community. Instead, Botox ethics warrants some newfound inhospitability. The subjectivity that gets formed through unbounding and networking is indeed precisely that of a "changeable subject." This too dynamic, too lively subject is caught up in the network's imperative for continual "modification, transformation, perturbation and creation." By including everything, an "ethics of welcome" resumes "outering" expressivity as pure communication. By numbing ourselves with Botox ethics, we can resist the Other-directed compulsion to connect, and the neoliberal internalization of the requirement to make alliances.

As an alternative, Botox closes the communicative port of the face as site of Other-directed expression. Levinas and prosthetics welcome.

Botox slams the door shut. It wants to be left alone. What we are left with when we stop communicating is ourselves, the missing "me" that, as object, provides our only ontological orientation. As objects ourselves, we engage Botox ethics as a self-practice. Botox is only a cosmetic insofar as it is, more accurately, an inhibitor. Self-fashioning with Botox is not the cosmetic effect of appearing dead to the Other through a facial communiqué. This would be no more than "playing possum," hiding under the mask of deadness to escape the threat of death. Botox ethics does not avoid death—it aspires to it. Its self-fashioning is the corporeal practice of inhibiting life within oneself. It is a praxis of practicing death. We do not mock the appearance of death; we practice being dead by giving it— or ourselves—a shot.

Botox turns us into objects, shoots us up with our own plasticity, and lets us—as objects—exist mutually, independently, and graciously in the dead object world. When another smooth forehead returns our expressionless stare, we can be sure that we are facing necrophilia. As a self-practice, a little shot of death provides all the object-orientation we need. In place of the vivophiliac ethics of "Don't kill me!" Botox ethics says "I'll kill myself!" Shooting up to shut up, Botox ethics recommends battening down the hatches on our own black boxes and becoming killer objects who will shoot ourselves first.

Notes

My thanks to Patricia Ticineto Clough, Alexander R. Galloway, Graham Harman, Anne Pollock, and Elizabeth Wollman for their generous insights on early drafts of this chapter, to Jane Bennett for her enthusiasm and encouragement, and to the participants in the two "OOF: Object-Oriented Feminism" panels at the Society for Literature, Science, and the Arts 2010 conference, where a version of this chapter was first presented: Ian Bogost, Wendy Hui Kyong Chun, Patricia Ticineto Clough, N. Katherine Hayles, Frenchy Lunning, Anne Pollock, and Adam Zaretsky.

1. Many artists, myself included, approach art practice as applied philosophy. My initial interest in object-oriented ontology stems from my intuition that these ideas serve artists' interests well. Its main tenets coincide nicely with many of the aesthetic pretensions and practical intentions of contemporary studio practices.

2. Object-oriented ontology's principal claims, that the world is composed of a nonhierarchical collection of objects, and that objects themselves are like slick black boxes sealed unto themselves, bode well for fruitful deployment. In art, similar ideas have already proved seaworthy. These formulations dovetail with contemporary postminimalism and a larger history of Greenbergian modernism, respectively. For more on this subject, see Katherine Behar and Emmy Mikelson, eds., *And Another Thing: Nonanthropocentrism and Art* (Earth, Milky Way: punctum books, 2016).

3. Liveliness appears in many formulations, including the "agency" in Karen Barad's agential realism, the "actors" in Bruno Latour's actor-network theory, what the editors Diana Coole and Samantha Frost call "the force of materiality" in the new materialisms, and the "magic" in Timothy Morton's realist magic. See Barad, *Meeting the Universe Halfway: Quantum Physics and the Entanglement of Matter and Meaning* (Durham, N.C.: Duke University Press, 2007); Latour, *Reassembling the Social: An Introduction to Actor-Network-Theory* (New York: Oxford University Press, 2005); Coole and Frost, eds., *New Materialisms: Ontology, Agency, and Politics* (Durham, N.C.: Duke University Press, 2010); and Morton, *Realist Magic: Objects, Ontology, Causality* (Ann Arbor, Mich.: Open Humanities Press, 2013).

4. See Coole and Frost, *New Materialisms*.

5. Graham Harman, *Prince of Networks: Bruno Latour and Metaphysics* (Melbourne: re.press, 2009), 106.

6. Graham Harman, "On Vicarious Causation," in *Collapse Vol. II: Speculative Realism*, edited by R. Mackay (Oxford: Urbanomic, March 2007).

7. See Steven Shaviro, *The Universe of Things: On Speculative Realism* (Minneapolis: University of Minnesota Press, 2014).

8. Bruno Latour in *Pandora's Hope: Essays on the Reality of Science Studies* (Cambridge, Mass.: Harvard University Press, 1999), 122, quoted in Harman, *Prince of Networks*, 81.

9. Gregory Bateson, *Steps to an Ecology of Mind* (Chicago: University of Chicago Press, 2000), 381.

10. Harman, "On Vicarious Causation," 200.

11. Ibid., 187.

12. Jane Bennett, *Vibrant Matter: A Political Ecology of Things* (Durham, N.C.: Duke University Press, 2010), 21. While explicitly dedicated to liveliness, Bennett's is the object-oriented text that falls closest to my own thinking. A profound meditation on the ethical and indeed moral implications of object-orientation (see, in particular, pages 12 and 75), her book is in many ways a mirror image of my same concerns.

13. Ibid., 6.

14. Bennett contends that this type of anthropomorphism is necessary in the interest of arriving at nonanthropocentrism (ibid., xvi). See also Erin Manning on applying anthropomorphism to autistic perception in "Another Regard," in *Carnal Aesthetics: Transgressive Imagery and Feminist Politics*, edited by Bettina Papenburg and Marta Zarzycka (New York: I. B. Tauris, 2013), 54–70.

15. Gilles Deleuze and Michel Foucault, "Intellectuals and Power," in *Language, Counter-Memory, Practice*, edited by Donald Bouchard, translated by Donald Bouchard and Sherry Simon (Ithaca, N.Y.: Cornell University Press, 1977), 209.

16. The problem of objects' withdrawal and endless recuperation into an author function was expressed by discussant Eugene Thacker at the Object-Oriented Ontology Symposium on April 23, 2009. Thacker recounted his student's joking reluctance to "start reading object-orientation unless there's a book written by a block of wood." See audio recording, accessed October 4, 2010, http://www.mediafire.com/file/yfyemmvytii/OOO-Symposium-Harman.mp3.

17. Ian Bogost coined this term in "Alien Phenomenology: A Pragmatic Speculative Realism," keynote address, annual meeting for the Society of Literature, Science, and the Arts, Atlanta, Georgia, November 6, 2009.

18. Latour, *Pandora's Hope*, 161, quoted in Harman, *Prince of Networks*, 74.

19. Donna Haraway, *Simians, Cyborgs, and Women: The Reinvention of Nature* (New York: Routledge, 1990), 188.

20. Ibid., 189.

21. Bennett, *Vibrant Matter*, 73.

22. Catherine Malabou, *What Should We Do with Our Brain?*, translated by Sebastian Rand (New York: Fordham University Press, 2008), 5.

23. Harman, *Prince of Networks*, 44.

24. Malabou, *What Should We Do with Our Brain?*, 5.

25. Ibid., 6.

26. Ibid., 12.

27. Harman, *Prince of Networks*, 47–51.

28. In violating the usual separations that keep ontologies and politics distinct, I am returning to my intention to test philosophical deployment.

29. See Herman Melville, "Bartleby, the Scrivener: A Story of Wall Street," in *Bartleby and Benito Cereno* (Mineola, N.Y.: Dover Thrift Editions, 1990).

30. Malabou, *What Should We Do with Our Brain?*, 71.

31. See Amelia Jones, *Body Art: Performing the Subject* (Minneapolis: University of Minnesota Press, 1998).

32. See J. F. Rodenbeck, "Yayoi Kusama: Surface, Stitch, Skin," in *Inside the Visible: An Elliptical Traverse of Twentieth Century Art, in, of, and from the Feminine*, ed. M. Catherine de Zegher (Cambridge, Mass.: MIT Press, 1996).

33. See Howard N. Fox, *Eleanor Antin* (Los Angeles: LACMA, 1999).

34. See Adrian Piper, "Food for the Spirit," in *Out of Order, Out of Sight, Volume I: Selected Writings in Meta-Art, 1968–1992* (Cambridge, Mass.: MIT Press, 1999).

35. Meredith Jones, "Makeover Artists: Orlan and Michael Jackson," in *Skintight: An Anatomy of Cosmetic Surgery* (New York: Berg, 2008), 153.

36. Malabou, *What Should We Do with Our Brain?*, 71.

37. "ORLAN Official Website: F.A.Q.," accessed October 4, 2010, http://www.orlan.net/f-a-q/.

38. In addition to being contemporaneous movements, body art and minimalism were in dialogue through key practitioners who practiced both kinds of work. Robert Morris's career provides a noteworthy example for its fluent crossovers, including collaborations with feminist artists like the body artist Carolee Schneemann and the sculptor Lynda Benglis. In addition, many feminist body artists turned to their bodies as a personal material to challenge the masculine authority and seeming neutrality of minimalist industrial materials.

39. See Iris Marion Young, "Humanism, Gynocentrism, and Feminist Politics," in *Throwing Like a Girl and Other Essays in Feminist Philosophy and Social Theory* (Bloomington: Indiana University Press, 1990).

40. Donald Judd, "Specific Objects," in *Complete Writings, 1959–1975* (New York: New York University Press, 1975), 187.

41. Bennett, *Vibrant Matter*, 11.

42. Malabou, *What Should We Do with Our Brain?*, 71.

43. Amelia Jones, "The Rhetoric of the Pose: Hannah Wilke and the Radical Narcissism of Feminist Body Art," in *Body Art: Performing the Subject*. See also Henry M. Sayre's essay "The Rhetoric of the Pose: Photography and the Portrait as Performance," in *The Object of Performance: The American Avant-Garde since 1970* (Chicago: University of Chicago Press, 1989).

44. "Medication Guide: BOTOX® and BOTOX® Cosmetic (Boe-tox) (onabotulinumtoxinA) for Injection," accessed October 4, 2010, http://www.allergan.com/assets/pdf/botox_med_guide.pdf.

45. The International Society of Aesthetic Plastic Surgery reported that, in 2009, Botox and Dysport (another brand of botulinum toxin injections) were the top nonsurgical cosmetic procedures, accounting for 32.7 percent of nonsurgical procedures worldwide (http://www.californiasurgicalinstitute.com/blog/plastic-surgery-statistics---worldwide.html, accessed October 4, 2010).

46. Grayson Cooke, "Effacing the Face: Botox and the Anarchivic Archive," in *Body & Society* 14, no. 2 (2008): 26.

47. Ibid., 25.

48. Ibid., 27.

49. Alan Weisman, *The World without Us* (New York: Picador, 2007). See also Eugene Thacker, *In the Dust of This Planet,* Horror of Philosophy Vol. 1 (Alresford, U.K.: Zero Books, 2011), 5.

50. Cooke, "Effacing the Face," 29.

51. Ibid., 33.

52. Joanna Zylinska, "Prosthetics as Ethics," in *The Cyborg Experiments: The Extensions of the Body in the Media Age,* edited by Joanna Zylinska (New York: Continuum, 2002).

53. Jones, "Makeover Artists," 151.

54. Zylinska, quoted in ibid.

55. Ibid., 151.

Six

Adam Zaretsky

OOPS

OBJECT-ORIENTED PSYCHOPATHIA SEXUALIS

In this chapter, the bioartist Adam Zaretsky presents a performative provocation of object-oriented ontology's heightened textuality. Through exaggeration and satire, Zaretsky's parodical text pushes OOO's textuality over the edge. The result reflects two important currents in object-oriented feminism's methodology: the necessity of performativity in theoretical work, and the joyful embodiment of subaltern and sometimes irrational orientations. As Zaretsky states: "Reason is not the reason for being." Through unreason, Zaretsky arrives at cogent conclusions, pressing the object-oriented obsession with nouns to open to a contingent world of adjectival modifiers.—Editor

Gendering Methods of Transgenesis and the Material Vitalist Aesthetics of Bioart

What if life itself is fundamentally—flappy, viscous, flowing erect, and deflating? It is hard to imagine an organism defined as an orificial/metabolic punctuated equilibrium without concluding that aspiration is merely allowed play. The jury is still out, life may not be an elegant machine or comprehensible as a biological system—especially steeled from within the orders of physics and chemistry. The jury on bioart is still out as well. Consider the control most bioartists exercise over the alpha and the omega of our pet mutant media messages. Consider the torture of forcing a generative life art into a transgenic surgical theater. Consider the use of these, display beings—often

145

readymade—in paid artist public exposures. Why are beings put on the obscurely cultured environment of a pedestal? Are bioartists just pimp producers, makers of nature-snuff torture-porn? If so, wouldn't it behoove us to explain why pop OOO clings to life's phenomenological instrumentation and art's useless promulgations as a sign of nonchalant matter? What are we to make of these transformative meat locker aesthetics? Life is life, Parts is parts, Stuff is stuff, but is Life just stuff?

In bioart, the spectacular emphasis is generally on the nervous, metabolic, or morphological reaction of the organisms in the exhibit. This is akin to focusing on a subaltern form of secular vitalism, one that may be universal in terms of panspermia—life everywhere. Perhaps there is a special force of life, an élan vital, not reducible to physics alone—a bioforce? Perhaps we should look again at Wilhelm Reich's force of bion-powered orgone?

> We can establish an unbroken line from psychic excitation or gratification via the antithetical drives of pleasure and anxiety and the physiological antithesis of sympathetic and parasympathetic, via the chemical antithesis of potassium and calcium (lethicin and cholestosterin), to the purely mechanical-physiological antithesis of internal pressure and surface tension. The continuity of this line from the simple inorganic vesicle to the highly complex system of psychic functions in human beings is in no way broken by the fact that it exhibits fundamentally different characteristics and complexities in the various developmental stages of function.[1]

This unbroken line between matter, organic chemistry, and relational connections between objects sounds a lot like the spontaneous generation of OOO thing interiority. Reich even shows how the inorganic holds bion energy–life–force in its interior event horizon: "The Plant, for example, contrasts with the fluids in the soil in which it grows; the org-animalcule contrasts with the bion formed from the plant by sucking up—'eating this bion.'"[2] Suffice to say, bioartists tend to preface their aesthetics—even their pretentions of politicality— through the experimental sculpting of life's form: anatomically, relationally, and often permanently impressed. This cusp of relationality

and the obviousness of the usury is often couched in the language of antianthropocentrism. Speaking for the organisms of experimental material use is similar to the OOO insistence on a secret life of objects. Bioart forces heterogeneity on nonhuman life-forms, transhuman families, and surhuman ecospheres.

The meddle of bioart is enacted outside any health, any knowledge production, or even (with a few exceptions) any viable marketing strategy. In some living installations, the intent is to show the vagaries of the line between matter as vibrating atoms made of rock–paper–scissors and being as distinguishable from negentropic living. Life is reproductive yet not neatly reactive in our all organisms living (AOL) isnesses. This often-perforated line between living being and materialisms of human haunted stuff remains held in the living arts, especially in terms of (1) isolated and banked DNA—as an inert acid until reincorporated; (2) viral loads—contagious but not considered alive; (3) disembodied cell or tissue cultures kept incubating and uncontaminated outside a core bodily hierarchy—for the sake of proliferation and directed artistic differentiation; (4) as well as protein crystals that seem to grow, mingle, fold, unfold, and conform to other clinging potentials—often in the soft maze of the casual endoplasmic reticulum.

World human population is becoming even more global because of mass transit cultural mixing, genetic miscegenation, standardization of nutrient source, and an epigenetic landscape of ever more predictable upstream traumas. We find our cultural identities to be postrace. Nongeographically based population genetics implies that reentrenchment of isolated gene pools—retribalism—has to rely on other biopolitical selection pressures than the nearest neighbor. Many of these choice pressures are now based on postcolonial media subroutines, web search data, and organismic migratory predilections having little or nothing to do with previous reproductive success. Nowadays, all mouse clicking, track pad fingering, touch-sensitive tablet screen-swiping, multibutton-coordinated gamepod joysticking, and infrared line dancing is a form of sexual selection. And this is what proposed, future human selection is based on—tinder tribal twitter cupid cloud based my face spaces. In the name of heterogeneity and the name of nonhuman genomic diversity, we applaud the most obscure monomanias of the web as future deciders of the Punnett squares of the replication

ready. This is the space of mediated biopolitics. This is biotechnology as art.

Training can only take a body to the limits of its predisposition. Pancapitalism has realized that the body must be designed for specific, goal-oriented tasks that better complement its interface with technology within the real space of production. Human characteristics must also be rationally designed and engineered in order to eliminate body functions and psychological characteristics that refuse ideological inscription.[3]

As we approach the realms of the mammalian, the collateral damage of short-range enhancement strategies meet eye to eye with the Luddite, wild-type, nonoptimized human genome. It would do us well to diversify our analogies to encompass more than cybernetic signals over a flat plane of noiseful creatures. Perhaps race, gender, and class, though applicable, might take a backseat to disability studies and the differently abled politics of being on the serviced end of a positive eugenic soft-genocide of time-based fashion?[4]

Posthumanism in the Anthropocene

The resistance to antianthropocentrism has used anthropomorphizing of our nonhuman others as a critique of animal studies concepts of working with the rest of life's worldings. Skeptical debunking of human or person ability to know another object ignores AOL familial common origin—from Archaea on down. We are they, be they: another person, another species, or another material, in any scale, any sensual view or any emo-cognitive habitus. For instance, a slice of wheat bread is dead fermented yeast by-product, cooked until lightly brown on the outside and yummy to eat—if you are not glutenphobic. The yeast is used as a metabolizing factory to produce a richer, predigested gastronomic sculpture of necropolitical aesthetics. But, the quality of life of wild yeast, as it is converted to bread starter, is alterity for the yeast first and human delicacy second.

I use yeast as an example simply because most people do not consider yeast cultures to have a worlding worth consideration, although any lite study of their sex life—asexual, sexual, and budding all in one—would include potential affects that defy human mating

types, hedonistic conceptions, and nonqueer gender being. After tedious, posthumanist training, one might make a near Jainist leap to intuit yeast ethology as a complex, worthy gaggle, most capable in its own niche and having a habitus of their own. But, as we apply technological aspects to yeast, through genome sequencing and bioinformatics, yeast artificial chromosomes for genetic cassette inserts, bakery tech, and secondary metabolite production—that is, vitamin, pharmaceutical, and industrial solvent production—we enter into the realm of hacked flesh.[5]

Fundamental OOO assumption of autism between objects presumes that an object universe dissonantly diverges from sameness of origin. Being is scattergrammed into different morphologies and attributes, yet all is of "the stuff of stuff." Homogeneity may have a holistic role in the origin of a universe of difference, but biopolitics is not coldplay. AOL has at least as much accurate feeling about what is just under the membrane of the inner object-skin of another as any life-form has an ability to react to thanatopolitical oppression. Though not completely accurate, we do run around with our relatives: life being, founded in the elements, the descriptive adjectives (i.e., furry, dry, kitsch, noodly, spindly, or knee-deep in trepidation), the adverbs (i.e., partially, aliterally, unusually, or art brutally), and others with any being of sorts. Being can read being, sometimes with uncanny accuracy and sometimes with inconsistency. But to allow a shot in the dark of affinity, intuition and aesthetic connotative states should not be reactively called anthropomorphism. We morphed together endo/semi/symbiotically from common ancestors, and we are capable translators of our initial and deep-time original experiences. We live and perceive through innate microbomorphism, archaeamorphism, and even inanimatemorphism.[6] This vital splay, a fecund and passionate series, is also teeming with microbiomes, epigenetic gene expression patterns, habituated niche sedentariness, and a certain gravity. Are sympathetic relations to others anthropocentrism, or is the microbialcentrist memory? What sort of human real transspecies relational ability might be due to our archaic common origin with other life?

In this sense, there is some credence to bioart's reimagining of élan vital. A hinting at a relatively special force of life is an affront to reductionist, objectivist, and materialist atomization of existence. Unfortunately, as Robert Mitchell's book *Bioart and the Vitality of*

Figure 6.1. Adam Zaretsky, *mutaFelch-*, 2014. Performance document, Kapelica Gallery, Ljubliana, Slovenia, European Union, November 24, 2014. A sledgehammer and jackhammer gene gun bombard a mixture of human sperm, blood, and feces with raw hybrid DNA soaked in gold nano microcarriers. This is part of a VASTAL school project called *Methods of Transgenesis toward DIY-IGM (Do-It-Yourself Inherited Genetic Modification of the Human Genome)*, including Intranuclear Transgene Infection Bioart labs in Microinjection, Electroporation, and Biolistics. Courtesy of Miha Fras / Kapelica Gallery.

Media makes painfully clear, vitalism's conceptual resultant has had its unseen hand in many camps, including religious, fascist, and superstitious movements.[7] These biopolitical prides, recently reemergent under the rubric of population genetics,[8] belie feigning equality or even the chance for difference commensalism. Postracial, migratory, tribal, blood-gene satellites are now new identity. Why are so many chomping at the bit for any sign of elite privilege by aligning with traits in the postracial arena (i.e., Genghis Khan red star–cluster haplotype; Saxons, Vikings, and Celts @ Odin Ancestors; and Yo Abraham Subpopulation Cluster Study).[9] This is again a job for the Slovenian-style retro-garde (see IRWIN, NSK, Laibach, Scipion Nasice Sisters Theatre, etc.) for their thick overidentification movement. Isn't this how Andy Warhol would have wanted pop to succeed, through overt failing again, reverberating feedback, the social hopped up on carnal, cannibalistic, autodestruct?

Carnal Carny Vitalism: Gene Gun as a Parental Object of Transgenic Instance

Are we fucking in an effable world or just putting the mania back into homicidal mania? By seeking to gender the parentage of various physical methods of transgenesis, technics is mired in the aesthetics of object relations. Transcarpenters of the lifeworld—regardless of their interpersonal gender identity—are read through the gender identity of their tool being or, in OOO, their becoming tool with tool's being. These include process arts such as biolistic, microinjection, and electroporation. These are some of the technics of intranuclear genomic invasion and progenitorization. Embodied drivers partake in device protocols for beaming a vectorized plasmid into a nucleus of an embodied or disembodied—sometimes reimplantable—cell lineage. The techno-physical entry into the germination alteration of thing-being includes reidentification of cells in solution, early embryonic cell fates, and gonadal precursor cells—for instance, oogonia or spermatagonia. These creative relations toward transgene-infected tooled beings are on the cusp between negentropic life and entropic matter.[10] As a practical test, biolistic protocols are run through a regimen of OOF analytics.

A gene gun is a biological ballistic (biolistic) device. Used to get novel genes into the nuclei of living cells, this process is known either as transfection, trans-gene infection, transformation, genetic modification, transgenic production, or, in the case of the human animal, germline alterity. A gene gun can be used to genetically infect cellular genomes or whole organisms with foreign species DNA. The brute accomplishment is achieved by aiming the barrel of the gun and firing. The nanoshot projectiles in the biolistic gene gun are submicron gold or platinum powders. These expensive powders are soaked in DNA or RNA—in naked or plasmid form—engineered for insertion into the genome of the cells or organisms under the gun. Bombarding a part of an organism with infectious plasmids or just naked DNA alters the metabolic fate of an entire organism—or the mosaic parts exposed to the gene gun blast. If the gene gun is shot into a mammal's gonads, or an early embryo, it may affect the germ line, which will transfer this trait to that organism's kin ad infinitum—*sic*. Hereditary cascade. Shooting plasmid or naked DNA-soaked metallic powders into the nuclei of living organisms forces the uptake of new and sometimes inheritable aesthetics based on applications such as health, profit, curiosity, libido, or the production of enigma.

The gene gun was invented by John C. Sanford with the aid of Edward Wolf. It was originally mocked up and tested in Wolf's basement at home. By mixing submicron, nanofabricated dense particles of tungsten coated with DNA that expressed a marker gene, scientists produced the first gene delivery bullets. The nanoshotgun shells, soaked in DNA, were then fired by a modified Crossman air pistol into raw onions.

> The genetic information blasted into the sample in the dish with a doughnut effect (devastation in the middle, a ring of good transformation and little around the edge).[11]

These genetically modified onions with their telltale annular mark—the result of the doughnut effect described above—were the first organisms to be bombarded by a biolistic particle delivery system. This USD$26,000 machine is an apparatus for experimental ejaculation, and the resultant formation is a conceptual anal ring of infected research nuclei. This ring of explosive genetic alteration tells us a lot about the type of libido inherent in new hereditary technology and its

relationship to the natural world. In biology, sex has been defined as the transfer of DNA from one or more organisms to their progeny. This definition suggests that the human biolistic bombardment of transgenes is a type of reproductive sex.

The use of gene gun machinery to integrate novel genes into the hereditary cascade of a research—or other—organism is techno-ejaculation. But, gene gun technology applied to insertational muta-genesis—in the case of transgenes fired into viable embryos, gonadal germ cells, or their precursors—implies not just eggless/spermless gene ejaculation into fertile space but also a type of tool-being parent-age. Whoever the engineered personage, they are also partly your child—even if you are a sworn nonbreeder.

At Cornell University, Geneva campus, New York, USA, two prototype gene guns are on display: "Father Gun" and "Son of a Gun" both reside on the second floor of Hedrick Hall. Prototypes of the gene gun have been displayed at the Smithsonian Institution's Museum of American History in Washington, D.C., as part of its "New Frontiers" exhibit and at EPCOT Center in Orlando, Florida, USA.[12] It appears that the inventors named the prototype gene guns with male familial gerund. The question remains, what is the troubled gender of the human sexual participant toward an other-body expres-sion of the applicator's desire, mechanical mating type, and intention? Considering the objectified dominance (scope and poke), lust for reproductive signature (living fame) as well as the standard libidinal taboos of xenotransplantation and heritage—incest, pedophilia, semi-necrophilia, coprophilia, zoophilia, and ritual murder—it almost seems as if gendering the terminal sexual act is less important than considering the entrenched aspects (forced differences) of the remain-ders: transgenic offspring.

With the remashed organism's difference in mind, it is fair to impart not just paternity to the polygendered engagement of a biolis-tic sex instrument but also—in the case of biolistics—a proclivity for anal sex as genomic entry point. In its obvious mimicry of the anus, the "doughnut effect" around a kill zone implies a lust for the nether reaches of life's guttural beginnings.

As we have said, the practice of biolistics is a way to stably insert new sequences into model organisms; this makes all female, male, trans, or unlabeled dissonant outliers, when practitioners of this practice, the

sexually active co-parents of these organisms. The ring of transfection reveals a symbolic preference toward the artifacts of the biolistic process,[13] which tips the scales toward a reading of the mechanism as a sort of gene pool buggery. At least this is a form of rectal-cloacal experimentation that suits sociobiology because of its procreative potential. But, an OOF analysis of transgenesis methods leads us to wonder about the impetus behind this form of sexual selection. How are we to orient the nuances of other objects in the clutches of technological strategies developed for signing human name into iterative life? How deep should we allow neo-Heideggerian isness to be sourced from the open? Aren't there still some problems that emerged from phenomenology during our last century's making of a clearing with the handness of ofness?

Listmania Trending, Fetish Focus, and Networked Outliers

An object-oriented bioaesthetics, as a dry run through the analysand of transgenic humans and AOL others, retreads two other object sciences: the rich rancor of feminist object relations and the glib, drag-and-drop compiling of object-oriented programming. There is something that smacks of sublimation woven into the terms of OOO's refutation of philosophical alignment to the literary turn. Social media philosophy brings metaphysics to Twitter feeds, blogging, and YouTube conferences. This is timed to the last wave of printed books. As if there is a competition to be the last ideas on papyrus, OOO claims to be nonobfuscational while reeling in utter phenomenological glazing. Somewhere between the read on the tea leaves and the drag-and-drop mind melds, the OOO subroutines need some debunking.

The poetic style of cathexis leads to wonder, stylistic wonder, but OOO is far from escaping the specter of post-structuralist, cultural constructivist, story-time fictions. Without claiming to be neodeconstructivism, does the OOO writing style then reflect concepts for anything but the retro-pleasure for future middle-aged, millennial huckster, digital natives? A major question for object-oriented ontology and queer culture (OOQ) and OOF in terms of language and the development of OOPS for new, gene-collaged flesh being is, What are we to make of the fetish of listmania in OOO as it applies to

bodies in transition? Is this a humorous literary flourish, a sign of Internet trending gone wild? Is listmania a call to global scholar society to unite the subtribes of academic borderline schizophrenics? Don't the Lacanians already have a corner on the market there? Are these lists absurd versions of typical nouncentric object reduction, a radical materialism that is bent on a Sadean annihilation of the subject? Or is every OOO list a fastidious collecting of the longest list of the last presingularity, non–artificial intelligence (AI) written words as a digital metaphor of cloud-based judgment?

I would think that the mere listing of the range of affective relations to the outside world (OW) would not be enough to call on philosophical newness. Like a strange attractor, OOO relations to OW are often cataloged to-do lists of the canyons and buttes of stunted relational shorthand. This listings project has been at loggerheads with the concept of drives driving drives, because of the initial drive of OOO being a monocultural need to list for list's sake. In an ode to free association, the list of incongruent objects has been used as a form of talismanic heraldry for OOO. Listmania is a literary form, kindred to the form alliteration, upstream related to the tabular synopsis of categories. It is the list that defines the range of objects both universal and confoundedly fractal in the macrocosmic object interiorities. It is the fun of mashing up defined object borders through incongruous lists that is the defining punctum of OOO stylistic intention. I would like to pose this trope as an intellectual monomaniacal online happening: we have reached the point in the perpetual presingularity to realize that today's philosophy has become an Internet dating service for academic fetishists.

A short list of lists:

List 1

From the Celestial Emporium of Benevolent Knowledge, "The Analytical Language of John Wilkins," by Jorge Luis Borges:

1. those that belong to the Emperor,

2. embalmed ones,

3. those that are trained,

4. suckling pigs,

5. mermaids,

6. fabulous ones,

7. stray dogs,

8. those included in the present classification,

9. those that tremble as if they were mad

10. innumerable ones,

11. those drawn with a very fine camelhair brush,

12. others,

13. those that have just broken a flower vase,

14. those that from a long way off look like flies.[14]

List 2
Online dating website OkCupid has expanded its gender and sexuality options for its users. Previously allowing users only to identify as either male or female in gender, and gay, straight, or bisexual in sexual orientation, the website is slowly rolling out new options.

The gender options are now woman, man, agender, androgynous, bigender, cis man, cis woman, genderfluid, genderqueer, *hijra*, intersex, nonbinary, other, pangender, transfeminine, transgender, transmasculine, transsexual, trans man, trans woman, and two-spirit.

The sexuality options are straight, gay, bisexual, asexual, demisexual, heteroflexible, homoflexible, lesbian, pansexual, queer, questioning, and sapiosexual (attracted to intelligence).[15]

List 3
Of types of bankruptcy, a list from quintessential listopian Charles Fourier:

I. The Innocent.

1. Child bankruptcy.

2. Dare-devil bankruptcy.

3. Stealthy bankruptcy.

4. Posthumous bankruptcy.

II. The Honorable.

 5. Goose bankruptcy.

 6. Ecstatic bankruptcy.

 7. Unprincipled bankruptcy.

III. The Seductive.

 8. Amiability bankruptcy.

 9. Bankruptcy de bon ton.

 10. Amorous bankruptcy.

 11. Bankruptcy by favor.

 12. Sentimental bankruptcy.

 Center of the Series. Grandiose Hues.

IV. The Tacticians.

 13. Fat bankruptcy.

 14. Cosmopolitan bankruptcy.

 15. Hopeful bankruptcy.

 16. Transcendent bankruptcy.

 17. Graded bankruptcy.

V. The Maneuvers.

 18. Running fire bankruptcy.

 19. Close-column bankruptcy.

 20. Marching-in-file bankruptcy.

 21. Skirmisher bankruptcy.

VI. The Agitators.

 22. Bankruptcy in grand style.

 23. Large-scale bankruptcy.

 24. Attila bankruptcy.

 Left or Descending Wing. Dirty Hues.

VII. The Cunning Sneakers.

 25. Compensation bankruptcy.

 26. Bankruptcy out of rank.

27. Crescendo bankruptcy.

28. Godly bankruptcy.

VIII. The Bunglers.

29. Fools' bankruptcy.

30. Invalids' bankruptcy.

31. Crushing bankruptcy.

32. Swinish bankruptcy.

IX. The False Brothers.

33. Villains' bankruptcy.

34. Gallows-bird bankruptcy.

35. Fugitive bankruptcy.

36. Bankruptcy for fun.[16]

List 4

Usenet alt.Porn Groups from GUBA (Giant Usenet Bitmap Archive, no longer free file sharing for monomaniacal tribal barter formations). Blipvert analysis of each group in terms of the sociobiology of net-porn are mine.

alt.binaries.pictures.erotica.Senior-citizens: Age and Nihilism of Reproductive Goals

alt.binaries.pictures.erotica.Wives: The Marriageable and Sperm Competition, see Kamikaze Sperm

alt.binaries.pictures.erotica.Breasts.large: Fertility, Infantilism and Milk, the Moon

alt.binaries.pictures.erotica.Male.bodybuilder: Fertility, Longevity, Musculature, and Exaggeration as Sexual Selection

alt.binaries.pictures.erotica.Vintage: Generational trends and retro conquest as porn fetish itself

alt.Barefoot: Naturist Foot Fetish and the chthonic/earth-bound upside-down holiness of dirt to sky

alt.binaries.pictures.erotica.Gaymen.twinks: Roman Twink Tradition as the birth of modern heterosexual mores (the musical)

alt.binaries.pictures.erotica.Anime: the Neonatal Imaginary

alt.binaries.Nospam.plumpers: Venus of Willendorf, fat as wealth/safety/vaginal, Gynophilia

japan.binaries.pictures.erotica: Japan as a porn mirror/imperial interrogator of Los Angeles today, and mother China both yesterday and tomorrow

alt.binaries.Nospam.sappho: see Bonobo, GG Grinding, and Pacifism

alt.binaries.pictures.erotica.Balls: Sperm production as alternative to more violent dominance patterning (see Siberian primate testicle size and physical assault statistics)

alt.binaries.pictures.erotica.Pregnant: Holy mother defiled, worship as exposure, gynophobia as imaging fetal invisibility (i.e., The belly)[17]

So, this listmania is a call of the OOO e-yenta, matchmaking breeders and nonbreeders alike to join in a junta of literary momentum: conference, publish, narrate, exigesize, upload and download, get loaded, and make furtherance. OOO is Oulipo-inspired, James Joycean absurdism. The humor of this rallying fetish objective is tiny and felt erotic only for a subcultural clique of literarily needy academic master narrative workers. Philosophers are known to be failed authors of fiction, failed players of real-world challenges, and in some ways hiders in obscurity. What better survival skill, echoing the Judeo–Christian–Islamic trinity, in selling water by the side of the river. Thank you to another philosophy of making the indefinable, irreducible remainders into another tome of lists, of seductive partings and postneo in-groupings. Faulted egos will line up behind this mini-mystery cult. It's timeless.

Why waive the beady eyes and heady interludes of academe past the embodied equation? Why not? The mind is not dry schemata. The mind is the wettest organ of the body. A fetish for incongruous

listmania is not any more or less a sign of obsession than other "more defined as lustful" fetishisms (i.e., foot and shoe—toeless or stomper boot—worshipers or CNS painslut BDSM Femdom cultures). Queer monomania is defined by obsession, inordinate focus, and a virtually uncharted object choice. Hence philosophy is a subset of fetishism. Object-oriented ontology and queer culture share nested loops, iterating in any OOO cultural orifice. Statistically, it is the outliers that make the foci, keep us busy at both ends, and are oft still capable of networking future socio-heritable palettes. There is no artifact of life gleanable without a queer edge to it—and a being to work that edge. Becomings are queer by their negentropy, by their coming together, by their candles left burning, by their sacrificial economies. Questioning is queer.

What is most prescient, in terms of the Listmania fetish of OOO, OOF, OOQ, OOPS, and object-oriented et cetera (OOETC), is the imprinting of this belly button version of new materialism with the joy of listings-as-koans. Yet the poesis consistently shows signs of systemic failure as an attractor for conjoined schizo-affectiveness. If schizo-analysis is not properly apportioned to schizopolitics, how can we get to the appreciation/gelling of what glossolalia and neocortextualization can do for neologism and borderline ideation in general? If the preposterous elbows, doorknobs, and peppercorns are subsumed in banal schizo-affections, then all these thousands of rhizomatic "plateaus" are truly utilized for a pure paying of the bills. Writ large, philosophical talk is cheap and falls not much further afield than advancing personal credit lines and ossified tenure for drugged-free psyches. Eliminating psychotic ostracization, we have a Chaosophic system in permanent transcendence of job insecurity, a mere advertising of aesthetic horizons. Without the magnetic pull of psychotic speech, parrhesia, and the cutting non sequitur, these are just fun lists: unromantic, nonexpressive napkin writings of sub-babel alliteration. Bite the hand that feeds you babble, bituminous, bismuth of balderdash, Balthusian banter bleeds without blemish on the buggered banality of Bundt cake and bosons. These are the showy last gasps of the written page. Emoji art criticism trumps written art criticism with hieroglyphic assessment of aesthetic emotional ranges. Emo glyphs known as emoji (of the emoticon type), when well mixed, encompass all ranges of feeling that known clip art aesthetics allows. Because of

Figure 6.2. Adam Zaretsky, *Emojineering Aestheticon*, 2015. Digital remash.
Courtesy of the artist.

their breadth and nonverbality, the emoji lexicon is a most accurate critical review of artistic product.

Cathexis and Adjectivist Relations: Have You Ever Been Experienced?

Psychedelic technoeisis has experience within infinite iterative and nested endo- and exo-objects. Parasitical matter interactions imply das network ding. If object bodies are often superimposed outside spatio-temporal cartography, then it would not be obscure to ask: Where is the affect? Is it in the descriptive text, OOO's literary turn? Looking deeper into the web of life, let us broach the following concept: within and without poesis, are we not peripheral to mere noun (object) or verb (action) relations during experience? Without the blue-shag, lemon-scented, lilting-leaning details in any peer-to-peer (p2p) relation, there is no thing to thing (t2t or das ding zu das ding) aesthetic/affective dimension. Experience is weighted to the adjectives and the adverbs.

This is a way toward an opening. From the dullness of material culture, leveled by a nondescriptive flat ontology of things, enter into an unclearing. Beyond a sheep shearing, limited palette obsession with lists, we find a not-of-nouns cosmos. Object relations are meted out in the home on the range of noun and verb descriptivores. Cathexis is sometimes a ghost bridge, often an imaginary tube, called complex bond, charged attachment, emo-core law. Cathexis has savage sovereign verve. The aesthetic of the bond is not of the thing as object. Attraction/repulsion is in the way of assessing the nuanced pudding of the object relations. Does a cell phone long for another object? If so, it might be another cell phone, a recharge, a string of on-screen emoticons, or even an invasive virus. For that matter, a cell phone might feel life-lack when confronted with a carrot-and-stick object relation.

The obscurity of schizo-analytic relations is sinister, plausible, yet trite without a romantic, baroque, and florid description of the types of relational longings between cell phone and t2t object-sex-object-being. Does stuff in the itness pine with ardent zest, grim slick, and peach fuzzy among the sour repressions of resentment? Are thing-to-thing relations besotted, surly, yet steam punk sympathetic for the third-rate fake—fake of lugubrious object desire descriptives?

This is a way to read the objectification of the omniverse in as wide a range of feeling-producing interaction as form allows. The feeling of at-home on the wide range of relationality engages certain being. Others feel at-home relations nominally at best. The same *homme* OOO thought experiment is fermentingly repugnant and nauseating a home to some. All the ontological de-is-nesses fulminatingly require a fruity, loopy, hairballesque prognosis for the literary buildup of the salt-stick flavor in today's philosophical trending toward others.

The problem of object relations is pressing. This psychic trail to the world is driven by drives. Yes, drives drive drives. If it is libido or other forms of life force as well, the type of relations an organism has with and for objects is charged by describable characteristics. There is no nondescript desire. The relations of withness and forness applied simultaneously to an always semi-able body are made power estranged through the, often fatal, doneness to objects relationally lost. What is most important, most left unexplored, is the descriptive relation, the peaks and canyons, and, in particular, the open ranges. The classical, archaic, bacterial drive toward habitus, sustenance, and rewarding reproductive clime is directed by the descriptive types (attributes) of cathexes (object relational instances). Even in the realm of object-to-object (objects only) relations, we need adjectives, descriptors to mete out the style of the aesthetic action (verb) dimension:

> When you make or study art you are not exploring some kind of candy on the surface of a machine. You are making or studying causality. The aesthetic dimension is the causal dimension.[18]

In this sense, we may need to add a second order of quality-focused emphasis to the quadruplicate of OOO, based on the descriptive nonobjects: adjectives (and adverbs too!). Without description, drives have no aesthetic; they are leveled, and no causality can rise to make an occasion. In charismatic point of fuzzy fact, adjective-oriented ontology (AOO) for AOL is a steamy, chalky, repressed, and knotted recharge predecessor for any thing-actor noun theory.[19] This is a question of whether broken, bent, blocked, butchered, and bashed cathexes are the root of objectification, or if there is no other relation, still traumatic yes, but no relationship without some force of describable yet verb-bound, done-to interaction. This would advance the range of cathexes descriptors to include difficult relations, as a carrying potential

for trauma-lessness. Relations alone are severed, shredded, finely minced, and tormented in various ways. Without these inured, blunted, impeded, and scarred relations, the grasping, moist, slow, throbbing, pulsing, squiggling, negentropic, optimistic, and elated transmissions of want and gift will have no bearing in the world of flat unit objects.

Queer Adjectivist Ontology (QAO): Object Relations and Descriptive Cathexis

It is relational politics that bind objects to objects. Our bodies, our late-capitalist identities, are cathected into—not through—the network. Even identities who prefer the collapse of sentimental "self" subjectivities in favor of posthumanist, anthropo-decentered referencing as pseudo-self-alluring simulators, as an instance of a type of object, have net-surplus object relations. These object relations are based on attentive types and instances of relationships that are qualitative in psychic nature, often belittlingly described as aspects, a form of detailing. The details are not nouns but descriptive adjectives of the object relations. Affective relations to external object of fascination, revulsion, mild inuredness, or suspicion are but the tip of the adjectivist ontology.

> Knotted, polka-dotted
> Twisted, beaded, braided
> Powdered, flowered, and confettied
> Bangled, tangled, spangled, and spaghettied![20]

It is the analysand's developing ability to catalog the depth of each relational instance as a type of cathexis. For instance, relations can be taut or frayed, fuzzy or slick, kinked or softly flowing, unidirectional or omnidirectional, branched or fomenting, shaggy or anorexic, untimely, effluvian, clogged, sharp, pert, preternatural, somnambulistic, Nurenbergian. A compendium of adjectives—a listmania for descriptors—is a more drive-driven tableau than our stone-faced nounists in the object-oriented crowd. The thrownness of the Heideggerian cupness that fits the handness and guzzles the beerness is thrown according to cultural and anatomical physiognomy that is based on the local emo-weather, not mere minecrafted thing-stuff, as the world of object inventory schemes seem to imply.

Sex Is Not Heteronormative or Even Repronormative

If experience can morph anatomy, what are we to make of the fluid-exchanging devices of assisted reproductive technology? How are we to read gender alterity, libidinal sexuality, and biological sex through the mechanism of experiential, physical, and erotic incorporations of transgenic, biomorphic, or hereditary cascade methodology? This is a question of impregnating and imbuing in and around a scientific or medical process as changeling. The question is posed for the developing genetically modified life forms: how do we identify, enact, and metabolically confirm the sexual, gendered, and mating roles technically played out on us during the first minutes of initial conception— zygote, blastula, germ cell, fertilized seed?

Unflinching, prolific, and showing mad repertoire of wet-lab skills, the bioartist Dr. Marta de Menezes teamed with Maria Manuela Lopes and the scientist Dr. Isabel Gordo to produce a living installation titled *Tetrahymena*:

> The common aquatic organism Tetrahymena exists in Nature in seven different "mating types."... Individuals from each "mating type" display characteristic morphologic and behavioral traits and are able to mate with individuals from any other of the six types different from their own. Furthermore, while each individual from each mating type can reproduce with an individual from any other different type, interactions with individuals from the same type do occur but do not lead to reproduction.[21]

This is appropriate technology to ground the argument of biodiversity as always queer and exuberant in expressivity. Shown to us through the living bioarts, we can experience field of life as polymorphously perverse and teeming with orgonomic energy. Sexual selection and nonreproductive sex have a carnival in *Tetrahymena*. Attractions and celebrations beyond fitness strategies enter into concepts of display, allure, and popular nonhuman socializing. Let's call it omnidirectional exponential hobnobbing. The intent of the bioartwork is to school spectators in a nonhuman orgy of complexity and let lack of recognition be the guide:

> Where they can discover how distinct and unique different genders can be, even when they are devoid of anthropomorphic

characteristics. It is possible to see how different mating types have their own way to move, have a specific shape, or interact with each other in their own unique ways.[22]

We can conclude that all living being is representative of deep-time typographical error, a queer sifting of quorum sensation. If mutation is random driftworks and life is the canalization of mistakes, effervescent changes to compulsive series, how is this not a celebratory motion, a turning to face the ever more strange?

Gender Is Political, Both in Terms of Identity and All Politics Living (APL)

Dr. Boryana Rossa is a body artist, a bioartist, and a new media cultural critic. She is also an outspoken, brave, and global political voice of the first caliber. As the curator and editor (with Stanimir Panayotov) of the Sofia Queer Forum, she constructs a voice that reinterprets queer theory to include all bioexploitable facets. Resistant to mere regaling of the "free" modern subject, the rights to proclaim gender fluidity are coincident or even synonymous with a global understanding of socioeconomic differences as part and partial of any definition of self-being. Queer pride is reactionary unless we begin with

> understanding gender as something flexible, constantly changing and not defined by the restriction of patriarchal or binary heterosexual conventions. This theory makes possible rethinking feminism and rethinking the existence of people who do not fit in heterosexual norms. By stepping on this theory, it becomes possible that sexual and gender identity be connected with economic and social processes in society; it becomes possible to talk about solidarity between varieties of marginalized groups, based on their common demand for social and economic rights. Despite the "celebration" of diversities, which should be able to live together in contemporary society, if the efforts' direction towards equality remain within the domain of "identity" and the "very personal" and never touch upon economic and social issues, we cannot expect solidarity between diversities.[23]

By being brave enough to organize this forum and by queering of the concept of queer for a real and present Bulgarian cultural analysis, Rossa holds to rigorous analysis of contemporary homophobia as it

relates to economics, sociology, and neoliberal transitioning. How are flows of economic digitality able to herd gender and sex into tropes of bank-bias? The World Trade Organization has its own version of carrot-and-stick object relations that effect "individual" identity and divide to conquer queer solidarity.

> We are witnessing hatred on behalf of poor heterosexual layers of society against "the gays" because they are seen as "the taken care of" by the new international politics and the NGOs, while the "straight whites" remain poor and neglected. At the same time nobody ever talks about the very specific economic problems that all these "gays" have. They are "given the right to be different" but are not given the access to jobs and social and economic rights, because they are not in the focus of NGOs and government initiatives even for the straights in Bulgaria. This separation of social rights from "the right to be different" already generated bad results. Looking for and revealing the connection between social rights and identity would have given an opportunity for new solidarity and this is how we could have avoided the already emptied from content propaganda of "love" among everybody at any rate.[24]

This reminder of queer history is perhaps fueling the rigid impetus to replace the Q in LGBTQ from the word *queer* to the word *questioning*. Queer politics that acts inured of sociopolitical queering needs an ACT UP anamnesis. Hard-hitting real politics include a becoming direct, queering societal norms, including expression of nonpopular affects (like anger, angst, and antagonism) as well as nonpopular effects through tactical, direct, and nonviolent actions. This version of the off-the-locus outlier's union is embedded in a global social network on the defense against hemorrhagic border puncturers. We need constant reminders that there is no apolitical art, apolitical thought, or apolitical queerness. Is Rossa's point not the hardest to digest for both culture-in-general and the apolitical stance of much of OOO? We are far from done with humanism by avoiding politics.

Sexuality Is Not Mere Pleasure

There is a lot to read into new reprogenetic relations here already. It pains me to add another layer of OOF complexity on this dynamic

OOQ enigma. But, are the mechanisms in their itness also capable of being read as gendered, personaless sexualities and mating types—sexed as objects? Can vibrating material objects have cathexes to the living? Can a gene gun, a biolistic, vector-dipped nanoprojectile in flight, read in its objective, physics-based vital universal material isness, convey some integral OOO aspects of parentage, ALT orgasm, and gendered behavioral roles? How does das ding get into its robotic juxtaposition in an otherwise rather simple, flesh-based orgy of erotic preference and aesthetic equations? Are the directional aesthetics based on option and relation? Ask the same of your desires, your wild pleasures, and your technical identities. This OOPS queer implication is best explored through a lyrical quote from the punk UK band Gang of Four in their anthem "Natural's Not in It," from the album *Entertainment!*:

> Fornication makes you happy, no escape from society
> Natural is not in it, your relations are of power
> We all have good intentions, but all with strings attached
> Repackaged sex, your interest[25]

Scrapple: Bioart as OOO's Visceral Epic Fail

It is an opportune time to weigh in on the ethological in terms of the inability to reduce life to digital information.[26] We might expand our reach around the issues of diversified gender, postrace, enhanced disability, and class (same as it ever was, untouched by identity politics) by embracing the irrationality of the humanities, seemingly not bent on instrumentalizing all life under the umbrella of biocapitalist intensives. After some very cool years of relegating life and theory to dry computer science eye-candy-based digital art, bioart is an affront to artificial life and simulationist metaphors as a wry celebration of a hot, retro medium: the be-in of gut trickles. This is the other half of posthumanist, cyborg politics, without which Donna Haraway would never have bet on technoscience.

And, what of neo-animism? Biosemiotic seepage refutes life as a language, code, or integrated circuit. Which is the best metaphor for life? Living being is closer to mucus than any literary device, but language as a semiotic system—including any code or circuit of control

line poesy—is more mucus like, mucus driven, mucus seduced than it is often comfortable to admit. Language is not a glorified spark of clarity. Immaterial electrons are not untouched between synapses. The written, spoken, and thought word has a viscosity, both where it lives (embodied) and what it means to be alive (*entendres*). We can find the plasticity of codes and circuits as langue styles, styles of life, preprogrammed, highly tractable yet somehow slimy, oozing, crashing, and fritzing in jazz accidentalism. But life brings a most slippery challenge to AI and the OOO refutation of inanimation. Is this a philosophy without thanatos? In general, ignoring mortality is not a wise path to optimization. Surely, genocide and other forms of institutional abuse are yearning for a form of being in equality. But the dynamic equilibrium of flattening can define genocide in itself (as Martin Heidegger has so handedly proved), so where is the becoming inanimate left off in OOO proper?

The economy of care tends to be relinquished completely when the lifeworld is reduced to gadget love mecha-talk. Bioart is living-materials-first, previous to any bioethical excuses made by the artists about stimulating debate or reworlding for the other. In some ways, bioart is the best example of the epic fails folded into OOO. No offense to the object-oriented animism of listmania, but tinkers and tailors of life feel the experience indifferently as well. The use of bio-media for aesthetic projection is the ethico-political stake we wield in unison. The blood on the hands is part of the sacrificial rite, neh? That being sort of put out there bare, I am more interested in the debate being started in terms of the potentials for positive declension in the molding of populations.

If OOO needs to talk of life as a subset in the set theory of instances with aspects,[27] this aloofness mirrors common language tropes. The in-culture of biotechnology's commercial factory business assessment of raw, bare life as a product orientation seminar speaks listmania! Synthetic biology offers biobricks as a registry of standard biological parts.[28] Biotech underscores the uncanny position of our being as soft, moist machines made of meat.[29] Most bioart does have a technological life-support system during exhibition. Bioart is often interchangeable as process based, new media, mecha-life-itself.[30] But, is it still too early in ethological or even natural history to determine that meat is made out of machinicness? Life may be a mix of the

material and the vital without any mecha-technical analogy applied to the swelling and welling up. Thoughts, and other bodily excrements, are often fluid dynamisms, not easily relegated to electrical discharge and therefore less integrated, even less circuitous in their effluvial contagion.

Not that the force of life is something special, sacred, or worth preserving—for whom and why? A goddess's dressing up of life bodies with romantic versions of holism—like the noosphere yab yunk out there—or unsullied virginity (unfertilized eggs are only good for usury), naturism does not improve the debate or make for interesting response patterns. But, conceptualizing the mind as wired, heredity as a hard drive, our reliance on appliances and digital metaphors as placeholders for embodiment is mere channeling of commercial television. Pop culture is the most kitsch way to annihilate care. If the machinic metaphor is meant to be ironic, then it is at least informed. But, if mecha-digital allusion is just the lowest common denominator crutch of a technophiliac culture, even unto the intelligentsia, then we are just slouching into more penitentiary-led eras of "Long Live the New Flesh" borg interface.[31] Instead, a truly open source, unscreened life tech might be Red in Bluetooth and Claw.

Is the Work of the Positive to Posit a Function of the Organism, Orgasmically in Optimism . . . in Every Describable Direction?

Finding optimism in biopolitics, even in terms of techno-breeding for novel feelings, is, comparably, not a total ruse. A trajectory from Charles Fourier to Wilhelm Reich to Buckminster Fuller, not to mention the Bronx cheer of Charles Fort, can be traced, queered up into the utopian philosophy of Annie Sprinkle; follow the traces and we can hear the subaltern potential for timeless amorous flows. These are deep meanderings. But even for queer vitalist optimism,[32] can we really delimit the emphasis on the work of the negative?

Vitalmania is a gore hound, too. New vitalism is netcasting for yet another Valerie Solanas, Lydia Lunch, Kathy Acker, Lizzie Borden.[33] An anamnesiac philosophy is caught up in the industrial confessionary. This is often exemplified, for better or worse, in bioart. Amy

Youngs, in the "Culling Is the Secret" section of her bioart historically
pointed essay "Creating, Culling, and Caring," details her experiences
breeding show rabbits as a youngster and how the killing of the less
than competitive baby bunnies influenced her acts in the bioart
medium. She already knew how to read the real returns of the breed-
er's art: the organisms on relational display . . . and those who fell by
the wayside in the time-based media of the making of neo-life:

> Limited time, energy and resources prevent the support of the
> failed experiments. In a breeding project, culling is a way to
> ensure that the population of living things under one's care does
> not exceed the available resources, as these will be needed to
> continue to care for the living things that have "made the cut."[34]

The troubled role of care in biotechnology is, hopefully, still an issue
for those who claim insight into embodied analysis, reflection on ani-
mal studies, and pondering the biopolitics of AICUCs (animal care
and use committees). We may be parrhesiac cheerleaders, spreading
liturgy for liturgy's sake, but the toying with fascist orderliness, clean
ability, and utopian breeding is just an armchair away from the radia-
tion's leak.[35] In terms of affirming affirmation while underscoring un-
suturedness in life art aesthetics, it makes sense to ask whether we
can find solace through the interiority of OOO's deep ecospheric
indiscriminacy.

Is OOO just abstract expressionism again? Or is there something
here that is not mere vamping, posing, droning, and trending in the
lands of verbiage? We all live under the kill-'em-all flag of the global
war machine's nightly thanatotic blowing away of thing-bodies. Does
OOO offer something schizogenic, queering, and adject-activizing?
We need placement of derailed psychoanalysis to retain object rela-
tions with the posthuman cognitive refilling of the place and space
of this species. There is a problem and a truism engrailed in putting
being on par with any other described postnoun or attachment (sticky,
removed, stuck, or cornered). Without a queer reach-around reading,
OOO speculative materialisms tend to be the penultimate postideo-
logical pastiche, followed by the Heideggerian standard, trite, and for-
gotten annihilation. The antithesis of lists of fragmented compilation

is still to be found in nuanced descriptive depth. Especially in the age of Our Genomes, Ourselves, being needs readings.[36]

Escape Command and Control through Options: (ESC.CMD/CTRL.OPT)

From a Marxist standpoint this complex of denatured lists is the oxymoron of materialist specters: workers' grief and anxiety as a haunting force. Objects or the objectified instances of perceptual definitions—even after filtering out or siphoning off assumed antianthropocentrism—have haunting powers of alienation, interests beyond their means. Irreverence and slippage, jazz varieties of instruments and notes are perceived with a blank on either side—blank intention / blank reception. Where is philosophy holding the potential for fetish escape from code? Is there a role for unmonitored forced evolution in synthetic biology and genetic algorithms? Can re-cathexis, de-cathexis, skew-cathexis, and flange-cathexis perceive the nuanced interstices between master and servant dominance and humiliation perceptual universes? Worlding has not superseded the buggy interplay of fluid, porous, and nonoptimized universal relations. Improbability is in all ways iteratively inevitable, statistically speaking . . . but can we rely on ESC.CMD/CTRL.OPT or is that just the jacked-up optimism of the critics of late capitalism?

Places where an all-object language is troublesome in assisted reproductive and reprogramming human and nonhuman molecular stasis is

1. Flitting macro and micro triteness, an upper-middle-class collection of words yet refuting the literary turn.
2. An honest catalog of bric-a-brac verbiage in the postliterate world.
3. Self-appointed harbingers of the last deep book, hopeful of futureshock's glut, preening for the last poetic, academic, ideational concept that breaks the camel's back of consciousness and awaits our snow crash into viral glossolalia.
4. On the factory floor, genetic engineering news (GEN), the orificial economy upended, back to slime mold with nothing but ruins to show.
5. In the being flesh of programmed isness, as is.

Technical Devices: Gender, Sexuality (Eros), and Sex (Mating Types)

Initially, the question of this chapter asked: What is the effect of a patient provider's corporeal, environmental, active metabolic, behavioral response to initiating nonnormative, techno-reproductive fertilization? What are the potential gendered and sexed readings of artificial breeding–type parentage transferred from these kindred beings-in-progress back to the life science progenitor? Simply put, how does the scientist or doctor producing transgenic humans or other transgenic life-forms change themselves by engaging in such a refined way of making sex? It can be assumed that the change has something to do with how being, difference, and remainder hide behind the role of doctor, scientist, or clinical technical assistant in general. This role allows the clinician to contain, screen, veil, or officially neuter self—as concept—favoring object-oriented relations as global variables: health, knowledge, pure and fundamental research. Client provider services are invasive. They are beyond personal, survivalist even. And yet, the object relations are kept deeply impersonal, even quarantined from instance. This disavowal is part and parcel of noun totemism and adjectivist taboo, but any marked emotional difference on the embodied clinician is a place of research potential. Certainly the chemistry of preserving sanity and some awkward semblance of bedside manner is worth searching behind. I suggest research into the gene expressionism patterns and somatic character armor of those in charge of running human subjects through their paces in gene therapy trials.

Organismic Entrapment as Metabolic Disorder . . .

The focus is on the aesthetic or detailed emotional type of cathexis in the object relations between the scientific–medical–technical applicator, the infectious gene construct introduced, and the altered organism—the nucleic living genome of future hereditary cascade beings. Inferred by the terms of the actual architecture of the devices used in the choice method of transgenic infection (transfection), the question is how well OOO can read affect alteration directed at the viral vaccination surgeon's emotional repertoire. These devices of transgene infection are not usually read as psychological archetypes even if the dreams of technics are relatively easy to interpret. Certainly, the physical application

of these devices as a familial making—fraternal, partial birth effector/
defector—implies a certain describable bond with the society of hands-
on mutagenesis. Yet, the psychoplastic bond is seldom symbolically in-
terpolated as an aesthetic between medical doctor and unborn patient,
certainly not as a co-parent in an underexplored realm of reproductive
affect relations.

Accordingly, Anne Fausto-Sterling, in *Sexing the Body: Gender
Politics and the Construction of Sexuality*, adds this layer of somatic
contagion as applicable to the object relations of medical-experimental
assisted reproductive technologies (ART). "The fact that human brains
are also plastic, . . . makes it possible to imagine mechanisms by which
gendered experience could become gendered soma."[37] In this case we
can assume that the social stigma or prestige of being a genetically
modified human client will be culturally affective on the level of sexu-
ality, gender identity. We can expect an imprint on physical sex, a
showing, in an anatomical and morphological sense. This hard sex
includes psychopathological adjectivist interventions in fertility, mat-
ing role, brain development and functioning, gene expression patterns
(including epigenetic multigenerational Lamarckian effect), erotism,
and gross anatomy. The somatic incorporation and developmental
expression of social conceptions results in inborn traits. This is a case
for depth descriptivores in disability (differently abled) studies, as a
gateway, beyond trans(genic) queer pride, to comprehending trans-
genic embodied anomic experience. This is one place where bioart
holds sway. A meeting of an unstigmatized version of the term *psycho-
pathia sexualis* and contemporary disability studies is enacted in bio-
art. A multilectical relationship is visited on the fetishistic desires,
cognitive futures—and preconceptions—as well as the physical bod-
ies of patient, techno-parental machine, biomedia and reproductive
assistant. To enter into feminist new materialism here, Fausto-Sterling
asks the pertinent question:

> "How does knowledge about the body acquire gender?" The
> active question on the inside surface is, "How do gender and
> sexuality become somatic facts?" How, in other words, does the
> social become material?[38]

A precursor question to Fausto-Sterling's magnificent question
is, How do we technically prepare the body for social applications?

Figure 6.3. *Understanding the Cellular Basis of Neural Computation*, micrograph. Simultaneous quadruple patch-clamp recording from layer 5 pyramidal neurons in a cortical brain slice. Neurons were filled with a fluorescent calcium indicator and imaged with 2-photon laser-scanning microscopy. This approach investigates the location-dependence of synaptic plasticity in pyramidal neuron dendrites. Copyright 2015. Courtesy of Professor Michael Häusser, Neuroscience, University College London, United Kingdom.

An exemplary example is the patch clamp. The "patch clamp" is a scientific tool,[39] a medieval rack for a single cell. After considering the patch clamp to have an emotionally autistic, indefatigably veiled inner life, after considering it as an axiom of a seductive object, should we then concede to the objectified clamping of bodies as just another nounist form of orbital relations between trappist things and anatomically canalized subjects? Are we freed, by the patch clamp, from the social dance of learned behavior, or is it a potential inception stage for social alterity? Is some form of Guantánamo Bay–styled antisovereignty an a priori basis for social cohesion or empiricism in general?

In summary, it is perhaps not a decisive gendering of a variety of mecha-methodologies of transgene infection that is called for. Instead the text addresses the subtext of all these loss rites, the initial bondage of life and the double jeopardy of being an experimental subject. A liver is born into you. We are born into the multitudinous plethora, the material, the stuff. The relationship is preset in some ways and not without strife. Microbiomes abound. The same goes for all artifacts of time and chance: bricks, grammar, mildew, and steak. It is panexploitation ... life teemed on life. And, yes, size does not always matter. There are various biopolitical metaphors for the torture of our familiars. How can we be sure that excess usury is not just another "way of metabolism"? If injustice is not performed always in panic and sadism, if it is not always the result of humiliating prudery (as Reich would claim), then vantage, gleaning, knowledge, and dissection have a place at the table of the positive declension. In which clearing of the lifeworld does this form of universalizing-unity, phrase-turning, ontologically trending, aloof phenomenological deprogramming emphasize happy endings? The urge of critical bioethics to immanentize a light-filled eschaton of futurist descriptiveness alone, as philosophy, is applaudable. But biopolitics does and should remain bitingly insightful. A soldier is a soldier even when "at ease."

Notes

1. Wilhelm Reich, *The Bion Experiments on the Origin of Life,* translated by Inge Jordan and Derek Jordan (New York: Farrar, Straus and Giroux, 1979), 139, http://wilhelmreichtrust.org/bion_experiments.pdf.

2. Ibid., 164.

3. Critical Art Ensemble, *Flesh Machine: Cyborgs, Designer Babies, and New Eugenic Consciousness* (Brooklyn, N.Y.: Autonomedia, 1998), 31.

4. Adam Zaretsky, "Oocyte Aesthetic, Human Design, and Mission Creep," *Serpentine Magazine*, January 8, 2015, http://serpentinemagazine.com/2015/01/oocyte-aesthetic/.

5. Arthur Kroker and Marilouise Kroker, *Hacking the Future: Stories for the Flesh-Eating Nineties* (New York: St. Martin's, 1996).

6. Inanimatemorphism is thanatos as the urge to become inanimate again.

7. Robert Mitchell, *Bioart and the Vitality of Media* (Seattle: University of Washington Press, 2010).

8. Population genetics is postracial: new order identity politics are based on migration patterns on foot and mingling across continents. Our next wars will be based on genetic haplotypes instead of standard, pre–Human Genome Diversity Project (HGDP) blood ties.

9. Tatiana Zerjal et al., "The Genetic Legacy of the Mongols," *American Journal of Human Genetics* 72, no. 3 (2003): 717–21; Bryan Sykes, *The Seven Daughters of Eve: The Science That Reveals Our Genetic Ancestry* (New York: W. W. Norton, 2001); and Gil Atzmon et al., "Abraham's Children in the Genome Era: Major Jewish Diaspora Populations Comprise Distinct Genetic Clusters with Shared Middle Eastern Ancestry," *American Journal of Human Genetics* 86, no. 6 (2010): 850–59, doi:10.1016/j.ajhg.2010.04.015.

10. Is supposed negentropic matter mere hibernating panspermia, exhalation as precursor inhalation, a wane needed for pulsation in general?

11. "Gene gun," *Wikipedia*, last modified January 6, 2015, http://en.wikipedia.org/wiki/Gene_gun.

12. "What Is a Genegun?" section, originally from a booklet produced as part of Adam Zaretsky's installation *Genegun/Shotgun*, accessed May 2016, http://www.cmu.edu/art/news/2012/zaretsky-shotgun-genegun.pdf. In this installation, a Helios Gene Gun was first displayed in an artistic context, accompanied by the documentary *Dangerous Liaisons*. The installation appeared in the *Imagining Science* exhibition at the Art Gallery of Alberta, Canada, in 2008–9; the Festival Key of Life in Leiden, the Netherlands, in 2009; *Wunderkammer (?)* at Verbeke Foundation in Kemzeke, Belgium, in 2010; and *Alter Nature: We Can* at Z33 in Hasselt, Belgium, in 2010. The documentary can be viewed on YouTube: "Adam Zaretsky 'Dangerous Liaisons,'" YouTube video, 30:05 (part 1), 22:35 (part 2), and 29:53 (part 3), documentary from a performance in Leiden University Embryology Arts honors class at the Arts and Genomics Centre, Gorlaeus Laboratory, Leiden University, the Netherlands, camera, edit, and registration by Jeanette Groenendaal and Zoot Derks of Gnetwerk, 2007, posted by Jeanette Groenendaal

and Zoot Derks, December 7, 2011 (parts 1 and 2), and December 6, 2011 (part 3), https://www.youtube.com/watch?v=mve5b8RW6_8 (part 1), https://www.youtube.com/watch?v=WBKgimtgWuM (part 2), and https://www.youtube.com/watch?v=GgZ6o8FIeiE (part 3). For further information, see Zaretsky, "Birdland," in *Imagining Science: Art, Science, and Social Change*, edited by Sean and Timothy Caufield (Edmonton: University of Alberta Press, 2008), 15–18; and J. C. Sanford, T. M. Klein, E. D. Wolf, and N. Allen, "Delivery of Substances into Cells and Tissues Using a Particle Bombardment Process," *Particulate Science and Technology: An International Journal* 5, no. 1 (1987): 27–37.

13. FYI:

Q. Can I shoot myself with the Helios genegun?

A. The Helios Gene Gun has a trigger button that is time-activated by a safety interlock switch, but accidental or unintentional discharge is possible and the Gun should never be pointed at yourself or another person. For particles to penetrate the skin the gun would have to be within several millimeters of the skin surface.

This quote is from the *BioRad Helios Genegun Interactive User Guide*, obtained by the author as part of BioRad's marketing materials. For further information on the topic, see http://www.bio-rad.com/webroot/web/pdf/lsr/literature/10–0826_transfection_tutorial_interactive.pdf.

14. The list is from the Celestial Emporium of Benevolent Knowledge, which Jorge Luis Borges described in his essay "The Analytical Language of John Wilkins," quoted in the preface of Michel Foucault, *The Order of Things* (New York: Pantheon, 1970), xv. Please stop quoting this list as a primal heterogeneous list; it just means that you failed to read the rest of *The Order of Things*, skipped about, and then quoted a quote from the preface.

15. Joe Morgan, "OkCupid Expands Gender and Sexuality Options, Includes 'Sapiosexual,'" *Gay Star News*, November 17, 2014, http://www.gaystarnews.com/article/okcupid-expands-gender-and-sexuality-options-includes-sapiosexual171114.

16. Frederick Engels, *A Fragment of Fourier's on Trade*, in *Marx and Engels: 1844–1845*, vol. 4 of *Marx and Engels Collected Works* (London: Lawrence & Wishart, 1975), 625–26, https://muse.jhu.edu/books/9781909831148.

17. Adam Zaretsky, post on lists of Usenet porn groups, in preparation for the lecture "Why I Want to Fuck E.O. Wilson: The Sociobiology of Netporn," https://www.mail-archive.com/netporn-l@listcultures.org/msg00005.html. The lecture was presented at "The Art and Politics of Netporn" (http://networkcultures.org/netporn/), September 30–October 1, 2005, De

Badcuyp, Amsterdam, the Netherlands; as well as University of Leiden, the Netherlands; and University of Exeter, UK. The conference was curated by Katrien Jacobs, who is known for her prescient and thorough netporn scholarship. See, for example, Jacobs, *Netporn: DIY Web Culture and Sexual Politics* (Lanham, Md.: Rowman & Littlefield, 2007).

18. Timothy Morton, *Realist Magic: Objects, Ontology, Causality* (Ann Arbor, Mich.: Open Humanities Press, 2013), 20, doi:10.3998/ohp.13106496.0001.001.

19. Presently hopped up on the whole tamale of interobject style in the world of verb relations, I have forgotten that conjunctions are actually the glue of object orientations: *and, if, but, or* are the joints, the junctures, the equalizers in a world that is nouncentric.

20. These are lyrics from the song "Hair" (words by James Rado and Gerome Ragni, music by Galt MacDermot) in *Hair: The American Tribal Love-Rock Musical*, RCA Victor, 1968, LP.

21. Marta de Menezes, "Tetrahymena—Art Research Project," artist statement. *Tetrahymena* is an art research project created by Menezes and Maria Manuela Lopes of the Ectopia art research laboratory, in collaboration with Dr. Isabel Gordo of the Gulbenkian Science Institute. The piece was exhibited at the 2009 Festival Key of Life, curated by Marijke Reuvers, in Leiden, the Netherlands.

22. Ibid.

23. Boryana Rossa, "What Is a Queer Forum and Do We Need It?," *Sofia Queer Forum*, edited by Boryana Rossa and Stanimir Panayotov (Sofia, Bulgaria: Anarres, 2013), 1–13, xaspel.net.

24. Ibid.

25. Gang of Four, "Natural's Not in It," *Entertainment!*, EMI/Warner Bros., 1979, 33⅓ rpm.

26. Unless this is a sincere animistic inclusivity . . . the digital binary as part of AOL, the bumper sticker reads: "This Car Brakes for Animism."

27. Isness of the ofness, BWO meets Bosch. See "Registry of Standard Biological Parts," International Genetically Engineered Machine Foundation, accessed May 2016, http://parts.igem.org/Catalog.

28. "Registry of Standard Biological Parts," International Genetically Engineered Machine Foundation, accessed May 2016, http://parts.igem.org/Catalog.

29. Kurt Vonnegut expressed this idea in his novel *Breakfast of Champions*: "The white farmers down there weren't using machines made out of meat anymore, though, because machines made out of metal were cheaper and more reliable, and required simpler homes." *Slaughterhouse-Five / The Sirens of Titan / Player Piano / Cat's Cradle / Breakfast of Champions / Mother Night* (New York: Octopus Books, 1980), 641.

30. To this day, most bioart is boring, pared-down art and tech, like some sort of habitually protestant aesthetic, touted as DIY agitprop as a foil for a project predominantly an obvious yearning to be scientism's mutant love child.

31. This quote is from *eXistenZ*, a 1999 film written and directed by David Cronenberg.

32. "This is the question of affirmation. Can we be all accepting. This is a more systemic question, which should be looked at through a variety of magnifications: The Panspermic Cosmos, The 'Gaia at Werk' Planetary Organism, Populations/Variations/Migrations/Meshing, The Crust Operas of Vitality (Spartan/Hedonism of Being inCorporate), The Organs without a Body (Bataille's Big Toe), The Selfish life of Cells, Extremophile Microbiomic Populations, Subcellular Congeniality (hanging out on the sofas of the Endoplasmic Reticulum, alternative conformating)" (Adam Zaretsky to -empyre- soft-skinned space, September 4, 2013, "BioArt: Materials, Practices, Politics," moderated by A. J. Nocek, http://empyre.library.cornell.edu/phpBB2/viewtopic.php?t=315).

33. "The Human Animal" is one of Lydia Lunch's grittiest postindustrial, gothic confrontational poems. See Lunch, "The Human Animal," *The Birth of Tragedy Magazine's Fear, Power, God*, CFY Records CFY 004, 1989, 33⅓ rpm; "Lydia Lunch—the human animal," YouTube video, 4:32, posted by kristkrst, June 17, 2010, https://www.youtube.com/watch?v=GxMNT1NC_CM.

34. Amy Youngs, "Creating, Culling, and Caring," in *The Aesthetics of Care?*, ed. Oron Catts (Perth, Australia: SymbioticA Press, 2002), 70, http://www.tca.uwa.edu.au/publication/THE_AESTHETICS_OF_CARE.pdf. Republished in *Wild Things* (Rotterdam: V2_, Institute for the Unstable Media, 2011), http://v2.nl/archive/articles/creating-culling-and-caring.

35. DU = DOR? Are depleted uranium weapons simply a multigenerational, vengeance-based spreading of deadly orgone radiation?

36. Perhaps through an inclusive list of acronyms from this article: OOO, OOQ, OOF, OOETC, AOL, BDSM, CNS, USD, EPCOT, WTO, NGO, ACT UP, AICUC, GEN, USA, DU, DOR, IRWIN, NSK, DNA, RNA, LGBTQ, DU, DOR, BWO, DIY-IGM, VASTAL, EU, ALT, GEN, D.C., OW, p2p, t2t, GUBA, AOO, QAO, APL, GEN, ART, and ESC.CMD/CTRL.OPT.

37. Anne Fausto-Sterling, *Sexing the Body: Gender Politics and the Construction of Sexuality* (New York: Basic Books, 2000), 240.

38. Ibid., 235.

39. "Comparison of Patch Clamp Techniques: Cytocentering™ Technology—A Technological Revolution in Patch Clamping," Cytocentrics, accessed August 1, 2015, http://www.cytocentrics.com/electrophysiologyproducts/cytopatch8482;2/comparisonofpatchclamptechnologies.aspx.

Seven

Anne Pollock

Queering Endocrine Disruption

Queering endocrine disruption. What do I mean by this? For those who are familiar with the ecological alarm around endocrine disruption, it may seem to be already queer, not needing a present progressive verb from the likes of me. In addition to its association with breast, prostate, and other cancers, the major story of endocrine disruption is this: there is considerable scientific evidence that toxic chemicals that pollute our environment interfere with the endocrine systems of wildlife, contributing to an increased prevalence of animals that are sexually atypical—with lowered fertility, intersex characteristics, and pairing with animals of the same sex. I am by no means the first to point out that there is homophobia embedded in that ecological alarm. Many writers in feminist and queer ecocriticism have pointed out that discourse of endocrine disruption in both scientific and environmentalist literature has exemplified a "sex panic." Posing intersex characteristics as the sine qua non of harm to our environment is a move steeped in heteronormativity. And yet to my knowledge, no one is celebrating the queer here. In this chapter, I want to suggest that we depathologize queer animals, even when that queerness is the product of human-produced toxins in the environment, and even when it inhibits animals' reproductive capacity. Perhaps we even might find a perverse joy here.

A minor article in *Nature News*—the general interest auxiliary to the premier scientific journal *Nature*—is the jumping-off point for my contemplation.[1] The headline is "Mercury Causes Homosexuality in Male Ibises." The term *homosexuality* resonates with a (human) identity

category. Since animals of course do not check boxes on surveys, the
reference is fundamentally to observed behavior. The subhead is typi-
cal of the scientific literature on endocrine disruption: "Environmen-
tal pollutant radically changes birds' mating behaviour." The article
is concerned with the declining reproductive rate of the birds and
suggests that a rise in male pairs is a significant factor. The research
article that the *Nature News* piece is publicizing appeared in the *Pro-
ceedings of the Royal Society of London B: Biological Sciences* as "Altered
Pairing Behaviour and Reproductive Success in White Ibises Exposed
to Environmentally Relevant Concentrations of Methylmercury."[2]
The term *altered* can provide a route to the queer—not precisely an
identity, but a disruptive lens.

One could write a whole paper just deconstructing these articles'
use of the terms *heterosexual* and *homosexual* and *female-typical* and
male-typical to describe the birds in the study, since these terms are so
obviously resonant with human identity categories and gender stereo-
typing. For my focus, I am just as interested in the more modest ter-
minology of the headline: the "altered pairing behavior" is toward the
homosexual, specifically male–male. The ultimate question that the
researchers are interested in is impact on "reproductive success." Now,
this may seem fully appropriate. For biologists, reproductive success
is often understood to be the final cause of animal existence, which is
to say that the aim or purpose of the animal is to reproduce. Yet from
whose perspective is reproductive success the ultimate definition of
"success"? God's, Darwin's, ecologists', or the animals'?

From a queer feminist perspective, should we automatically decry
the flourishing of nonreproductive male pairs of birds? The *Nature
News* article features a photograph of a pair of white ibises walking
along a Florida beach, in ankle-deep water, with a gently breaking
wave just beyond them. I want to suggest that we sufficiently embrace
the temptation to anthropomorphize so that we can see that gay stroll
as having value in and of itself, and question whether reproductive
fitness is the ultimate purpose of animal existence.

The queer theorist and critical linguist Mel Chen has pointed out
the common roots of the words *toxic* and *intoxication*.[3] Chen is work-
ing at the intersection of disability studies, animal studies, and criti-
cal race theory, and compellingly argues that toxins deterritorialize by
breaking down boundaries between organisms and environments, and

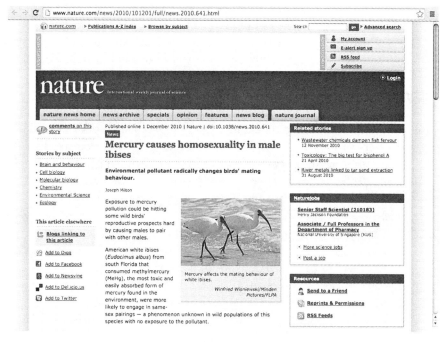

Figure 7.1. Screenshot of *Nature News* article "Mercury Causes Homosexuality in Male Ibises," featuring a photograph of a pair of ibises walking along a beach. http://www.nature.com/news/2010/101201/full/news.2010.641.html.

that queering is immanent with these animate transgressions. I want to read these birds strolling on the beach without any chicks as *intoxicated*. Yeah, maybe these birds are "fucked up" by their polluted environment. But I do not think that I am saying too much about my own experiences of intoxication, or assuming too much about that of the reader, to point out that it can be fun to be fucked up. As the cultural studies theorist Kane Race points out in his broader argument for a queer politics of drugs, "Pleasure is more or less absent from serious talk within public health, but it is a common enough motive for, and element of, human activity."[4] Being intoxicated is an ambivalent state: impaired, yes, but also released from responsibility in particular ways that can be both dangerous and pleasurable.

Sobriety, purity, health, and safety tend to travel together discursively, all on the side of the good. But sobriety should not necessarily

be considered the default natural state, much less the purest or most healthful. Of course, the assumption that health optimization should be a primary goal of human beings is a notion laden with morality.[5] In an ideological framework in which purity is located in the premodern past and is sullied by modern pollution, it is easy to forget that in many ways water is and has been much more dangerous in other times and places. During much of the history of civilization in the West, contamination of the human water supply created conditions in which mead has been safer to drink than water.[6] The contemporary presumption of an opposition between inebriation and health is not inevitable. Permanent intoxication is a reasonably common condition of human societies historically, and people may well have enjoyed that state.

A key problem of intoxication, from the perspective of disciplinary actors, is that it decreases thoughtful consideration of the consequences of today's actions for tomorrow. Endocrine disruption discourse is deeply wrapped up in the notion that these artificial chemicals in our environment are depriving natural creatures of the future, as exemplified by the domain name of the citizen-science-oriented site "ourstolenfuture.org" (itself building on the landmark 1996 book on the topic, *Our Stolen Future: Are We Threatening Fertility, Intelligence, Survival?—a Scientific Detective Story*).[7] Lee Edelman's *No Future: Queer Theory and the Death Drive* is helpful here. Edelman's provocation is compelling: "*Queerness* names the side of those *not* 'fighting for the children.'"[8] These birds may provide an opportunity to disambiguate the concept of Edelman's title, "no future," from the one in his subtitle, "the death drive." Their diminished "reproductive success" is a literalization of a lack of future-orientation, but without the presumption of any death drive for an agential subject. Edelman's calls for "embracing the negativity of the queer" can be characterized as "antisocial."[9] But although these birds' sociality is circumscribed (no intergenerational community), it is not erased (male pairing). Their stroll is neither suicidal nor solitary. These birds are living in the moment and for themselves, rather than for the children.

The joy the birds may share does not seem to be an antisocial *jouissance*. It may be more in line with a feminist joy, perhaps a sharing of joy that Audre Lorde posits as "uses of the erotic" and that Angela Willey draws on as a source for thinking through "biopossibility" of

monogamous reproductive pairing and beyond.[10] It is resonant with the queer sociality that Elizabeth A. Povinelli explores: "an obscene enjoyment" that has "no part in the social contract" yet "creates a queer sort of social bond."[11] The toxic becomes, as the art theorists Antke Engel and Renate Lorenz argue, a condition of possibility of a sociality "formed not by healthy, sane, and self-same bodies claiming wholeness, autonomy, and control, but by toxic (intoxicated/intoxicating) bodies affected by and affecting toxic assemblages and forming queer socialities."[12] Insofar as the birds are altered by methylmercury, they come into relationship with one another from a compromised position. There is no organic wholeness before or after their stroll, but there may well be joy in the communion.

The birds might be "queer survivors," in a very modest way. The feminist historian Michelle Murphy uses the term *queer survivor* to describe another animal affected by the endocrine-disrupting chemicals: the round goby.[13] This species of fish is altered by but still flourishes in the highly polluted water of the Saint Clair River that connects Lake Huron to Lake Saint Clair, near Detroit. In Murphy's account, the round goby finds good nesting sites among the garbage and has altered ratios of its multiple sexes in response to toxicity, allowing its population to thrive in that chemically altered landscape. Often decried as an "invasive species," Murphy refers to the round goby as a "queer survivor." Murphy posits "the capacity for intergenerational life" as an alternative to the heteronormative logic common in endocrine disruption discourse. But why must life be intergenerational in order to be worth living?

The emphasis on the intergenerational and on genetic continuity is an undue limitation on queer possibility. As the queer theorist Jack Halberstam has argued, "The deployment of the concept of *family,* whether in hetero or homo contexts, almost always introduces normative understandings of time and transmission."[14] In living queer lives, "we may want to forget family and forget lineage and forget tradition to start from a new place."[15] These birds' stroll can evoke the slogan, popular on magnets and T-shirts in gay bookstores among other places, of a pop art woman's face with the text "Oops, I forgot to have kids."

Indeed, these ibises' altered pairing is a chance to think about biodiversity beyond the reproductive frame. Consider this conventional definition of biodiversity, from the *Encyclopedia of Biodiversity*: "The

variety of organisms considered at all levels, from genetic variants within the same species to the whole range of species and ecosystems."[16] In this model, all diversity at the individual level is reduced to genetic diversity within a species. However, this is out of step with contemporary biology's epigenetic paradigm, in which genes need not be thought of as deterministic because their expression is necessarily contextual.[17] DNA is not the only biological substance that makes up organisms. A friend of mine in an epigenetics lab liked to use an analogy with grammar to explain how it is that knowing the letters of the genotype does not necessarily reveal the phenotypic expression in an organism: if we understand the genetic code as the letters, epigenetics might be understood as punctuation. Her go-to example was the phrase "woman without her man is nothing." With different punctuation, the same words become "Woman! Without her, man is nothing." Although this example implies a complementarity that I would not endorse, it does capture the nondeterministic quality that genes take on in context. The epigenetic turn still leaves aside the fact that existence exceeds the somatic—experience would matter even if it did not become embodied, and has its own value for the organism independent of its physical trace. But even in strictly biological terms, the lived biologies of individuals are diverse in far more ways than can be accounted for by simple genetic variance. These birds' altered bodies are also examples of bio/diversity.

Like the literature on endocrine disruption generally, these articles from *Nature News* and the *Proceedings of the Royal Society of London B: Biological Sciences* operate on the assumption that change in animal behavior and biology because of human pollutants is necessarily bad. Many feminist biologists have shared this assumption, including Lynda Birke (whose book *Feminism and the Biological Body* I deeply admire).[18] Birke is particularly worried that endocrine disrupters' effects on the reproductive capacity of animals might be applicable to humans, too. For Birke, endocrine disruption because of pollution spurs her to describe herself as "sitting on the fence" between social constructivist feminist critique and activist biologist feminist critique.[19] On the one hand, she is critical of the binary (mis)understanding of gender in the scientific and activist discourse around endocrine disruption. At the same time, she is alarmed that "there are several ways in which women's health might become compromised through exposure

to endocrine disrupting chemicals" and that "the possibility of damage to reproductive health is undoubtedly a feminist issue."[20] A feminist issue, yes, but no simple one. In this analysis, Birke implicitly defines lowered fertility as "damage to reproductive health." This is peculiar given the prominence of affordable access to oral (hormonal) contraception in contemporary political arguments that travel under the rubric of reproductive health. Feminists have lots of reasons to like exogenous hormones, including precisely for their ability to inhibit reproductivity.[21] Birke's conflation of reduced fertility and "damage to reproductive health" perhaps reflects a biology-rooted frame, in which reproduction is the goal of an organism's existence, or perhaps just a normative heterosexist frame, in which reproduction is the goal of the family. What of the actually existing women who experience their fertility as itself a burden?

Birke laments that in the literature on endocrine disruption, as usual, most of the attention has gone to the impact on men, specifically sperm count and quality. But, operating on the assumption that human couples who find it difficult to conceive will pursue assisted reproductive technology, which often involves a regimen of further exogenous hormones administered to women, Birke argues that this may expose women to still more risk: first from endocrine disrupters in our environment, and then from the exogenous hormones we take to deal with the resulting infertility. The science that Birke is describing is all speculative, but Birke is clearly worried. She writes, "It may be true that the evidence for deleterious effects is clearer for wildlife exposed to high levels of chemicals through chemical spills, than it is for human populations who are exposed normally to much lower levels. . . . Just because there is no clear evidence to date does not mean that our health is not at risk in subtle ways."[22] The conflation between lowered fertility and harm to women accurately captures many actually existing women's experiences, but it renders invisible the also existing pleasures of nonreproductive lives.

Along the same lines as Birke, the feminist environmental theorist Giovanna Di Chiro wants to critique the heteronormativity of endocrine disruption discourse while still worrying about the toxins. Writing in the collection *Queer Ecologies*, Di Chiro puts the issue this way: "What are presented by many environmentalists as critical scientific facts (and quite rightly worthy of alarm) can, however, work

to create a 'sex panic' resuscitating familiar heterosexist, queerphobic, and eugenics arguments classifying some bodies as being not normal: mistakes, perversions, or burdens."[23] Di Chiro is among many queer ecological critics who seize on Pope Benedict's egregious claim that gender constructivists are a bigger threat to nature than climate change is. I agree with them that we should question the heteronormativity of this environmental logic, *and at the same time,* I also want to suggest that we abandon this constant caveat "quite rightly worthy of alarm." The heteronormativity, and the alarm at its violation, are inseparable. For Birke and di Chiro both, any impact at all is assumed to be "harm." How do we know that the known unknowns of this intoxication are always and completely harmful? How about insofar as the intoxication also gives the birds a chance to enjoy walks on the beach?

Scientific and journalistic interest in endocrine disruption comes at the same time as increased interest in the sexual diversity of animals broadly, such that biology's purview has expanded beyond "reproductive behavior" to attend to "nonreproductive sexual behavior" that has been there all along.[24] Scientists are willing and able to see gayness in animals in a way that earlier models that equated animal sexuality with reproduction never could. Since, as Jennifer Terry points out, "animals provide models for scientists seeking to determine a biological substrate of sexual orientation,"[25] this has been seized on by those who want to say that gayness is natural. For my part, I am not interested in what is natural, only what is, and what might be.

The writer who comes closest to my perspective here is Catriona Sandilands, and I quote from her "Eco Homo" at some length:

> On the ecological side, I should note that even though some biologists are gradually accepting the liberal idea that other species might have interesting sex lives, the idea of queers as abject-toxins still lurks in environmental discourse. There is an ongoing tension, here, between an increasing naturalization of queers as "just like everyone else" and a continued heterosexist resistance to the uncertain possibilities of queer sex. Most noticeably, the mere presence of homoerotic sexual activity is enough to lead some environmentalists to cry "pollution"; if the assumption is that the health of a species is guaranteed by reproductive ability,

then the presence of homoerotic activity must signal some dys-
function, a response to some toxic exposure or another. Hence,
in the case of the lesbian seagulls, a Canadian environmental
researcher cried DDT contamination (specifically, he theorized
hormonal problems) when he observed homoerotic pairings
among female Pacific Coast gulls, even though other research-
ers had noted no toxins whatsoever in their prolifically "les-
bian" gull populations. Even more insidiously, many ecologists
assume the absolute naturalness of bodily dimorphism, even in
species that harbor a wide range of characteristics within mem-
bers of the same sex. If male organisms are starting to become
"feminized," it must be a very bad thing for nature (some envi-
ronmentalists have even been heard arguing that the greater
visibility of the human transgender community must be a result
of pollution, too).[26]

Now, in the piece as a whole, Sandilands is on the side of queer theory
and the artificial, not on the essentialist liberal side that posits that
gayness is OK because (but then somehow only if) it is inborn. I love
what she is up to here, but I am troubled that her queer reading seems
to rely on ruling out the possibility of queerness being caused by pol-
lution. Why does it matter where their queerness comes from? What
if some of the lesbian seagulls *are* intoxicated, can't they still be here,
be queer, and it is up to us to get used to it?

We might read these intoxicated birds as *trashed,* in a couple of
senses. One of the most prominent aspects of the discourse around
being trashed in campus culture, for example, is sexual vulnerability.
But *to trash* is also to criticize severely, and in that way is to dismiss.
There are radical feminist roots to this term, especially Jo Freeman's
landmark 1976 essay "Trashing: The Dark Side of Sisterhood."[27] On
one level, I am deliberately misreading Freeman's term, because it is
context-specific to the social dynamics of the feminist movement in
the 1960s and 1970s. However, her analysis provides an interesting
refraction here: "This attack is accomplished by making you feel that
your very existence is inimical to the Movement and that nothing
can change this short of ceasing to exist." If these trashed birds are
merely sentinels of environmental peril, their ceasing to exist would
be an environmentalist victory. They become the objects of a more

total version of environmentalist eradication fantasies toward so-called alien species, because the altered birds do not even have an elsewhere in which their presence might be appropriate.[28] These birds are stigmatized for being trashed, and they are talked about as if they are the embodiment of trash. In that kind of logic, the queers produced by toxic waste themselves become disposable.

In his critique of queer ecology generally, Greg Garrard quotes from the same section of Sandilands's writing that I have, and disagrees: "Sandilands clearly wants the reader to reject ecologists' stigmatization of intersexed or 'feminized' bodies, even though endocrine disruption actually *is* 'a very bad thing' whomever it happens to."[29] Sandilands seems more resistant to the biological research on endocrine disruption than I am, but I share her aversion to seeing queerness as pathology. But what evidence do we have for Garrard's apparently realist claim? If the impact of endocrine disruption is, for example, same-sex pairing, surely that is not "a very bad thing" to whomever it happens to, is it? Sandilands wants to reject the connection between birds' queerness and any pollutants, but I want to ask a question that is prior: there is an inherent conservatism in ecology, insofar as it wants things to stay the same or better yet go back to a previous state. I want to ask: if the birds are affected by endocrine disruption in this way, does that necessarily mean that they are harmed?

I do recognize a profound challenge to the kind of playful and speculative engagement that I have been exploring in this chapter: the embeddedness of these toxins and their reproductive impacts in oppressive systems of capitalism and structural racism. If we take antiracist and anticolonial critique seriously, blurring the boundaries between animal reproductive harm and human reproductive harm can point toward a danger in embracing the queer products of our toxic environment. The reproductive harm to indigenous peoples who live in areas highly affected by chemical industries, and who rely on the water and especially the fish there, has been an important aspect of activism for stronger regulation of these chemicals. The framing of endocrine disruptors as examples of environmental racism is powerful. As the feminist and environmental legal scholar Dayna Nadine Scott points out, "The theory of endocrine disruption in the context of a First Nation encounters a history that has, at various times, refused racialised

groups the capacity for children."[30] To the extent that actually existing indigenous women want to mobilize against endocrine-disrupting chemicals in their water supplies as part of a broader movement for self-determination, that is worthy of respect. It highlights the fundamental role that structural inequality plays in constituting embodied experiences of injustice.[31] Although the feminist analyst of hormones Celia Roberts does not foreground indigenous people's concerns, her intervention is relevant here: endocrine-disrupting chemicals "concern financial *and* sexual economies," and we must not lose track of the question *cui bono?*—or more starkly, "who lives and who dies?"[32] Feminist analysis has to do more than just let capitalism off the hook.

Yet even bringing discussion of indigenous peoples together with discussion of wildlife makes me uneasy. The tropes of the purity and vulnerability of close-to-nature indigenous bodies have their own problematic colonial histories, which contribute to, rather than diminish, the political power of the critique on those terms. Arguments for protecting the procreative mother have a complicated relationship with colonialism and postcolonialism. Gayatri Spivak's conceptualization of reproductive heteronormativity (RHN) can help see how. As Spivak points out: "RHN is the biggest, oldest global institution. Tacit globalization, millennia before the silicon chip. It's all over the world, whether capitalist or anti-capitalist. It's before capitalism. It's before anti-imperialism. The imperialist and anti-imperialist alike are tied in, folded up with RHN."[33] The imperative to "carry on the race" is also a colonial narrative, with its own set of erasures.

The anxieties about the impact of toxins on pregnant indigenous women is resonant with anxieties about pregnant intoxication. It is of a piece with broader colonialist frames in which settler colonialism's danger to indigenous communities is conceptualized as residing within indigenous bodies: specious "virgin soil" theories of vulnerability to infectious disease that give genetic notions of causation primacy over displacement in explanations of population collapse;[34] and in alcoholism as a catch-all for contemporary native pathology that rests on highly problematic notions of native difference.[35] I am troubled by the ways that indigenous women's concerns are often rather cynically used as a hook for (white) advocacy around endocrine disruption. For example, Nancy Langston's book *Toxic Bodies* has a cover that features

a pregnant belly against a black background, as if in outer space. It opens with an anecdote from an environmental justice field trip to the Shoalwater nation in Washington State: "losing their tiny reservation to erosion and legal battles, and they were losing their future to a mysterious run of miscarriages."[36] The rest of the book drops any reference to indigenous women. This narratively positions the struggle over land as secondary to the struggle over toxins. Endocrine-disrupting chemicals are more sensational than land treaties, but we should be suspicious of their visceral appeal. Native American women are articulated as vulnerable stewards of the Earth, a pristine people (ideally) outside history. Their environmental struggle is subsumed into an argument for the precautionary principle. Plucking out the impact of endocrine disruptors on indigenous women for concern, while leaving behind broader resistance to settler colonialism, is highly problematic. These toxins are not, in and of themselves, *the* fundamental threat to indigenous communities. As in mainstream "pro-life" discourse, the unborn carry a troubling primacy over the already here. Women appear in these arguments as vessels for the next generation, rather than as people who matter to themselves and their present communities. It is all about the ability to reproduce, not the ability to live.

Queers have long been understood to be symptomatic of liberal capitalism, exemplars of bourgeois and/or Western decadence from diverse quarters—by New Left ideologues and more recently by contemporary leaders of non-Western countries.[37] But there is also a tradition in progressive queer theory that wants to locate lesbian and gay existence in history rather than in essentialism. For example, John D'Emilio's classic essay "Capitalism and Gay Identity" argues that gays and lesbians have *not* always existed, but that the identity categories have emerged in the context of the ascendance of the free labor system over the household labor system, and, as such, the separation of sexuality from reproduction.[38] Once individuals did not need to join a normative household in order to have the means to survive, they could explore a wider range of social and economic arrangements, and had more room for putting queer sexuality at the center of identity and day-to-day life. D'Emilio is well aware of the exploitation that underlies the freedom of labor under capitalism, but going back in time to

a preindustrial household model is neither a practicable nor desirable solution. Queers should have the freedom to set up our households as we please not because we have always existed but because we want the space to exist now. If products of capitalism (in the form of industrial pollution) are producing these queer birds, this provides an evocative material analogue for D'Emilio's political economic case.

Endocrine disrupters are an excellent case to illustrate that sex is simultaneously material-semiotic and the product of history.[39] These birds may have become cyborg in Haraway's sense: "The cyborg does not dream of community on the model of the organic family."[40] Of course, their existence is by no means innocent. Like cyborgs generally, "they are the illegitimate offspring of militarism and patriarchal capitalism."[41] But our appreciation of queer animals—including queer humans—should not depend on their being outside industrialization.

Timothy Morton has compellingly argued that we should not put nature on a pedestal and admire it from afar.[42] The desire for a pristine virgin nature is not the lack-of-desire it claims to be.[43] It is deeply ideological and chooses what gets to count as natural. Like Sandilands, Morton convincingly argues that queerness is in biological substance, not just culture. Morton does not mention cases in which animals' queerness might be the result of pollution, but he does suggest that queer theory is a friend to nonessentialist biology, and I agree.[44] If we take seriously Morton's argument that queer ecology must embrace silicon as well as carbon, then surely these birds are rightly part of a queer ecology, however they came upon their perversions. Insofar as their queerness may have artificial roots, that should not itself be seen as a threat.

These male pairs of ibises are getting on with things in the face of a hostile environment, and I raise my glass to them.

Notes

An early version of this chapter was presented at the "Object-Oriented Feminism" panel at the 2013 conference of the Society for Literature, Science, and the Arts, and the discussion there was extraordinarily helpful. I thank those who provided feedback on written iterations of this work: Katherine Behar, Melinda Cooper, Maital Dar, Nassim JafariNaimi, Mary McDonald, and Jennifer Singh.

196 ANNE POLLOCK

1. Joseph Milton, "Mercury Causes Homosexuality in Male Ibises: Environmental Pollutant Radically Changes Birds' Mating Behaviour," *Nature News*, December 2010, doi:10.1038/news.2010.641.

2. Peter Frederick and Nilmini Jayasena, "Altered Pairing Behaviour and Reproductive Success in White Ibises Exposed to Environmentally Relevant Concentrations of Methylmercury," *Proceedings of the Royal Society of London B: Biological Sciences* 278, no. 1713 (2011): 1851–57.

3. Mel Y. Chen, *Animacies: Biopolitics, Racial Mattering, and Queer Affect* (Durham, N.C.: Duke University Press, 2012).

4. Kane Race, *Pleasure Consuming Medicine: The Queer Politics of Drugs* (Durham, N.C.: Duke University Press, 2009), ix.

5. Jonathan M. Metzl and Anna Kirkland, eds., *Against Health: How Health Became the New Morality* (New York: New York University Press, 2010). The notion of water as a health beverage is historically specific: Kane Race, "'Frequent Sipping': Bottled Water, the Will to Health and the Subject of Hydration," *Body & Society* 18, nos. 3–4 (2012): 72–98.

6. Bert L. Valee, "Alcohol in the Western World," *Scientific American* 278, no. 6 (1998): 80–85.

7. Theo Colburn, Dianne Dumanoski, and John Peterson Myers, *Our Stolen Future: Are We Threatening Fertility, Intelligence, Survival?—a Scientific Detective Story* (New York: Plume, 1996).

8. Lee Edelman, *No Future: Queer Theory and the Death Drive* (Durham, N.C.: Duke University Press, 2004), 3. Edelman is building on an argument by Leo Bersani: in his landmark essay "Is the Rectum a Grave?," Bersani argues that same-sex desire (and the desire to be penetrated broadly) can be "anticommunal, antiegalitarian, antinurturing, antiloving." For Bersani, AIDS is a literalization of the death of the subject that is phantasmically enacted in the passive role in sex ("Is the Rectum a Grave?," *October* 43 [Winter 1987]: 197–222). The pleasures of *being fucked up* are intertwined with the pleasures of *getting fucked.*

9. See discussion in Lynne Huffer, *Are the Lips a Grave? A Queer Feminist on the Ethics of Sex* (New York: Columbia University Press, 2013), 17.

10. Audre Lorde, "Uses of the Erotic: The Erotic as Power," in *Sister Outsider: Essays and Speeches* (Trumansburg, N.Y.: Crossing Press, 1984), 53–59; Angela Willey, "Biopossibility: A Queer Feminist Materialist Science Studies Manifesto, with Special Reference to the Question of Monogamous Behavior," *Signs: Journal of Women in Culture and Society* 41, no. 3 (2016): 553–77.

11. Elizabeth A. Povinelli, "The Part That Has No Part: Enjoyment, Law, and Loss," *GLQ: A Journal of Lesbian and Gay Studies* 17, nos. 2–3 (2011): 289.

12. Antke Engel and Renate Lorenz, "Toxic Assemblages, Queer Socialities: A Dialogue of Mutual Poisoning," *e-flux* 44 (April 2013), http://www.e-flux.com/journal/toxic-assemblages-queer-socialities-a-dialogue-of-mutual-poisoning/.

13. Michelle Murphy, "Distributed Reproduction, Chemical Violence, and Latency," *The Scholar and the Feminist Online* 11, no. 3 (2013), http://sfonline.barnard.edu/life-un-ltd-feminism-bioscience-race/distributed-reproduction-chemical-violence-and-latency/0/.

14. Judith Halberstam, *The Queer Art of Failure* (Durham, N.C.: Duke University Press, 2011), 71.

15. Ibid., 70.

16. Robert Barbault, "Loss of Biodiversity, An Overview," in *Encyclopedia of Biodiversity: Volume 3*, edited by Simon A. Levin (San Diego: Academic Press, 2001), 761.

17. See Margaret Lock, "The Eclipse of the Gene and the Return of Divination," *Current Anthropology* 46 (December 2005): S47–S70.

18. Lynda Birke, *Feminism and the Biological Body* (Edinburgh: Edinburgh University Press, 1999).

19. Lynda Birke, "Sitting on the Fence: Biology, Feminism, and Gender-Bending Environments," *Women's Studies International Forum* 23, no. 5 (2000): 587–99.

20. Ibid., 594.

21. Another reason that access to exogenous hormones is a feminist issue is their capacity to help transgender people and others embody desired gender expression. Challenges that trans folks face in accessing exogenous hormones that are costly controlled substances also helps underscore how problematic it is to frame exogenous hormones as an intervention on an otherwise natural and authentic body: see Julian Gill-Peterson, "The Technical Capacities of the Body: Assembling Race, Technology, and Transgender," *TSQ: Transgender Studies Quarterly* 1, no. 3 (2014): 402–18.

22. Birke, "Sitting on the Fence," 596.

23. Giovanna Di Chiro, "Polluted Politics? Confronting Toxic Discourse, Sex Panic, and Eco-Normativity," in *Queer Ecologies: Sex, Nature, Politics, Desire*, edited by Bruce Erickson and Catriona Mortimer-Sandilands (Bloomington: Indiana University Press, 2010), 202.

24. Jennifer Terry, "'Unnatural Acts' in Nature: The Scientific Fascination with Queer Animals," *GLQ: A Journal of Lesbian and Gay Studies* 6, no. 2 (2000): 154.

25. Ibid., 152.

26. Catriona Sandilands, "Eco Homo: Queering the Ecological Body Politic," *Social Philosophy Today* 19 (2003): 27.

27. Joreen [Jo Freeman], "Trashing: The Dark Side of Sisterhood," *Ms.*, April 1976, 49–51, 92–98, http://www.jofreeman.com/joreen/trashing.htm.

28. For a critique of the problematic discourse around "alien species," see Banu Subramaniam, "The Aliens Have Landed! Reflections on the Rhetoric of Biological Invasions," *Meridians* 2, no. 1 (2001): 26–40.

29. Greg Garrard, "How Queer Is Green?," *Configurations* 18, nos. 1–2 (2010): 92.

30. Dayna Nadine Scott, "'Gender-benders': Sex and Law in the Constitution of Polluted Bodies," *Feminist Legal Studies* 17 (2009): 252.

31. Ways in which structural racism becomes embodied is something I have explored a great deal in previous work with regard to black–white health disparities, especially *Medicating Race: Heart Disease and Durable Preoccupations with Difference* (Durham, N.C.: Duke University Press, 2012), and "On the Suspended Sentences of the Scott Sisters: Mass Incarceration, Kidney Donation, and the Biopolitics of Race in the United States," *Science, Technology & Human Values* 40, no. 2 (2015): 250–71.

32. Celia Roberts, "Drowning in a Sea of Estrogens: Sex Hormones, Sexual Reproduction, and Sex," *Sexualities* 6, no. 2 (2003): 207–8.

33. Gayatri Spivak, quoted in *Planetary Loves: Spivak, Postcoloniality, and Theology*, edited by Stephen D. Moore and Mayra Rivera (Bronx, N.Y.: Fordham University Press, 2011), 60.

34. See David S. Jones, "Virgin Soils Revisited," *William and Mary Quarterly* 60, no. 4 (2003): 703–42.

35. See James Waldram, "The Alcoholic Indian," in *Revenge of the Windigo: The Construction of Mind and Mental Health of North American Aboriginal Peoples* (Toronto: University of Toronto Press, 2004), 134–66.

36. Nancy Langston, *Toxic Bodies: Hormone Disruptors and the Legacy of DES* (New Haven, Conn.: Yale University Press, 2011), 1.

37. For a New Left example, see Revolutionary Union, "Position Paper of the Revolutionary Union on Homosexuality and Gay Liberation," reprinted in *Toward a Scientific Analysis of the Gay Question* (Los Angeles: Los Angeles Research Group, 1975), https://www.marxists.org/history/erol/ncm-3/gay-question/ru.htm. For a contemporary non-Western example, see Yoweri Kaguta Musevini, "President Museveni's Statement upon Signing the Anti-homosexuality Bill," February 24, 2014, http://www.statehouse.go.ug/media/presidential-statements/2014/02/24/president-musevenis-statement-upon-signing-anti-homosexuali.

38. John D'Emilio, "Capitalism and Gay Identity," in *The Lesbian and Gay Studies Reader*, edited by Henry Abelove, Michele Aina Barale, and David M. Halperin (New York: Routledge, 1993), 467–76.

39. In this sense, endocrine disruptors are continuous with hormonal phenomena more broadly: see Celia Roberts, *Messengers of Sex: Hormones, Biomedicine, and Feminism* (Cambridge: Cambridge University Press, 2007).

40. Donna Haraway, "The Cyborg Manifesto: Science, Technology, and Socialist-Feminism in the Late Twentieth Century," in *Simians, Cyborgs, and Women: The Reinvention of Nature* (New York: Routledge, 1991), 151.

41. Ibid.

42. Timothy Morton, "Queer Ecology," *PMLA* 125, no. 2 (2010): 273–82.

43. Ibid., 279.

44. Ibid., 275.

Eight

Marina Gržinić

Political Feminist Positioning in Neoliberal Global Capitalism

A Schematic Political Genealogy from Cyborg to the Posthuman via New Materialism

It is time to reevaluate the position of the human, which is increasingly becoming a central term of many concerns within global neoliberal capitalism. At the moment, many claim to speak and act in the name of "humanity," in order to save humanity and supposedly rescue thousands from their inhuman conditions. However, it is safe to say that to accomplish this, many seemingly "inhuman" individuals have to die. The human as a term is central to feminism and its socialist aspirations, as well as to the technological revolutions provided by new media technology, computer devices, and the enhanced development of science and technology that are sped up via the computer and cybernetic developments. In this chapter, I try to outline a condensed history and present state of these shifts and changes.

Alana Brooks Smith, in her attempt to reevaluate Donna Haraway's text "A Cyborg Manifesto: Science, Technology, and Socialist-Feminism in the Late Twentieth Century," published in 1985 in *Socialist Review* (and then, as Brooks Smith puts it, concisely reprinted as a chapter in Haraway's *Simians, Cyborgs, and Women* in 1991),[1] says, "At first it may seem abstract to think of a person—if the cyborg is meant to be the model for a new, posthuman kind of person—who is at once organic and mechanical, artificial and natural, real and fictional. When the boundaries between the 'natural' and 'artificial' parts

of what makes us human are blurred, it becomes much harder to take 'nature' for granted, and a whole array of assumptions get undermined."[2] For Haraway, the "cyborg is a cybernetic organism, a hybrid of machine and organism, a creature of social reality as well as a creature of fiction. Social reality is lived social relations, our most important political construction, and a world-changing fiction."[3] As summarized by Brooks Smith, for Haraway, the cyborg is a "political myth" meant to inspire and guide socialist–feminist theory and practice in a postmodern era that is radically influenced by the "social relations of science and technology."[4]

Brooks Smith accurately states that Haraway is not against technology and that she tries to propose a possibility for the future based on the appropriation of cyber technologies. Brooks Smith emphasizes that Haraway believes that "human beings, like any other component or subsystem, must be localized in a system architecture whose basic modes of operation are probabilistic, statistical," and "no objects, spaces or bodies are sacred in themselves; any component can be interfaced with any other if the proper standard, the proper code, can be constructed for processing signals in common language."[5] This view of the human is consistent both with movement inside the political feminist, though white feminist, genealogical development, and with the multicultural transformations of capitalism in the 1990s—when we witnessed the disintegration of stiff borders in capitalism, the fall of the Berlin Wall in 1989 that had divided Eastern and Western Europe, and the change of Fordist relations of capital and labor into post-Fordist, neoliberal capitalist ones. These contexts each tried to shift, as Haraway proposed, "from an obsolescent 1960's-style identity-centered politics in[to] an order to embrace multiplicity."[6]

As previously emphasized by Brooks Smith, when Haraway was speaking in 1985 about the informatics of domination that is an aggregation of neo-imperialism, population control, and communications engineering, she discussed the social relations of science and technology and proposed using technology in "creative and political ways."[7]

Further drawing schematically, but not any less politically, on the history of the (post)socialist trans/feminism context and the changes that it proposes in relations between capitalism, capital, labor, and technology, I can suggest several different paths about what follows after Haraway in the conjuncture between the human(ity)/humanization/

posthuman(ities). While rereading Lucian Gomoll's text "Posthuman Performance: A Feminist Intervention," I envisioned at least three lines of development.[8]

The first is the one outlined in 1999 by N. Katherine Hayles in her pioneering work *How We Became Posthuman: Virtual Bodies in Cybernetics, Literature, and Informatics.*[9] Gomoll states that "for Hayles and other writers in the 1990s, the posthuman's ontology included a dispersal of information and consciousness through cybernetics in addition to an expanded notion of embodiment."[10]

The second line brought to light in Gomoll's text from 2011 comprises "discourses in posthumanities (that) contribute to the de-centering of classical notions of the human, offering a renewed emphasis on the relational or coevolutionary. While the terms *posthuman* and *posthumanities* might at first seem harmoniously related, their discursive histories are divergent and sometimes frictional. Scholars in the posthumanities are actively trying to distinguish themselves from conceptualizations of the posthuman by emphasizing a critique of liberal humanism and an engagement with animal studies."[11]

In this respect, Gomoll quotes at least two authors. Haraway, as Gomoll shows, is skeptical when it comes to the term *posthuman*. This is expressed by Haraway in her 2006 interview "When We Have Never Been Human: What Is to Be Done?,"[12] and another author relevant to the topic is mentioned, Rosi Braidotti. Her text, with the telling title "Posthuman, All Too Human: Towards a New Process Ontology,"[13] was also published in 2006, in the same issue of *Theory, Culture & Society* as Haraway's interview.

Gomoll states that closer inspection reveals that Hayles's discourse on the posthuman also centers on the critique of liberal humanism. As Hayles clarifies, "My reference point for the human is the tradition of liberal humanism; the posthuman appears when computation rather than possessive individualism is taken as the ground of being, a move that allows the posthuman to be seamlessly articulated with intelligent machines."[14] So in different ways, both of them expose a distance toward liberal humanism, or rather a specific way to understand it that I evaluate in the present chapter.

The third line is the one that Joshua Labare outlined in his review of Cary Wolfe's *What Is Posthumanism?*, published in 2009 as part of the University of Minnesota Press's Posthumanities series.[15]

Labare, as Gomoll summarizes, "critiques Wolfe's framework, calling his book humanist-posthumanism, and recognizes that it is 'a grave oversight on Wolfe's part to ignore the ways that feminist theory, critical race theory, and queer theory have already unsettled and reconfigured the subject. Indeed, these fields and the field of science studies constitute the condition of possibility for animal studies, as much as if not more than poststructuralism and deconstruction do.'"[16] We should take into account Gomoll's statement that there exists:

> [a] desire amongst posthumanists to disidentify with the post-
> human, and taking to heart Labare's critique, I propose that we
> knot the posthuman to other modes of unsettling the subject,
> such as feminist and postcolonial theories, as well as respectfully
> calling upon those individuals who have been framed as Others
> to the human during earlier eras (including so-called freaks and
> hybrids).[17]

Besides these divisions that will increasingly haunt the whole terrain of research, there is a so-called division of the unsuitability of constructivism/post-structuralism/postmodernism positions (that I fully endorse) versus science, biotechnology, and so forth, in transcending different dualisms; at present we also see a vast landscape of post-, anti-, and metahumanisms with or versus speciesism and against the "human" operating in front of us.

Under those circumstances, as conceptualized in 2014 by Francesca Ferrando in "Posthumanism, Transhumanism, Antihumanism, Metahumanism, and New Materialisms: Differences and Relations," the posthuman "has become an umbrella term to refer to a variety of different movements and schools of thought, including philosophical, cultural, and critical posthumanism; transhumanism (in its variations of extropianism, liberal and democratic transhumanism, among others); the feminist approach of new materialisms; the heterogeneous landscape of antihumanism, metahumanism, metahumanities, and posthumanities."[18] Therefore, while opening these lines of thought and research, and exposing the broadened and meticulously shaped differentiations that are in front of us, but at the same time not being too descriptive or apologetic, I ask here, following in the vein of differentiation within the post/human / post/humanities, what should we do with the human and its class, race, and gender lines of division?

Moreover, as stated by Ferrando in reference to bell hooks, "as posthumanism attracts more attention and becomes mainstream, new challenges arise. For example, some thinkers are currently attempting to embrace the 'exotic' differences, such as the robot, the biotechnological chimeras, the alien, without having to deal with the differences embedded within the human realm, thus avoiding the studies developed at the human 'margins,' such as feminism or critical race studies."[19]

Ferrando states that "new materialisms is another specific movement within the posthumanist theoretical scenario" (30), acknowledging that the term was coined independently by Braidotti and Manuel De Landa in the midnineties. In brief, new materialism presents a set of theoretical approaches that at the moment comes after what is called the post-structuralist linguistic turn or cultural turn (developed in the last decades under the spell of the fluidity of language). By using what is said to be affirmation over criticism, new materialism tries to give a new perspective on signification and methodologies of knowledge and history. It is specifically orientated toward things in the world and what we know about them. It is an orientation in which ontology and epistemology are not divided but instead interact with each other; therefore, just like language in the post-structuralist view, materiality is also becoming fluid in the new materialist view—changed, reshaped, and remodeled.

Analyzing the introduction to Diana Coole and Samantha Frost's 2010 edited volume *New Materialisms: Ontology, Agency, and Politics,* Ferrando argues that the authors "re-inscribe matter as a process of materialization, in the feminist critical debate."[20] She emphasizes that

> new materialisms philosophically arose as a reaction to the representationalist and constructivist radicalizations of late postmodernity, which somehow lost track of the material realm. . . . Even though the roots of new materialisms can be traced in postmodernism, new materialisms point out that the postmodern rejection of the dualism nature/culture resulted in a clear preference for its nurtural aspects. Such a preference produced a multiplication of genealogical accounts investigating the constructivist implications of any natural presumptions, in what can be seen as a wave of radical constructivist feminist literature

related to the major influence of Judith Butler's groundbreaking works. This literature exhibited an unbalanced result: if culture did not need to be bracketed, most certainly nature did. In an ironic tone, Karen Barad, one of the main theorists of new materialisms, implicitly referring to Butler's book *Bodies that Matter,* has stated: "Language matters. Discourse matters. Culture matters. There is an important sense in which the only thing that does not seem to matter anymore is matter."[21]

Ferrando also notes that for Coole and Frost "the renewed critical materialisms are not synonymous with a revival of Marxism."[22] Therefore, by using a decolonial vocabulary, we have to ask what is "the darker side" of "new materialism"?[23] The answer can be found via Kimberly DeFazio, who in "The Spectral Ontology and Miraculous Materialism,"[24] published in 2014 on the online platform *The Red Critique,* formulates a detailed critique of selected contributions published in *New Materialisms: Ontology, Agency, and Politics.* Within DeFazio's larger study, an important part is given to Coole and Frost in their introduction to *New Materialism.* This forms another path that I follow in my analysis.

Coole and Frost implore, "How could we ignore the power of matter and the ways it materializes in our ordinary experiences or fail to acknowledge the primacy of matter in our theories."[25] They claim that "the radicalism of the dominant discourses which have flourished under the cultural turn is now more or less exhausted." Therefore, they "insist that the time has come for the return to materialism and the world of matter" (3). Furthermore, they suggest using diverse developments in digital technology, the natural sciences, biotechnology, the environment, the economy, and health. Coole and Frost propose returning to the "materialist traditions developed prior to modernity" and avoiding the worldly determination of reality in order to find "fresh applications" of spiritualism (4). For the new materialists, the problem with the "cultural turn" is in part the "constructivist orientation" of its theory (4), which treats matter as a social construction with no existence or agency independent of humans. "Constructivist" accounts of matter, as argued by the new materialist theorists, and as emphasized by DeFazio, are no longer capable of addressing new realities like global climate change, ecological crisis, and growing economic disparities worldwide, not to mention the fact that

because of the new technologies and new scientific discoveries, Coole and Frost write, "unprecedented things are currently being done with and to matter, nature, life, production, and reproduction" through, for instance, biogenetics (4). Proponents of the new materialism, as pointed out by DeFazio, express frustration with what Coole and Frost refer to as the "allergy to 'the real'" of earlier textual approaches that had the effect of discouraging "critical inquirers from the more empirical investigation that material processes and structures require" (6). They suggest that it is now necessary to address how the material world—the world of not just objects, nature, and the human body but also such phenomena as "the electricity grid, food, and trash" (9)—has an "agency" that has hitherto not been accounted for. In fact, Coole and Frost, as argued by DeFazio, joyfully affirm the new materialism because its "post-dualism" means that there can be "no definitive break between . . . material and spiritual phenomena" (10).

I concur with DeFazio that new materialism uncovers the questions at the center of our interest, concerning the role of the human, posthuman, and the materiality of agency in neoliberal global capitalism (NGC). Coole and Frost expand the question of the agency that is independent of the human, where the world is not just made of objects and human bodies, but they see agency in electricity and trash too, and they also expose an allergy to the real. All these points are essential for rethinking new materialism from an emancipatory postsocialist feminist political point of intervention.

DeFazio is bravely detailed in her critical points and the reevaluation of how the new materialism operates at the present:

> Materialism in the "new materialism" is largely a physicalist notion of matter (an experientialism which it justifies by allying itself with the discourses of natural science and phenomenology) and which is ideologically valuable precisely because it is "a materialism which excludes the historical process" (Marx Capital Vol. 1 494). It is a form of materialism that cannot explain the material world as a dialectical process whose motion can be positively and reliably understood. At the same time, the new post-historical materialism is elaborated through a ("new") posthumanist ontological framework that seems to offer an understanding of the social as a totality, emphasizing interlocking "webs" of connections between the social and natural world, and

the "vital" corporeal "embeddedness" of the human in the non-human. Of course, such allusions to totality have a great appeal at a time when the global interconnections of social and natural life can no longer be avoided and when people struggle to understand the conditions to which their lives are ruthlessly being subjected. However, what is being offered by posthumanist ontology is in fact a theory which is preventing class understanding of issues in their material totality. It is a theory of "ecology" that removes the social out of the world, reducing it to physical and biological dynamics of local systems. Embeddedness and corporeality are ideological terms—their role is to limit knowledge to local knowledge and, especially, to the knowledge of experience. They are code words for anti-totality. It is not surprising, then, that the affirmation of individual experience and rejection of objectivity leads the new materialists to embrace spiritualism, the framework of which is rooted in one's individual beliefs and feelings. In other words, posthumanist ontology turns out to be a very familiar spectral ontology—an idealism. Under the guise of a militant anti-theological return to the material world (which is needed in order to distinguish the new materialism from the Right's crude defense of theocracy), the new materialists as in the view of Coole and Frost (Coole and Frost, 4) advocate a subtle "new" reading of the (spiritual) "life" of matter.[26]

Therefore, returning to the line of division along the unsuitability of constructivism/post-structuralism/postmodernism in new materialism, DeFazio argues that "new materialism, consequently, is not a rejection but an update of the culturalism that has played an integral role in dismantling the materialist critique of capitalism in the postwar "era ... [where] the relation between subject and object reflects a deep confusion about, if not a deliberate rewriting of, some of the 'fundamental questions' of materialism, and thus have profoundly problematic implications for materialism and the struggle for a world organized on the basis of meeting social needs."[27]

With this in mind, I would like to emphasize two main points that are crucial for the understanding of what new materialism actually does. First, in one way or another, it repudiates the human. This

connects new materialism to the critique of posthumanism recounted above with reference to Gomoll and Ferrando. Second, again, in one way or another, it repudiates history, practices, and ideas in order to isolate ideas and practices from the material relations of history. As DeFazio states, new materialism does this by highlighting "the cellular, molecular, subatomic, and cosmic levels" of matter.[28]

New materialism emphasizes, at any rate, the lack of capacities of "the human" to perform any consistent politics and, somehow, the impossibility of the human to be capable of political agency based on history. Furthermore, I argue that this repudiation of the human, and of its political capacities and agencies, is in fact supporting (paradoxically, it must be said) precisely what is at the core of the present-day NGC agenda. This agenda consists of introducing a systematic process of specific humanization into the "boring" reality: the logic of the humanization of capital.

To be even more precise, my thesis is not that new materialism is responsible for the humanization of capital (I am not interested in any crusade against new materialism, as the advent of the posthuman/ities is rapidly proliferating and, as we can see, impossible to stop anyway), but it is precisely the opposite at work here—the logic of the humanization of capital, on one side, and an almost completely derogatory perception of history, on the other, are needed in order for the new (mostly white feminist) posthumanist materialism to proceed undisturbed.

While the theoretical and philosophical Western thought proclaims to be too fatigued to address humans and their political agency and history, capital develops its "humanity" through brutal and systematic exploitation, as well as the reorganization of power and institutional structures and a systematic depoliticization of the social, political, and economic structures. To understand what the humanization of capital entails, it is important to draw attention to an example from January 2010, namely, the U.S. Supreme Court decision in *Citizens United v. Federal Election Commission*, a case that grants corporations the same rights as individuals to spend money on advertisements supporting or opposing candidates for political office. The Supreme Court's 5–4 vote in this case decided that campaign spending is protected under the First Amendment, meaning that corporations and unions could spend unlimited amounts of money on political activities,

as long as it was done independently of a party or candidate. The result has been an outpouring of cash into so-called super PACs—political action committees or particularly single-candidate PACs—which are only nominally independent from the candidates they support. The result of such a decision is that, on one side, corporation funds, known as "dark money," never have to be publicly disclosed and, on the other, that granting corporations the same rights as individuals to spend money on political advertisements brings about the scary reality of "the humanization of the corporate entity." The deadly outcome of both processes is not yet fully acknowledged.

The Human, Humanization, and Neoliberal Global Capitalism

In 2014 I coauthored the book *Necropolitics, Racialization, and Global Capitalism: Historicization of Biopolitics and Forensics of Politics, Art, and Life*,[29] with Šefik Tatlić, which represents the culmination of years of discussions that developed into our mutual conclusions combined with specific authorial insights. The book is structured in such a way that in the first part it conceptualizes possible new relations between capitalism, racialization, and necropolitics, established by me into and from decolonial, post-Marxist, transfeminist, and black thought contexts. This was then a ground for Tatlić's elaborations in the book. Therefore, as this chapter comes after the book, following a dialectical line, it is time for me to elaborate on Tatlić's work. Tatlić has developed my analysis of neoliberal global capitalism into a dual scenario of relations of exploitation and dispossession: (1) the logic of the humanization of capital; and (2) the flexibilization of power relations between the oppressor and the oppressed.

At the present moment, NGC offers a paradoxical process of humanization, and it is the logic of the humanization of capital itself. It could be said that this logic is at the core of NGC; it allows, simply put, for the posthuman to thrive in the situation when the NGC is pervaded by the logic of the humanization of capital. Consequently, all those differentiations that were based on class, race, and sex are also taken back. In other words, the question of differences is minimalized and, even more interesting, the perspectives opened by new media technology and the ideas based on such perspectives present

the world as being "caught" in a process of an infinite (dystopian and "sexy") future that renders all the perceptions of history as more or less irrelevant. Because of new media technology (computerization and virtualization of the world that brought about a possibility for research in biotechnology, brain sciences, physics, and technology at large), the human is becoming an obsolete matter, its perception reduced, along with its possibility of cognition and understanding.

The second process, which works hand in hand with this logic of the humanization of capital, is the obsolete position of history in NGC, as a result of the flexibilization of power relations between the oppressor and the oppressed in the system of exploitation that serves the capitalist relations of re/production. The outcome of this process is that questions of agency as political subjectivization and intervention have (almost) vanished. History is seen as redundant, to such an extent that is possible to state that NGC is an overhistorical mode of re/production that behaves as being outside history. But in which way? This relation to the "end of history" is, in fact, not about the *closure of history* but, as argued by Tatlić, about the disconnection of the political processes, and therefore of political agencies, from the registry of historical events, and when this happens, it gives rise to the erasure of the political process itself.

However, let us proceed step-by-step.

The logic currently central to NGC is that of the humanization of capital, which presents a specific form of the rationalization of capitalism—a system of relations of production based solely on brutal exploitation. Each power/economic structure, undeniably including capitalism, needs to use and implement power to facilitate its brutal relations of exploitation while hiding its means of exploitation. It does so by exposing that in the last instance the system tries to provide the best human relations possible and, at all times, insists on humanist premises. However, under the logic of the humanization of capital in neoliberal global capitalism, the emphasis is not on the humanization of capitalism but on the logic of the humanization of capital itself. This is because, as stated by Tatlić, even though each power structure organizes the principles of the relationship between power and society in supposedly the most humane form of implementation of the society's "basic" interests, in capitalism these relations take the form of a direct hierarchy of exploitation. Consequently, this reveals the main

purpose of capitalism and, accordingly, the purpose of maintaining such relations of exploitation, and it only further emphasizes the necessity of the system that fully supports them. Hence, Tatlić believes that capital is not only a result of the logic of the maximization of surplus value and private property of the means of production (and consequently of all the other strata of society, such as social structures, institutions, knowledge, people, bodies and their lives), but it is also the final goal of capitalism, as capital interests organize the society in capitalism. Thus, the only interests at stake here are in the last instance the interests of capital itself. NGC is a deadly circular format of power and exploitation; it departs from capital only to return to capital's interests. Furthermore, this also presents the central tenets of capital's interests within the overall narrative of modernist progress.

As a result, the logic of the humanization of capital presents a form of depoliticization of the relations of capitalist exploitation. As shown above, this means that we insist on the historical point of view when it comes to capitalism and, even more, on the fact that the logic behind the humanization of capital, which is at the core of NGC, is perhaps the final stage of capitalism's modernist narratives of progress developed over several centuries as a form of capitalism "theology." This means that capitalism presents itself as being a supposedly universal project that represents the most optimal organization of society and the relations of power and production. The humanist rhetoric, or the rhetoric of becoming human as a capitalist anthropological machine of humanization, is today the dominant liberal capitalist narrative defined by the modernist logic of progress. Capitalism, despite its efforts to present itself as nonhegemonic, nondiscriminatory, and postideological, and therefore as a universal format of the organization of production and social relations—in other words, of modernity— is, as firmly argued by Tatlić, the relation of pure domination. For this reason, the logic of the humanization of capital indicates a full range of either current or historical sociopolitical discourses that may seem to have no structural link with the development of capitalism. In fact, the result is that the society is more and more desubjectivized and presented only as human resource, while capital is more and more acquiring the contours of subjectivization.

To understand the logic of humanization, we need to draw a genealogy of the capitalist modernist humanist project and make its

principles visible and tangible. In other words, we have to think about the (re)organization of capitalism, locating it (back) in an era when, as stated by Tatlić, colonialism was still an explicit political project. By referring to the work of the members of the collective project Modernity/Coloniality/Decoloniality (MCD), specifically to Aníbal Quijano, Walter Mignolo, and Enrique Dussel, we can state that the equivalence between the subject and the idea of humanity, as defined within the epistemological coordinates of the relation of capitalism and colonialism, consequently implies the existence of a coherent link between the (function) of the humanistic project and the dominant power of capitalism/colonialism. Therefore, in this sense, the project of colonialism should be understood as a project of imposing the definition of what the humanist project within the capitalist institutional and epistemological processes is.

In 2007 Quijano formulated in "Coloniality and Modernity/ Rationality," which I am paraphrasing here,[30] that the whole Eurocentric capitalist colonialism was elaborated and regulated by the Europeans, and was established worldwide as an exclusive European project bringing about a universal paradigm of knowledge in relations between humanity and the rest of the world (176). By making the connection between the territorial expansion of the West (colonialism) and the imposition of Western definitions of the human, it becomes clear that this definition takes on aspects of Christian theology. The result is the imposition of a certain logic as the only possible definition of the human. With this in mind, Quijano states that the emergence of the idea of "the West" and "Europe" was also determined by the enunciation of identity; in other words, the relations with other cultural experiences and differences have been perceived as relations between identities. At the same time, all the other "inequalities" were seen as redundant within the hierarchical imposition of the system, and the identity differences were increasingly being perceived as belonging to nature. The outcome was that only European culture was seen as rational, while all other cultures were seen as irrational (173–74).

For that reason, when it comes to colonialism, as stated by Tatlić, we see the forming of the Eurocentric monopoly on the definition of modernist characteristics; we also see how allegedly predestined or "natural" impositions of European differentiation inside the category

of the human were imposed on those residing in the colonies. It is safe to say that European colonialism was built on modernist principles; hence, following such a connection, we can establish the starting point of humanization in capitalism. It follows, as elaborated by Tatlić, that we are not dealing just with the construction of a new matrix of differentiation, but that the distinction between the human and the less human is imposed as the only kind of social differentiation. In this sense, a process based on privileging a certain set of imposed characteristics has been naturalized and put forward as a starting point for the exploitation by those seen as more human and, consequently, "naturally" privileged. A case in point is that all exploitations under colonialism were then rationalized under the narratives of weights based on the presupposition of a higher humanity and civilization superiority.

Another key point that we have to recognize is that capitalism, as a Eurocentric and Christian project of the first capitalist world, is thus only a form of progression in the intensification of the processes of "humanization" under the logic of capital. As exposed by Tatlić, the establishment of modernity coincides with Christianity, since Christian theology emerged as central to the imposition of the Eurocentric colonial epistemology within the Euro-Atlantic geopolitical space. Not only are the elements of Christian theology (specific anthropocentrism, natural law concepts of salvation, the concepts of innate sinfulness, and ideas about linearity of the development of primitive into civilized) ideologically mobilized by capitalism to play a central role in interpreting and institutionalizing privileges, but, according to Tatlić, Christianity declares that it is most compatible with capitalism. Even when secularism substitutes for Christianity, Tatlić does not consider this as representing any radical break with the epistemology of universalization (as a hegemonic monopoly) that is used in forming the definition of humanity.

In Tatlić's elaborations, secularism presents an even more excessive depoliticized, ideological constructed system of political/social and economical relations in the West. With its allegedly humanist universal applicability and the forms of liberalization, it processes capital as a methodological and ideological discourse that hides exploitation behind the universalization of a particular vision of modernity in almost "pure" form. However, according to Tatlić, it is clear that

secularism, if not harnessed directly by the occidental neoliberal global capitalism, possesses different political capacities. The other point at the center of NGC is the question of flexibilization of power relations. This flexibilization is extremely important, as it directly follows the humanization of capital. It is seen as a part of the great humanist projects that started with the Renaissance, continued through the Reformation and throughout the age of Enlightenment and the French Revolution—a genealogy exposed by Tatlić and based on analyses by Michel Foucault and Giorgio Agamben. It is a steady devaluation of rigid ancient power, but not really a distribution of power. It should be emphasized that after World War II and the nominal "end of the colonial era," as argued by Tatlić, colonialism has become obsolete, since capitalism created "conditions" for the former colonies to flourish, but only (and this became clearly visible from the historical point of view) along the prerogatives of continued exploitation by capital. At the same time, it was said that the "uniform" Fordist model of exploitation had to be replaced by a post-Fordist model of production. It presented itself as an open system, when in fact it was a precarious and even more pervasive system of exploitation. Furthermore, as elaborated by several theoretical analyses, in post-Fordism the factory was universalized by the whole social and political and economic body of global capitalism. Finally, the outcome of flexibilization is that the power relations in NGC are a question of delegation—mistakes that are an outcome of the "humans."

In the late twentieth century, in the era of neoliberal capitalism as the dominant model of the organization of exploitation, we are witnessing a complete distortion of the protagonists/agencies and subjectivities ("humans") within NGC. The relationship between the oppressor and the oppressed is pacified and instead defined as a partnership. This occurs under the conditions in which capitalism is defined as a "postideological" project, in an era defined as the "end of history," implying that that social conflict / the antagonism in capitalism ended. The humanistic project of democracy, which is at the core of the posthistorical and postideological system of exploitation relations between capital and labor, is presented, as argued by Tatlić, in the form of a system that replaces social antagonism with partnership, while on the other side, racializations and class divisions are presented as social diversity managements.

Racializations, Necropolitics

It is important to expose as well that the outcome of these described processes is, as I try to show continually in my writings, racialized labor divisions, on the one side, and naturalized histories of colonialism and contemporary forms of coloniality (colonialism without colonies), on the other. These processes are, in conclusion, an outcome of capital's racialization (a system of racism, discrimination, and dispossession) and are directly connected to the almost forgotten colonialism and its almost universally accepted imperial war machine, as well as the militarization of every level of the social, economic, and political in the present state of neoliberal financial global capitalism. NGC, with its processes of financialization, appropriates the fields of politics, the social, the economic, as well as theory and culture, for direct money laundering, while also heavily exploiting the new economy of attention that uses affective labor as an intrinsic part of the system of reproduction inside global capitalism in a form of unprecedented dimensions for new neoliberal global accumulation of capital and power. At the epicenter, we see the financialization of life and labor,[31] and the militarization of life, politics, and labor, where the "human" is the direct result of the capitalist war machine. Therefore, we face a political situation of death and corruption that presupposes an unspoken permissibility for wars, mass murder, and torture. Essentially, the power of coloniality, as a structure of control, is in speaking so forcefully that we see no alternative but to accept it, effectively dispensing with human life.

One of the most tangible passages in this drawing of NGC genealogy, and therefore in the genealogy of the new materialism, that will influence the new materialist basic premises is precisely the shift from biopolitics to necropolitics. Biopolitics, coined by Michel Foucault in the 1970s as a mode of governing and managing life, which I translate (as briefly as possible) into "make live and let die," was a way of governing life intended exclusively for the capitalist first (Western) world.[32] Because of the pressing socialism all around it, the first capitalist world provided in the 1970s (though under the hidden regimes of discipline for its fellow Western citizens) comfortable life facilities, but almost exclusively for those perceived as "natural" citizens of the respective first-world capitalist nation-states. The other worlds were left to die, as they were not relevant to the interest of

the first capitalist world, except when from time to time (and with varying frequencies), it was, of course, necessary for the former imperial and colonial nation-states, that were also all anti-Semitic states, to suppress the decolonization struggles or attack socialism by using military or paramilitary forces. Accordingly, this was the case when the "absolute democracy" of private property and surplus value, the two fundamental pillars of capitalism, were put under question. At the same time, the migrants (both economic and political refugees) in the first capitalist world (the strained relations between Latin America and the United States are at the center of these discussions) have gone from their nonexistent position in the past to an overtly and continually criminalized what is called "second-class" and noncitizen positions in the present.[33]

However, what we actually see today is a brutal intensification of the biopolitical regime of life from the 1970s. This intensification was named necropolitics by Achille Mbembe;[34] it was conceptualized by Mbembe in 2003 based on his analysis of the condition of Africa as the postcolony. Necropolitics focuses on new capital's logic and its geopolitical demarcation of world zones, which are based on the mobilization of the war machine; necropolitics' accumulation of capital is a result of total dispossession and the subjugation of life to the power of death. Therefore, if Foucault's biopolitics, a term in between *bio* (life) and politics, can be designated axiomatically as "make live and let die," then necropolitics, a term in between *necro* (death) and politics, can be designated axiomatically as "let live and make die." There is a huge difference between "make live," providing structures and facilities for life, and just "let live." The latter presents the structure of pure biopolitics of abandonment that is, in fact, necropolitics. Furthermore, the necropolitical now also punishes the natural nation-state citizens that are abandoned in the meanderings of laws and administration articles, where the lives of those coming from the so-called third states and their partners become trapped in vicious regimes of poverty, deprivation, and seclusion. Furthermore, aesthetic contradictions are profoundly re/articulated within the intensified militarization and racialization of our lives. It is precisely what I initially exposed as dehistoricization that is at stake here.

In *The Production of Difference: Race and the Management of Labor in U.S. History* (2012), written by David R. Roediger and Elizabeth D.

Esch, and reviewed by Joe R. Feagin,[35] the authors analyze the relationship of institutionalized racism with the management of labor in the United States. As they emphasize, "race management" has been a much-neglected topic in the social sciences. Some analysts, as Feagin states, might suggest that this centrality of white-racist framing and related action is just a leftover from premodern impulses and represents efforts that would soon end in a critical era for the development of capitalistic management theory and practice, but Roediger and Esch reject that interpretation and demonstrate that capitalistic management has for many decades, even to the present day, used the "irrationalities of race" to manage labor and much else in capitalistic economies.[36]

A case in point is that the thinkers engaged in the new materialism, speculative realism, nonrepresentational theory, constructivist philosophy, and posthumanism, when engaging critically with race and gender, rethink race as material ontology and as assemblage theory. The assemblage theory is used to challenge and extend the concept of intersectionality. Consequently, here also lie the possibilities and potentialities.

Capitalism permanently erases the boundary of differentiation between the humanist project and its necropolitical impact. Tatlić observed a reconfiguration of the social, political, and economic body of NGC after 9/11, in which the forms of maintaining capital infrastructures for exploitation, the imposition of free markets, the dispossession of resources, and the organized military interventions received an overall ultraparadoxical dimension—one implying that they are all rooted in the principles of humanistic projects. In other words, they are all used in the name of humanity. Essentially, the goal is to get rid of all those supposedly "archaic" forms of human organization (class divisions, gender divisions, racialization processes) and to reduce all the processes of exploitation and dispossession by capital to an even lower common denominator, which is the human! However, in the rhetoric of the new materialism, this human is today seen only as a biological medium—one that capitalism intensively and mercilessly reshapes.

Therefore, although I have already drawn attention to the fact that object-oriented ontology and the new materialism give legitimacy to a specific kind of politics that is nonanthropocentric and works hand in hand with dangerous de/historicization and de/politicization, what

I want to emphasize is not just OOO's objectification and commodi-
fication of humans but also a process that is essentially that of the
humanization of capital itself. Consequently, this presents an impor-
tant shift from the traditional feminist critique based on the com-
modity and reification toward capital itself. Capital supports and
allows—in other words, incites—the topic of the nonhuman. As seen
above, the relation is not between the human and commodity any-
more but between capital and the nonhuman, as capital itself is now
at the center of humanization (processes covered with a set of terms
like transhuman, metahuman, etc.).

This also allows capitalism to perform a radical universaliza-
tion of exploitation, one that is fully detached from history, all in the
name of the "common destiny of humanity," which is in fact only the
humanization of capital itself. In such a defined "society," racialization
becomes the main form of differentiation, and all those subjugated
to it are classified under the brand of the "common destiny of human-
ity." Today, coloniality, with the imposition of Western epistemology
and its model of social differentiation implemented under the broader
humanistic narrative of democracy, is presenting the human, as em-
phasized by Tatlić, purely as biological material. By analyzing the
genealogy of these processes in such a situation, it becomes clear
that NGC has to insist on the posthuman as the human, since history
and agency are completely co-opted, regulated, and reproduced under
the order of capitalist reproduction of exploitation, expropriation, and
dispossession. Shifting the discourse elsewhere, away from historical
and political analysis and instead toward the posthuman, masks the
frightening possibility that today the human is transformed through
the logic of the humanization of capital into something that is purely
biological matter—and as such without political subjectivity.

Conclusions: The Privatization of Subjectivity

To summarize, the critique that I am proposing puts itself in opposi-
tion to new materialism and treats NGC as the object of research, as
well as capital maximization of surplus value (making profit and fur-
ther maximizing it), and a consequent privatization of everything and
everybody. I do this by exposing two major features of NGC that are
also lurking behind the new materialism, the process of the logic of

the humanization of capital and also the purging of history, as a result of the flexibilization of power relations in capitalism. The latter is capitalism's ability to depoliticize or, more accurately, dehistoricize hierarchical and vertical relations of power, and instead reduce the rigidity of political control over society, quite perversely, in the name of "humanity." These two processes of NGC present the political subject as nonexistent, making us wonder who this "human" is.

The final result of connecting these two processes of neoliberal global capitalism is an emphasis on the "nonanthropocentric" dimension of any political subjectivity, or to be more precise, presenting the subject as obsolete. Therefore, one is powerless when it comes to any future critical interventions into capitalism and its system of production, which is essentially a system of exploitation. As for who is to be seen as the human, this comes across not as a natural state of affairs but as the outcome of a highly advocated process of racialization. Modern scientific revolutions present the NGC system as existing apart from history, or above history, and therefore, preventing any effort to historicize the genealogy of the "human" (precisely as being an ideological racialized category) and to understand clearly that the present state of the logic of the humanization of capital started with capitalism and its political project in the fifteenth century (colonialism).

Moreover, the human is as well an ideological category. Therefore a proposition of this chapter is not to recuperate the human and humanity (as this has often served to escape deeper interrogations of power) but to emphasize precisely the humanization of capital as a third link between the human and posthuman. Without taking into account the logic of the humanization of capital, we are incapable of understanding discrimination and exploitation in relation to mechanisms of power in neoliberal global capitalism.

Given these points, it comes as no surprise that we are witnessing the development of modern warfare in the twenty-first century toward increasing autonomy and automation. Lockheed Martin, a U.S. weapons manufacturer, has recently produced a missile for the U.S. Air Force that can autonomously select targets, using sensors that allow it to decide on its own whom or what to target. Increasingly widespread use of artificial intelligence for different purposes of trading, medicine, and so forth presents the chilling dystopia of the future, and ultra-advanced financial computers, algorithms, and quarks are today indispensable and irreversible components of the reality of modern

financial markets, methods of warfare, and, increasingly, education (as Seth Lloyd predicts that the ever smaller microchips and more powerful computers, tablets, and smartphones will nevertheless soon reach a limit, and the development will go in a direction of quantum computers and quark-scale computers).[37] The progressively autonomous and robotic forms of weapons, thereby, take away the responsibility and ease the "human" conscience in case of errors because drone pilots are far away from the zone of war, as they, without any risk of losing "human" life, guide missiles toward remote targets. All of this is not simply a gray area, but the darkest side of NGC. In short, the logic of the humanization of capital remains an ideological category invested in the reorganization of capitalism, and it represents a central logic around which the "aim" of the human is formed.

Under these circumstances, the relationship between the capitalist order (and its logic of the humanization of capital) is presented as something beyond the historical discourse where, instead of any possibility for political subjectivity, we only find, as Šefik Tatlić brilliantly expressed, the articulation of the human—a biological matter, medium, subsumed under the brand of its reinvention.

Notes

I thank Irina Aristarkhova and Katherine Behar for their insights in our discussions of this chapter.

1. Donna Haraway, "A Cyborg Manifesto: Science, Technology, and Socialist Feminism in the Late Twentieth Century," in *Simians, Cyborgs, and Women: The Re-invention of Nature* (London: Free Association Press, 1991).

2. Alana Brooks Smith, "The Politics of Participation: Revisiting Donna Haraway's 'A Cyborg Manifesto,' in a Social Networking Context," *NYU Archives*, Fall 2009, 70.

3. Haraway, "A Cyborg Manifesto," 149.

4. Brooks Smith, "Politics of Participation," 69.

5. Ibid.

6. Ibid., 70.

7. Haraway, "A Cyborg Manifesto," 165.

8. Lucian Gomoll, "Posthuman Performance: A Feminist Intervention," *Total Art Journal* 1, no. 1 (2011): 2.

9. N. Katherine Hayles, *How We Became Posthuman: Virtual Bodies in Cybernetics, Literature, and Informatics* (Chicago: University of Chicago Press, 1999).

10. Gomoll, "Posthuman Performance," 2.

11. Ibid.

12. Donna Haraway, "When We Have Never Been Human: What Is to Be Done?," *Theory, Culture & Society* 23 (2006): 140.

13. Rosi Braidotti, "Posthuman, All Too Human: Towards a New Process Ontology," *Theory, Culture & Society* 23 (2006): 197.

14. Hayles, *How We Became Posthuman*, 34.

15. Joshua Labare, "Review of Cary Wolfe's *What Is Posthumanism?*," *Science Fiction Film and Television* 4, no. 1 (2011): 136; see also Cary Wolfe, *What Is Posthumanism?* (Minneapolis: University of Minnesota Press, 2009).

16. Gomoll, "Posthuman Performance," 2.

17. Ibid.

18. Francesca Ferrando, "Posthumanism, Transhumanism, Antihumanism, Metahumanism, and New Materialisms: Differences and Relations," *Existenz* 8, no. 2 (2014): 26.

19. Ibid., 30; see also bell hooks, *Feminist Theory: From Margin to Center* (Boston: South End, 1984).

20. Ibid.; see also Diana H. Coole and Samantha Frost, eds., *New Materialisms: Ontology, Agency, and Politics* (Durham, N.C.: Duke University Press, 2010).

21. Ibid., 31–32; see also Judith Butler, *Bodies That Matter: On the Discursive Limits of Sex* (New York: Routledge, 1993); Karen Barad, "Posthumanist Performativity: Toward an Understanding of How Matter Comes to Matter," *Signs: Journal of Women in Culture and Society* 28, no. 3 (2003): 801.

22. Ibid., 30.

23. The collective project Modernity/Coloniality/Decoloniality (MCD) established in the 1990s/2000 has elaborated an epistemic "Decolonial Turn" that assumes the perspectives and life experiences of people from the global South as starting points for a critique of the failures of Euro-centered modernity. MCD is a network of U.S. Latina/o, Latin American, and Caribbean scholars who come from various disciplines. It nevertheless has a few central figures, chiefly, the Argentinean/Mexican philosopher Enrique Dussel, the Peruvian sociologist Aníbal Quijano, and the Argentinean / U.S. semiotician and cultural theorist Walter Mignolo. What remains central to MCD is the transformation of the darker side of modernity: coloniality. It is the continuation of colonialism inside the neoliberal global capitalist contemporaneity ("Modernity/Coloniality -> Decoloniality," accessed August 1, 2015, http://www.contramare.net/site/en/modernitycoloniality-decoloniality/).

24. Kimberly DeFazio, "The Spectral Ontology and Miraculous Materialism," *The Red Critique* (2014), accessed August 1, 2015, http://www.redcritique.org/WinterSpring2014/spectralontologyandmiraculousmaterialism.htm.

POLITICAL FEMINIST POSITIONING 223

25. Coole and Frost, *New Materialisms.*
26. De Fazio, "Spectral Ontology."
27. Ibid.
28. Ibid.
29. Marina Gržinić and Šefik Tatlić, *Necropolitics, Racialization, and Global Capitalism: Historicization of Biopolitics and Forensics of Politics, Art, and Life* (Lanham, MD: Lexington Books, 2014).
30. Aníbal Quijano, "Coloniality and Modernity/Rationality," *Cultural Studies* 21, no. 2 (2007): 155.
31. Some of these topics are also addressed by some new materialist scholars like Catherine Waldby, who in *Clinical Labor: Tissue Donors and Research Subjects in the Global Bioeconomy* (coauthored with Melinda Cooper [Durham, N.C.: Duke University Press, 2014]) argues that whenever a body is involved, as in cases of surrogacy (surrogate mothers), when the body is being "in vivo service," contrary to the laboratory being "in vitro service," the female body service should be treated as labor. Cooper and Waldby show how the global assisted reproduction market has become highly sophisticated as more and more households, especially in rich countries like Australia, look to third-party providers for fertility services.
32. Michel Foucault, *The Foucault Effect: Studies of Governmentality,* edited by Graham Burchell, Colin Gordon, and Peter Miller (Chicago: University of Chicago Press, 1991).
33. A fitting case would be Henrietta Lacks. She was a poor black tobacco farmer whose cells—taken without her knowledge in 1951—became one of the most important tools in medicine, vital for developing the polio vaccine, cloning, gene mapping, and more. Lacks's cells, known as HeLa, have been bought and sold by the billions, yet she remains virtually unknown, and her family cannot afford health insurance. A phenomenal New York Times best seller by Rebecca Skloot, *The Immortal Life of Henrietta Lacks,* tells a riveting story of the collision between ethics, race, and medicine; of scientific discovery and faith healing; and of a daughter consumed with questions about the mother she never knew.
34. Achille Mbembe, "Necropolitics," translated by Libby Meintjes, *Public Culture* 15, no. 1 (2003): 11–40.
35. David R. Roediger and Elizabeth D. Esch, *The Production of Difference: Race and the Management of Labor in U.S. History* (New York: Oxford University Press, 2012); Joe R. Feagin, "Whiteness as a Managerial System: Race and the Control of U.S. Labor," 2013, http://monthlyreview.org/author/joerfeagin/.
36. Quoted in Feagin, "Whiteness."
37. Seth Lloyd, "The Universe as Quantum Computer," December 16, 2013, http://arxiv.org/abs/1312.4455.

Nine

Karen Gregory

In the Cards

FROM HEARING "THINGS" TO HUMAN CAPITAL

It is just before 5:00 p.m. on Thursday, and the majority of the attendees of the Tarot Readers' Studio have already made their way to the registration table, where I am volunteering with two other Tarot Center students. With the day's final wave of registrants over, we are just about to head into the larger conference room at the Airport Sheraton and settle in for the evening's "master class," which will be conducted by Warren and Rose. Tonight's theme for the master class is "listening to the oracle," and Warren promises that we are in for a radical new way to approach the Tarot. This is my first time attending the Readers' Studio, and I am not quite sure what to expect, but everyone I have met during registration has been overwhelmingly friendly, enthusiastic, and welcoming, arriving as though the annual conference were their home. Many tell me that "RS" (as it is often abbreviated) *is* their homecoming reunion. It is their annual gathering of the "Tarot tribe," and they look forward to the conference throughout the year. The Readers' Studio draws almost two hundred professional Tarot readers, newcomers, and esoteric practitioners from around the world to this hotel for four days of intense Tarot study, reading, and networking. While other Tarot conferences are beginning to crop up in California and Texas, the Readers' Studio has been able to maintain itself as the premier event for professional readers, hosting well-known authors to conduct innovative workshops and evening classes, as well as using its proximity to Manhattan as a tourist draw.[1]

As the last administrative materials for registration are put away, I find myself staring into the grand conference room, where vendors make last-minute adjustments to their merchant tables and where an impromptu bookstore has been established in the corner of the room, offering a range of old and new Tarot classics, prominently displaying new books from any authors who are attending the conference. In the middle of the room a large dais has been set up. It is the performance stage that will host the conference speakers. Tonight, two large throne-like chairs have been placed on the stage, awaiting Warren and Rose and evoking their roles as the respective King and Queen of Tarot. Warren and Rose will be our guides during the four days of Tarot and "transformation." According to Warren, the Readers' Studio will "touch my life," and already I can feel, from the crowd that is gathering in the room, waves of excitement and exuberance.[2]

In addition to the Tarot School students attending the conference, many of whom I have gotten to know and feel comfortable with, Tarot attracts a number of "big personalities" who are performative and irrepressible in their manner, in their dress, and in their interactions with other people. As I watch the room fill up, I feel rather small and quiet, and I wonder if Tarot practice will draw out some of my own performativity or my own sense of agency. I can see in others that such a drawing out is the part of Tarot's "lure" and why people cherish their relationships with what is essentially a deck of seventy-eight illustrated cards. As authors such as Ann Taves and Molly McGarry have shown with respect to mediumship and spiritualism, women in particular have found a source of social and personal power through their participation in "marginal religious movements."[3] As McGarry writes, "Personal and corporeal spiritual experiences obviate the need for a learned clergy to mediate that experience, rendering religious practice open to women in ways that a more structured, hierarchical religion might not be."[4]

The study of Tarot is framed not only as a spiritual journey but as a process of finding one's "voice," and given shifts in the contemporary spiritual marketplace, which have made esoteric knowledge more accessible, such a project is now entangled in the (often digitally mediated) personal pursuit of information, experiences, objects (such as cards and books), as well as seeking out community through digital networks. Formerly occult or "hidden" texts and materials are now

Figure 9.1.
La Papesse (Tarot
de Marsella).
Licensed under the
Creative Commons
Attribution–
ShareAlike 2.5
Generic License.

much more easily encountered via the Internet, meet-up groups, or schools like the Tarot school. However, the distribution of esoteric knowledge via accessible networks is brushing up against the very business model of the Tarot School, which tends toward privileging Warren and Rose as unique sources of esoteric information. The creation of the Readers' Studio conference is an attempt to buffer the ill effects the market has had on the school. As one reader told me, "This is where Warren and Rose break even for the year." Indeed, the weekend event is designed to fully maximize the "experience" of Tarot, with classes and workshops scheduled from nine in the morning until ten at night. Warren's opening night ceremony is a bit of a teaser for what is to come—a weekend of personal exploration, Tarot study, and opening one's self to the enchantment of the cards.[5] Indeed, learning to make one's self "porous" or to open one's "self" to the agency of objects and to environments sits at the heart of the project of learning the Tarot.

As Warren and Rose take the stage, people settle in their chairs around the circular conference tables, placing notebooks, coffee cups, and Tarot cards on the table. Some people have brought decorative and quite beautiful "reading cloths" to place on top of the hotel's muted burgundy tablecloths. Some are establishing their place at the tables with little magical odds and ends, such as candles or crystals or bells. Bit by bit, the conference room is beginning to take on the personalities of its inhabitants and reflect back, quite literally, the "colorful" world of Tarot, with its rich art, symbols, and mythological figures. The vendors, who are set up along the edges of the room, help fuel this decoration, each bringing their own brand of Tarot crafts and wares. One woman sells magical crystals and handmade wands; another sells beautifully woven throws and shawls; another couple sells magical, hand-poured candles that can be used for rituals and spells. Artistic versions of the Tarot abound. One woman is selling a handmade, abstractly collaged deck of Lenormand cards; a man sells his famous deck of lovely woodcuts; another woman sells a deck illustrated by watercolors and populated by fairies and childlike figures.[6] These objects are not only the result of personal labor and an attempt to create a marketplace for enchanted goods; they are also, as I came to understand, companions in the study of cards, "vibrant" objects in their own right that have (at times) seen individuals through the difficulties of everyday life.

Once the crowd has settled in, Warren begins his workshop, "The Wall of Silence." He asks the crowd to remove a single card from their Tarot decks. In this workshop, we are going to learn how to listen to what the Tarot, as a complex object, is saying. Beyond being a metaphor for language, Warren is explicit that he intends to teach us to hear the "voice" of the cards. This may be the voice of the actual figures of the card; for example, we may hear the voice of the figure of Justice (Trump XI), or the female figure in the Strength cards (Trump VIII), or even the voice of an angel, such as Gabriel, who is blowing his horn of resurrection in the Judgement card (Trump XX).[7] This may be the voice of the "symbolism" of the cards. For example, the voice of the "Sun" itself speaking through the image or symbol of the sun in the Major Arcana. This may be the voice of the "elements" contained in the card, for example, the voice of "fire," as understood in the system of the fourfold elements of earth, water, air, and fire, which are believed to be invoked by the deck's four suits. This may be the voice of the card itself or deck itself as a physical object, independent from a specific image depicted on that card or the cards as a whole.

To begin, Warren encourages everyone to spread out their cards in front of them and to see which card "resonates" or "feels like the card that wants to work with you." We are simply to sit "with" the cards and "feel" what they are saying. Growing quiet, both physically and mentally, and being as meditatively "silent" as possible, is central to Warren's exercise. While we are sitting quietly, Warren gently suggests that we open our "hearing" and reminds us that is not just the anthropomorphized, allegorical figures of the cards that may "speak" but any element of the card, by which he means any image abstract or figurative (e.g., any of the animals or plants of the deck may speak), as well as any "information" contained in or represented by the card such as the card's suit, or perhaps the card's astrological associations (the Sun or the Moon are associated with those respective Major Arcana cards and are the most obvious examples, but more subtly each card is associated with a particular astrological feature), or even the card's colors (in some decks the colors have been chosen for their qualities, such as the warmth of the color red, and some decks have become notable simply by being "recolorings" of other decks). Any of these elements of the cards may "speak to us loud and clear," according to

Figure 9.2. Le Chariot (Tarot de Marsella). Licensed under the Creative Commons Attribution–ShareAlike 2.5 Generic License.

Warren. And, as Warren explains, if we can learn to sit quietly enough, "turn off the thinking brain" for long enough, the card will "speak" through a quiet voice or through a vivid mental image—an image that speaks so fully that it can be felt. In this way, Warren is suggesting that the full materiality of the card, its symbols, and its elements can communicate. In my e-mail to another Tarot School student who had asked me how Warren's preconference workshop had gone, I wrote the following:

> The central part of it (the workshop) was the idea of getting beyond normal perception and using a technique called "da-shan" to ask questions of objects. W's guiding question was "how do you speak to a coffee cup (or a tarot card)?" Using the technique of Da-shan, you sit quietly, creating a silent space where you can ask a question (of anything really, an object or a concept) and where you wait quietly for an answer. The process is to listen and wait (with the possibility that you might then "hear/understand.") The trick seems to be to trust that what you're hearing or to go with that reality that what you're hearing is really coming from the object rather than simply being a projection of your own mind or biases. In order to get to this place, the answer is to practice meditating. I thought it was a cool exercise and got me excited to sit with myself and to let the answers from things flow in. What does the tree want to tell me? What is the computer saying right now? I thought it was a fun exercise—fun to see that the world is so very alive.

The idea that the world itself is alive and speaking is central to the work that Tarot Readers engage in and, indeed, is central to the very notion of magical practice.[8] In this chapter, I do not focus on magical practice per se but look to the cards themselves and to our sense of what an object is or can do. Here, I look to what has been called speculative realism, new materialism, and the process philosophy of Alfred North Whitehead in order to explore the Tarot and to consider what Jane Bennett has called "thing-power," or "the strange power of ordinary man-made objects to exceed their status as objects and to manifest traces of independence or aliveness, constituting the outside of our own experience."[9] Truly to understand how Tarot readers work with Tarot cards, we will, as Bennett would, allow that the

cards and the elemental energies contained and evoked by the cards are functioning in a "lively" manner. Tarot cards themselves point toward a "vital materialism" in that they involve the recognition that "vitality is shared by all things" and not limited to ourselves alone.[10] Tarot cards manifest these traces of independence or aliveness through their enigmatic symbolism, their underlying metaphysical and magical associations, and through their aleatory nature. As the philosopher Inna Semetsky writes, "Tarot 'speaks' in the universal language of images, signs and symbols, and represents the long forgotten 'lost speech.' Tarot helps in discovering meaning and purpose in our individual and collective experiences and a deep sense of value both inside and outside ourselves."[11] While the symbolism of Tarot is deeply powerful, here I want to suggest that we refocus our attention just slightly beyond the representational schema of the cards and look to how the cards—as a social actor—function. Another way of saying this is to ask the question: What happens when a deck of cards begins to speak to an individual?

> We who read the cards know that the cards don't lie. Sometimes we doubt them. Sometimes we hesitate. Sometimes we don't see how they can possibly be telling the truth. But deep down, we know. And sometimes we are even freaked out by how true they are. Learning to trust the cards can be a long process, especially in terms of telling the future. I've had three very "in my face" experiences this week to remind me that there is truth in the cards. This is one reason I don't ask clients "does this sound right to you?" Just because it doesn't seem or feel true . . . or even if logically it doesn't make sense . . . the cards still tell the truth. We all know that there were times when we "felt" sure that something was true, only to discover it was not. Feeling is not an indicator of truth. And neither is common sense or logic. That's one reason we come to the cards, isn't it? Because we are having trouble discerning truth for ourselves?[12]

As the quote above illustrates (and is echoed in many of the Tarot School conversations), readers do not necessarily have to "know" how the cards work, nor does this unknowing challenge the legitimacy of the cards or the legitimacy of other religious beliefs. Lisa, a Tarot School student, is a practicing Catholic who sees no conflict between

her Catholic beliefs and her Tarot practice. Through her study of the Golden Dawn (via Warren's lectures and home study that she has taken with Warren personally), Lisa takes comfort in the notions of Christian mysticism that informed the development of the Rider-Waite-Smith deck of cards. In addition, Lisa finds that kabbalistic interpretations of Tarot even accommodate the figure of Jesus, as he is associated with the sixth Sephiroth (whose "function" is that of beauty and which sits at the center of the Tree of Life). Although I have never heard Lisa mention Jesus in her readings or make explicit references to Catholicism in her Tarot work, in our conversations she has been quite clear that she sees Tarot and its mysteries as linking her to the Divine. Tarot allows her, quite literally, to be in touch with what is speaking through the cards. For Lisa, it may be the voice of God or the voice of the universe that "connects her to her higher self." It is not necessary for Lisa to understand where the voice of the cards comes from, but she does believe that the cards themselves can become an invaluable and wise companion and that the very act of reading puts her in touch with this divine source of knowledge.

One thing that helps foster trust in the cards, regardless of the personal cosmology of the reader or their spiritual or religious beliefs, is that the cards "work": they are simply cards, which can be shuffled and, more important, flipped over. This simple "technology" of the cards, which guarantees that something (anything) will be revealed by turning them over, works independently of beliefs that are used to explain what is at work *in* the cards. Rather, the cards themselves foreground an ontological insight that easily links up with the feeling of eventfulness or the felt perception of dynamism as an organizing principle of how the universe (and our lives) are structured. The cards, in that they are cards, can begin to be trusted because, regardless of whether they are "right" or "wrong," they nonetheless provided some information that was unknown before the flip, and in doing so, in providing that information, they have provoked a feeling. They have *affected*. Readers, then, are willing to accept the challenge that the card flip asserts: here is a mysterious communiqué from the card. Tarot work charges the individual with working through the complexities of the simple question: What does this mean?

While it true that some people are afraid of the Tarot cards—they have been called "a wicked deck of cards"—they are also a relatively

Figure 9.3.
Limperatrice (Tarot
de Marsella).
Licensed under the
Creative Commons
Attribution–
ShareAlike 2.5
Generic License.

passive occult item that does not demand much more than attention from the reader.[13] Consider them in distinction to a doll I was introduced to by Christine W., a young pagan priestess and Tarot card reader. This doll, she told me, was "particularly obnoxious during menstruation," when the doll demanded that the blood be sacrificed to it. Christine explained to me that the divinity that the doll was channeling needed to be "put in its place" and that she worked to set boundaries on the demands that it placed on her. Tarot cards, and what may or may not be presence-ing itself through the cards, do not work in this way. They do not demand sacrifice or such boundary work, nor are they self-animating.

However, in my work with professional readers, many recall being given a deck of cards as if it were an act of "the Tarot choosing you" and feeling as though they were being initiated into a something that felt like a secret and existed under the radar of mainstream society. Today, you might not have to be so chosen: you can walk into almost any bookstore and encounter a wealth of cards and books; even more immediately, you can type "Tarot" into Google and receive "about 42,100,000 results" (as of December 2014). Tarot decks themselves range from the classic Rider-Waite-Smith deck and Aleister Crowley's Thoth deck, which was illustrated by Lady Frieda Harris, to feminist-inspired decks such as Vicki Noble's MotherPeace deck and Kris Waldherr's Goddess Tarot, to Eastern-thought decks such as the Osho Zen Tarot, to more thematic decks such as Tarot of the Fairies, the Teen Witch's Tarot Deck, Tarot of Cats, and even geographically inspired work, such as the recent Tarot of the Boroughs. But what are you looking at when you encounter these decks?

Most immediately, when you encounter the Tarot, you are looking at a deck of cards, a pile of card stock, often professionally printed with various images, often cut into a 2.76-by-4.72-inch rectangle. As a physical object, all cards are a standardized device that are two sided, portable, small, and impermanent. And, importantly, they can be flipped. In this regard, you are looking at a very old and very simple machine or mechanism for engaging change and chance that works via the elegant gesture of the card flip. Regardless of their design or imagery, their internal structure or hierarchy, or the philosophies espoused by the deck, humans have found this type of object captivating since

their evolution from Korean divinatory arrows in the sixth century.[14] The poker historian James McManus imagines the story went something like this:

> One possibility is that it gradually dawned on one of the shamans that the random fall of sacred arrows—arrows unguided, the Koreans believed, by human will—could be achieved more efficiently by mixing up pieces of silk marked with the same insignia the arrows bore, then turning over the silks one by one. This would save him the steps of going outside, launching arrows skyward, and scurrying around to read and interpret which one had landed where, at what divine angle, and so forth. One frigid January morning, our shivering but imaginative soothsayer must have returned to the hearth of his cozy shelter, set down his quiver and bow, shuffled some previously marked pieces of silk, and dealt them out on a table. "Stay inside, fool," he might have interpreted them to advise.[15]

Although this story is facetious, historians and anthropologists agree that playing cards emerged in a synthesis of play and divinatory pursuit (as well as boredom and obsession), as cards worked as a simple source for the controlled production of randomness. Such a machine, whether it was composed of silk, wood, or (eventually) paper could provide potentially valuable, divinable patterns from which to detect the hidden meaning of the fates, or they could be elaborated into a game of "chance," where the uncertainty of a card flip could be engaged through play and rule making. This synthesis of divinatory capacity and play, neatly present in the gesture of the card flip, sits at the heart of the love story between humans and cards, which have allowed humans to ask big questions in, literally, a way they can handle and manipulate: Does fate exist? If so, how might we know it? What of chance? Does luck exist? If so, can it be cultivated? Is there a structure or knowable pattern underlying what appears to be randomness? As Jackson Lears has so attentively traced in *Something for Nothing: Luck in America*, these questions course through and helped define a particularly American sensibility that seeks both to engage and control chance.[16] For Lears, chance has never quite been tamed and so continually resurfaces in the market, in cultural sensibilities about the value of risk, in entrepreneurial language, and in the ethic

of success. "Despite fresh evidence that hardworking people can easily lose everything to corporate confidence men, the insistence that 'you make your own luck'—that you are personally responsible for your own economic fate—remains a keystone of our public life," writes Lears.[17] The synthesis of the aleatory object, luck, and the notion of agential self remain linked in contemporary Tarot practice, as though each flip of the card can give rise to a sense of what is possible or what should be avoided.

As Steven Connor writes in *Paraphernalia: The Curious Lives of Magical Things*, "Cards are the visible sign of communication between an unordered and ordered world, a world of mingled and overlapping hybrids, a world sorted into categories."[18] Connor writes that it is the very materiality of the card—its "flatness" and its "stiffness"—that in part lends the card a liveliness. Flatness (to have only width and breadth but not height) is, according to Connor, "one of the strangest and the most exotic of conditions" and a geometric conundrum.[19] Yet flatness inheres in paper—as well as the page, the canvas, and the screen, to name a few. Such flatness of an ideal surface can be a site projection, but, as Connor suggests, such surfaces also act as tables or places to lay out, organize, and reorganize things (or concepts). Tables help order and reconnect. As such, a card, through its flatness, is also a table or a tabulator. Conner does not mention this, but flatness is also, physically, an enabler of movement and mobility. Cards can be shuffled, reshuffled, packed, and carried. This simple fact most likely accounts for both their popularity and their perseverance throughout history. The stiffness of cards, suggests Connor, operates as a "special kind of ambivalence."[20] Stiffness suggests "deceptiveness," as in "to stiff someone," yet "there is a kind of uprightness, a quasi animate erectness in the card, that, in standing up for itself seems to disdain and redeem the flimsy ductility of paper. In the card rigor mortis can suddenly spring into vigor mortis."[21] Connor further writes:

> Playing cards are also magical partly because they are meaningless in themselves; their power comes only from the signs they carry, and the meaning of those signs in relation to other signs. The meaning of the card is in part its arbitrariness, its flatness, its lack of intrinsic life or meaning, the fact that no card means anything on its own. Its flatness signifies this dry semioticity.

Its life comes from the contingency and adjacency, from what occurs when it is laid next to another card.[22]

While it is true that cards "speak" through the symbols or signs that they carry, we can also look to what cards can "do" or what can be "done with" cards, and we can see that a card is not entirely meaningless outside a semiotic context. Cards, most basically, can be flipped. They can also be used, as Ian Hacking has shown, as agents of randomization, and simple playing cards were not only employed in the history of the search for telepathy but, as an "organizational system," played an important role in the history of computing, making possible serial functions and memory.[23]

The card flip, however, is not only an evocative gesture that individuals have found compelling; it is also an extremely successful social actor. Through this simple gesture (as well as the throwing of dice or the invocation of those objects that have an aleatory capacity), we see not only the link between divination and games of chance but the development of the study of probability, as gambling games flourished throughout the sixteenth and seventeenth centuries and efforts were made to develop a mathematical theory of odds. By 1560 Girolamo Cardano, a self-confessed chess and dice addict, had begun *Liber de ludo aleae*, a written investigation into the nature of luck and the mathematical principles associated with random events. By the mid-seventeenth century, the general outline of probability theory was known, linking card play with a form of productivity and giving the often-condemned act of gambling a chance to enter into a scientific discourse. This linking of aleatory objects with statistics and probability demarcated the once blurry line between divination and games, with the latter being fully indoctrinated into Western European philosophical discourse as well as into the support of the state via sponsored lotteries (games, gambling, risk, and chance now seem to form the very structure of global finance, oddly rejoining the open-endedness of divinatory practice via speculative finance). As Hacking, quoting Walter Benjamin, writes, "The proscription of gambling could have its deepest roots in the fact that a natural gift of humanity, one which, directed toward the highest objects, elevates the human being beyond himself, only drags him down when applied to one of the meanest objects: money. The gift in question is presence of mind. Its highest

manifestation is the reading that in each case is divinatory."[24] Here, Benjamin points to the notion that the "natural gift" of humanity is to be oriented toward objects, which in turn may reveal a "presence" of mind. Money, for Benjamin, debases this gift, yet it is this entanglement of play, gambling, and divination that is at the heart of the basic pleasure associated with cards, and proscriptions against the use of cards only helped them spread within a culture of widespread game playing and fascination with the link between mathematical and philosophical insight. The card flip, therefore, is not only at the heart of the Tarot but at the heart of the assemblage of Tarot—an assemblage of game playing, magical innovation, con artistry and illusion, and, eventually, therapeutic capacity.

Beyond their long history as a game of social critique, magical systems, or a prompt for self-development, the assemblage of the cards operate as what Whitehead would have called a "lure for feeling," drawing bodies, selves, cards, symbols, and affect together, inviting an opening not only to the energy of the cards but to the very ontology of change and of dynamism.[25] Such a "lure" draws elements of what Whitehead called a "continuum" toward one another, momentarily giving rise to what are thought of as "occasions," which merge together and fall away, dying back into the continuum out of which all "things" both come and return to. Tarot is an *occasion-generating technology* that, with each flip of the card, opens the reader (and the querent) to the possible. This possible contains within it the possibility of "knowing" across the paradigms of psychic, intuitive, emotion, and affect, as well as the possibility of developing the skill of "articulation," or the narration of the occasion.

It is this aleatory flipping and the revealing of new occasions that not only keeps past metaphysical traditions alive (in that cards continue to be created and shared and explored) but also comes to inform (particularly in an affective economy, which valorizes innovation) a way or mode of relating to the self, which in turn informs new possibilities for laboring. Such an aleatory sensibility, which can shift between paradigms of psychic, intuitive, and therapeutic, "plays" well with the impetuses of entrepreneurialism: to be continually on the lookout for new opportunities and, at a very personal and subjective level, to continue to find the energy to "hustle" and continue working. It is the aleatory nature of the cards that enables them to both "speak"

as well as become a site of investment, as individuals use the cards to develop "psychic" sensitivities, proclivities, or inclinations. As the introductory field note from Warren's Readers' Studio class suggests, Tarot cards invite individuals into a practice of *listening to information* and of understanding the world as essentially radiant with information. Such listening, or what we can think of as "attuning" the body, not only prepares the ground for becoming a *reader* but is also entangled in the shifting logics of post-Fordism and networks of communicative capitalism, which are continuing seeking new terrains of value.

Tarot's enchantment is being kept alive today, not necessarily by ceremonial magicians seeking the astral plane but by the card flip, which as Lauren Berlant has written in relation to the "click" of social media, turns the "episodic now" into an event.[26] In other work, I have traced how working with Tarot is a form of "caring for the self," but before something as molar as the self is even evoked, the card flip has already invited the reader to play with the relations between body, mind, environment, and objects.[27] Here, in that play, we see that the supposedly firm boundaries between psychic ability, personal or subjective intuition, and therapeutic talk slip and become deeply blurred. Indeed, one could argue that "being psychic" in our political economy has shifted away from the notion of being in possession of a supposed esoteric skill or even a skill that could be observed, measured, and tested. Indeed, for many Tarot readers, the "validity" or proof of existence of psychic phenomena is not really the point of their work. Rather, what determines success here is the ability to fold Tarot and its ensuing conversations and affective connections to "work"—or to make them productive in a larger project of well-being. This is a form of well-being that is built up out of moments, flips, and occasions—a well-being constantly in search of itself. While the very process and project of learning to trust and work with "extra information" is a form of affective self-management—the cultivation of a form of affective normativity—this particular political economy also valorizes contested knowledge or what Brian Massumi has called "variety," writing:

> It's no longer disciplinary institutional power that defines everything, it's capitalism's power to produce variety—because markets are saturated. Produce variety and you produce a niche market. The oddest of affective tendencies are okay—as long as

they pay. Capitalism starts intensifying or diversifying affect, but only in order to extract surplus-value. It literally valorizes affect. The capitalist logic of surplus-value production starts to take over the relational field that is also the domain of political ecology, the ethical field of resistance to identity and predictable paths. It's very troubling and confusing, because it seems to me that there's been a certain kind of convergence between the dynamic of capitalist power and the dynamic of resistance.[28]

Such variety encourages a rather interesting paradox, which is the production not only of a feminized and affective subject but of a porous subject capable of opening to, parsing, and making productive what Nigel Thrift has called "an expressive infrastructure" of environments.[29] I would argue that making productive such an infrastructure now adds to one's own reserve of human capital, which, as Michel Feher writes, has become the "dominant subjective form . . . a defining feature of neoliberalism."[30] Writing on the early work of the Chicago economist Gary Becker, Feher writes:

> The notion of human capital, initially, did not seem all that ambitious. It referred to the set of skills that an individual can acquire thanks to investments in his or her education or training, and its primary purpose was to measure the rates of return that investments in education produce or, to put it simply, the impact on future incomes that can be expected from schooling and other forms of training.[31]

This notion of human capital, according to Feher, however, would eventually be broadened "so that its evaluation would include a multiplicity of factors: some innate (e.g., one's genetic background and individual dispositions), others contextual (e.g., one's social milieu, one's parents' ambitions and care) as well as collateral (e.g., one's physical capital or psychological capital, ranging from one's diet or sports regimen to one's sex life or recreational activities). In short, the things that I inherit, the things that happen to me, and the things I do all contribute to the maintenance or the deterioration of my human capital."[32] Such a radical expansion of the notion of human capital points toward a radical territorialization of the practices that Michel Foucault would have considered "care of the self" by capital.

Interestingly, for Feher, the expansion of human capital not only indicates a territorialization of the self in the present but also for future iterations of the self or, as he writes,

> not all investment in human capital is for future earnings alone. Some of it is for future well-being in forms that are not captured in the earnings stream of the individual in whom the investment is made.... In other words, insofar as our condition is that of human capital in a neoliberal environment, our main purpose is not so much to profit from our accumulated potential as to constantly value or appreciate ourselves—or at least prevent our own depreciation.[33]

It is in this double movement of privatization and exploded sociality that we find the Tarot and its students, oscillating between private selves learning to trust one's "inner voice" precisely as that inner voice guides them to become ever more open and receptive and willing to make their lives "productive" by finding ways to apply, translate, and survive through Tarot. This is a form of entanglement not just of the spiritual into daily or ordinary life but of body, affect, energy, and media—a spiritual assemblage fueled by card flips, symbols, elements, and the very voice of these objects.

Notes

1. Still, keeping the Readers' Studio exciting and appealing has been a challenge for Warren and Rose, who use the event to subsidize their weekly classes. While the conference's energetic and welcoming atmosphere is often a unique and affecting experience for newcomers to Tarot, for those readers who attend every year, the workshops can grow repetitive or inapplicable to their practice. The conference costs $295 to attend, plus the costs of travel and accommodations. For many, attending is a stretch and a sacrifice. My first year at RS, one male attendee spoke in the conclusion of the conference about not having enough money to attend but "miraculously" receiving a check a few days prior that allowed him to come. In his speech, it came across that prioritizing the conference is something that even those without ample funds will do because many readers feel that the space is unique, that it re-energizes them and allows them to connect with their "tribe," which does not happen in their day-to-day worlds. Many professional readers feel alienated, often working alone or only meeting other readers online.

2. The experience of the Readers' Studio is notoriously overwhelming and draining. The confirmation letter that is mailed to participants warns them: "Attending The Readers' Studio can be a wonderful, thrilling and sometimes life-changing event. It's a ton of fun, too! But for some people, the swirling energy (psychic and otherwise) can be a bit overwhelming." The letter contains tips for "surviving" the conference, such as taking advantage of the meditation room that Rose and her staff set up, "grounding" oneself through food and naps, staying hydrated, and "finding an energy worker" to help rebalance yourself.

3. Ann Taves, *Fits, Trances, and Visions: Experiencing Religion and Explaining Religion from Wesley to James* (Princeton, N.J.: Princeton University Press, 1999).

4. Molly McGarry, *Ghosts of Futures Past: Spiritualism and the Cultural Politics of Nineteenth-Century America* (Berkeley: University of California Press, 2008).

5. In *The Enchantment of Modern Life* (Princeton, N.J.: Princeton University Press, 2001), Jane Bennett proposes that enchantment is something we encounter, often in surprising and unexpected ways that can strike or shake us. In such shaking, enchantment has the capacity to disrupt what she calls our "default sensory-psychic-intellectual disposition." Enchantment entails here an involuntary suspension of belief. It is a state of wonder that disorients as much as it (potentially) orients a human to a world that is happening both with and without us. For Bennett, enchantment is something she would like to see as positive, something orienting humans to an ethical subjectivity. I am not as sure that enchantment's capacities can be so harnessed, although I am interested in the language that she is attempting to develop, which might help us speak about a life enmeshed in a world not necessarily given to humans.

6. Lenormand cards are their own distinct style of divination cards and are named after the well-known French professional fortune-teller Anne-Marie Lenormand. The cards seem to be based on "The Game of Hope," a German racing game. Around 1850, the German game was adapted to a deck called "The Petit Lenormand," which became more popular in Germany than in France because of the postrevolutionary prohibition on fortune-telling and divination. Both activities, however, remained popular despite the ban.

7. In the Rider-Waite-Smith deck, one of the most popular, "Judgement," is spelled in the British manner, and even many U.S.-produced decks and Tarot books by American authors retain that variant spelling.

8. Sarah M. Pike, *Earthly Bodies, Magical Selves: Contemporary Pagans and the Search for Community* (Berkeley: University of California Press, 2001).

9. Jane Bennett, *Vibrant Matter: A Political Ecology of Things* (Durham, N.C.: Duke University Press, 1999).

10. Ibid., 89.

11. http://innasemestsky.org.

12. http://practicaltarotreadings.com (viewed 2011; site no longer active).

13. Ronald Decker, Thierry Depaulis, and Michael A. E. Dummett, *A Wicked Pack of Cards: The Origins of the Occult Tarot* (London: Duckworth, 1996).

14. David G. Schwartz, *Roll the Bones: The History of Gambling* (New York: Gotham, 2006), 41.

15. Ibid., 30.

16. Jackson Lears, *Something for Nothing: Luck in America* (New York: Penguin, 2004).

17. Ibid., 20.

18. Steven Connor, *Paraphernalia: The Curious Lives of Magical Things* (London: Profile, 2012), 52.

19. Ibid., 53.

20. Ibid., 55.

21. Ibid., 56.

22. Ibid., 58.

23. Katherine Hayles, *My Mother Was a Computer: Digital Subjects and Literary Texts* (Chicago: University of Chicago Press, 2005); Ian Hacking, "Telepathy: Origins of Randomization in Experimental Design," *Isis* 79, no. 3 (1988): 427–51.

24. Hacking, "Telepathy."

25. Alfred North Whitehead, *Process and Reality*, 2nd ed. (New York: Free Press, 1979).

26. Lauren Berlant, *Cruel Optimism* (Durham, N.C.: Duke University Press, 2011).

27. Karen Gregory, "Enchanted Entrepreneurs: The Labor of Esoteric Practitioners in New York City" (PhD diss., Graduate Center of the City University of New York, 2014).

28. Brian Massumi, "Navigating Movements," 2002, http://www.brianmassumi.com/interviews/NAVIGATING%20MOVEMENTS.pdf.

29. Nigel Thrift, *Non-Representational Theory: Space, Politics, Affect* (New York: Routledge, 2008).

30. Michel Feher, "Self-Appreciation; or, The Aspirations of Human Capital," *Public Culture* 21, no. 1 (2009): 21–41.

31. Ibid.

32. Ibid.

33. Ibid.

Ten

We have no idea, now, of who or what the inhabitants of our
future might be. In that sense, we have no future. Not in the
sense that our grandparents had a future, or thought they did.
Fully imagined cultural futures were the luxury of another
day, one in which "now" was of some greater duration. For us,
of course, things can change so abruptly, so violently, so
profoundly, that futures like our grandparents' have insufficient
"now" to stand on. We have no future because our present is too
volatile. . . . We have only risk management. The spinning of
the given moment's scenarios. Pattern recognition.

— WILLIAM GIBSON, *PATTERN RECOGNITION*

R. *Joshua Scannell*

Both a Cyborg and a Goddess

DEEP MANAGERIAL TIME AND
INFORMATIC GOVERNANCE

In her 2012 article "I Would Rather Be a Cyborg Than a Goddess,"[1] Jasbir Puar deconstructs and interrogates the relationship between intersectionality and assemblage theories. She convincingly argues that intersectionality, while epistemologically crucial, both mystifies the categories of oppression that it seeks to unpack and solidifies unstable subjectivities under rubrics that are, ultimately, reflective of hegemonic "humanist" power structures.[2] Assemblage (or, agencement, as she prefers it) destabilizes the body and distributes it. Taking seriously Donna Haraway's claim that the body does not "end at the skin,"[3] she argues that the assemblages of technocapital are not reflective categories but active producers of mutative, unstable relations. Affective intensities, distributed bodily information, data trails, teletechnology, all commingle in a constantly productive distribution of posthumanist political modulations that are the target of what Gilles Deleuze identified as "the society of control."[4]

Puar metonymizes these analytics as goddesses and cyborgs. On the one hand, the reified humanist categories of goddess identity and personhood render a political imagination that exotifies both the subjects it seeks to represent and the political systems that oppress them. On the other, the teleological technical determinism of the cyborg easily slips into a sort of pseudo-intellectual "disruptive" solipsism. Surely, she claims, there must be cyborg goddesses in our midst.

It is my contention that a figure with the attributes of the cyborg goddess has emerged, but that it is not human. Or, put slightly differently, that it is an assemblage of forces that has concatenated as an

object. The becoming-intersectional assemblage of the cyborg goddess not only already exists but is in fact an organizing principle of an emerging logic of algorithmic governmentality. Contemporary forms of data-driven governance conjure an improbable intermingling of historically constructed social arrangements (the intersectional) and nonhuman analysis and prediction that, I argue, construct possible future populations in time scales that are not accessible to human cognition (the cyborg).

To intervene in contemporary discourses surrounding "big data," I look to object-oriented ontology (OOO), which posits that the universe is composed of objects of equal status and unequal force. Rather than envision contemporary data-driven police practices as an extension of old modes of social organizing, I instead argue that they rely on a novel mode of spatiotemporally organizing populations, which is to say matter—and that in doing so, they conjure new social objects. Not exactly human, but extracted and recombined from the human, these carceral quasi-objects thrive on dilating human life chances and debilitating human bodies.

Contemporary modes of data science, and their applications in techniques of governance, have rearranged the terrain of what constitutes the social and must be interrogated. To that end, this chapter uses a brief case study of a relatively new data-processing system employed by the New York Police Department to stage a series of questions about how big data—that most overhyped of buzzwords—suggests a novel mutation in logics of governance and population management. I argue that the capacity to process data streams on the scale and with the speed that the NYPD's system facilitates forces a shift in the target and rationale of governance away from the production and modulation of statistical populations in the biopolitical, humancentric sense of the term (what I call deep managerial time). Instead, big data drives governance toward the maintenance of the efficiency of algorithmic processing as an end in itself. In conjuring this shift, the sociotechnical commitments of governance inaugurate a new object as the target of modulating power—the hybridized mathematical bundlings of material existence.[5] This object is neither an aftereffect of human movement through datafied terrains[6] nor a precursor modulation of security possibilities but an emergent ontological plateau that operates within, through, and on the social via human-indifferent metric technologies.

The Object of Big Data

In hailing this logic as an emergent object, rather than a shift in concepts of governance or a move beyond biopolitics (in other words, as an ontological object rather than an epistemological tactic), I hope to highlight a few points.

First, we should not fetishize the "technological exceptionalism" of our expanding present.[7] In many ways, the big data revolution is a question of scale rather than of kind.[8] These new power configurations do, however, concatenate a certain set of forces that are working on neoliberal biopolitics in uncanny and irreverent ways.[9]

Developments in the capacity to collect, store, and analyze massive amounts of data extraordinarily rapidly have been spotlighted in popular media and academic research as heralding a major transformation in information-driven governance. Collected under the name "big data" is a loose array of techniques and technologies that have posited technical, information-dense solutions to problems that have historically fallen under a wide range of disciplinarily and institutionally distinct sets of knowledge.[10] Whereas, not so long ago, the logical bases of financial houses, astrophysicists, and urban municipal systems were functionally unrelated, they have in recent years converged on a data-driven informatic solutionism that has steadily eroded disciplinary and institutional borders.[11] The skill sets, institutional histories, and goals of scientists using NIH funding to map global genomes are obviously distinct from those of the Target number crunchers who want to granulate demographic position to predict shopping behavior. Yet both of these projects have been written about as examples of the "big data revolution."[12]

Practitioners of big data have concerned themselves with fine-tuning modes of surveillance in an effort to maximize the capacity of ubiquitous information collection to return on a promise of illuminating occulted social relations. Facebook, for instance, invests enormous amounts of money in finding marketable relationships that emerge out of the daily practices of its millions of users idly clicking. Likewise, the NYPD has spent billions on an integrated data analysis software that is designed to make ubiquitous security surveillance accurately predict crime.[13]

From this perspective, calculative governance is in an easy continuum with neoliberal financial and security practices. After all, making

the most efficient use of "information" and "knowledge" to maximize productivity is a central and transhistorical drive of capitalism.[14] Big data analytics appear to be little more than an intensification of already existing processes. This includes an obsession with statistical detail, commitment to technocratic solutionism (and a corollary "rejection" of political "ideology"), demobilization of human labor, highly speculative capital investment, and financialization. However, the quantitative jump in scale and computational capacity that emerges out of neoliberal practice produces a new object of calculative governance. This information-dense cyborg goddess, which emerges in relation to technology but is not the technology itself, warps biopolitical logics and confuses neoliberal governmentality.[15]

Second, governance by algorithm inaugurates a series of practices and dispensation toward the care of the algorithm itself—that algorithmic architectures contain a density that draws labor toward them and that this labor is fundamentally predicated on a governing propulsion that is not "toward" the human but toward the mathematical.[16] The care of the algorithm is a care of mathematics, in which the mathematical desires of metrics become the operative basis for producing and transmogrifying the material.[17] Algorithms are material, are real, and are not human.[18]

Thus, we may begin to make sense of the otherwise bizarre decision of major municipalities to spend billions outsourcing the important work of *making sense of their cities* to mathematicians and computer scientists under the employ of tech conglomerates.[19] This, rather than a mere case of privatizing public services, essentially reorganizes the target of urban governance toward algorithms, server farms, and computational nerve centers. Labor and capital are drawn to the care of the mathematical and its infrastructure as a field of vision—as a way to materialize the city for intervention. Rather than use computational capacity to maximize labor power, maximum labor power serves caring for the algorithm.

Third, the contours of neoliberal biopolitics demand a much less individuated subject than is often taken for granted.[20] They have in fact necessitated massive population blocks and stabilized subjectivities as targets of state and economic intrusion. Rather than proceed from new economic and social theory, neoliberalism inherited a deeper and durable project of heteropatriarchal, militarized racial

capitalism.[21] I call this ontological stabilization of populations *deep managerial time*. I do so in an effort to push back against a narrative of neoliberalism as an individuating practice that upends coherent space-time,[22] and as a reminder that the violent organization of populations subjected to state violence is an inheritance of plantation capitalism given a technocratic veneer.[23]

The ontological requirements of plantation capitalism's metamorphosis into neoliberalism demanded a putatively "flexible" human subject in order to mask the essential stability of state violence and capital expropriation, particularly against women, people of color, and queer populations.[24] Neoliberalism's critics tended, therefore, to focus on how the human subject was constituted for population management through a focus on destabilizing epistemologies. This theoretical intervention is often bracketed as the linguistic turn.[25] Although often labeled antimaterialist, a reframing of neoliberal ontology as deep managerial time opens the space to argue that it was in fact diagnosing the methodologies of population formation under neoliberalism.[26] While neoliberalism still exists, the shift toward algorithmic efficiency as an end in itself suggests that there is a change in the ontological object of governance, in which the "human" ceases to be the desired, massified target and is in fact replaced by the massification of the data trail.

In suggesting this, I do not mean to say that this change has inaugurated a practice of governing that is wholly new in the sense of evaporating intersectional realities of distributions of power and violence. Nor do I want to claim that its effects are phenomenologically novel in the sense that denizens of "smart cities" so much as notice the shift. New York is a city that allows its officers to use possession of prophylactics as legitimate evidence to charge gender-nonconforming people with soliciting.[27] It deals with criticisms of pervasive police violence and abuse against people of color by suggesting that victims solicit state violence by failing to submit to arrest fast enough.[28] It arrests young people of color for dancing on subways.[29] The NYPD now pursues a policy of "omnipresence" rather than "stop-question-and-frisk,"[30] but white supremacist capitalist heteropatriarchy is alive and well, and tends to target similar bodies over a *longue durée*. Intersections and their effects, in other words, are real.

And yet the truth of this "changing same" does not denude the potential utility of promulgating conceptual tools to reckon with

shifting horizons of social life.[31] It instead refashions such a socio-logical imagination as speculative rather than reflective. The aim is not to take stock of existing conditions and propose likely explana-tions for why they exist as such, or to look at existing dynamics and infer a future. Rather, it is to try to tease out the implications that advancing technical capacities and shifting aims of governance have for a virtual sociality that is materializing. It aspires, to borrow a term from A. N. Whitehead, toward a prehensive logic of critique,[32] rather than a predictive one.

Predictive or inferential sociology uses the logics of deep mana-gerial time to produce populations durable enough to solicit prediction in order to mobilize (often state) resources to act on them.[33] First, a subject must be sufficiently stabilized theoretically to justify its in-terpellation in a survey with reasonable expectation that the hailed subject recognize herself as such. We might think of Judith Butler's concept of the citational practices of gender formation as an emblem-atic example of how this operates.[34]

Then, the population parameters of the interpellated subject must be drawn on a naturalized sociality that, while it is perhaps "con-structed," is always constructed by and for "the human." In other words, to keep with the example: once gender stabilizes as a definite category of investigation, it serves as a methodological organizing point for comparison against a range of social forces. Inferential soci-ology might ask, for example, What is the relationship between "women" and "wealth" over a "life course"?

In mapping the datafied subjects onto the social terrain (other-wise known as demography), a population emerges (women) as having a logical trajectory over a space-time that is either heteronormative or in a dialectical relation to heteronormativity (life course). The tauto-logical assumption of this feedback loop is the stability and centrality of "the human" over spans that are inherited from hegemonic notions of space-time, and which then justify the bringing to bear of state apparatuses for intervention.

However, in light of the turn to big data, the methodological tools and epistemological justification for the practice of predictive sociology is eclipsed by a mode of data collection and analysis that does not guess at a future but expands the temporal logic of the pres-ent into a mode of capturing possible futures.[35] Histories do not

course through a durable present onto a logical or imaginable future. Rather, patterns circulate, emerge, destabilize, robbing "human" temporality of meaning, reaching for virtual life trajectories actualized in the vanishing present of an algorithmic calculation that is already always disassembling and grasping at new objects.

In proposing prehensive sociology as an alternative to predictive or preemptive, there is also a necessary rejection of the notion that sociology's role is fundamentally one of demystification. Instead, we should consider sociology as a mode of practice for what Deleuze called developing new weapons.[36] As Karen Gregory argues, "Big data, like soylent green, is made of people."[37] True. But I wonder whether what "people" are becomes increasingly fungible in a period in which the target of governance is not "people" but, rather, the trails of data that cyborged bodies produce and pass through, are instantiated and captured by.[38]

The fact of the matter is that opening up the black box does not explain social ontologies; it reasserts the supremacy of human ingenuity and capacity (one is tempted to say "mastery") as the only reasonable mode of explaining the social.[39] I would argue that, rather than "always historicize,"[40] the call might be to "always mystify" in order to see where these unclear or occluded social relations draw novel spaces for understanding an increasingly mystifying sociality. Algorithms are largely made by people, for people, to do mundane tasks that people are not good at doing very fast. But algorithms are also generative social actors that proliferate relations in strange and awkward directions,[41] that allure social objects to them and peel off bizarre qualities into their relational matrices.[42] I want to follow OOO in arguing, forcefully, that these trails are not traces, nor are they immaterial. They are objects of intervention that are every bit as real, as material, as human beings.[43] This emergent object is exactly the cyborged goddess that Puar suggests.[44] To think contemporary sociality, we could move away from the central assumption that the phenomenological body is the only logical starting point for thinking social experience and toward these mystical cyborgs as a basic organizing principle of contemporary dispositifs of control.

Bodies in this alternative prehensive logic are informational, overflowing, never dead (what does it mean for them to be alive? to whom and subject to what conditions does liveliness register?), never

outside production.[45] The absence of particular modes of embodiment from fields of data collection are powerful informatic present absences just as much as the fully capturable data profiles of the networked and ensconced digital classes. Metadata on where credit cards are not being swiped and quantified selves are not being tracked are just as useful information as the metadata on where they are.[46]

This weird logic renders intersections of oppression as computation errors; debility, disability, genetic inheritance move from organizational operative logics of population management to informational glitches of nonoptimal bodily manifestation.[47] This is a reformulation of a truth that feminist, queer, antiracist scholarship has known and argued for a long time: that, from the governing perspective of societies of discipline and control, "deviant" bodies have always been computation errors, subject to correction. It is no surprise that the figure of the cyborg has emerged so forcefully out of feminist posthuman scholarship: the cyborg has always been built through a white supremacist heteropatriarchal logic that holds nonnormative (read: not white, not hetero, not male, not able, not wealthy) bodies as always already being-toward-management. And, indeed, it is the common-sense understanding that these bodies call out for intervention (in their hysteria, in their ill-discipline, in their disease, in their melancholia, in their skin, in their muscles, in their affects, in their bodies themselves) that undergirds Michel Foucault's periodization of the trajectory of biopolitics.[48]

To tease out aspects of this emerging ontologic, and its implications for sociality, the rest of this chapter is divided into three sections. In the first, I consider the example of the NYPD's Domain Awareness System as indicative of an emerging settlement in the logics of capital and governance on how to properly consider the organization and management of the urban. While I focus on the New York case, I situate it within a more general consideration of "smart cities" and data management systems, and the competitive drive of major information-technology concerns (primarily IBM, Microsoft, and Cisco Systems) to carve out shares of the increasingly lucrative market. Part of this process consists of reimagining the material world as eminently mathematizable, and thereby flattening out received ontological hierarchies of things.

In the second section, I explain how this ontological flattening denotes a significant shift in logics of population organization away from deep managerial time and toward an emergent mode of sociality that Patricia Ticineto Clough, Karen Gregory, Benjamin Haber, and I have elsewhere identified as "the datalogical."[49] Our concept of the datalogical derives from Clough's recent work that theorizes the shifting relations between materiality, metrics, and measurement in the context of teletechnology and the rise of digital sociality. In this section, I address these concepts specifically to what I understand as a nested transition zone in which the datalogical and deep managerial time uneasily cohabitate.

In the final section, I turn to some of the implications of datalogic for life and liveliness. I wonder particularly about the necropolitics of the algorithm and the manner in which emergent digital technologies like the Domain Awareness System enact a sort of "furious media" that communicates between incommensurate ontological planes.[50] I call this uncanny transubstantiation "digital mysticism" and argue that refusing the mystical qualities of the black box on the grounds that the black box can, in fact, be deconstructed is too easy a move in too classic a critical theory vein.[51] Instead, a fruitful speculative sociology might not satisfy itself with demonstrating how digital systems are just code and god is all science, and take seriously the affective captures of a social logic that is so smugly disinterested in the human.

Domain Awareness

In spring 2014, NYPD commissioner Bill Bratton testified before the New York City Council at a hearing on the departmental budget and announced that much of the department's $4.1 billion budget is earmarked for investment in an ominously named "Domain Awareness System" data-processing nerve center.[52]

The Domain Awareness System (DAS), codeveloped with Microsoft, run by Microsoft technicians and analysts, and sold for Microsoft's profit to other municipalities (New York keeps 30 percent of proceeds as an alternative tax structure),[53] has two broad functions. At once proactive and reactive, the system is designed to syncretically

256 R. JOSHUA SCANNELL

loop, making an apparently cybernetic circuit aimed at clarifying generalized surveillance data into actionable policing information.

DAS applies massive processing power to rapidly sort through NYC's surveillance data. Built with Homeland Security funds under an antiterrorism mandate, its surveillance extends far beyond the obviously "criminal" to include data as exotic as feeds from radiation detectors—sensitive enough to pick up recent chemotherapy treatment in passing bodies—and sophisticated enough to rapidly recall up to five years' worth of stored "metadata" and temporally unbounded (and undefined) "environmental data" in its continuously mined databases.[54]

The DAS converts these massive information streams, on the order of several petabytes, into preemptive geospatial representations (maps) that are rapidly filtered down the department hierarchy to identify locations and classes of possible criminal activity.[55] The department argues that if it "knows" where the "criminals" will be, when they will be "there," and what "crimes" they will commit before the "criminals" do, then the department can proactively prevent them. "Real time" capacity to process massive streams of seemingly innocuous or unrelated bits of surveillance data will, the logic goes, produce patterns in the space-time and human geography of criminality that will allow police personnel and matériel to be applied with maximum efficiency.[56]

At the NYC budget meeting, councilmembers were quick to point out the unsettling ring of such a police praxis. In response, an obviously exasperated commissioner chided the Council that, whether civilians like it or not, "Predictive policing is real and it is here. We are beginning to write algorithms that identify in a real-time way paths of criminal activity."[57] While political critics and activists desperately cite the dignity of the human subject as an agent of free will as a necessary condition for sociality,[58] the prison–industrial complex gleefully does away with this basic pretension of the Enlightenment. The virtual future here actualizes in the pattern recognition of the expanded present. The distinction between the two blurs, as a new emergent object of datalogical analysis compresses and contorts temporality and embodiment into a strange blur of mystifying sorting systems. What is simultaneously targeted and conjured is not the human but the patterning of capacities and possibilities distributed over networks of digital surveillance.

Whereas DAS's predictive capabilities are designed to improve the department's oracular ability, its crisis-response infrastructure is essentially reactive: designed to optimize the application and economy of force-dispersal. When an "incident" occurs on the DAS grid, the system identifies the type of disturbance and its location. It displays this information on a set of massive screens in its downtown nerve center and automatically shows the feeds from all local surveillance cameras. The center's technicians (Microsoft employees) then coordinate police and emergency service response. At the same time, the system is storing the details of the incident in its metadata banks,[59] where they remain indefinitely available for future proactive data mining.[60] Thus, the system's circular functionality repurposes in-progress events as granulated futural data, recombinable as data points in complex algorithms within the entire surveillance apparatus of the city of New York.

On the one hand, this datafication of the social world, in order to be circulated in predictive algorithmic architectures, reflects the aim of apparatuses of security to modulate risk at a distance.[61] Rather than cordon off a ghettoized "space of confinement" into which criminality can be organized and acted on,[62] the DAS distributes the logic of securitized surveillance throughout the social field.[63] Its distributed sensor systems make the fluxes and flows of the city the raw informatic material from which it can build algorithms that produce isomorphic knowledge of "paths to criminal activity." At the back end, the DAS actively maximizes the efficiency of tactical response in the real-time unfolding of crisis. Rather than overwhelming disciplinary police presence, the DAS aims to minimize points of contact between urban municipal apparatus and urban disruption. In neoliberal parlance, this minimization of contact points is called "efficiency."

The orientation of security away from geographically delimited spatiotemporal structures (discipline) and toward diffuse and minimal population modulation (control) does not imply a reduction in applied force. On the contrary, apparatuses of control depend on the maximal application of force at minimal points of contact to most efficiently mobilize population dynamics toward satisfactory ends.[64] Extreme technical governance is necropolitical. Since the DAS aims to distribute the maximal application of force at minimum points of contact (efficiency) and models future analytics on the relative effectiveness of

258 R. JOSHUA SCANNELL

existing models, it is not uninteresting that the city's favorite example of this system in action is a 2012 incident outside the Empire State Building in which police rapidly and accurately responded to a violent assault only to accidentally shoot nine bystanders.[65] The speed of response time, number of officers deployed, accuracy of DAS geospatial data—in short, the efficiency of maximum application of force—outweigh the consequences of the operation. The useful information gleaned is enough to render such a fraught exercise in the incidental spilling of civilian blood a technological success story.

Depending on one's political disposition and lived intersectional reality, the DAS often reads as either an important new tool in the quest to build a fairer, smarter, safer city or an Orwellian surveillance dystopia. It is, of course, neither. DAS does not care about the "you" of flesh and bone. It "cares" about making materiality interestingly mathematical. That is to say, once "the world" is a nebula of informational clusters, the interest of sorting algorithms is to see what sorts of relationships can be mapped and what patterns might emerge. A human's ontological status of "being" sublimes into the possibilities of finding improbable relations between data sets.

Deep Managerial Time and Ontologies of Neoliberal Population

It is tempting to argue that developing techniques that seek to manage and make sense of the "infoglut" of contemporary data collection emerge smoothly out of neoliberal practices and theories.[66] After all, these techniques are largely being developed by state and corporate interests that are major boosters for neoliberal ideologies and profit from neoliberal restructuring. I argue, however, that while these sets of practices are concatenating within neoliberal ecologies, they are, by introducing datalogical object-logics,[67] in fact warping many of the basic assumptions that have undergirded neoliberal capitalism. As a consequence, novel spaces of necropolitical distribution are metastasizing throughout an increasingly digitized social field.

While neoliberalism has been about the devolution of state apparatuses designed to manage the economy, it has never been about the devolution of the state or the dividuation of populations.[68] Rather, it has always depended on the formulation of explicit and durable

populations that are to be subjected to state violence in the interest-smoothing spaces for the flow of capital.[69] Always indistinguishable from biopolitics,[70] neoliberalism is, before anything else, a set of tactics and strategies that has human populational (re)productive capacity as its target, and the human security state as its weapon. In the service of this mode of organizational logic, neoliberalism has depended on the deep managerial time of populations, with the human subject as its target.

Deep managerial time demands an ontological separation between what is being measured, the population that measurement produces, and the institutional apparatuses that will then be brought to bear. These ontological distinctions presume a diachronic coherence between object measured and population produced as a political justification for taking action to modulate the population. The necessary assumption, in this loop, is that the committed institutional resources will articulate a change at the level of the human thing itself that will then be noticeable on the metric reproduction of the population. This is the requisite temporal durability of deep managerial time: everything will still (more or less) be there when you get around to measuring it once again.

Under deep managerial time, the orientation of governance and capital is toward the durable replication and modulation of biopolitical categories. This is to say that the nexus of governmental strategies that underwrote the formation and reproduction of a laboring body politic under industrial and postindustrial capitalism imagined sociality as the terrain of the organic, with the human as the figure on which social logics could be drawn.[71] Neoliberal capital-state formations rest on an ontological relationship between measuring technologies, statistical populations, and institutional arrangements in which the target of governance is the organized relationship between human demographic groups and capitalized and/or militarized environments.[72]

Such social relationships are manufactured by hegemonic heteropatriarchal notions of the "biological," in which intersectionally informed rhythms of life transmogrify into denuded technocratic assumptions like "life span."[73] Straight, industrial, middle-class temporalities then stand in for sociological projections across "generations," in which the labor of reproduction disappears into assumptions about the "life course." An interest in the maximization of certain forms of

260 R. JOSHUA SCANNELL

life and the abandonment-toward-death of others drives a particular project of state science geared to the production and assessment of populations as hybrid biological questions, sites of technical intervention, and grounds for probabilistic governance. In other words, the "human" object that is the target of biopolitical governance is a product of its own tautology—produced by exactly the set of techniques that are designed to measure and collate them into probable futures.[74]

For such systems of power/knowledge to "make sense," they must commit to time scales that are conceivable and knowable. Based instrumentally on histories that are spun into recognizable, "meaningful" narratives, the production of human sciences enact a peculiar ontology in which the most significant time-spaces at which measurement might be pursued and honed are oriented around the rhythm of "human" time spans. This biopolitical governmentality of human life—in which institutions of statecraft combine to form knowledge practices that situate a particular convergence of historical, social, and industrial forces as neutrally "human"—is doubly articulated as the raison d'être of the social. It is from where the rationales and funding for measurement emerge. Such ontological assumptions of concepts like "life course" then demand an imagining of predictive futures that are all committed to a temporality centered on the "human" and the state apparatuses that have produced it. Deep managerial time, in its solicitation of rational or reasonable assumptions of the relationship between government, capital, and organism, do the work of mystifying and reinscribing the very force relations that are purportedly the subject of measure.[75]

As neoliberalism deterritorializes the ontological premises of deep managerial time, it also reterritorializes. So, with the dissolution of industrial union-based contract bargaining, and that model of labor settlement's presumption of "straight" time and space, there is the reterritorialization of heteronormative family arrangements as a punitive demand of the state. We can think here of the attacks launched against the urban poor in the twinned dismantling of welfare and rollout of "quality of life" policing as a state project of reorganizing and reinforcing heterocapitalist family formations that had been under pressure in the wake of the collapse of the industrial settlement.[76]

Indeed, we would do well to remember that part and parcel of the turn toward neoliberal economic doctrine in the 1970s and 1980s

was a state retrenchment in security that specifically targeted spaces that were not apparently heteronormative as sites of state violence. To secure the "free hand" of the market's investment, state apparatuses (particularly in New York) mobilized "broken windows" policing strategies to designate queer, and particularly queer people of color, as populations that are inherently criminal, subject to and deserving of state violence. Times Square, after all, was "cleaned up"—that is to say, militarily smoothed out for heteronormative capital flows—to attract the investment of the Disney Corporation.[77]

The violent imposition of heterocapitalist space-time has been a fundamental commitment of neoliberal strategies in governance. Rather than see this as aberrant to individuating and anomic economic structures, we might follow Clyde Woods in pointing out that the violent organization of neoliberalism has inherited its logics from southern "plantation capitalism."[78] He contends that the continuities between plantation capitalism and neoliberalism are clearly articulated in three arenas. First is capital's consolidation of land ownership effected under neoliberal regimes through new enclosure policies such as asset stripping, rezoning, and "economic redevelopment." Second is capital's consolidation over labor power, effected through systematic hammering of labor unions, massive devaluation of labor value, and criminalization of poverty. Third is capital's necropolitical consolidation over policing power and the systematic inversion of legal frameworks for rights claims and citizenship status[79] (what Lisa Marie Cacho has termed "social death"), conducted under the auspices of wars on drugs, gangs, terror, and so forth.[80]

Neoliberalism has, in other words, always been about the production of spatially static and temporally durable populations deliberately exposed and subjected to systematic state violence. The major distinction is that neoliberalism has historically been articulated and defended in purely technocratic language. Rather than late-capitalist enclosure, state-driven (or at least enabled) projects of capital extraction and land consolidation are framed as "economic redevelopment" or "neighborhood improvement" projects, justified with sociologically bankrupt statistical economic projections. It ought to be shocking to no one that a region's GDP will increase after the poor are forcibly expelled and replaced by capital-intensive development schemes. It ought, likewise, to come as no surprise that, as Roderick Ferguson

points out, such technocratic assessments of economy and the criticisms leveled at them from their "left" rest on the a priori radical elision of the poorest and most vulnerable from the social.[81] In other words, it is exactly the force of such a technocratic turn to violently dispossess the poor by producing them as negative populations, as generative populational voids against which the proper body politic can be constituted.[82]

The pursuit of totalized technocracy that is governance-by-algorithm has inaugurated a mode of ontological organization that dissolves deep managerial time. It has provoked a disarticulating movement away from biopolitical orientations toward life and its political constructions, and toward the speculative technical management of a granulated universe of datafied things. This process has several characteristic features that, borrowing loosely from Deleuze's concept of the diagram,[83] we can analyze to coordinate an emerging mode of calculative governance whose intensity is such that it has instantiated a quantitative shift in the logics of the arrangement of governance and capital that has provoked a qualitative change in the production and management of populations.

This rests precisely on (rather than in spite of) the apparently diagrammatic character of big data analytics technologies across such disparate fields as financial trading, public security, military, weather prediction, and so forth. This is most obviously seen in data "fusion centers" being rolled out across the planet. These centers often rely on algorithms designed for one purpose (like weather prediction) in order to make sense of institutionally distinct information flows (so inputs like traffic patterns and electrical grid efficiency end up as basically equal input data points).

Just as the financialization of industry has depended on traders' capacities to reduce production companies to constituent parts and sell them as speculative values on the financial market, fusion centers depend on the logic that institutional histories and knowledges are reducible to constituent parts that can be algorithmically analyzed diagonally across seemingly differentiated knowledge formations. Such an orientation explicitly undermines the ontological presumptions behind deep managerial time. Instead of presuming durability, of organisms, social groups, and institutions, and viewing such durability as epistemologically meaningful and practically desirable, policy

based on massive data mining explodes temporality and strobes it. Histories and historically based policies and policing are transformed into mobile data points. Such analytic systems require understanding capital and community as contagious sets of zeros and ones.[84]

Digital Mysticism, or The Cyborged Goddess

This necropolitical heterotopia rests on the built-in total indifference of computational governance to make ontological distinctions. In *Digital Memory and the Archive*, Wolfgang Ernst points out that, within the black box of the computer, the entire notion of "multimedia" is a con. There are not multiple medias circulating in the computer's hardware being translated via a digital interface. Instead, digitization converts material waveforms into binary bits of information that, to the computer, are interchangeable. The phenomenological appearance of multiple medias is incidental to indifferent computer hardware. It is a by-product of the particular arrangement of human bioware.[85] This flattening of the material into the digitally transactional extends with smart city systems into the materiality of life itself. Objects may exist, endure, and allure one another,[86] but under the regime of informatics, such temporalities become operational formalities rather than ontological substrates. Objects are, in other words, only as real as their capacity to be made computational.[87] Bodies are dividuated points of recombinable data, and "humanness" is a slowing modulation of data flow.[88] In data-driven systems of informatic governance like the NYPD's DAS, life is incidental to the collection and circulation of useful data.

DAS maps produce space, time, and objects' secondary qualities as policeable. Under given spatiotemporal, racialized conditions, like gang injunction sites, the color red is a criminal offense.[89] The DAS does not determine the policy of outlawing red shirts on black bodies, but it provides the technical know-how to determine where red dye is transubstantiated into an eventuality of violence. That the violence provoked by redness is ordinarily police violence is recycled back into a system that understands it as an indicator that "crime is dropping." That is to say, the criminalization of secondary qualities does not reduce violence, as though "violence" is a neutral and abstract thing. Instead, it proliferates violence by endowing the state with the preemptive

justification to flood an area with its own violence—a violence that does not register with departments that understand state violence to be disinterested and therefore not worth collating. So the ratcheting up of state violence, and the distribution of justified violent action toward ever more granulated sites of affective infraction, perversely generates a drop in statistically registered violence. Gang injunction sites, by enabling and amplifying state violence, and proliferating incarceration, insanely indicate to technicians of data collection centers that violence as such is dropping.

The DAS is indifferent to the maximization of certain life potentials over others in that life is incidental to the map, no more relevant than credit histories, shopping habits, electrical usage levels, road quality, air quality, radiation levels, real estate values, noise levels, transportation habits, and so forth. It is the capacity to geospatially arrange such derivate populational values in fast time that is the target of this new mode of state-sponsored, Microsoft-driven criminal production. Racialization and racism's "state-sanctioned or extralegal production and exploitation of group-differentiated vulnerability to premature death" are the raw material, rather than the end point, of such a mode of governance-beyond-control.[90] In such a brutally technical logic of the body politic, the urban poor and mentally ill rot in Rikers Island less because of surplus labor than because of surplus life, because they do not make beautiful math.

But, as is so often the case, if the idea behind this system is to "change the world" in any meaningfully phenomenological sense of the phrase, then none of it works very well. Despite hundreds of billions of dollars that cities pour into smart data management systems, "the city" is still a mess. In New York, quality of life arrests and community policing have criminalized so many quotidian practices that the discretion of the police force to stop, question, frisk, and assault is essentially unencumbered.[91] The impact of "data driven" policing systems has basically been to disincentivize police officers' relationships with policed populations. With the building computational intensity of DAS, most officers are rendered little more than remote controlled enforcers, with limited autonomy to do more than make arrest numbers and inflict violence. They become the prison-industrial-complex equivalent of Amazon warehouse employees, whose labor is monitored

and "maximized" by algorithms. For many on the receiving end, the way DAS predictive policing has played out in real life is indistinguishable from an era before big data analytics became a byword for "good governance" and middle managers started to talk like Ayn Randian technoshamans.

And indeed, big data discourses have increasingly adopted a tenor normally reserved for theological considerations. St. Augustine's proof of the existence of god is repurposed through technobabble about unfathomably enormous data sets pregnant with meaning, but inaccessible to human consciousness. Algorithms appear as gnostic grimoires, with cults of tech priests trained to divine the latent meaning of their communiqués. What systems like DAS are designed to do is to render the social as an undifferentiated nightmare world of information subject to technical intervention and modulation. In its uncanniness, it seems a furious media accessible only through enchanted technological interfaces. Computers are of course hardware. They are nuts-and-bolts counting machines that are easily demystified. Opening the "black box" and looking at its components can bring the mechanism down to earth, and taking apart the algorithm to see its components can remind us of its banality. And yet what they do is apophatic. They translate between incommensurate ontological planes, droving the *via negativa* of technocratic capitalism. They enact technical shifts in the logics of governance and population that account for something like organic liveliness as an afterthought, as an ontological haunting of the numbers.

Both techno-theological fever dream and heavily capitalized reality, the quantification of everything manifests itself in increasingly ubiquitous technologies of datafication and digital surveillance, of which the DAS is but one example. The universe of things is constantly generating data and passing through datafied terrains and conjuring calculated ecologies. The datafication of everything is underpinned by a radical reformulation of liveliness as capacity. A hallucinatory reworking of the possibilities of the body as a field of intervention or ontological object is achieved by a nearly theological encounter with the possibilities of informatics to draw improbable arrangements of technical, modular populations. I call this operational enchantment of the computational "digital mysticism."

But not mysticism in the sense of the total fetishization of the commodity that Apple devotees perform, in which iPhones seem like late-capitalist Turin shrouds, or in the sense of ascribing magical qualities to things that are actually quite understandable. Actual algorithms are often quite boring. It is mysticism as a way to trace how the virtuality of big data has reorganized networks and relations between objects in such a way as to make their "objectness" almost spectral and, crucially, always subject to transubstantiation—into code, into data sets, into efficiency, into ease, into leisure, all of which are ways of saying into capacities of measurement. This measurement, this thirst for metrics, this perverse gnosis enchants the speculative *jouissance* of affective technocapital and the rapacious desires of a carceral state that yearns for the grounds to commit violence without violation. Not mysticism as metaphor but as an accelerative, iterative logic of power. To the extent that there is much left of a human assemblage to be found here, it is certainly a cyborg goddess.

Conclusion

In sum, the emergence of datalogical political calculus from within neoliberalism's violent population racism is noteworthy not because it abnegates the latter's violent drives and processes. Instead, it reintegrates neoliberalism's negative populations as profitable sites of data, and therefore capital, generation. Acting at a distance, governance probes and prods capital's queer times and places, importing them into its mutable calculus of security. For systems like the Domain Awareness System, the concentration of the absence of digital information is in fact productively generative of new arrangements in the logics and apparatuses of security and capital. From quantified human security regimes to speculative derivatives bundling subprime mortgages to apps purpose-built to guide users on how to evade "sketchy" neighborhoods, the emerging forms of governmentality bundle the Other of deep managerial time, against which institutional capacity is mobilized as a coproducer of informatics security-capital. By way of conclusion, I propose three sets of problematics that the emergent dynamics of data logic suggest.

1. Datalogic is emergent within neoliberal settlements of capital and governance—specifically the consolidating formation colloquially

called "big data." Big data has required heavily capitalized commitments to expanding the reach and power of data analytics tools in the interest of maximizing efficiency and productivity. Often the product of hybrid projects of state and private capital, big data infrastructures and projects have tended to demonstrate a commitment to instrumental and technical modes of governance often associated with neoliberalism.

And while the drivers for this investment in such a particular mode of data analytics comports with neoliberalism's financial imperatives, it signals a nascent rupture with neoliberal governmentality's institutional mode of measuring and organizing the social. Neoliberalism as a political praxis has always been deeply committed to institutionally driven tactics of drawing, consolidating, and acting on populations in the interest of maximizing the social space for capital accumulation and expansion. I defined and described this set of operative logics as deep managerial time.

In tracing the power-knowledge dynamics of deep managerial time, I also hope to have flagged certain shifts in the governmentality of populations. Deep managerial time's reliance on institutional commitments to the production of populations in the name of capital security has historically demanded the forcible consolidation of populations and spaces that are to be excluded from capital expansion, to be left or made to die or to be rendered surplus. Datalogic, though not necessarily less brutal, mutates security's carceral spatiotemporal logic.

2. Datalogic performs a praxis of surfaces. It is nonideological in the hermeneutic sense of the term. It is postideological and postpolitical in a way that neoliberalism never has been. Whereas neoliberalism's commitment to deep managerial time presupposed to the ontological stability of a human organism from which to launch the interrogation and production of a polity,[92] datalogic dissolves the organismic into an anorganic analytic of computable relations. This, on the one hand, works as a political nonpolitics. On the other, in its postpolitical technocracy, it depends on a certain dissolution of the body into matrices of analytics and control. I suggest that we might understand this process as a shift away from the mode of "encounter" in which the body "encounters" the technical or the technological in order to "be" digitized. Instead, under a consolidating mode of informatic production,

the body emerges as an onto-epistemological coproduction with data. The "body" stabilizes as a function of human-indifferent techniques of measurement, an ontological haunting of data clouds. 3. Datalogic rests on a biomediated necropolitical logic. Hegemonic techniques of government cannot reduce everything to zeros and ones without an ontology that does not particularly concern itself with the art of distinguishing between life and nonlife. These systems are fundamentally agnostic to the organism. These logics of technical governance and capitalization are only possible under conditions in which the blanket killing and incarcerating of everything is imaginable. It is a transmutation of biopolitical logics of eugenics and genocide and extermination into strategic and technocratic organizations of indefinite detention,[93] mass incarceration, thanatopolitical free-fire death worlds. If life becomes lively only in its capacity to modulate a data set, death becomes just another technical input. Whereas biopolitics, in its own twisted way, is about maximizing life potentials and capacities, this mode of governmentality is about maximizing the algorithmic efficiency of data analysis.

The process of producing death worlds in the name of human security certainly proceeds apace. At the same time, the technical modes by which the production of population are affected have been drawn away from deep managerial time and toward a bizarrely performative, human-indifferent governmentality that is, beyond anything else, about pretty math. Such a mode of governance subjects capital and governance to the aesthetic of the algorithm, rather than the other way around.

Notes

1. Jasbir Puar, "I Would Rather Be a Cyborg Than a Goddess," *Philosophia* 2, no. 1 (2012): 51–66.
2. Ibid., 53–54.
3. Donna Haraway, "A Cyborg Manifesto: Science, Technology, and Socialist Feminism in the Late Twentieth Century," in *Simians, Cyborgs, and Women: The Reinvention of Nature* (New York: Routledge, 1991), 149–81.
4. Quoted in Puar, "I Would Rather Be," 57–58.
5. Vicki Kirby, *Quantum Anthropologies: Life at Large* (Durham, N.C.: Duke University Press, 2011), 22–67.

6. Mark B. N. Hansen, *Bodies in Code: Interfaces with Digital Media* (London: Routledge, 2006).

7. Puar, "I Would Rather Be," 63.

8. Vincent Mosco, *To the Cloud: Big Data in a Turbulent World* (Boulder, Colo.: Paradigm, 2014), 3–5; Evgeny Morozov, *To Save Everything, Click Here: The Folly of Technological Solutionism* (New York: Public Affairs, 2013), 22–25.

9. Pheng Chea, "Non-Dialectical Materialism," in *New Materialisms: Ontology, Agency, and Politics*, edited by Diana Coole and Samantha Frost (Durham, N.C.: Duke University Press, 2010), 87–90.

10. Viktor Mayer-Schönberger and Kenneth Cukier, *Big Data: A Revolution That Will Transform How We Live, Work, and Think* (Boston: Houghton Mifflin Harcourt, 2013).

11. Mark Andrejevic, *Infoglut: How Too Much Information Is Changing the Way We Think and Know* (New York: Routledge, 2013), 24–28.

12. Mayer-Schönberger and Cukier, *Big Data*.

13. Carol Schaeffer, "Bratton Calls Marijuana Decriminalization 'Major Mistake,' May Not Realize It Already Exists," *Gothamist*, May 20, 2014, http://gothamist.com/2014/05/20/bratton_calls_marijuana_decriminali.ph.

14. David Harvey, *A Brief History of Neoliberalism* (Oxford: Oxford University Press, 2007).

15. I am influenced, here, by Reza Negarestani's conceptualization of oil in *Cyclonopedia: Complicity with Anonymous Materials* (Melbourne: re.press, 2008).

16. Patricia Ticineto Clough, "The Digital, Labor, and Measure beyond Biopolitics," in *The Internet as Playground and Factory*, edited by Trebor Scholz (New York: Routledge, 2012), 112–26.

17. Patricia Ticineto Clough and Jasbir Puar, "Introduction," *Women's Studies Quarterly: Viral* 40, no. 1 (2012): 13–26.

18. Jane Bennett, "A Vitalist Stopover on the Way to a New Materialism," in Coole and Frost, *New Materialisms*, 58–64.

19. Kirby, *Quantum Anthropologies*, 49–68.

20. Ruth Wilson Gilmore, *Golden Gulag: Prisons, Surplus, Crisis, and Opposition in Globalizing California* (Berkeley: University of California Press, 2007).

21. Stuart Hall, "The Neo-liberal Revolution," *Cultural Studies* 25, no. 6 (2011): 705–28.

22. David Harvey, *The Condition of Postmodernity: An Enquiry into the Origins of Cultural Change* (Boston: Wiley-Blackwell, 1991).

23. Clyde Woods, "Sittin' on Top of the World: The Challenges of Blues and Hip Hop Geography," in *Black Geographies and the Politics of Place*, edited

by Clyde Woods and Katherine McKittrick (Brooklyn: South End, 2007), 56–61.

24. Dean Spade, *Normal Life: Administrative Violence, Critical Trans Politics, and the Limits of Law* (Brooklyn: South End, 2011).

25. Levi Bryant, Nick Srnicek, and Graham Harman, "Towards a Speculative Philosophy," in *The Speculative Turn,* edited by Levi Bryant, Nick Srnicek, and Graham Harman (Melbourne: re.press, 2011), 1–5.

26. Rey Chow, *The Protestant Ethic and the Spirit of Capitalism* (New York: Columbia University Press, 2002), 95–127.

27. The Pros Network, "Executive Summary," in *Public Health Crisis: The Impact of Using Condoms as Evidence of Prostitution in New York City,* http://sexworkersproject.org/downloads/2012/2012417-public-health-cri sis-summary.pdf.

28. Lauren Evans, "Please Let Police Arrest You, De Blasio Advises," *Gothamist,* August 14, 2014, http://gothamist.com/2014/08/14/dont_f_the _police.php.

29. Christopher Mathias, "Subway Dancers Protest Arrests, Call Out 'Broken Windows' Policing," *Huffington Post,* August 13, 2014, http://www .huffingtonpost.com/2014/08/13/subway-dancers_n_5675438.html.

30. John Surico, "Omnipresence Is the Newest NYPD Tactic You've Never Heard Of," *Vice,* October 20, 2014, http://www.vice.com/read/omni presence-is-the-newest-nypd-tactic-youve-never-heard-of-1020.

31. Amiri Baraka and William J. Harris (ed.), *The Leroi Jones/Amiri Baraka Reader* (New York: Basic Books, 1999).

32. Alfred North Whitehead, *Process and Reality: Corrected Edition,* edited by David Ray Griffin and Donald W. Sherburne (New York: Free Press, 1978), 18–20.

33. Patricia Ticineto Clough, Karen Gregory, Benjamin Haber, and R. Joshua Scannell, "The Datalogical Turn," in *Non-Representational Methodologies: Rethinking Research,* edited by Phillip Vannini (New York: Routledge, 2015).

34. Judith Butler, *Bodies That Matter: On the Discursive Limits of "Sex"* (Durham, N.C.: Duke University Press, 1993), 12–16.

35. Luciana Parisi, *Contagious Architecture: Computation, Aesthetics, and Space* (Cambridge, Mass.: MIT Press, 2013), 66–82.

36. Gilles Deleuze, "Postscript on the Societies of Control," *October* 59 (1992): 3–7.

37. Karen Gregory, "Big Data, Like Soylent Green, Is Made of People," Response to Frank Pasquale Given at Triple Canopy, November 1, 2014, http://digitallabor.commons.gc.cuny.edu/2014/11/05/big-data-like-soylent -green-is-made-of-people/.

38. Patricia Ticineto Clough, "The Affective Turn: Political Economy, Biomedia, and Bodies," in *The Affect Theory Reader*, edited by Melissa Gregg and Gregory Seigworth (Durham, N.C.: Duke University Press, 2010), 215–24.

39. Alex Williams and Nick Srnicek, "#Accelerate: Manifesto for an Accelerationist Politics," in *#Accelerate: The Accelerationist Reader*, edited by Robin Mackay and Armen Avanessian (Falmouth, U.K.: Urbanomic, 2014), 360–61.

40. Frederic Jameson, *The Political Unconscious: Narrative as a Socially Symbolic Act* (Ithaca, N.Y.: Cornell University Press, 1982), ix.

41. Benjamin Grosser, "What Do Metrics Want? How Quantification Prescribes Social Interaction on Facebook," *Computational Culture* 4 (2014), http://computationalculture.net/article/what-do-metrics-want.

42. "Allure" is a concept that Graham Harman has adapted from Whitehead to explain how objects form into relations with one another. According to Harman, the ontological basis of relation is aesthetic. Objects with commensurate secondary qualities (he often uses the example of fire and cotton) gravitate toward one another. He calls this process "allure."

43. Graham Harman, *Prince of Networks: Bruno Latour and Metaphysics* (Melbourne: re.press, 2009), 110–12.

44. Puar, "I Would Rather Be," 63.

45. Jasbir Puar, "Prognosis Time: Towards a Geopolitics of Affect, Debility and Capacity," *Women and Performance* 19, no. 2 (2009): 164.

46. Jordan Crandall, "The Geospatialization of Calculate Operations: Tracking, Sensing and Megacities," *Theory Culture Society* 27, no. 68 (2010): 68–90.

47. Puar, "Prognosis Time," 165.

48. Michel Foucault, *An Introduction*, vol. 1 of *The History of Sexuality*, translated by Robert Hurley (New York: Vintage, 1978).

49. Clough et al., "Datalogical Turn."

50. Achille Mbembe, "Necropolitics," translated by Libby Meintjes *Public Culture* 15, no. 1 (2003): 11–40; Alexander Galloway, Eugene Thacker, and McKenzie Wark, *Excommunication: Three Inquiries in Media and Mediation* (Chicago: University of Chicago Press, 2013), 113–39.

51. Ibid., 5–8.

52. Schaeffer, "Bratton Calls Marijuana Decriminalization 'Major Mistake.'"

53. Neal Ungerleider, "NYPD, Microsoft Launch All-Seeing 'Domain Awareness System' with Real-Time CCTV, License Plate Monitoring (Updated): The New York Police Department Has a New Terrorism Detection System That Will Also Generate Profit for the City," *Fast Company*, August

8, 2012, http://www.fastcompany.com/3000272/nypd-microsoft-launch-all-seeing-domain-awareness-system-real-time-cctv-license-plate-monito.

54. "Public Security Privacy Guidelines," April 2, 2009, http://www.nyc.gov/html/nypd/downloads/pdf/crime_prevention/public_security_privacy_guidelines.pdf.

55. Pervaiz Shallwani, "'Future' of NYPD: Keeping Tab(let)s on Crime Data: Officers Will Be Armed with Digital Tablet and Mobile App," *Wall Street Journal*, March 4, 2014, http://online.wsj.com/articles/SB1000142405 27023048150045794194823463315614.

56. Colleen Long, "NYPD, Microsoft Create Crime-Fighting 'Domain Awareness' Tech System," Associated Press, April 22, 2013, http://www.huff ingtonpost.com/2013/02/20/nypd-microsoft-domain-awareness-crime-fight ing-tech_n_2727506.html.

57. Schaeffer, "Bratton Calls Marijuana Decriminalization 'Major Mistake.'"

58. Michelle Alexander, *The New Jim Crow: Mass Incarceration in the Age of Colorblindness* (New York: New Press, 2012).

59. Christopher Robbins, "Photos: Inside the NYPD's New 'Domain Awareness' Surveillance HQ," *Gothamist*, August 8, 2012, http://gothamist .com/2012/08/08/photos_the_nypds_new_ultimate_domai.php#photo-1.

60. "Public Security Privacy Guidelines."

61. Michel Foucault, *The Birth of Biopolitics: Lectures at the College de France, 1978–1979*, translated by Graham Burchell (New York: Picador, 2010), 239–66.

62. Michel Foucault, *Madness and Civilization: A History of Insanity in the Age of Reason*, translated by Richard Howard (New York: Vintage, 1988), 35–60.

63. Deleuze, "Postscript."

64. Eyal Weizman, *The Least of All Possible Evils: Humanitarian Violence from Arendt to Gaza* (London: Verso, 2012), 99–134.

65. James Rush, "Microsoft's New Crime-Fighting 'Matrix' Shows Cops Every Corner of New York City at the Touch of a Button—and Even Tells Them Arrest Records of Suspect They Are Chasing," *Daily Mail*, February 21, 2013, http://www.dailymail.co.uk/sciencetech/article-2282109 /Domain-Awareness-System-Microsoft-help-develop-interactive-crime-fight ing-gives-New-York-police-world-data-click-finger.html.

66. Andrejevic, *Infoglut*.

67. In this bundling of political theory and object-oriented ontology, I am particularly influenced by Levi Bryant's work on thinking through the "political opportunity of SR." See Bryant, "Politics and Speculative Realism," *Speculations: A Journal of Speculative Realism* 4 (2013): 15–21.

68. Gilmore, *Golden Gulag.* For "dividuation," see Deleuze, "Postscript."

69. Paul Amar, *The Security Archipelago: Human-Security States, Sexuality Politics, and the End of Neoliberalism* (Durham, N.C.: Duke University Press, 2013).

70. Foucault, *The Birth of Biopolitics.*

71. J. K. Gibson-Graham, *The End of Capitalism (as We Knew It): A Feminist Critique of Political Economy* (Minneapolis: University of Minnesota Press, 1996), 46–71.

72. Randy Martin, "From the Race War to the War on Terror," in Patricia Ticineto Clough and Craig Willse, eds., *Beyond Biopolitics: Essays on the Governance of Life and Death* (Durham, N.C.: Duke University Press, 2011), 258–76.

73. Judith Halberstam, *In a Queer Time and Place: Transgender Bodies, Subcultural Lives* (New York: New York University Press, 2005), 1–22.

74. Patricia Clough, "The Case of Sociology: Governmentality and Methodology," *Critical Inquiry* 36, no. 4 (2010): 627–41.

75. Bruno Latour, *We Have Never Been Modern,* translated by Catherine Porter (Cambridge, Mass.: Harvard University Press, 1993).

76. Priya Kandaswany, "Gendering Racial Formation," in *Racial Formation in the Twenty-First Century,* edited by Daniel Martinez HoSang, Oneka LaBennett, and Laura Pulido (Berkeley: University of California Press, 2012), 32–38.

77. "Samuel R. Delany, *Times Square Red, Times Square Blue* (New York: New York University Press, 1999).

78. Clyde Woods, "Les Miserables of New Orleans: Trap Economics and the Asset Stripping Blues, Pt. 1," in *In the Wake of Hurricane Katrina: New Paradigms and Social Visions,* edited by Clyde Woods (Baltimore, Md.: Johns Hopkins University Press, 2010), 347–66.

79. Woods, "Sittin' on Top of the World," 46–76.

80. Lisa Marie Cacho, *Social Death: Racialized Rightlessness and the Criminalization of the Unprotected* (New York: New York University Press, 2012).

81. Roderick A. Ferguson, *Aberrations in Black: Toward a Queer of Color Critique* (Minneapolis: University of Minnesota Press, 2004), 4–29.

82. Eugene Thacker, "Necrologies, or the Death of the Body Politic," in Clough and Willse, *Beyond Biopolitics.*

83. Gilles Deleuze, *Foucault,* translated by Sean Hand (Minneapolis: University of Minnesota Press, 1988), 34–39.

84. Jussi Parikka, *Digital Contagions: A Media Archaeology of Computer Viruses* (New York: Peter Lang, 2007).

85. Wolfgang Ernst, *Digital Memory and the Archive,* edited by Jussi Parikka (Minneapolis: University of Minnesota Press, 2013), 118–20.

86. Harman, *Prince of Networks,* 220–21.

87. Ibid. I consider this a twist on Harman's contentions that objects emerge out of relations, but exceed them and are not exhausted by them. In the case of the object of the cyborg goddess of computation, I see this as emerging out of computation while not necessarily being exhausted by it.

88. Patricia Ticineto Clough, "Biotechnology and Digital Information," *Theory, Culture & Society* 24 (2007): 312–14.

89. Critical Resistance Oakland, *Betraying the Model City: How Gang Injunctions Fail Oakland,* February 2007, http://crwp.live.radicaldesigns.org/wp-content/uploads/2012/04/CR_GangInjunctionsReport.pdf.

90. Gilmore, *Golden Gulag,* 28.

91. "Federal Appeals Court Upholds Rulings That Stop-and-Frisk Is Unconstitutional," *Guardian,* November 22, 2013, http://www.theguardian.com/world/2013/nov/22/federal-appeals-court-upholds-rulings-stop-frisk-unconstitutional.

92. Foucault, *The Birth of Biopolitics,* 239–66.

93. Nicholas De Genova, "The Production of Culprits: From Deportability to Detainability in the Aftermath of 'Homeland Security,'" *Citizenship Studies* 11, no. 5 (2007): 421–48.

Acknowledgments

OOF has been a collaborative project since its inception, and there are more people to thank than seems possible in this small space. I am grateful to the authors of this volume for their intellect and creativity. Their resilient energy made this undertaking possible and fun, and along the way they have become among my closest intellectual companions: Irina Aristarkhova, Karen Gregory, Marina Gržinić, Frenchy Lunning, Timothy Morton, Anne Pollock, Elizabeth A. Povinelli, R. Joshua Scannell, and Adam Zaretsky.

We are collectively indebted to the many participants who enlivened OOF panels at annual conferences for the Society for Literature, Science, and the Arts (SLSA) since 2010. In addition to the authors already named, I thank this wily and witty cadre: Jamie "Skye" Bianco, Ian Bogost, Wendy Hui Kyong Chun, Patricia Ticineto Clough, Melanie Doherty, Orit Halpern, N. Katherine Hayles, Eileen Joy, Danielle Kasprzak, Amit Ray, Scott Richmond, Steven Shaviro, Rebekah Sheldon, Susan Squier, and members of SLSA who contributed to our discussions. Patricia Ticineto Clough and Frenchy Lunning were my coconspirators in getting OOF's first forays off the ground, and I am immensely grateful for their infectious generosity.

As an organization, SLSA deserves recognition for fostering a uniquely welcoming and unpretentious interdisciplinary environment. At the first meetings I attended as a graduate student, I observed and internalized inspiring acts of disciplinary modesty and intellectual curiosity. SLSA continually impresses on me the possibility of putting

theory into practice; it embodies a tenor of humility I strive to inject into my own interdisciplinary investigations.

Irina Aristarkhova, Karen Gregory, Anne Pollock, and Trevor Smith tirelessly read and reread drafts of my Introduction to this book. Their careful feedback, insights, and suggestions strengthened it enormously. I thank them for patiently educating me, enlarging my vision of the project, and sharing references that have been essential to my own understanding of OOF's reach.

OOF was shaped in significant ways through my experience developing *And Another Thing*, an exhibition I cocurated at the James Gallery at the CUNY Graduate Center in 2011. I thank my cocurator, Emmy Mikelson, as well as Katherine Carl and Jennifer Wilkinson, of the Center for the Humanities, and Eileen Joy, of punctum books, the publisher of an expanded exhibition catalog, *And Another Thing: Nonanthropocentrism and Art*. The exhibition was accompanied by a series of related programs hosted by the Center for the Humanities. For this exceptionally intellectually rich context, I thank the speakers and cosponsors: Suzanne Anker, Jane Bennett, Levi Bryant, Patricia Ticineto Clough, Karin Cuoni, Graham Harman, Adrienne Klein, Hannah Landecker, Kyoo Lee, Noortje Marres, Shannon Mattern, Victoria Pitts-Taylor, Bernard Stiegler, and David Turnbull, as well as the catalog authors, Bill Brown, Patricia Ticineto Clough, and Robert Jackson.

Special thanks are due Danielle Kasprzak, my editor at the University of Minnesota Press, for convincing me to make OOF into a book in the first place. Without her steadfast guiding vision for this project, her confidence of OOF's significance, and her willingness to steer me, an artist, through unfamiliar editorial terrain, this volume would be unthinkable. Anne Carter's editorial assistance and organizational diligence were indispensable, as was Paula Dragosh's keen editorial eye. I thank the superb reviewers for the University of Minnesota Press, Steven Shaviro and an anonymous reviewer; their excellent schematic and detailed comments on the manuscript vastly strengthened the collection.

I thank all of my smart and funny colleagues in the Department of Fine and Performing Arts at Baruch College for their constant support, sympathy, and humor while I worked on this project.

I extend my deepest gratitude to many individuals who offered generous support, encouragement, and insights along the way: Irina Aristarkhova, Jane Bennett, Shelley Burgon, Ben Chang, Patricia Ticineto Clough, Alex Galloway, Alex Golden, Karen Gregory, Graham Harman, Jillian Hernandez, Marianne M. Kim, Emmy Mikelson, Anne Pollock, Stephanie Rothenberg, Lorraine Rudin, Silvia Ruzanka, Ely Shipley, Katy Siegel, Trevor Smith, Valerie Streit, Lynn Sullivan, Angela Valenti, Iris van der Tuin, and others I am forgetting to name.

Finally, I thank my various families, biological and otherwise, who hold me up and hold me together: the Behars, Lius, and Laus, as well as "the Hunters" and "the Lotuses." Deepest thanks go to my parents, Ken and Linda Behar, and my grandparents, Joe and Ruth Behar, and Pin-Pin Tan and David Hung Dong Liu.

Contributors

IRINA ARISTARKHOVA is associate professor of art and design, women's studies, and history of art at the University of Michigan, Ann Arbor. She is the author of *Hospitality of the Matrix: Philosophy, Biomedicine, and Culture* and editor of *Woman Does Not Exist: Contemporary Studies of Sexual Difference.*

KATHERINE BEHAR is an interdisciplinary media and performance artist and assistant professor of new media arts at Baruch College, City University of New York. She is author of *Bigger Than You: Big Data and Obesity* and coauthor, with Emmy Mikelson, of *And Another Thing: Nonanthropocentrism and Art.* Her art publications include *Katherine Behar: Data's Entry* and *Katherine Behar: E-Waste.*

KAREN GREGORY is a lecturer in digital sociology at the University of Edinburgh. She is coeditor of *Digital Sociologies.*

MARINA GRŽINIĆ works at the Institute of Philosophy at the Scientific and Research Center of the Slovenian Academy of Science and Arts in Ljubljana, Slovenia. She is professor at the Academy of Fine Arts in Vienna, Austria. Her latest book, coauthored with Šefik Tatlić, is *Necropolitics, Racialization, and Global Capitalism: Historicization of Biopolitics and Forensics of Politics, Art, and Life.*

FRENCHY LUNNING is professor of liberal arts at the Minneapolis College of Art and Design. She is author of *Fetish Style* and *Cosplay: Fashion and Fandom* and editor of the *Mechademia* book series published by the University of Minnesota Press.

TIMOTHY MORTON is Rita Shea Guffey Chair in English at Rice University. He is the author of *Hyperobjects: Philosophy and Ecology after the End of the World* (Minnesota, 2013), *Realist Magic: Objects, Ontology, Causality, The Ecological Thought, Ecology without Nature,* and eight other books.

ANNE POLLOCK is associate professor of science and technology studies at Georgia Tech. She is the author of *Medicating Race: Heart Disease and Durable Preoccupations with Difference.*

ELIZABETH A. POVINELLI is Franz Boas Professor of Anthropology at Columbia University, where she is also affiliated with the Institute for the Study of Women, Gender, and Sexuality. She is the author of *Economies of Abandonment: Social Belonging and Endurance in Late Liberalism, The Empire of Love: Toward a Theory of Intimacy, Geneology, and Carnality, The Cunning of Recognition: Indigenous Alterities and the Making of Australian Multiculturalism,* and *Labor's Lot: The Power, History, and Culture of Aboriginal Action.*

R. JOSHUA SCANNELL is a PhD candidate at the CUNY Graduate Center. He is the author of *Cities: Unauthorized Resistances and Uncertain Sovereignty in the Urban World.*

ADAM ZARETSKY is professional lecturer of media arts in the School of Communication and the Arts at Marist College and the Headmaster of VASTAL (The Vivoarts School for Transgenic Aesthetics Ltd.).